THE AMASIS PAINTER AND HIS WORLD

THE
AMASIS PAINTER
AND HIS WORLD

VASE-PAINTING IN
SIXTH-CENTURY B.C. ATHENS

DIETRICH VON BOTHMER

with an introduction by

ALAN L. BOEGEHOLD

THE J. PAUL GETTY MUSEUM
Malibu, California

THAMES AND HUDSON LTD.
New York / London

Exhibition dates:
The Metropolitan Museum of Art, New York, September 13 – October 27, 1985
The Toledo Museum of Art, November 24, 1985 – January 5, 1986
Los Angeles County Museum of Art, February 20 – April 6, 1986

Copublished by Thames and Hudson New York and London

Library of Congress Cataloging-in-Publication Data

Von Bothmer, Dietrich, 1918 –
 The Amasis Painter and his world.

 Bibliography: p. 32
 Includes concordances
 1. Amasis, 6th cent. B.C.—Exhibitions.
2. Vase painting, Greek—Greece—Athens—
Exhibitions. I. Title.
ND115.A55A4 1985 738′.092′4 85-12590
ISBN 0-89236-086-0 (pbk.)
ISBN 0-500-23443-4 (hbk.)

The cover illustration is a detail of side B of a panel-amphora (type B) by the Amasis Painter in the collection of the Staatliche Antikensammlung und Glyptothek, Munich (Cat. 4).

CONTENTS

Exhibitions of Greek and Roman art have become increasingly popular in the United States in the last thirty years. Greek vases were singled out in *Attic Vase Painting in New England Collections* (Fogg Art Museum, Harvard University, 1972), *Greek Vase-Painting in Midwestern Collections* (The Art Institute of Chicago, 1980), and *Art, Myth, and Culture: Greek Vases from Southern Collections* (New Orleans Museum of Art and Tulane University, New Orleans, 1981 – 1982). The horizon was widened and the focus sharpened with *The Art of South Italy: Vases from Magna Graecia* (Virginia Museum of Fine Arts, Richmond; Philbrook Art Center, Tulsa; and Detroit Institute of Arts, 1982 – 1983). The current exhibition and catalogue continue in this direction; yet they concentrate neither on vases now located in a given region, nor on those from a certain geographic area of the ancient world. Instead, the opportunity is taken to unite many of the preserved works of a single Archaic artist, the Attic vase-painter known as the Amasis Painter. Dietrich von Bothmer, Chairman of the Department of Greek and Roman Art at the Metropolitan Museum of Art, proposed opening the exhibition on September 13, 1985, the centenary of the birth of Sir John Beazley (1885 – 1970), the man who in sixty years of scholarly life did more for the recognition and appreciation of Attic vase-painting than anyone else.

A one-man exhibition was first suggested by Kurt T. Luckner, Curator of Ancient Art at the Toledo Museum of Art, whose first choice was the great Attic master Exekias. At a meeting held in Toledo in May 1983 with Dr. von Bothmer, however, the difficulties of exhibiting Exekias in a representative manner led to the selection instead of Exekias' colleague the Amasis Painter for a variety of reasons: the

much larger number of his works that have been preserved, the high proportion of his vases already owned by museums and collectors in the United States, and the willingness of certain European museums to lend their vases, a willingness that had already been expressed in 1972 when Dr. von Bothmer first thought of holding an exhibition of the artist's work at the Metropolitan Museum. In subsequent meetings the project was carried forward with the active support of four institutions, the Toledo Museum of Art, the Metropolitan Museum of Art, the J. Paul Getty Museum, and the Los Angeles County Museum of Art.

Dr. von Bothmer is responsible for the selection of the painter's work and has written an essay on the painter and the entries for this catalogue, which the J. Paul Getty Museum undertook to fund and produce. Alan L. Boegehold, Professor of Classics, Brown University, kindly agreed to write an introductory essay, "The Time of the Amasis Painter," which gives a concise account of the geography, history, and political and cultural climate of Athens in the days of the Amasis Painter. Martha Ohly-Dumm contributed a special appendix (Appendix 4), an advance publication of the unique and important fragmentary tripod-pyxis excavated in 1971 by Dieter Ohly at the temple of Athena Aphaia on Aegina. The catalogue has been seen through production with admirable skill by Sandra Knudsen Morgan, Director of Publications at the J. Paul Getty Museum. Educational materials accompanying the exhibition were produced jointly by the Education Department of the Los Angeles County Museum of Art, under the guidance of William Lillys and Jane Burrell, and by Kurt Luckner and Rose Glennon at the Toledo Museum of Art.

We owe warm thanks to our museum colleagues and private collectors in the United States and Europe for their exceptionally generous response to our requests for loans from their collections. In many instances, vases have been cleaned or restored expressly for this exhibition. We wish to extend particular thanks to Prof. Dr. Herbert Cahn, Basel; Dr. Ernst Berger, Director, and Dr. Margot Schmidt, Assistant Director and Curator, Antikenmuseum und Sammlung Ludwig, Basel; Prof. Dr. Wolf-Dieter Heilmeyer, Director of the Staatliche Museen Preußischer Kulturbesitz, Antikenmuseum, Berlin; Thomas T. Solley, Director, and Adriana Calinescu, Curator of Ancient Art, Indiana University Art Museum, Bloomington; Cornelius C. Vermeule, Curator of Classical Art, Museum of Fine Arts, Boston; Dietrich von Bothmer, Centre Island, New York; Steffen Trolle, Assistant Keeper, Antiksamlingen, Nationalmuseet, Copenhagen; Jacques Chamay, Conservateur, Musée d'art et d'histoire, Geneva; Norbert Schimmel, Kings Point, New York; Brian F. Cook, Keeper, and Dyfri Williams, Assistant Keeper, Department of Greek and Roman Antiquities, The British Museum; Prof. Dr. Bur-

khardt Wesenberg, Chief of Department, and Prof. Dr. Robert Fleischer, Institut für Klassische Archäologie, Universität Mainz; John and Elsbeth Dusenbery, Montclair, New Jersey; Dr. Klaus Vierneisel, Director, Staatliche Antikensammlungen und Glyptothek, Munich; Martha Ohly-Dumm, Munich; P.R.S. Moorey, Keeper, and Michael Vickers, Assistant Keeper, Department of Antiquities, Ashmolean Museum of Art and Archaeology, Oxford; Alain Pasquier, Conservateur en Chef, Département des Antiquités Grecques et Romaines, Musée du Louvre, Paris; André Miquel, Administrateur Général, and Andrée Pouderoux, Conservateur, Bibliothèque Nationale, Paris; Irène Aghion, Conservateur, Cabinet des Médailles, Paris; G. Roger Edwards, Keeper of Collections, Mediterranean Section, The University Museum, University of Pennsylvania, Philadelphia; Dr. B. von Freytag gen. Löringhoff, Kustos der Antikensammlungen, Archäologisches Institut der Universität Tübingen; Prof. Carlo Pietrangeli, Director General, Monumenti, Musei, e Gallerie Pontificie, Vatican; and Prof. Dr. Erika Simon, Director, and Dr. Guntram Beckel, Konservator der Antiken, Martin von Wagner Museum der Universität Würzburg.

The organization of the exhibition was directed by Kurt T. Luckner. The securing of loans and grant support and the management of myriad details were coordinated from Toledo. Special thanks are due to Patricia J. Whitesides, Registrar at the Toledo Museum of Art, for her care in organizing the transportation, insurance, and indemnification. Kim Coventry, curatorial intern at Toledo, assisted Kurt Luckner. At the Los Angeles County Museum, John Passi acted as exhibition coordinator. We also thank the members of the curatorial departments of our museums for their efforts in making this exhibition a reality. Kurt Luckner in Toledo; Marion True and Arthur Houghton, Associate Curators of Antiquities at the Getty Museum; Dietrich von Bothmer, Chairman, and Joan Mertens, Curator and Administrator, of the Department of Greek and Roman Art at the Metropolitan Museum; and Constantina Oldknow, Associate Curator of Ancient Art at the Los Angeles County Museum, became a team that effectively addressed every aspect of the exhibition's organization. We are grateful to Kurt Forster and Herbert Hymans, Director and Program Director of the Getty Center for the History of Art and the Humanities, Marion True, Arthur Houghton, and Constantina Oldknow for their joint efforts in bringing together leading scholars from the United States and Europe for two symposia held in Los Angeles in the spring of 1986 on the political, economic, and cultural life of sixth-century Athens.

Support for the exhibition has come from public and private sources. We are indebted to the National Endowment for the Humanities, a Federal Agency, for generous grants underwriting the planning and implementation. The exhibition is also supported by an indemnity

from the Federal Council on the Arts and the Humanities. We are further indebted to the private donors who have supported the exhibition both with generous gifts and with personal commitments to furthering the knowledge of ancient art. These sponsors comprise Mr. and Mrs. Walter Bareiss, Mr. Christos Bastis, Mr. and Mrs. Torkom Demirjian, Mr. and Mrs. Leon Levy, Mr. and Mrs. Herbert W. Lucas, Mr. and Mrs. Bruce P. McNall, Mr. Jonathan P. Rosen, Mr. Norbert Schimmel, two anonymous friends of the American School of Classical Studies at Athens, Axios (Greek-American Foundation, Los Angeles), and Neutrogena Corporation.

This catalogue has been made possible with the support of an anonymous friend of the exhibition.

<div align="right">

ROGER MANDLE
Director
The Toledo Museum of Art

PHILIPPE DE MONTEBELLO
Director
The Metropolitan Museum of Art

EARL A. POWELL III
Director
Los Angeles County Museum of Art

JOHN WALSH, JR.
Director
The J. Paul Getty Museum

</div>

There are 117 vases attributed to the Amasis Painter in J.D. Beazley's *Attic Black-figure Vase-painters* (Oxford 1956) and *Paralipomena* (Oxford 1971)—or more precisely, 116, since 2 of his entries are from the same vase. After 1971, 16 more vases and fragments have come to light or have been recognized as by the Amasis Painter, making a total at the time of writing of 132. Of this impressive number, about half, 65, are here united in an exhibition and fully catalogued. Two of the Amasis Painter's vases have been lost from view for more than 150 years; others have been lost or are feared destroyed during the Second World War, but an effort has been made to bring together a representative selection that includes all of the preserved vases by the Amasis Painter signed by Amasis the potter and to illustrate by way of comparison most of his vases that are not included in the exhibition.

The catalogue entries are based on detailed notes taken in almost fifty years of studying Greek vase-painting. I confess that I have never myself seen ten of the Amasis Painter's vases and seventeen of his fragments. Six of these are unpublished, and for them I have had to rely on photographs and drawings. In my studies I have been greatly assisted by many curators and collectors. In addition to thanking those who have contributed to the current exhibition, I should like to thank in particular my friends and colleagues at the National Museum, the Agora Museum, and the American School of Classical Studies in Athens, who on my twelve journeys to Greece between 1950 and 1983 have received me with traditional Greek hospitality. This is also the place to record my deepfelt thanks to Semni Karouzou, not only for her own penetrating studies of the Amasis Painter, which go back to 1931, but also for the friendly interest she has taken in my work for over thirty years. The greatest debt, of course, is owed by all of us to Sir John Beazley. The first international exhibition of vases by one great Greek vase-painter opens

on September 13, 1985, the centenary of Beazley's birth, and it is to be hoped that the exhibition and catalogue may serve as a memorial tribute to the great scholar and friend.

If the catalogue is somewhat more detailed than other exhibition catalogues, especially in measurements and records of added color, this is no accident but represents a deliberate effort to combine the essential information given in more recent fascicules of the *Corpus Vasorum Antiquorum* with observations on style and composition. With this in mind, I have also included profile drawings. Those taken of oinochoai are the work of Andrew J. Clark, who kindly made available his detailed notes as well. Kurt T. Luckner verified and supplemented measurements and descriptive notes on the Amasis Painter's vases in Geneva, Munich, Würzburg, London, and Oxford. Dyfri Williams most helpfully checked particulars of the vases in the British Museum, and Guntram Beckel reexamined the vases in Würzburg. Steffen Trolle contributed with some measurements of the lekythos in Copenhagen, and Friederike Naumann performed a similar service in Mayence. Of my colleagues in the Metropolitan Museum of Art, Joan R. Mertens, Curator and Administrator of the Department of Greek and Roman Art, read and improved the entire manuscript, Maxwell L. Anderson, Assistant Curator of Greek and Roman Art, helped to track down entries for the bibliography, and Lydia Mannara, in addition to typing an unwieldy text, assisted in many different ways in the preparation of the manuscript.

Sandra Knudsen Morgan and Sylvia Tidwell undertook the task of editing the manuscript and were ably assisted by Marcia Reed, Carol Sommer, and Judy Sandell of the Getty Center for the History of Art and the Humanities. Their careful scrutiny saved me from some errors and irritating inconsistencies, and I am grateful for the scrupulous attention they paid to a manuscript that became much longer than anticipated. The layout and design are the work of Dana Levy of Perpetua Press, Los Angeles, who in consultation with Sandra Knudsen Morgan worked very hard to strike a happy balance between a scholarly book and an appealing one. Though the catalogue was produced far from New York, there was never a problem of proper communication.

While the bibliographies are rather long, it is quite possible that many a mention has escaped me. For any such omission I wish to apologize in advance. The "height of figures" given in the catalogue is measured along the curving wall of the vase and is intended to serve as an indication of the scale of the figures. Unless otherwise indicated, the profile drawings, graffiti, and dipinti are reproduced 1:2; the fragments of vases in the catalogue are all 1:1.

DIETRICH VON BOTHMER
April 1985

ABBREVIATIONS

Frequently cited publications are abbreviated as listed below:

AA	*Archäologischer Anzeiger*
ABFV	J. Boardman, *Athenian Black Figure Vases: A Handbook* (New York 1974)
ABL	C.H.E. Haspels, *Attic Black-figured Lekythoi* (Paris 1936)
ABS	J.D. Beazley, *Attic Black-figure: a Sketch* (London 1928)
ABV	J.D. Beazley, *Attic Black-figure Vase-painters* (Oxford 1956)
AJA	*American Journal of Archaeology*
AM	*Mitteilungen des Deutschen Archäologischen Instituts, Athenische Abteilung*
Agora 11	E.B. Harrison, *The Athenian Agora* 11: *Archaic and Archaistic Sculpture* (Princeton, N.J., 1965)
ARV²	*Attic Red-figure Vase-Painters,* 2nd ed. (Oxford 1963)
BABesch	*Bulletin van de Vereeniging tot Bevordering der Kennis van de Antieke Beschaving*
BCH	*Bulletin de correspondence hellénique*
Black-figured Vases	J.C. Hoppin, *A Handbook of Greek Black-figured Vases* (Paris 1924)
BSA	*Annual of the British School at Athens*
Cabinet Durand	J. de Witte, *Description des antiquités et objets d'art qui composent le cabinet de feu M. le Chevalier E. Durand* (Paris 1836)
Catalogue 2	*A Catalogue of the Greek and Etruscan Vases in the British Museum* 2: H.B. Walters, *Black-figured Vases* (London 1893)
Catalogue des vases antiques	E. Pottier, *Catalogue des vases antiques de terre cuite* (Paris 1896 – 1906)
CVA	*Corpus Vasorum Antiquorum*
Development	J.D. Beazley, *The Development of Attic Black-figure* (Berkeley, Calif., 1951)
Führer	E. Simon, *Führer durch die Antikenabteilung des Martin von Wagner Museums der Universität Würzburg* (Mainz 1975)
GettyMusJ	*The J. Paul Getty Museum Journal*
Greek Vase Painting	P.E. Arias and M. Hirmer, *A History of One Thousand Years of Greek Vase Painting,* translated and revised by B. Shefton (New York 1962)
Hermitage	K.S. Gorbunova, *Chernofigurnye atticheskie vasy v Ermitazhe* (Leningrad 1983)
Horses	M.B. Moore, *Horses on Black-figured Vases of the Archaic Period, ca. 620 – 480 B.C.* (Ann Arbor, Mich.: University Microfilms International 1978)
JdI	*Jahrbuch des Deutschen Archäologischen Instituts*
JHS	*Journal of Hellenic Studies*
JOAI	*Jahreshefte des Oesterreichischen Archäologischen Instituts in Wien*
LIMC	*Lexicon Iconographicum Mythologiae Classicae* (Zurich 1981 –)
Meistersignaturen²	W. Klein, *Die griechischen Vasen mit Meistersignaturen²* (Vienna 1887)
MM	*Mitteilung des Deutschen Archäologischen Instituts, Madrider Abteilung*
MMA	The Metropolitan Museum of Art
MMA Bulletin	*The Metropolitan Museum of Art Bulletin*

MuZ	E. Pfuhl, *Malerei und Zeichnung der Griechen* (Munich 1923)
NSc	*Notizie degli scavi di antichità* [Accademia Nazionale dei Lincei]
Paralipomena	J.D. Beazley, *Paralipomena: Additions to Attic Black-figure Vase-painters and to Attic Red-figure Vase-painters, 2nd ed.* (Oxford 1971)
RA	*Revue archéologique*
REA	*Revue des études anciennes*
RM	*Mitteilungen des Deutschen Archäologischen Instituts, Römische Abteilung*
Sammlung Ludwig	*Antike Kunstwerke aus der Sammlung Ludwig,* ed. E. Berger and R. Lullies, vol. 1 (Basel 1979)
Spätarch. Kunst	K. Schefold, *Götter- und Heldensagen der Griechen in der spätarchaischen Kunst* (Munich 1978)
Techniques	J.V. Noble, *Techniques of Painted Attic Pottery* (New York 1965)
Trademarks	A.W. Johnston, *Trademarks on Greek Vases* (Warminster 1979)
Vasi del Vaticano	C. Albizzati, *Vasi antichi dipinti del Vaticano* (Rome 1925 – 1939)
Wiener Vorlegeblätter	*Wiener Vorlegeblätter für archaeologische Übungen* (Vienna 1879 – 1891)
Zeitbestimmung	E. Langlotz, *Zur Zeitbestimmung der strengrotfigurigen Vasenmalerei und der gleichzeitigen Plastik* (Leipzig 1920)

THE TIME OF THE AMASIS PAINTER

Alan L. Boegehold

GREECE

The world of the Amasis Painter is Greece, in particular, Athens during the years from roughly 560 to 515 B.C. Greece in those years was not a geographical entity; it was delimited instead by a distinctive way of thinking and talking. Communities identified themselves as Greek by their use of the Greek language, which, if not the same in all parts of Greece—there were dialects and even variations in alphabets—had an essential identity. Those who spoke other tongues were stutterers; they made noises that sounded like *bar-bar-bar* and so were duly labeled "barbarians."

In the legendary past, Greek heroes had wandered over the whole world. Two, Theseus and Herakles, had even visited the underworld. But their time, the time of the great Minoan and Mycenaean civilizations, had ended and was followed by a long dark age, usually calculated as lasting from the twelfth century B.C. until some time in the ninth century B.C. And so in the time of the Amasis Painter, the world was still being rediscovered. Colonists and entrepreneurs of every sort moved ceaselessly back and forth and around the Mediterranean Sea (fig. 1). The colonists went because of need, as when drought brought famine and sickness. In their search for new places to live, they founded more than 150 colonies, among them Syracuse, Neapolis, Thasos, and Byzantium (fig. 1). Colonists also went because of ambition, curiosity, and greed. Greek traders had discovered the possibilities of commerce. Their amphorae full of wine, grain, and oil brought them, in exchange, wealth and the luxuries that foreign lands, especially those to the east, provided.

Traces of Greek civilization—mostly pottery and metal objects, some monuments and writings as well—are found on the shores of the Black Sea, down the western coast of Turkey, at Al Mina, on Cyprus, throughout the islands in the Aegean Sea, the Peloponnese, mainland Greece north to Albania, islands of the Ionian Sea, southern Italy, France,

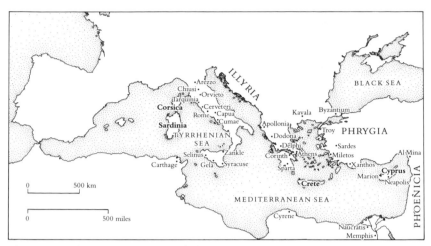

Fig. 1. Map of the eastern Mediterranean Sea, showing Greek colonies in the sixth century B.C..

Germany, Corsica, Spain, and the northern coast of Africa, including Memphis, Naucratis, and Tell Defenneh in Egypt. Populations were small. Laconia, one of the two chief powers in Greece in 480 B.C., had in its chief city, Sparta, only around eight thousand citizens—that is to say, males of a certain age who could take an active part in government (Herodotus 7.234). Athens, as populous as any state, had twenty thousand citizens in the late fifth century, making for a total population—counting wives, children, slaves, and metics—of perhaps two hundred thousand. Most communities, though, were much smaller.

The shallow, blue-green Mediterranean Sea was never far from any Greek settlement. Islands in the Aegean Sea, that stretch of the Mediterranean between Greece and Turkey, are bare and unwatered tips of limestone mountains that rise from the sea floor (fig. 2). Faults run along parts of that sea floor, causing catastrophic earthquakes from time to time. The lands encircling the sea are dry and fragrant with heather, thyme, rosemary, oregano—all the plants that make up the Mediterranean maquis. On rocky hillsides in winter are cyclamen; in spring, poppies, irises, and anemones fill the meadows. Trees include olives, figs, cypresses, maples, box, firs, pines, holm oaks, beeches, ashes, chestnuts, laurels, planes, and poplars. In ancient Greece, topographical features—hills, ravines, mountain ranges, rivers, and sea—defined boundaries for communities. Access to fresh water, in critically short supply in many places in the eighth century, determined where people could live, for the deep artesian wells of the Romans were many years in the future. "Water is best," sang Pindar (*Olympian Odes* 1.1).

Thessaly alone among these lands had extensive grassy plains for horses. Sparta, Argos, Corinth, Sicyon, and Boeotia, while not without horses, gave their fertile fields over to cultivation. Arcadians, it was commonly said, ate acorns in their rugged mountains, since they had few arable fields. Throughout Greece, sheep and goats supplied milk and meat. Meat, however, was not a dietary staple. It was eaten after a sheep or goat had been sacrificed. For the most part, as Plato describes the decent, early settlers of his *Republic* (372B), people ate wheat and barley made into bread and cakes, salt, olives, and cheese, with figs and peas for dessert.

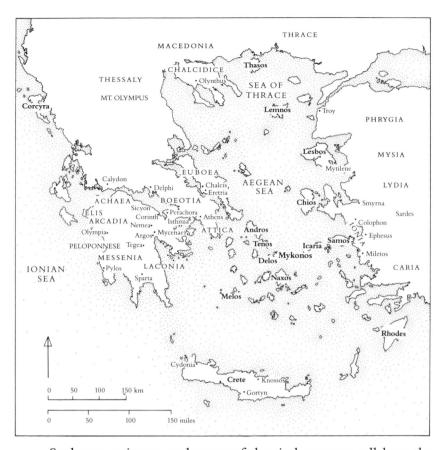

Fig. 2. Map of Greece in the sixth century B.C., including the Aegean Sea and East Greece.

Sculptors, painters, and poets of the sixth century tell how the people looked and behaved at home, on festal days, and at war. Writers in prose, all a hundred years or more later, preserve anecdotes, achievements, and defeats. Men worked outdoors, moving freely in their communities and beyond into the wide world. Women worked at home, spinning thread from flax and wool and weaving at their looms (see Cat. 48). Contemporary sixth-century witnesses, almost without exception aristocrats in spirit, recognize two sorts of people: landholders and others. Kings as great landholders had largely disappeared, remembered as legendary, not to say fabulous, ancestors, looking in retrospect perhaps like the perfect king Odysseus describes, "ruling a populous and mighty state with the fear of god in his heart and upholding the right, so that the dark soil yields its wheat and barley, the trees are laden with ripe fruit, the sheep never fail to bring forth their lambs, nor the sea to provide its fish—all as a result of his good government—and his people prosper under him" (Homer, *The Illustrated Odyssey* 19.110 – 19.114, trans. E. V. Rieu [New York 1981]).

While kings had passed away, nobles remained. They were the biggest landholders, and from among them came adventurers who fitted out ships and explored the world. With them went dependent kinsmen, tenants, and smallholders who wanted adventure. Small landholders fought beside the great in battle, and even the least of them also had dependents. The others—the unpropertied folk—were in some states

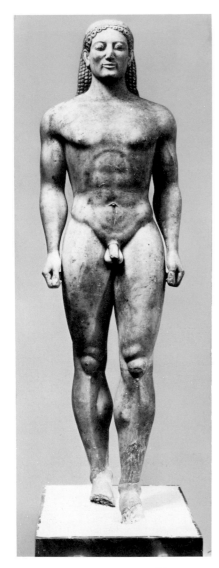

Fig. 3a,b. Kouros, or youth from Anavysos. The inscription on the base reads: "Stand by the tomb of Kroisos who died and mourn: / Him as he fought at the head of battle / Did wrathful Ares fell." (It is not absolutely certain that the base belongs.) Circa 530 B.C. Athens, National Museum, 3851.

(Sparta, for instance) possibly descendants of an original native population, having survived but remaining distinct from invaders who came and conquered and remained. In some communities, foreigners with a trade or skill could live and even thrive, but were not allowed to own real property unless they became citizens.

There were also slaves, whose modes and degrees of bondage were various. They could be men and women who had been taken in war, and no one at home had ransomed them. Or perhaps they had offered their persons as security for loans, which it then turned out they could not repay. Or parents had abandoned them at birth, leaving them somewhere for another to find and rear, eventually to profit from their toil. This toil could be any form of work—as a domestic, teacher, miner, prostitute, day laborer. In Athens slaves and citizens might work side by side for the same wage, as they are documented as doing on some major building projects in the fifth century.

The nobles who became explorers contracted marriages with the progeny of kings and potentates they came to know in their travels. Marriage between members of one Greek community and another was not customary without a prior formal agreement by which such unions could be contracted. The great ones of the world, however, seem not to be impeded by constraints of custom. In addition to these marriage ties, members of powerful families established guest-friendships, whereby one great house bound itself in solemnly consecrated tradition to another such house in another land. They and their descendants scrupulously observed the consequent duties of hospitality and friendship for generations. By the time of the Amasis Painter, there were many such connections, not only between Greeks but also between Greeks and barbarians.

A comparatively new phenomenon in that world was the *polis,* or city-state, a population center with a coherent, identifiable populace and formal administrative procedures concerning justice, membership in the community, and land—both that given to dwellings and places of worship and that of the surrounding country generally. *Polis* is usually translated "city-state," because the concept includes land far beyond the central living area. Most Greeks, in fact, were born and brought up as country folk, including those who as adults made their living in a city; and even most of those who had always lived at the center would go daily to their fields just outside the city.

In the sixth century, a Greek might use the word *beautiful* (*kalos* or *kale*) to describe male and female alike. Painters and sculptors represented men and boys either naked or clad in such a way as to accentuate their bodies underneath. The men we see as kouroi (fig. 3) or on vases (Cat. 4) have broad shoulders, deep chests, narrow waists, and muscular buttocks and thighs. They wore their hair long, pulled back into braids or a club and bound with a fillet. Clothes consisted of chiton, himation, and chlamys, and leather hats for winter (see Glossary, p. 241). Many men also carried a sword or dagger as an item of personal attire. This custom was both cause and result of their looking at the world in a certain way: since every Greek man went through his days with a nicely

calibrated measure of the honor his own personal dignity required, slights, intentional or not, were inevitable. In a world where combat tested and certified manhood, such slights could easily lead to fighting that had a fatal outcome.

From before Homeric times, when a man died by violence, though not in war—it could be in combat or by accident or even by mistake—his death was a family affair: blood relatives had a duty to avenge the death. Families could avoid further bloodletting by agreeing to pay or receive compensation for a homicide. A sense that violent death might infect plants, animals, and people with dangerous pollution led to widely practiced cleansing rites. Even so, forced exiles and long vendettas continued to be endemic in the sixth century.

Women and girls, when they came from a family that could afford to dower them, were rarely seen in public. On certain feast days, however, they could show off their fine clothing and their physical attributes. They wore chitons or peploi that would on such occasions be richly decorated (fig. 4 and Cat. 53). These feast days were the chief times when young men could look at the marriageable young women of their towns. Those considered beautiful had straight shoulders, deep bosoms, high, muscular buttocks, straight noses, and high foreheads.

While women had no official part in civic affairs and were not actually citizens, they were the mothers, wives, and daughters of citizens, hence free. In some states, Athens and Gortyn, for instance, they could even own and bequeath property. In parts of Greece, notably Lesbos and Sparta, women had independence and a well-developed sense of their identity as important, articulate persons—witness the great Lesbian poet Sappho (fig. 5) and Alkman's Spartan singers. Moreover, a girl or woman in Sparta could compete in state athletic contests. Women were also priestesses in the service of certain gods—Athena at Athens, Hera at Argos, and Artemis at Brauron; these offices (as opposed, say, to that of Sibyl at Delphi) may have entailed administrative responsibilities.

A Greek man, to judge from contemporary literature, mostly poetry, was not introspective. To the question of what he thought of himself, he might have answered briefly: He was mortal. He did not contend with gods. (This was a practical application of the Delphic precept "know thyself.") He might hope that his conduct and achievements would encourage posterity to measure him with Homer's heroes. He did contend with his fellows, both in peacetime and in war—and in Greece, war, if not actually present, was always either imminent or just past.

Men and women learned what they knew by watching and listening, not by reading. Some six or seven hundred years before the Amasis Painter's time, Greeks at Knossos, Mycenae, and Pylos represented the sounds of Greek by written signs. The syllabary they used is now conventionally termed Linear B and is in no way related to the Greek alphabet. For some reason Linear B disappeared (one reason for the term "dark" age); not until the ninth century did voyagers discover and appropriate a North Semitic alphabet that they could modify to repre-

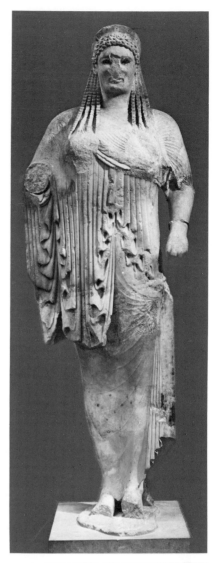

Fig. 4a,b. Kore, or maiden displaying her fine clothing and physical attributes. Signed by the sculptor Antenor and dedicated, as the inscription on the base records, by the potter Nearchos: Νέαρχος ἀνεθεκε[ν ηο κεραμε]- / ὺς ἔργον ἀπαρχὲν τἀθ[εναίαι] / ᾿Αντένὸρ ἐπο[ίεσεν η] / ο Εὐμάρος τ[ὸ ἄγαλμα]. After 520 B.C. Athens, Acropolis Museum, 681.

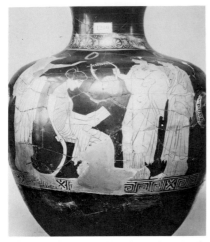

Fig. 5. The poetess Sappho, as imagined by an Athenian painter of the mid fifth century. Detail of a red-figured hydria attributed to the Group of Polygnotos. Circa 450 B.C. Athens, National Museum, 1260.

Fig. 6. "Who now by dancing sports most nicely of all. . . ." Inscription on the shoulder of the Dipylon oinochoe. Circa 725 B.C. Athens, National Museum, 192.

sent Greek. Exactly how and where they found it is a mystery. Cadmus, founder of Thebes in Boeotia, was the agent in one tradition. Palamedes, legendary inventor of ballots, dice, and game-board tallies, was the discoverer in another. And in yet another, the Titan Prometheus claims credit (Aeschylus, *Prometheus Vinctus* 459 – 462). To judge from the earliest uses Greeks made of their àlphabet, they may first have valued letters as elements of decoration and as a way to make poetry visible. The earliest monuments on which Greek writing is preserved attest to egocentricity and playfulness, two strong components of the aesthetic impulse. "Who now by dancing sports most nicely of all," a line of verse scratched into an oinochoe, apparently announces a prize (fig. 6). "Whoever drinks from this cup, fair-crowned Aphrodite's yearning will take him straightaway," also verse, is scratched into a cup identified by inscription as belonging to a man named Nestor (fig. 7). Other early examples of writing decorate aryballoi—oil or perfume bottles—or identify grave monuments. By the artist's day, communities were publishing their laws in written form on the assumption that those concerned could read them. But for the most part, people learned by word of mouth what they needed to know.

If men and women were careful of their honor, it was because their families and communities gave them their conception of themselves. To be thought a coward or slave or to be laughed at for the wrong kind of folly could be intolerable. They did not have immortal souls, they only had their standing in this life. And this life was a precarious thing. Gods were beautiful, remote powers whose help traditional lore regularly showed to be paradoxical. Consider, for instance, the help Croesus had from Apollo, who delayed the capture of Sardes and saved Croesus from being burned alive. Neither form of aid was at all what Croesus expected (Herodotus 1.91).

Zeus, Hera, Athena, Apollo, Artemis, Hermes, Aphrodite, Ares, Hestia, Poseidon, Demeter, and Hephaistos—the Olympians—all stood for elements, qualities, or impulses: sky, love, rain, hunt, fire, wisdom, war, and so on. They were not, however, popularly conceived of as powers or essences whose meanings and forces were unique. Poseidon, lord of horses (see Cat. 60), was the sea and earthquakes that shook the land. Demeter was earth and grain, and Dionysos, "not only the liquid fire in the grape, but the sap thrusting in a young tree, the blood pumping in the veins of a young animal, all the mysterious and uncontrollable tides that ebb and flow in the life of nature" (E.R. Dodds, *Euripides: Bacchae* [Oxford 1953] x; see also Cats. 2, 19). There were other gods, too—Hades and Rhea and Hekate—and there were more to come. In praying, Greeks called upon a particular god in a special aspect—as guardian of their city or house or of oaths, or as healer or god of prophecy, for example. If the time seemed right, there was no reason for them not to include any potentially helpful foreign god in their prayers.

Thoughtful men at the same time were questioning popular notions of godhead. Thales of Miletos theorized that "everything is full of gods" (H. Diels and W. Kranz, *Die Fragmente der Vorsokratiker* [Berlin 1960] fr. 22). Xenophanes of Colophon was amused at the way humans pictured

gods as looking like humans: "If cows had hands, and horses and lions, or could write with hands and do works of man, horses would draw gods that looked like horses, and cows, cows" (H. Diels and W. Kranz, *Die Fragmente,* fr. 15).

Bygone heroes and heroines were also important as immediate forces or influences on life. Secure the bones of Orestes to protect your land. Sacrifice to Helen to make your daughter beautiful. And mark off places on the ground where supernatural forces had concentrated themselves, spots where lightning had struck, for instance: do not walk there. Communities, nonetheless, were not frozen into rigid attitudes. Memorials of a city's founding hero could vanish without a trace if it seemed expedient to install a different "founding hero."

Song and dancing to flute and lyre were integral to all ceremonial— one might say, all of life's functions. People expressed themselves with their whole bodies, whether at a feast, at a ritual, in the marketplace, or at home, striking postures and gesturing with head and hand to fill out or, indeed, even to say what they wanted (Cat. 2).

Fig. 7. "Whoever drinks from this cup, fair-crowned Aphrodite's yearning will take him straightaway." Inscription on a fragmentary cup, which is also inscribed with the name of owner, Nestor. Circa 550 B.C. Ischia, Museum.

ATHENS

ATHENS IS ATHENA'S CITY. According to the myth of the city's founding, the goddess won Athens for her own when she defeated Poseidon in a competition to see which of them could present the best gift to Athens. Poseidon offered the sea; Athena, the victor, offered the olive, whose oil, shipped in amphorae, was one day to form a basis for the city's wealth. The city-state of Athens included all the land called Attic (an old name that has no connection with the name Athena) and occupied an area about the size of Rhode Island (fig. 8). It is bordered east and south by the Aegean Sea; north and west by the low mountains Aigaleos, Parnes, and Kithairon. These separate Athens from Thebes to the north and Megara to the west. Within the space enclosed by mountains and sea, some rocky hills, Mount Pentelikon, Mount Hymettos, and especially the Acropolis and Hill of Ares, defined Athenian settlement. Athenians also had farms in the hilly country around Laureion toward Cape Sounion, to the northeast around Rhamnous, and around the foot of Mount Parnes.

The streams of Athens—Eridanos, Kephisos, and Ilissos—flow in and around a much smaller area, south, east, and north of the Acropolis, near the heart of the ancient city-state; in the time of the Amasis Painter most of the town dwellers lived and worked at the foot of the Acropolis on its south and east sides (fig. 9). At the same time they were using the Agora, or marketplace (and later civic center), just north of the Acropolis. Excavations there, conducted by the American School of Classical Studies in Athens, have recovered the Altar of the Twelve Gods, a focal point of the later city. The Amasis Painter may still have been alive when Peisistratos, Hippias' son, dedicated it in 522/21.

Landholders planted olive trees and vines on the productive land. Those who lived in the walled urban area had fields and gardens just outside the wall. Other usable land was found east of Mount Hymettos,

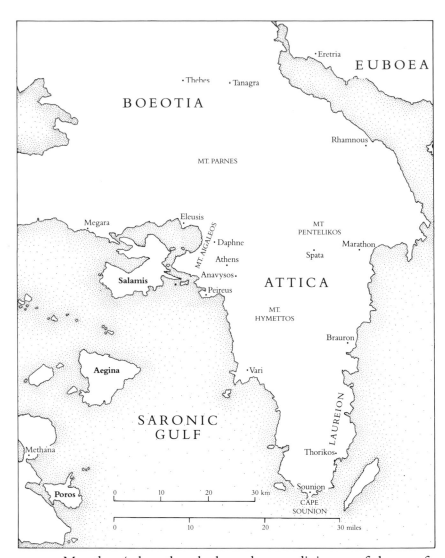

Fig. 8. Map of Attica in the sixth century B.C.

up near Marathon (where there had once been a religious confederacy of neighboring communities called the Tetrapolis), and around Eleusis, where Demeter's mysteries were celebrated. In traditional practice at least, if not by written law, land stayed in the family. Transfers of ownership may have been possible within a given family or tribe, and land was sometimes appropriated when a smallholder could not meet a debt, but on the whole, land only changed hands through bequest.

Yet suppose a piece of land lost its productivity, having been used over and over again for the same crops. Or a multiplying family needed more food than the land could give, or they produced more heirs than the size of the property could sustain through subdivision. What did a family do then? They could go out and cultivate new tracts. But in rocky Attica that is not a solution that can be applied over many generations. Land, especially flat land, was valuable, its extent finite. Emigration, therefore, was an option that was regularly exercised.

Some Athenians lived in less promising areas among the lower hills. Nowhere was the soil rich and deep. The "bones of earth," an old metonymy for the limestone substructure of the land, obtrude everywhere as ledge or slabs of rock. "Thin-soiled," Thucydides called Attica (1.2), and he gave this as a reason for the state's history of long, uninterrupted occupation. If invaders came, they had little cause to stay. Indeed, Athenians began in the fifth century B.C. to style themselves autochthonous—sprung, that is, from the very ground of Attica—and this unifying claim, insofar as it meant that the same race of people had always lived there, may have had a basis in fact. In the Amasis Painter's time, however, a number of prominent Athenians traced their lineage to other states. Peisistratos, to take a notable instance, traced his descent from King Neleus, a hero from Pylos in the southwestern corner of the Peloponnese. Harmodios and Aristogeiton (fig. 10), who in one Athenian tradition killed the Peisistratid tyrant, came from a family called Gephyraioi. Herodotus identifies them as Phoenicians originally, who came to Boeotia with Cadmus. Their Athenian citizenship was made subject to certain conditions that Herodotus does not explain. They brought to Athens their own customs of worship (Herodotus 5.57 – 5.60).

At some time long enough before recorded history to be given legendary origins, Attica was united under a central administration. Hamlets and towns that later came to be some of the demes in the administrative structure of the fully developed democratic city-state once had been principalities, each with its own council house, or bouleuterion, each independent of the rest. Thucydides writes that Theseus, a generation or so before the Trojan War, became king of Athens and established a single central council house for the whole state (2.15). The final unification of Attica, however, may not have been completed before the seventh century B.C. By that time, nobles had appropriated the king's office and were administering the state's affairs as archons. One acted as chief executive. Another, called king, inherited the king's sacred and ceremonial functions. A third, the war archon, commanded in wartime. Later an additional six archons came into being. They had some executive and some judicial functions, whence they were called thesmothetai, or lawgivers.

Nobles jockeyed for position among one another and fought for archonships. Kylon provides a cautionary example of such strife and its results. An Olympic champion, he had linked himself to Theagenes, tyrant of Megara, by marrying the tyrant's daughter. Around 636 B.C., he and his supporters went up onto the Acropolis, hoping to seize control of the city. The Acropolis, meaning literally "the top of the city," is a limestone plateau about one hundred fifty meters high that had served for hundreds of years as cult center and refuge from enemy invaders (fig. 11). Cut off from other public and private land, the level top of the Acropolis was consecrated chiefly to Athena, who sustained and protected the city in her many aspects, among which were those of City-holder (Poliouchos) and Leader in Battle (Promachos). Control of the Acropolis offered those who held it, besides symbolic eminence,

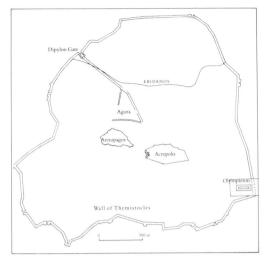

Fig. 9. Map of Athens in the sixth century B.C. showing the fifth-century Wall of Themistocles; the exact location of the sixth-century wall is unknown.

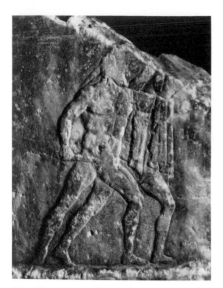

Fig. 10. Harmodios and Aristogeiton. Detail of the relief on the right side of the Elgin Throne representing the Tyrant Slayers, the bronze group by the sculptors Kritias and Nesiotes; this group was erected in 476/75 B.C. to replace the group by Antenor that had been set up in the Agora of Athens in 505 and stolen by the Persians in 480/79. "I shall wear my sword in a myrtle branch / just as Harmodios and Aristogeiton did / when they killed the tyrant / and made Athens a place / of equal rights for all" (a skolion, or drinking song, D.L. Page, *Poetae Melici Graeci* 893). Malibu, The J. Paul Getty Museum, 74.AA.12.

tactical advantages in battle. There were also rich offerings in the temples and treasuries.

As it turned out, Kylon's attempt was frustrated. Since the city was small and the fields ringed the city, news spread quickly and the populace could be effectively assembled. So Athenians came in from their fields and besieged Kylon. He himself escaped, but a number of his followers were eventually killed. The Athenians judged immediately responsible for their deaths, members of another great Athenian family, the Alkmaionidai, seem not to have obtained ritual cleansing from this pollution, nor did they satisfy the claims that the injured families had against them as a result of the violence. The Alkmaionidai, therefore, continued to answer for old blood deeds: members of the family spent years in exile during the sixth century, and even as late as the fifth century B.C., charges concerning the old pollution served the politics of their enemies.

The nobles finally saw that they had to find other solutions if they were to survive. There was an old custom whereby a man who killed another could pay compensation to the family of the dead man, thereby ending what otherwise would become a deadly continuing quarrel between the two families. But uncertainties arose as to who could be called family: A father, a brother, a son—those are unquestionably family. But what about uncles and cousins and members of the same tribe? What were the criteria? These contentious and quick-spirited nobles had to have a secure basis for determining who exactly could act as family in such circumstances. In 621 B.C., the lawgiver Draco gave Athens a code of laws in which the provisions for homicide carried exactly such stipulations. His homicide laws proved serviceable enough to continue in use even with Solon's new law code and the rule of the Peisistratids. More than two hundred years after its first appearance, Draco's laws on homicide were republished (fig. 12).

By the beginning of the sixth century, if nobles had found a way to keep from exterminating one another, it became clear that their dependents—the poor relations, tenant farmers, servants, and slaves, who made up their support—were becoming universally disaffected. We do not know exactly what form their resistance took. The solution, however, shows that it was necessary to mitigate what had become a quarrel between powerful landed gentry on one side and smallholders and laborers on the other.

In 594, Solon, an Athenian noble chosen by his peers to make Athens livable for all citizens, issued a law code by which he took some rights and privileges away from the nobles and gave them to the people. He canceled debts and he stopped men from binding their own persons as security for loans. The people had perhaps been hoping for a general reapportionment of land, but Solon did not give them that. He records his decision in trochaic tetrameters: "nor is it my choice to act with tyranny's violence, nor that the noble and the base have an equal share in our rich land" (Solon apud Aristotle, *Constitution of the Athenians* 12.3). Nor did any subsequent Athenian government. In the fourth century, jurors were sworn to oppose land redistribution.

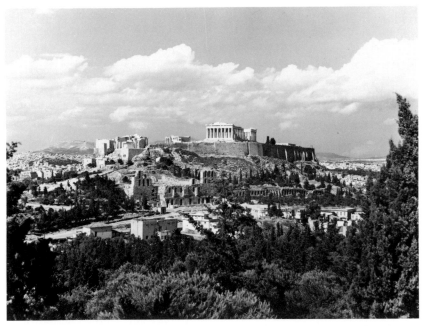

Fig. 11. The Acropolis of Athens today.

Solon classified citizens by wealth. At the top were the five-hundred-bushel men, that is, men whose property produced five hundred bushels of produce, wet or dry, in a year. Next there were the knights, who had enough substance to keep a horse; next again, the so-called yoke-men, who could arm themselves in the costly equipment of a hoplite soldier (see, e.g., Cat. 12 and Glossary, p. 241), and last, there were the thetes, who owned very little—nothing, if they had been dispossessed by debts. Members of the first three classes had the right to hold the more important offices in the state. The thetes, nevertheless, had certain important rights as citizens, rights that foreigners did not: they could vote at general assemblies of the citizenry, they could participate in the judicial system, and they could bequeath and inherit land. The new classification displaced some prerogatives that nobles had enjoyed exclusively until then, among them access to offices that gave them the right to administer and judge; now men who had won a place in the community through industry and enterprise rather than by birth also could exercise those powers.

For the landed, for whom inheritance questions were unrelenting, Solon made new laws. Questions would arise concerning identity and place in the family tree. Was a would-be heir a legitimate child? If not, could he or she inherit? Who really was the father? In a state, like Athens, that welcomed foreigners and made it possible for them to settle and practice their trade, the father's statehood had to be known. Solon was said to be hospitable to foreign artisans (even to the point of granting them citizenship), but this hospitality eventually created additional complications. Yet Solon's laws on inheritance served until Aristotle's time, around 325 B.C., or later, although Aristotle, who records the fact, also notes that some of his contemporaries criticized those laws as vague and hard to apply. Some charged that Solon had made them that way

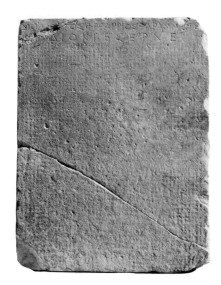

Fig. 12. A marble stele on which Draco's laws were republished in 409 B.C. "Prosecution is to be shared by cousins, sons of cousins, sons-in-law, fathers-in-law, and members of the phratry . . ." (*Inscriptiones Graecae* i³ 104, lines 21 – 23). Athens, Epigraphical Museum.

deliberately, to force people to take such disputes to the court of law (*heliaia*) he had instituted (Aristotle, *Constitution of the Athenians* 9). But the reality is that no one yet has been able to reconcile in a wholly consistent way the conflicting claims of private ownership and the public weal.

Solon left Athens to avoid being urged to change parts of his code. His subsequent travels supplied colorful and edifying anecdotes, such as that Herodotus preserves in his circumstantial but dubious account of conversations between King Croesus and Solon at Sardes. Croesus, vastly rich, wanted Solon, who was visiting him, to admit that Croesus was richer and happier than anyone else in the world. Solon countered with examples of men he considered better off. Don't call anyone happy, he concluded, until you see how things turn out at the end (Herodotus 1.30 – 1.32).

Peisistratos, son of Hippokrates, and his son Hippias after him ruled Athens as tyrants during the Amasis Painter's years there. *Tyrant* was not at that time a pejorative term. A tyrant came to rule a state because he had won it by force of arms or by one sort of trick or another, but not by constitutional or hereditary succession. Inasmuch as the world saw pursuit and acquisition of power as natural and desirable, a would-be ruler went about his quest as he might. People judged him finally not by how he got power but how he used it.

A later tradition of playful and erotic anecdote may soften our picture of the actual tyrant Peisistratos. Some of the tales appear to be no more than mere gossip, but writers as searching and austere as Thucydides and Aristotle have found them worth recording, if only—as Aristotle does in the case of the report that Solon was Peisistratos' lover—to deny them. The private lives of leaders have public consequence.

One chronological scheme of his years as tyrant goes as follows: in 561/60, he first became tyrant, and he was expelled in 556/55. In 552/51 he reestablished himself and was expelled a second time, in 546/45. His third coup took place in 536/35, and he died of illness, still tyrant, in 528/27. Hippias succeeded him and ruled until he was expelled in 511/10. Hippias' rule, before Harmodios and Aristogeiton killed his brother Hipparchos in 514 (as a result of unrequited love's frustration), is remembered as kindly.

To survey Peisistratos' entrances and exits, we are told, among other things, the following: He fooled the Athenians into granting him a bodyguard, and with these club bearers he went up onto the Acropolis (as did Kylon, but with better success). He dressed up a large woman in an Athena costume and convinced his compatriots that Athena was sponsoring his second coup. He made love with his (politically necessary) second wife in an unorthodox way in order to avoid conception, and an outraged father-in-law ran him out of town. He fooled Athenians into moving away from their weapons after they had stacked them, so that his men could pick them up and remove them to a "safe" place.

Stories of this sort established Peisistratos in later tradition as immediate and resourceful. Others show him as benevolent and just. One has him traveling in the country. He has imposed a tax of 10 percent

on farm income. On Mount Hymettos he sees a man working away at a patch of ground that is nothing but stones. He has an attendant ask the man what he is getting. The man says, "aches and pains—and Peisistratos should have 10 percent of them as his tithe." Peisistratos likes the wry answer and remits taxes on that farm. In another anecdote, an Athenian charges Peisistratos with homicide. Peisistratos duly appears at the court named after the Hill of Ares (Areiopagos) to make his defense, just as any citizen might (Aristotle, *Constitution of the Athenians* 16). The prosecuting citizen, however, loses his nerve and flees, a denouement that contributes to our understanding of a tyrant's ways.

Peisistratos loaned money to farmers and encouraged them to stay out of the city, where they might be tempted to meddle in politics. One way he did this was by establishing circuit judges who went out into the countryside on regular tours to judge disputes. He made a more complex urban life possible by building the fountain house Enneakrounos and establishing an effective water system (fig. 13). He (or it may have been his sons or grandsons) began a great temple to Olympian Zeus (the Olympieion), and he created a sanctuary to Pythian Apollo. He may have built a temple to Athena on the Acropolis, and he may have been influential in the translation of Dionysos Eleuthereus to Athens in 534/33. The god's festival became the City Dionysia, at which within two generations, dramas of unparalleled quality were played. Unfortunately, we do not know exactly what form the earliest dramatic celebrations took. Peisistratos and his sons may have enlarged the festival called Panathenaia, a competition for athletes like those at Olympia, Delphi, Nemea, and Isthmia, except that prizes included panathenaic amphorae full of olive oil (fig. 14), and there were competitions for musicians as well. Whether or not Peisistratos himself was personally responsible for each of these changes, we can infer that during those years Athens began to look more and more like a city, and one of the developing city's features was a potter's quarter, the Ceramicus.

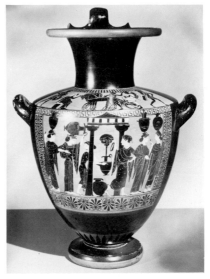

Fig. 13. "Water is best" (Pindar, *Olympian Odes* 1.1). Fountain house in Athens (perhaps the Enneakrounos erected by Peisistratos) depicted on a hydria attributed to the Priam Painter. Circa 520 B.C. The Toledo Museum of Art, 61.23, gift of Edward Drummond Libbey.

AMASIS AND THE AMASIS PAINTER

WITHIN THE LARGER DIMENSIONS of Greece and Athens, there was a smaller world, the Ceramicus. Here potters and painters worked, designing some pots to order, producing others on speculation. Fine black-glazed pieces and unglazed coarseware were all made in the same workshop. These men worked hard, earned their living, and took pride in themselves and their craft.

Some decades before the beginning of the sixth century, Athenian black-figure potters and painters began to appropriate a market that Corinth had held for many years: the Nettos Painter, Sophilos, Kleitias and Ergotimos, Nearchos, and others flourished. They were followed by Amasis the potter, the painter who has been assigned the name the Amasis Painter, and his contemporaries, Lydos, Exekias, and others. By the middle of the sixth century, a market for pots decorated in the well-known black-figure technique was securely established throughout much of the Greek world.

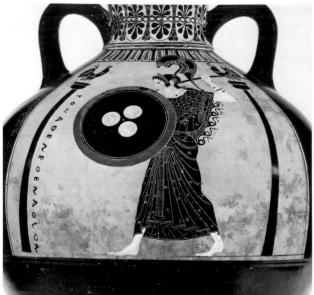
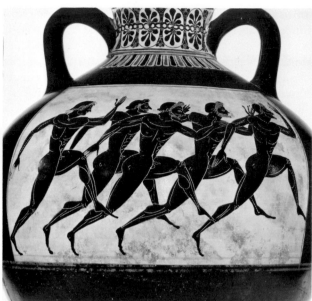

Fig. 14a,b. Panathenaic amphora attributed to the Euphiletos Painter. Side A, panel: Athena; side B, panel: footrace. The inscription reads: "A prize from the games at Athens." Circa 530 B.C. New York, The Metropolitan Museum of Art, 14.130.12, Rogers Fund.

A potter might own a pottery and hire other potters and painters to work for him. He needed at least a boy to turn his wheel, but more often would have from eight to twenty workers—more, if we count loans at need from neighboring establishments. The potter needed working space—a great deal of space to dry his clay—and a cover over his head. Scenes depicting potteries show by the presence of a single column that there was a roof over the working space (fig. 15), and we can speculate that potters occupied something more substantial than a simple lean-to. The roofed structure could have been the potter's house or conceivably a stoa where he had acquired a right to space. This would be just a roofed colonnade, not an elaborate and costly structure like those that adorned the later marketplace. The larger space outside was for unworked clay, for the kiln, and for display of finished pots. Inside the stoa, a man might run up a light reed partition to designate his space. There he had water, a wheel, calipers, incising tools, compass, pigments, and applicators.

It is hard to fix the position that potters and painters—especially potters—held in this society. It is notable, however, that our authorities think of them as citizens, even when, like Herodotus, they assign them a low place in men's estimation (2.167). Plato cites potters as examples of citizens who must not be too poor (for then they cannot buy the necessary tools and equipment) or too rich (for then they will not work hard) (*Republic* 421). Speaking of citizens who are potters, Xenophon deprecates the bad effect some kinds of work have on workers' bodies and hence on their spirits (*Oeconomicus* 4.2.3). But what is the status of a potter in mid-sixth-century Greece? Were all potters, then, also citizens?

We do know one thing. Some of them had extra, disposable income. Potters made dedications on the Acropolis frequently enough so that as an identifiable class of dedicators, they outnumber all others. Some dedicated modest terracotta plaques, but others dedicated works in stone or bronze by famous sculptors, such as Endoios and Antenor (fig. 4).

And many of them could read and write: they were proud of their work and signed it with their names; they labeled figures and cited this or that young man as *kalos.*

One painter, a certain Smikros, who was working around 520 B.C., had a name that recurs in aristocratic contexts in Athens. This would not in itself deserve note, except that on at least one occasion he pictures himself on a stamnos as a participant in a symposion. These drink-togethers were a characteristically aristocratic amusement. Guests dined while reclining on couches and then afterward drank sometimes a little, sometimes a lot, depending on how much water their elected drinking master ruled should be added to the wine. With wine, they politicked, sang, composed verse, capped one another's verses, played drinking games, made love, and philosophized. The night could be bawdy. It could also result in plots or conspiracies that were in deadly earnest. If Smikros was not a member of this genial company, he wanted to be. Did he aspire beyond himself? Perhaps not, for Euphronios, a contemporary, pictures him flatteringly, again at a symposion. Like poets of the time and earlier, he was at least an aristocrat in spirit.

The question of names is relevant here. Over and over again in ancient Greece we encounter names that are curiously appropriate—a doctor called "Save-man" (Sosimrotos), a wood-carver named Chisel (Smilis). "Best-exhibitor" (Aristophanes) is the name of the best of the comic playwrights, and "People's-strength" (Demosthenes) is that of an influential orator and statesman. These are not mere coincidences: Parents were hopeful and could make a good guess at what careers their sons would follow. Dexterous (Eucharides), "Good-worker's-son" (Euergides), and "Honor-in-work" (Ergotimos) were all potters. (We can only wonder why parents would call a son Nightmare—Ephialtes— a name that we find given to a giant, to a traitor, and to a statesman, among others.)

Fig. 15. Potters at work. The potter-owner wears a mantle that sets him apart from his colleagues, who work naked. Fragmentary hydria attributed to the Leagros Group. Circa 515 B.C. Munich, Staatliche Antikensammlung und Glyptothek, 1717.

Fig. 16. "Exekias painted and made me." Inscription on the rim of a neck-amphora signed by Exekias as painter and potter. Circa 540 B.C. Berlin, Staatliche Museen, 1720.

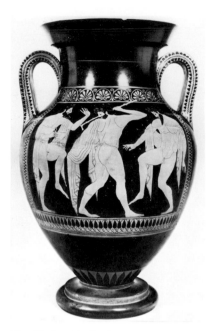

Fig. 17a,b. "As Euphronios never, ever could." The inscription refers to the scene of revelers. Red-figured panel-amphora of type A signed by Euthymides as painter. Circa 510 B.C. Munich, Staatliche Antikensammlung und Glyptothek, 2307.

ΗΟΣΟΥΔΕΠΟΤΕΕΥΦΡΟΝΙΟΣ

In addition to names that parents conferred in hope, there were names that men assumed or were given in later life. Such names again have their own propriety. Teisias, who composed choral poetry, became "Stands-the-chorus" (Stesichoros), and Tyrtamos, a philosopher, earned the name "God-designate" (Theophrastos). Theophrastos himself instances a Safety (Sosias, who may be a slave but is certainly not the earlier potter of the same name) who became "Saves-the-army" (Sostratos) after some military service, and "Saves-the-people" (Sosidemos) after being enrolled as a citizen at Athens (*Characters* 28.2).

Some names, those of foreign potentates or those derived from an ethnicon, are interpreted as notices of a family connection (when, that is, the family is known to have been rich and powerful). Kypselos II of Corinth bore the pharaonic name Psammetichos (Psamtik), and Croesus (Kroisos), an aristocratic youth from Anavysos (fig. 3), that of Gyges' rich descendant, King Croesus of Lydia. Peisistratos' son Hegesistratos was also called Thessalos, and Cimon had a son named Lakedaimonios.

Amasis, a potter, signed (or had his painter sign) his pots with the legend "Amasis made me." A number of other potters (but by no means all) used the same formula. Three (namely, Exekias, Sophilos, and Nearchos) distinguished between potting and painting the pot, and claimed both functions (fig. 16). Although Amasis does not identify himself as painter, many scholars today generally assume that Amasis the potter and the Amasis Painter were the same man (see, however, pp. 37–39). Whether or not he had any proprietary rights in the pottery where he worked is not known. He had a long career, and Kleophrades, his son (see Appendix 2), was also a potter. He appears therefore to have been a settled person and a family man.

It is sometimes conjectured, principally on the basis of his name, that Amasis was a foreigner, since *Amasis* is a Greek adaptation of an Egyptian name. A King Amasis (A-ames) ruled Egypt from 569/68 until 526 B.C. An earlier Egyptian king had the same name, as did other Egyptians. If Amasis the Athenian was Egyptian in origin, he may, the theory continues, have arrived at Athens via Naucratis. But the instances of some Greeks having foreign names—Croesus and Psammetichos noted above, for example—show that such a name does not in itself permit any firm inference regarding origin.

What, however, of other potters' and painters' names? Lydos, Skythes, Mys, Sikelos, Sikanos, Thrax, Syriskos, and Kolkhos all sound like ethnicons, the sort of names that slaves had. Yet these need not have been slaves' names. A Skythes was tyrant of Zankle. And think of the names Thessalos and Lakedaimonios: They differ only in that they refer to Greek, not barbarian, place names, and once we have accepted Kroisos as a member of the Athenian aristocracy, connection of a name with a barbarian country no longer seems an issue.

There are other names that do not sound Athenian, Oltos and Chelis, for instance, and at least one has an antic ring—namely, Priapos. Can it be that we have to do with nicknames? Potters and painters made up a closed and occasionally (at least) congenial society. Their cheerful

salutations and badinage are still reflected in inscriptions that they painted into their pictures. "In a way that Euphronios never, ever could" sounds like a challenge to a colleague's skill (fig. 17). "Two obols—hands off " is another, where the painter is saying, "My work does not come cheap" (fig. 18). And finally, Exekias on two separate occasions paints "Amasis" and "Amasos" as labels for Ethiopians (fig. 19). Whether he intends his conjunction of picture and label to be seen as a humorous shorthand reference to Amasis' origin or nickname is not a question we can answer now. It may be that there is no connection at all between label and potter. In any case, the atmosphere of the Ceramicus, so far as we can tell from our great distance, was one in which nicknames could have been freely given, some in fun, others perhaps not—after all, remember the proverbial Greek expression "Potter rankles potter."

There seem undeniably to have been foreign craftsmen among native-born Athenian potters and painters, among them some of the first and best. On their vases, the Nettos Painter and the Brygos Painter spelled names as foreigners might. But for all the others, the question is moot. The existence of an Attic style is clear, and some of those who worked within that style were foreign born and educated, but not all, and perhaps not as many as the odd names tempt one to suppose.

So we have hints concerning Amasis' place in the world, but no unambiguous evidence. It is not likely that he was a slave. He might have come from Egypt. He might, on the contrary, have been a citizen in good standing from a prominent Athenian family. His parents could have given him the name Amasis because of an old guest-friendship. Or his colleagues could have given him the name because he looked Egyptian or because he once admired some Egyptian artistic shape or convention, or because of some altogether unrelated caprice. Whatever his origins or rank, however, his spirit is Attic.

Fig. 18. "Two obols—don't touch me." Inscription on the panel of side A of a panel-amphora of type B with a catch phrase of the moment with a $\pi\alpha\varrho\grave{\alpha}$ $\pi\varrho\sigma\delta\sigma\kappa\acute{\iota}\alpha\nu$; attributed to a painter of Group E. Circa 540 – 530 B.C. New York, The Metropolitan Museum of Art, 56.171.13, Fletcher Fund.

Fig. 19. Representation of an Amasos on a fragment of a panel-amphora of type A attributed to Exekias. Circa 530 B.C. Philadelphia, University Museum, MS 3442.

FURTHER READING

A. Andrewes, *The Greeks*. New York 1967.

————, *The Greek Tyrants,* London 1969.

Aristotle, *The Athenian Constitution,* trans. P. Rhodes. London 1982.

J.D. Beazley, *Potter and Painter in Ancient Athens.* London 1946.

J. Boardman, *The Greeks Overseas.* Baltimore 1964.

————, *Athenian Black Figure Vases.* London 1974.

J. Boardman and N.G.L. Hammond, eds., *The Cambridge Ancient History* second ed., vol. 3, part 3: *The Expansion of the Greek World, Eighth to Sixth Centuries B.C.* Cambridge 1982.

A. Burford, *Craftsmen in Greek and Roman Society.* Ithaca, N.Y., 1972.

N.G.L. Hammond, *A History of Greece to 322 B.C.* Oxford 1967.

Herodotus, *The Persian Wars,* trans. G. Rawlinson. New York 1942.

L.H. Jeffery, *Archaic Greece: The City-States, c. 700 – 500 B.C.* New York 1976.

H.D.F. Kitto, *The Greeks.* Chicago 1964.

J.V. Noble, *The Techniques of Painted Attic Pottery.* New York 1965.

H.W. Parke, *Festivals of the Athenians.* Ithaca, N.Y., 1979.

A.E. Raubitschek, *Dedications from the Athenian Akropolis.* Cambridge, Mass., 1949.

R. Sealey, *A History of the Greek City States, ca. 700 – 338 B.C.* Berkeley, Calif., 1976.

H.A. Thompson and R.E. Wycherley, *The Athenian Agora* 14: *The Agora of Athens.* Princeton, N.J., 1972.

T.B.L. Webster, *Potter and Patron in Classical Athens.* London 1972.

R.E. Wycherley, *The Stones of Athens.* Princeton, N.J., 1978.

THE WORLD OF THE AMASIS PAINTER

Dietrich von Bothmer

Of the Attic vase-painters active between the late seventh and the second half of the fourth century B.C., very few are known to us by their own proper names. More frequently we know the names of potters; in Attic black-figure, they outnumber by five to one the painters who are known to us from signatures, probably because the potters were more concerned with the sale of their products than were the painters. Sophilos, on one vase, signs twice, once as potter and once as painter (fig. 36).[1] Nearchos and Exekias also sign as potter and painter, combining the two aspects in one sentence, with "painted" first (fig. 22,16).[2]

THE NAME

AMASIS FIRST BECAME KNOWN as a potter when an olpe with his signature— AMASIS MEΓOIESEN "Amasis made me"—was found at Vulci in the winter of 1828/29 (Cat. 31). Another signed olpe (*ABV* 153, no. 33) was published by Giuseppe Micali in 1833.[3] The next potter's signature of his to emerge was published when a neck-amphora, now in the Cabinet des Médailles of the Bibliothèque Nationale in Paris (Cat. 23), was sold with the Durand collection in 1836. An olpe, the fourth signed work by the potter, was acquired by the University of Würzburg in 1872 (Cat. 28), and in 1880 the Louvre also bought a signed olpe (Cat. 27). The two signed neck-amphorae now in Boston (Cats. 24, 25) were both found in the Etruscan site of Orvieto in Tuscany, the first in 1877 and the second shortly before 1896. The signed eye-cup (Cat. 62), now in the Vatican, began to become known in 1907, when the fragments with the signature, then in Boston, were published. These eight vases, all signed by Amasis as potter, were taken to be the work of one painter, and John D. Beazley assumed that "the signed vases are evidently all by one

hand."[4] Thus the name Amasis has become a kind of archaeological shorthand when the Amasis Painter and his style of drawing are discussed. Beazley himself coined the adjectives *Amasean* and *Amasian,* just as he used the adjective *Brygan* to stand not for the potter Brygos but for the Brygos Painter, his manner, and his following.[5]

As long as it could be maintained that all vases signed by Amasis as potter were, indeed, painted by a single painter, it was tempting to think that potter and painter were the same man. Yet a lekythos that bears the signature of Amasis as potter on the underside of the foot, acquired by the J. Paul Getty Museum in 1976, was painted by a different hand, that of the Taleides Painter (see Appendix 1). Hence we are compelled to be more cautious, calling the painter not just Amasis, but the Amasis Painter.

Nor is it absolutely certain that all the vases painted by this man, the Amasis Painter, were fashioned by a single potter. It is also curious that among the works of the Amasis Painter, the potter's full signature, including the verb, is known only from four olpai, three neck-amphorae, and an eye-cup, all belonging to the painter's middle and late periods. The known works of the potter Amasis have recently been augmented with the 1979 acquisition by the Getty Museum of a fragmentary band-cup painted by the Amasis Painter (Cat. 55), bearing under one handle the name but not the verb (which most probably was written under the other handle, now missing). The Getty band-cup is earlier than the other vases signed by Amasis as potter and attributed to the Amasis Painter, but there is nothing very special about the potting, and one wonders, as one often does when examining the absence or presence of signatures, why Amasis chose to sign this band-cup rather than one of the vases of unusual shape, such as the cup-skyphos in the Louvre (Cat. 54) or his mastoid in the same collection (Cat. 53).

There remain two vases with only fragmentary signatures of the potter that were painted by the Amasis Painter. In 1972, in the sanctuary of Athena Aphaia on Aegina, Dieter Ohly found a fragmentary tripod-pyxis (described by Martha Ohly in Appendix 4); it is profusely inscribed. The name Amasis does not appear, but in the middle of the leg depicting a courting scene are most of the last four letters of ΕΓΟΙΕΣΕΝ , so that the whole inscription should be restored (as Dieter Ohly has seen) to [ΑΜΑΣΙΣ ΜΕΓΟΙ]ΕΣΕΝ . The twelfth known signature of the potter occurs on the fragment of an amphora now in New York (Cat. 17). Here the remains of the signature are even smaller: again, the name Amasis does not appear, and there are just the last two letters of the verb: ΕΝ , written sideways in a straight line above an upright spear. I suspect that the complete signature was in two lines separated by the spear, as on the olpai in the Louvre and Würzburg (Cats. 27, 28). Finally, ΑΜΑΣΙΣ is written on the bottom of a small beaker (*ABV* 157, foot) found in 1937 or 1938 on the North Slope of the Acropolis and now in the Agora Museum in Athens. As nothing is left of the figure-work, it cannot be ascertained whether this vase was painted by the Amasis Painter or, indeed, like the lekythos in Malibu (Appendix 1), by another hand. Nor do we know whether the technique was black-figure or red-figure.

We thus have at least twelve—possibly thirteen—black-figured vases signed by Amasis as potter, of which eleven are certainly painted by the artist we call the Amasis Painter. It is worth recounting how this painter has gradually come to be recognized in the course of the last 150 years.

ATTRIBUTIONS

ATTRIBUTIONS OF UNSIGNED VASES, so frequently and easily made by scholars and students today, were not always normal practice. Jean de Witte deserves the credit for having been, in 1836, the first to discover and to say in print that two vases by Myson, the Croesus amphora in the Louvre and the Aithra calyx-krater in the British Museum,[6] were comparable in style.[7] This is the more remarkable when one remembers that through the eighteenth century and well into the nineteenth, even the distinction between Attic and Etruscan vases was not recognized, and that the dates assigned to vases were quite wild.

A nucleus of five amphorae and an olpe by the Amasis Painter[8] was assembled by Adolf Furtwängler in 1885 (the year Beazley was born) in his Berlin catalogue.[9] Furtwängler praised this group for its especially brilliant technique and most careful style. The sequence of numbers for the amphorae in the Berlin vase catalogue is no coincidence, for Furtwängler was the first to arrange the vases in a museum by fabric, period, and style, and to number his entries accordingly. The earlier catalogues of vases in Munich (1854), the Hermitage (1869), and Naples (1872)[10] merely followed the fortuitous arrangement of vases by rooms, vitrines, and shelves; these earlier catalogues, though quite erudite, are rather extensive inventories by location.

In 1889 Otto Benndorf published the six known vases signed by Amasis as potter.[11] This must have stimulated interest in the artist, for in 1891 Charles Fossey attributed two unsigned vases, an olpe in London (Cat. 26) and a small amphora in the Louvre (Cat. 11), to the Amasis Painter.[12] When in 1892 Berlin bought a splendid amphora of type A (*ABV* 151, no. 21), Furtwängler published it the following year[13] and recognized that it was by the same hand as the neck-amphora in the Cabinet de Médailles signed by Amasis as potter (Cat. 23). Following Furtwängler's attribution, Ferdinand Dümmler, also in 1893, attributed the amphora of type A in Würzburg (Cat. 19) to the same hand,[14] and Ludwig Adamek returned in 1895 to the five amphorae and the olpe that Furtwängler had singled out as a special group in his Berlin catalogue, ascribing them to the Amasis Painter.[15] In the meantime, Furtwängler had left Berlin for Munich, and in his first year there he published his *Führer durch die Vasen-Sammlung König Ludwigs I* (Leipzig 1895), in which he attributed the amphora Munich 1383 (Cat. 14), at that time the only vase in Munich by the Amasis Painter.

By now the interest in Amasis (or as we should say, the Amasis *Painter*) had grown considerably, and in 1899 Georg Karo published a penetrating article on "Amasis and Ionic Black-figured Pottery."[16] Karo added two more amphorae, both in the Louvre (Cats. 5, 12), and the

amphora in Orvieto (*ABV* 151, no. 14), but the thrust of his article is the recognition of the Affecter and his relation to the Amasis Painter.[17] Edmond Pottier, Friedrich Hauser, Ernst Buschor, and Ernst Pfuhl discussed the Amasis Painter in various writings, and Joseph Clark Hoppin in 1924 performed a valuable service by listing twenty-two unsigned vases that had been attributed to the painter[18] (it has since been recognized, however, that seven of his additions are not by the Amasis Painter). It must be remembered that until the late twenties, no history of Attic black-figure vase-painting had yet been written. On June 27, 1928, however, Beazley read a lecture before the British Academy entitled *Attic Black-figure: a Sketch,* in which he declared his aim: "In my brief sketch of Attic black-figure, I shall try to give some notion of its nature, of the periods into which its story divides itself, and of the chief personalities among the artists. Omitting what seems unimportant, or less important."[19]

J.D. Beazley

BEAZLEY'S ARCHAEOLOGICAL PUBLICATIONS began in 1908, the year after Furtwängler's death, and in sixty years of untiring labor he succeeded in doing more for the scholarship of Attic vase-painting than any man has ever done. While he never met Furtwängler (and for that matter never "majored" in archaeology as an undergraduate at Oxford), his passion for Greek art was such that by intelligent observation and diligent reading, he soon acquired a higher degree of familiarity and knowledge than many of his contemporaries. His first love was Attic red-figure, and most of his early publications were devoted to it. By 1927, though, he began to address himself to Attic black-figure, and in the opening paragraph of his article on the Antimenes Painter, he announced "a series of essays on black-figure artists."[20] The publication the next year of the British Academy lecture *Attic Black-figure: a Sketch* revealed that Beazley had applied his scrutiny to the entire range of Attic black-figure. Appended to his lecture are lists of vases by Exekias, the Amasis Painter, the Affecter, the Acheloos Painter, the Nikoxenos Painter, and the Lysippides Painter, as well as addenda to his earlier list of the Antimenes Painter and a list of hydriai of the Leagros Group. The ground was laid, and other articles were to follow. As soon as the first edition of *Attic Red-figure Vase-painters* had been sent to press in 1939 (it was published in 1942), Beazley set to work on a companion volume, *Attic Black-figure Vase-painters.* Beginning in 1940 he sent an early draft in several installments to Gisela Richter in New York. In October 1946 he gave five lectures on Attic black-figured vases at the Metropolitan Museum of Art; these lectures were expanded for the Sather lectures at the University of California at Berkeley in 1949 and published as *The Development of Attic Black-figure* in 1951.[21] *Attic Black-figure Vase-painters* was published in Oxford in 1956.

Once Beazley had directed his attention to black-figure painters, attributions to the Amasis Painter increased rapidly. At the time of his 1928 British Academy lecture, the count stood at forty-one vases, with

most of the additions being Beazley's own; three years later, more were attributed by him in the article "Amasea."[22] He added others in the publication of the Naucratis fragments in London (1929),[23] in the Ashmolean Museum's *Corpus Vasorum Antiquorum* (1931),[24] and in his 1934 article on "Groups of Mid-Sixth-Century Black-figure."[25] In the meantime, other scholars, especially Wilhelm Kraiker[26] and Semni Karouzou,[27] studied the Amasis Painter, and Mrs. Karouzou was invited in 1938 by Beazley and Paul Jacobsthal to publish a monograph on the painter for the German series *Bilder griechischer Vasen,* a book that actually appeared in 1956, in English and considerably expanded, in the *Oxford Monographs on Classical Archaeology,* edited by Beazley and Jacobsthal.

Though the discovery of every new piece attributed to the Amasis Painter forces us to reexamine his entire work, some of the newcomers, such as the Schimmel cup with the stable of Poseidon (Cat. 60), the Munich amphora with the splendid cavalcade (Cat. 4), and the band-cup in Malibu (Cat. 55), are more important than others in that they help to destroy old generalizations, such as the misconception that the Amasis Painter, unlike Exekias, had no passion for horses,[28] or the notion that he shunned Amazonomachies.[29] Yet the most significant change in our view of the Amasis Painter occurred when Beazley realized that certain lekythoi C.H.E. Haspels had connected with the Amasis Painter[30] were, in fact, by the painter himself: this conclusion led to the attribution of many more lekythoi and also put the beginnings of the Amasis Painter earlier than had previously been thought.

AMASIS THE POTTER

THE NEXUS OF ATTRIBUTIONS to the Amasis Painter is well established, but the name of the potter Amasis, with whom the painter used to be identified, has brought on much confusion. Amasis is the name of two Egyptian kings, of whom the second, an Egyptian general, was proclaimed king in 569/68 B.C., when the priests and people rebelled against Apries following the disastrous defeat of an Egyptian expedition against Cyrene. At first Amasis and Apries ruled as co-regents, but in 567/66, Apries fled from his palace at Saïs and enlisted the aid of his Greek mercenaries to regain sole power. He was defeated in the battle of Momemphis (in 566 B.C.) and was killed by his own men while sleeping on his houseboat on the Nile; Amasis was now in complete control.

Unlike his immediate predecessors, Amasis was not at first a philhellene, since the very revolution that had put him on the throne was nationalist and antiforeign. He restricted the freedom of the Greek settlers at Daphne and relocated them in Naucratis, the "treaty port," and in 566/65 he turned Naucratis into a settlement for all Greeks then living in Egypt. The surviving Greek mercenaries of his predecessor Apries were transferred to Memphis. We know of the friendship of Amasis with Polycrates of Samos and Croesus of Lydia, thanks to Herodotus, who also reports his many gifts to the Greek temples on Rhodes and Samos and at Delphi. But Amasis' reputation as a philhellene could hardly have been established before the death of Apries and the forced relocation and

Fig. 20. Lekythos. Attributed to the C Painter. A warrior leaving home. Orvieto, Museo Civico, 296.

resettlement of the Greeks living in Egypt. Any official pro-Greek attitude would have been unwise in the troublesome early years of his reign; later, of course, a friendship with the Greeks would have been useful in dealing with his menacing neighbors in the East.

Franz Studniczka believed that the Athenian potter Amasis came from Naucratis,[31] but Mrs. Karouzou has argued strongly for a purely Attic origin, reminding us that Greeks could be named after illustrious foreign philhellenes.[32] But Greek children were normally given their names at birth, and it is unlikely that an Attic child would have been named after an Egyptian king until the king had become famous as a philhellene; which, in the case of Amasis, is hardly likely to have occurred before 565 B.C. It is also unlikely that a Greek boy would become a potter or painter much before the age of at least fifteen, which would therefore put the beginnings of the work of an artist born in Greece and named Amasis, after the Egyptian king, not earlier than 550 B.C.

In 1958 John Boardman stated that the Amasis Painter and the potter Amasis were probably the same person and that "the distinctive elements in each craft seem to share a common spirit."[33] He therefore reverted to Studniczka's idea that Amasis came from Egypt and was a Greek child who grew up "most likely in Naukratis," thus being exposed early in life to Greek pottery from mainland Greece and Ionia. Since Amasis was an Egyptian name, already borne by an earlier Egyptian king as well as by commoners, Boardman's suggestion would remove the necessity of the artist's having been named Amasis by Athenian parents, in 565 B.C. or later.

Studniczka's and Boardman's proposal of a Naucratite origin for Amasis would be more attractive if a distinct foreign flavor could be detected in the shapes of vases signed by Amasis as potter or in the style of drawing on the hundred-and-thirty-odd vases attributed by now to the Amasis Painter. Yet, neither the vases nor their decoration reveal any traits of foreign birth and upbringing.

Assuming that Amasis was an Athenian named after the philhellene Egyptian king, perhaps we can best reconcile the conflicting evidence by not insisting that the potter and painter are the same man. The earliest known signature of Amasis is found on the fragmentary band-cup in Malibu (Cat. 55) that need not be dated earlier than 550 B.C. Of the two vases painted by Lydos that Robert Cook reported Hansjörg Bloesch to have ascribed to the potter Amasis,[34] the psykter-amphora in London, though close in style to the works of the Amasis Painter,[35] is not close enough in profile and proportions to warrant an attribution to the potter Amasis;[36] in any event, neither vase need be dated quite so early as Cook implied.

Until more evidence turns up—preferably a vase by the Amasis Painter signed with the painter's name rather than the potter's—it appears more prudent to consider the Amasis Painter as thoroughly Athenian and a different man from the potter who called himself Amasis. I would not be surprised if of the two, the Amasis Painter were the older, having worked for a number of minor potters in his youth

before, in his middle period, he began collaborating with the potter Amasis. In the brief outline of the painter's career that follows, I have therefore devoted more attention to his style of painting than to the shapes of the vases he decorated.

Fig. 21. Aryballos. Signed by Nearchos as potter and attributed to Nearchos. Handle: satyrs. New York, The Metropolitan Museum of Art, 26.49, purchase, 1926, funds from various donors.

THE AMASIS PAINTER'S DEVELOPMENT

WHEN THE AMASIS PAINTER started on his artistic career, about 560 B.C., Attic black-figure was already fully established and about to overtake Corinthian pottery in the competition for the Etruscan market. Sophilos, Kleitias, the Painter of Acropolis 606, Nearchos, and Lydos were the most prominent vase-painters at that time; the C Painter and the Heidelberg Painter had popularized a shape of drinking cup called a Siana cup, named after a site on Rhodes, and a dozen enterprising painters of the so-called Tyrrhenian Group had flooded the Etruscan market with neck-amphorae of a special type that perpetuated the fashion of subsidiary animal friezes so dear to the Corinthian and the first generation of Attic black-figure artists.

The Amasis Painter was an eager student of style and a keen observer. If the variety of preserved works is a fair indication of his development, it can be stated that he began with modest cups and lekythoi, moved on to amphorae and oinochoai, painted an alabastron, an aryballos, a tripod-pyxis, small and large plaques, a standlet, and perhaps a column-krater. Though conservative in outlook, he did not limit himself to standard shapes: his cups, for example, comprise a modified Siana cup, several band-cups, and cups of type A, culminating in cups of the latest fashion—ones that come close to the even later standard cup type, type B. From band-cups he found his way to cup-skyphoi that keep the black rim. Shunning the canonical neck-amphorae introduced by the painters of Group E and perfected by Exekias, he nevertheless explored the new shape of neck-amphorae in a number of variations, and among his panel-amphorae are several that reflect the new fashion of angular handles and feet rather than the round handles and echinus feet of type B.

We have not met the style of the Amasis Painter on dinoi, stamnoi, hydriai, or lekanides, and the reasons for their absence in his repertory are not very clear; nor should we emphasize too much the current lack of certain shapes, since any day a new find may compel us to revise our generalizations. So much depends on fortuitous discoveries: indeed, in the last fifty years, we have witnessed the appearance of such diverse shapes as an alabastron, an aryballos, a tripod-pyxis, and a full-size cup of type A; there is thus every hope that in the next fifty years, other shapes, now not known to have been painted by the Amasis Painter, will come to light.

In the style of his earliest period, a certain similarity to paintings by the Heidelberg Painter has already been noted,[37] but it cannot be said that the Amasis Painter was the pupil of just one master. From the Heidelberg Painter he took little more than the love of stately processions and elegant garments with fringes, as well as some conventions for

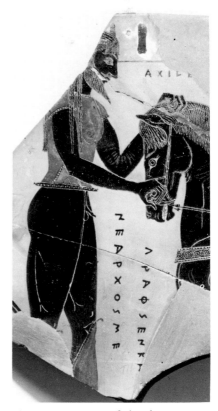

Fig. 22. Fragment of a kantharos. Signed by Nearchos as potter and painter. Detail showing the signature. Athens, National Museum, Acr. 611.

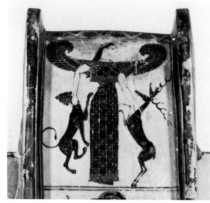

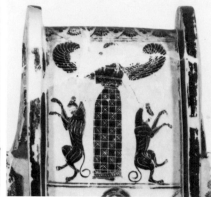

Fig. 23a,b. Volute-krater. Signed by Ergotimos as potter and Kleitias as painter. Details of the handles showing Artemis, on A/B, with a panther and a stag, on B/A, with lions. Florence, Museo Archeologico, 4209.

Fig. 24. Fragmentary dinos. Signed by Lydos as painter. Detail showing the shield of Hermes with a gorgoneion. Athens, National Museum, Acr. 607.

Fig. 25. Fragment of a plate. Attributed to Lydos. Gods. New York, The Metropolitan Museum of Art, 1985.11.1, gift of Nicholas S. Zoullas.

the anatomical incisions. The many horsemen on the C Painter's cups may have inspired him to adapt a cavalcade to the different proportions of a panel-amphora (Cat. 4), and the late lekythoi by the C Painter, especially the one in Orvieto (fig. 20),[38] are not too far from the early lekythoi by the Amasis Painter. From an aryballos by Nearchos (fig. 21)[39] he must have taken the line border for the handle of his aryballos (Cat. 52), and he must have been impressed by the neat lettering in two vertical lines of Nearchos' signature on the kantharos from the Acropolis (fig. 22).[40]

With Kleitias the Amasis Painter shares the perfection of a miniature style; he is indebted to that painter for the image of the winged Artemis as mistress of the wild beasts, which at least once, on the reverse of the Basel neck-amphora (Cat. 21), follows a type established by Kleitias on the François vase (fig. 23).[41] He may well have been encouraged, moreover, by Kleitias' successful renderings of architecture on the François vase when he painted the bridal chamber on the wedding lekythos in New York (Cat. 47). And do not the dancing maidens on the shoulders of the two New York lekythoi (Cats. 47, 48) owe something to the dancers and running Nereids on several vases by Kleitias?[42]

The Amasis Painter has much in common also with Lydos, and it is not surprising that two of his vases, the psykter-amphora in London and the panel-amphora of type B in the Cabinet des Médailles, were considered near the Amasis Painter by Beazley at a time when Lydos had not yet been recognized.[43] The kinship, however, goes far beyond the symmetrical compositions of amphora panels, for example, or the special breed of hairy satyrs: it extends to a surprising number of details in drawing. The Amasis Painter's convention of a red hair circle around the male nipples is frequent in Lydos.[44] The white ears of gorgoneia on the Amasis Painter's standlet (*ABV* 157, no. 90), on his cup in the Vatican (Cat. 62), and on the shield device of the Berlin amphora of type A (*ABV* 151, no. 21) were first employed by Lydos on the shield device of Hermes on Lydos' signed dinos in Athens (fig. 24)[45] and his plate in Munich.[46] The curious ornamental border along the neck and shoulders of the Amasis Painter's short-sleeved garment (e.g., Cats. 5, 6, 9, 11, 13, 15, 21, 25 – 27, 29, 31)[47] can be matched on two plate fragments by Lydos (see

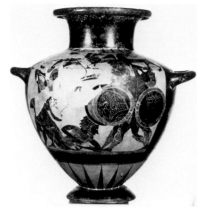

fig. 25).[48] The Amasis Painter's shield devices of a lion's protome (e.g., Cats. 1, 5, 23, 60)[49] are not too far from Geryon's device on Lydos' hydria at the Villa Giulia in Rome (fig. 26),[50] just as the device of a wasp on the Amasis Painter's band-cup in the Louvre (Cat. 57) is a worthy descendant of the wasp that Lydos gave Aphrodite's opponent on his dinos from the Acropolis.[51]

Other details of ornamentation establish more links. On the Amasis Painter's very fragmentary amphora in Bonn (fig. 27; *ABV* 151, no. 20), the palmette-lotus festoon above the panels goes beyond the width of the panel, as do the ornaments above the panel on two amphorae by Lydos (see fig. 28).[52] The zigzag lines that the Amasis Painter employs as borders on the fragment of an amphora of type A in New York (Cat. 18), on the New York aryballos (Cat. 52), on the Agora alabastron (*ABV* 155, no. 64), on the flange of the lid of the panel-amphora in the Vatican (Cat. 3), on the lekythoi in London and Montclair (Cats. 49, 50), and on the roots of the handles of his amphora in Würzburg (Cat. 19) are known on vases by Lydos: they occur on his column-kraters in London (fig. 29)[53] and Toronto (Borowski collection)[54] and on the top of the spout of his psykter-amphora, also in London (fig. 30).[55] This psykter-amphora has in addition the unusual feature of a small palmette painted at the lower junction of its handles of type B (fig. 31), and we are hardly surprised that the Amasis Painter felt free to apply such palmettes at the handle junctions on his vintage amphora of type B in Basel (fig. 32; Kä 420, *Paralipomena* 65) and its companion piece in Kavala (*Paralipomena* 65), even though such palmettes belong more rightfully below the flanged handles of amphorae of type A.

The C Painter, the Heidelberg Painter, and Lydos are older colleagues of the Amasis Painter. The BMN Painter, however, may well have been his contemporary, and we have instances of correspondence in subject matter and composition, especially between the wrestlers on the neck of the Basel neck-amphora (Cat. 21) and the name piece of the BMN Painter in London (fig. 33).[56] While his relationship to the Affecter is not quite that of master to pupil, it is clear that the Affecter learned from the Amasis Painter a certain neatness of incisions and ornaments, as well as relied for his repertory on compositions estab-

Fig. 26. Hydria. Attributed to Lydos. Herakles and Geryon. Rome, Museo Nazionale Etrusco di Villa Giulia, M.430.

Fig. 27. Fragmentary panel-amphora of type A. Attributed to the Amasis Painter. Fragment showing the overhang of the palmette-lotus festoon. Bonn, University, Akademisches Kunstmuseum, 504.

Fig. 28. Fragmentary panel-amphora of type B. Attributed to Lydos. Detail showing the overhang of the palmette-lotus festoon. Basel, collection of Helene Kambli.

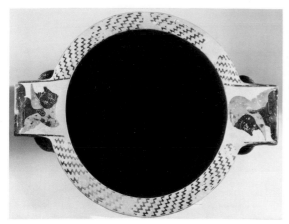

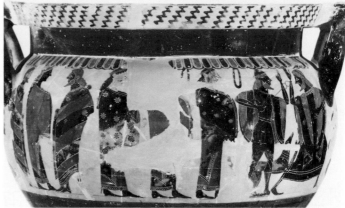

Fig. 29a,b. Column-krater. Attributed to Lydos. Detail of side A and a top view showing the zigzag pattern on the rim. London, The British Museum, 1948.10-15.1.

Fig. 30. Psykter-amphora. Attributed to Lydos. Side B: detail showing the zigzag pattern on the top of the spout. London, The British Museum, B 148.

lished by his teacher. Though there are no red-figured vases that have been attributed to the Amasis Painter, toward the end of his career he adopted with some ease the innovations of the Pioneer Group and should also be considered to have inspired the great bilingual painter Psiax.

STYLE

THE STYLE OF THE AMASIS PAINTER has been described more than once, and it is hardly necessary to repeat in tedious detail what to viewers of this exhibition will be obvious. In the catalogue, moreover, an attempt has been made to make as many comparisons among the vases as possible, drawing on the entire work of the painter rather than the sixty-five vases shown in this exhibition.

It is customary in the scholarship of vase-painting to distinguish between early and late, the more so since we have no absolute dates that would allow us to put each work in an exact chronological sequence. With the Amasis Painter, however, a slight difficulty is presented by the extraordinary conservatism of the painter, a man who repeated himself not because he was devoid of new ideas but because he liked his way of drawing. This is especially vexing in his middle period, when many new ideas emerge without, in every instance, replacing earlier conventions. Scholars, of course, would prefer it if each innovation automatically outlawed the continued use of older formulae, but then an artist may be pardoned if in the pursuit of his craft he thinks of the work on hand rather than of the problems of posterity.

There is also the question of quality. As Beazley so aptly put it in his instructions for use of the second edition of *Attic Red-figure Vase-painters:* "A list of vases assigned to a good artist sometimes includes pieces that are unworthy of him. It is my experience that Greek vase-painters were not always at their best, differing in this respect from modern artists."[57] In this particular, the current exhibition will prove salutary, for the visitor will not be limited in his appreciation to the dozen or so well-known masterpieces that are selected over and over again in all the handbooks and coffee table works on Greek art; rather, he will be able to

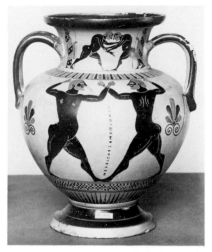

accompany the artist through the forty-odd years of his long creative life, and the favorites of his that are not included in the exhibition will at least be illustrated on these pages.

One astonishing facet of the Amasis Painter is his ability to work at different scales: his figures range from very small friezes—such as those on his New York aryballos (Cat. 52), on the alabastron in the Agora (fig. 34; *ABV* 155, no. 64), in the bands above his panels on five amphorae of type A (Cat. 18 bis; *ABV* 151, nos. 18, 20, 21; and a fragment from Cyrene [fig. 42]), and on his Little-Master cups (*ABV* 156 – 157, nos. 81 – 85)—to the impressive size of a dedicatory plaque in Athens (*ABV* 157, no. 92). Beazley has remarked that the Amasis Painter is an excellent miniaturist,[58] and since other mid-sixth-century painters—Nearchos and Lydos, for example—are equally at home painting large-scale figures as tiny ones, it may have been a prerequisite at the Ceramicus to excel at more than one scale; what sets the Amasis Painter apart, however, is that his small pictures are often better than his larger ones, and I suspect that he had all the advantages of the nearsighted artist whose ability to focus on fine and small images did not change in middle life, as invariably happens to those who start with normal vision. This assumption may also explain why his artistic career is so much longer than that of almost every other vase-painter whose style we have identified, and why, in the precision of drawing, especially in the use of incised lines and the application of decorative touches with the added colors red and white, there is no difference in perfection between his mature works, whether of his middle or late period.

If his very earliest vases have a somewhat rude, untutored look, we can attribute this to his relative inexperience, not to a lack of talent. Many of his compositions must have been formulated early in his career, and surely he repeated them because he liked them and considered them proper subjects for the decoration of vases.

The Amasis Painter, more than others, consistently paid attention to the harmony between potted shape and decoration, especially on his favorite shape, the panel-amphora. A vase with two handles demanded a certain symmetry in the figure decoration, not merely in the exact placing of the figures but in the distribution of the black and light areas as

Fig. 31. Psykter-amphora. Attributed to Lydos. Detail showing the palmette under handle A/B. London, The British Museum, B 148.

Fig. 32. Panel-amphora of type B. Attributed to the Amasis Painter. Detail showing the palmette under handle A/B. Basel, Antikenmuseum und Sammlung Ludwig, Kä 420.

Fig. 33. Neck-amphora. Signed by Nikosthenes as potter and attributed to the BMN Painter. Side A: athletes. London, The British Museum, B 295.

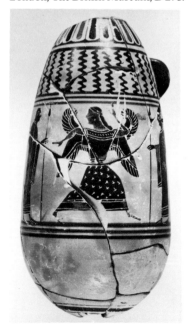

Fig. 34. Alabastron. Attributed to the Amasis Painter. Winged goddess. Athens, Agora Museum, P 12628.

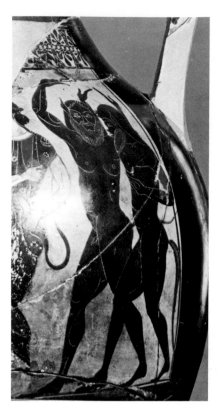

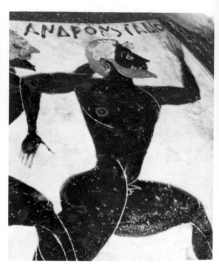

Fig. 35. Panel-amphora of type A. Attributed to Exekias. Side B: detail showing two dancing satyrs. Budapest, Hungarian Museum of Fine Arts, 50.189.

Fig. 36. Fragment of a dinos. Signed by Sophilos as potter and painter. The funeral games of Patroklos. Athens, National Museum, 15499.

Fig. 37. Panathenaic amphora. Signed by Nikias as potter. Side B: detail with the legend "stadion race of men." New York, The Metropolitan Museum of Art, 1978.11.13, Classical Fund, 1978.

well, something Exekias (a painter who does not have much in common with the Amasis Painter) did not consider worth stressing on his early panel-amphorae, although in his later works it receives his due attention—an attention that culminates, both with regard to symmetry and an airiness implied by the background, in the memorable picture of Ajax and Achilles playing a game.[59] Until fairly recently it was fashionable to contrast Exekias with the Amasis Painter and to minimize rather than stress some of the points the two have in common, but with the publication of the Budapest amphora by Exekias (fig. 35),[60] we now can suggest that he was not averse to employing a composition made famous by the Amasis Painter, the pair of dancing satyrs (seen on Cat. 19, side B).

SUBJECTS

THE WORLD OF THE AMASIS PAINTER is a very rich one, extending from the solemnity of the Olympian gods to the sphere shared by gods and heroes, and thence to daily life as witnessed in Athens and the Attic countryside. On these vases there is seldom much interaction between the figures, a trait that can be ascribed to the artist's preference for figures representative of their class or station shown in elegant clothing, or for the proud nudity of athletic youths: participants in courtly scenes, if you wish, that are somewhat removed from the crowds and babble of the marketplace. Like their masters, the dogs by the Amasis Painter (with the notable exception of those on the Boston cup [Cat. 61]) are equally well-bred.

Vase-paintings normally do not bear painted titles; the few that are known identify the funeral games of Patroklos (fig. 36)[61] and the competitions portrayed on several panathenaic prize amphorae (see fig. 37).[62] Instead of inscribing picture titles, vase-painters often merely wrote out proper names next to the figures. The best examples in black-figure of this practice are the Sophilos dinos in London[63] and the François vase, painted by Kleitias.[64] Such labeling was, however, rather haphazard, and many mysterious figures remain unidentified, while others, easily rec-

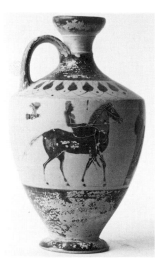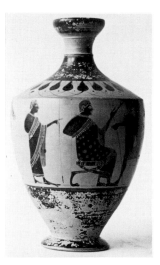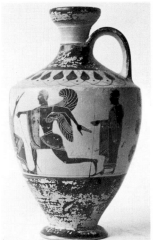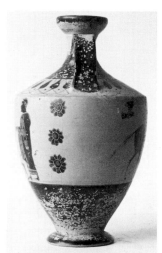

ognizable by their attributes—Zeus, Athena, Poseidon, Dionysos, Hermes, Apollo, Artemis, or, among the heroes, Herakles and Perseus—are named.

The Amasis Painter uses such names written next to the figures sparingly: on the neck-amphorae in the Cabinet des Médailles and in Boston (Cats. 23, 25) and on the tripod-pyxis in Aegina, but the very vases that are difficult to interpret are, alas, devoid of inscriptions. This is particularly regrettable for the many early vases that show a winged male figure (see figs. 38, 39 and Cats. 24, 40, 52, 59).[65] It should also be helpful if inscriptions would one day elucidate the identity of the male mortals so often shown with Dionysos on amphorae by the Amasis Painter (e.g., Basel Kä 420 [fig. 40][66] and Cats. 2, 4, 8). We are justified in calling the youth holding an oinochoe Oinopion, since Exekias, on a neck-amphora in London (fig. 41),[67] expressly named this son of Dionysos and Ariadne. Whether the other youths shown in such scenes are his brothers Thoas, Staphylos, Latramys, Euanthes, Tauropolis (to name but a few) remains uncertain. There is also some question of whether the archer shown on Basel L 20 (Cat. 8) is Apollo and whether the subject of the vase is related to that of the amphora Berlin 1688 seen here (Cat. 9)—and who, exactly, is the man shown behind Athena on the trefoil olpe in Oxford (Cat. 29)?

Puzzling though some of the subjects are, they are not, as Sir Thomas Browne put it, "beyond all conjecture,"[68] and we take courage from such solutions for rare scenes as were furnished by Marjorie J. Milne for the outside of the Schimmel cup (Cat. 60); it is by no means necessary to hide our twentieth-century ignorance of subjects that may have been quite familiar ones in the sixth century B.C. by claiming that the Amasis Painter shows a certain lack of concern for the scenes he represents or that he was more interested in technical perfection and "art" than in the content.[69] It is hazardous in the extreme to draw generalizing conclusions about the preferences of any but the least competent vase-painters, since we can hardly ever be certain that their preserved works are truly representative of their entire production, even if

Fig. 38a,b,c,d. Lekythos (shoulder type). Attributed to the Amasis Painter. Athens, collection of Pavlos Kanellopoulos.

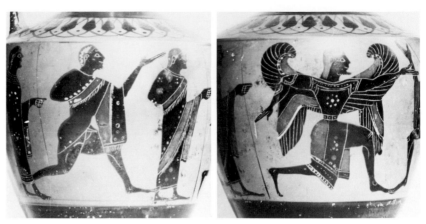

in the case of the Amasis Painter, the wide distribution of find spots attests to the popularity he enjoyed in antiquity.

DISTRIBUTION

THE AMASIS PAINTER'S VASES were exported to many parts of the ancient world: Berezan in south Russia (fig. 39),[70] Rhodes,[71] Cyprus,[72] Naucratis,[73] Cyrene (figs. 42, 52),[74] Samos,[75] Delos,[76] Kavala,[77] Perachora,[78] Eleusis,[79] Tanagra,[80] Selinus,[81] Cumae,[82] Capua,[83] Gravisca (the port of Tarquinia),[84] Vulci,[85] Orvieto,[86] and Chiusi.[87] Many of the others without recorded find spots undoubtedly come from Etruria, probably from Cerveteri (ancient Caere);[88] I do not include in this list the fragmentary phiale from near Arezzo (*ABV* 156, no. 77), since I take it to be by the Painter of Louvre E 705, Elbows Out, rather than by the Amasis Painter. From Athens itself came various discoveries. Fragments of seven vases were found on the Acropolis,[89] and three vases come from the Agora;[90] one lekythos has been excavated in the Ceramicus (fig. 59),[91] and three lekythoi are from Vari;[92] a fourth lekythos is said to come from Athens,[93] and a fifth was acquired in Athens (fig. 38);[94] two fragments, perhaps of a chous, were found in the Olympieion at Athens.[95]

This distribution of provenances agrees by and large with the exportation of vases known from other Attic painters and potters. If western sites, especially in Etruria, predominate, it must be remembered that the Etruscan tomb constructions favored survival while Attic tombs did not, and that for many ancient settlements, especially on the coast of Anatolia, the main burial sites have not yet been discovered.[96]

GODS AND MEN

THERE ARE VERY FEW human activities that the Amasis Painter does not depict or allude to. The sphere of the gods, moreover, is often treated as an extension of daily life, with immortals such as Dionysos appearing on earth on visits, or heroes such as Herakles being received on Mount Olympus after a life of toil on earth. The frequent theophanies are a constant reminder that the gods are never very far away, and, conversely,

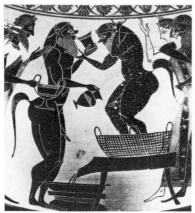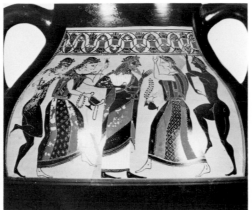

many of the Athenians represented on these vases show by their poise and well-dressed elegance that they are prepared to encounter the gods.

In the scene of women working at wool and weaving (Cat. 48), whether or not the garment woven is the peplos that was carried in the panathenaic procession to Athena's temple on the Acropolis, we sense that the work is being done with the encouragement, if not under the supervision, of Athena. The goddess, moreover, could make her appearance as unobtrusively as on the fifth-century B.C. hydria in Milan that portrays her accompanied by Victories rewarding a vase-painter and his crew,[97] and even the dance of maidens on the shoulder of the lekythos with wool-working scenes is elevated to the level of a cult through the central group with a seated goddess. Seen in this context, the spear-holding youths on the neck-amphora in Basel (Cat. 21) who flank Artemis, mistress of the wild beasts, are drawn into the circle of the goddess: they address and worship her, even if their lips do not move.

The characteristic stance of the Amasis Painter's nude youths is that of the kouros in sculpture (fig. 3): well balanced, the weight evenly distributed between legs that are slightly apart, the body erect yet not stiff. If the figures recall kouroi, the resemblance is not the result of deliberate copying of a statuary type but derives from the artists' conviction that this stance of the male body was the ideal position, hence chosen by painters as well as sculptors. Sculptural though these figures are in their general outline, they participate in their scenes by gestures of their arms and hands, gestures that include, on occasion, spears carried at a diagonal rather than upright.[98] The figures' unencumbered arms and hands are held in a variety of expressive positions, of which the most common can be interpreted as a gesture of greeting.

Fig. 40a,b. Panel-amphora of type B. Attributed to the Amasis Painter. Side A, detail of panel: vintage scene with Dionysos, satyrs, and maenads; side B, panel: Dionysos, dancing maenads, and youths. Basel, Antikenmuseum und Sammlung Ludwig, Kä 420.

Fig. 41. Neck-amphora. Signed by Exekias as potter and attributed to Exekias. Side B: detail showing Oinopion and Dionysos. London, The British Museum, B 210.

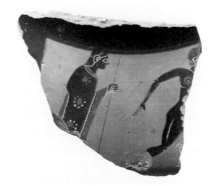

Fig. 42. Fragment of a vase. Attributed to the Amasis Painter. Cyrene, Museum. inv. 81.40

ORNAMENTS

BEGINNING IN HIS EARLY PERIOD, the Amasis Painter developed a special way of emphasizing the frames of his panel pictures: while he shares the decorative floral ornaments above the panels with other black-figure vase-painters, he reinforces the lateral frames by glaze lines. On amphorae of type B he usually paints two vertical lines on each side

Fig. 43a,b. Panel-amphora of type B. Attributed to the Amasis Painter. Side A, panel: Menelaos and Helen; side B, panel: fight. Great Britain, private collection (once in Riehen, collection of Dr. Heinz Hoek).

rather than the single line that other painters are content with; he also employs two lines to separate the ornamental top-band from the picture below and from the black of the neck above; on the amphora in Bloomington (Cat. 2) he even uses three lines on each side of the panels, and on a fragment in New York (Cat. 2 bis), he separates the ornamental band from the panel by three lines, features that do not recur on the other vases of his known to us. Four times, and quite exceptionally, he employs single lines for the lateral frames (see, e.g., fig. 43 and Cats. 11, 12);[99] and the single lines also occur on his amphorae of type A in New York (Cat. 18 bis), Würzburg (Cat. 19), Kavala (*Paralipomena* 65), and Bonn (fig. 44; *ABV* 151, no. 20). Yet on his most elaborate amphora of type A, Berlin inv. 3210 (fig. 45; *ABV* 151, no. 21), a cable-pattern separates the panels proper from the small subsidiary friezes above, and the main panels are framed on the sides by running maeanders.

These double lines that the Amasis Painter is so fond of can be traced back to an amphora by the Heidelberg Painter (fig. 46),[100] an artist who influenced him in many ways, and it is therefore not surprising to encounter the same double lines on the sides of a fragmentary amphora in Brunswick that is akin to vases by the Heidelberg Painter.[101] Among other early panel-amphorae, a small and vigorous amphora of type B with a pair of wrestlers on each side (on the Basel market in 1963 [here fig. 47]; *Münzen und Medaillen Auktion XXVI, 5. Oktober 1963* 45, no. 93, pl. 30) has the double lines as well as a small frieze above the panel showing a hound chasing a hare. This vase may count as one in the manner of the Amasis Painter.

A maeander on the sides, known in the works of the Amasis Painter from Berlin inv. 3210 (*ABV* 151, no. 21), is encountered on an unattributed amphora of type B in the Ludwig collection (fig. 48),[102] which, however, owes little to the Amasis Painter in its figure style. An oddly shaped neck-amphora in Munich by the Painter of Cambridge 47 (fig. 49)[103] reveals on its obverse two ornaments dear to the Amasis Painter: the lateral frames of the main scene are bands of diagonal zigzags (as on the fragment in New York [Cat. 18]), and the ornamental strip that separates the scene on the shoulder from the body is a row of rosettes that reminds us of the rosettes on the lekythos in the Louvre

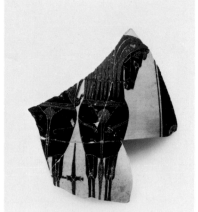

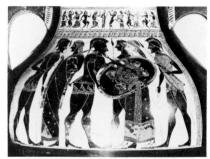

Fig. 44a,b. Fragments of a panel-amphora of type A. Attributed to the Amasis Painter. On each side: a frontal quadriga. Bonn, University, Akademisches Kunstmuseum, 504.

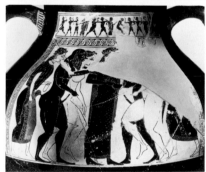

Fig. 45a,b. Panel-amphora of type A (special model). Attributed to the Amasis Painter. Side A, panel: a warrior leaving home; side B, panel: Dionysos with satyrs and maenads. Above the main panels, on side A: Dionysos and Ariadne with satyrs and maenads; on side B: athletes. Once in Berlin, Staatliche Museen, inv. 3210.

(Cat. 43), on the Kanellopoulos lekythos in Athens (fig. 38; *Paralipomena* 66), and on the lid of the Würzburg amphora (Cat. 19), where two rosettes separate the beginning from the end of the figure-zone.

Continuing to explore further links in the decorative schemes of the Amasis Painter beyond the vases securely attributed to him, we encounter some of his features on a pair of vases recently exhibited together, an amphora in Chicago (fig. 50) and one in Madison (fig. 51).[104] The one in Chicago has chevron borders on both sides of the panels, and the one in Madison has the double lines. While the somewhat crowded compositions do not evoke the neat groupings of the Amasis Painter, one surprising detail on the Madison vase does: the undraped parts of the woman behind the departing warrior on the obverse are painted in outline, just as is the woman in the arming scene on the Amasis Painter's amphora of type A in Berlin (*ABV* 151, no. 21), and as are his maenads, such as those on Catalogue 18 bis and his vases in Samos (*ABV* 151, no. 18), Kavala (*Paralipomena* 65), Basel (fig. 40; Kä 420, *Paralipomena* 65), and the Cabinet des Médailles (Cat. 23).

The double lines on the sides of the panels recur on the four amphorae of type B by the Painter of Munich 1393, once with a cable-pattern on top.[105] He is not a very careful artist and hardly worthy to be compared with the Amasis Painter, but he is obviously not averse to borrowing from him. The Painter of Munich 1393 has been put by Beazley in his Princeton Group, another member of which, the Group of Leningrad 1469, is known from amphorae that Beazley characterized as "small neat amphorae of good quality, emulating, as Villard has seen, the amphoriskoi of Amasis."[106]

Above the panels on amphorae of this group is a band of upright buds with dots in the interstices. Upright buds—much rarer than hanging buds—occur on vases by the Amasis Painter on nine of his amphorae of type B (see figs. 52, 58, 60, 63 and Cats. 3, 8, 10, 11),[107] seven of his choes (Cats. 33–36),[108] thirteen of his lekythoi (Cats. 40, 41, 44, 45, 49, 50),[109] his trefoil olpe in London (Cat. 26), and two fragments from either a chous or an amphora (*ABV* 155, nos. 67, 68).

Some examples of upright buds on amphorae not by the Amasis Painter were given by me in volume 3 of *Antike Kunst,*[110] and we shall

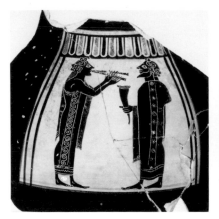 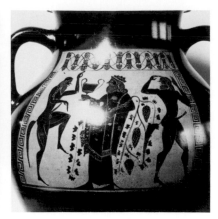

Fig. 46. Fragmentary panel-amphora. Attributed to the Heidelberg Painter. Side B: flute player and Dionysos. Once Riehen, collection of Mrs. Margarete Gsell-Busse.

Fig. 47. Panel-amphora of type B. In the manner of the Amasis Painter. Panel: wrestlers; in the small picture above the panel, a hound pursuing a hare. Once on the Basel market.

Fig. 48. Panel-amphora of type B. Unattributed. Panel: Dionysos between two satyrs. Basel, Ludwig collection.

take them up presently. What should be stressed here is that while the Amasis Painter did not create a school, he had imitators: his accomplishments were noted in the Ceramicus, and other painters gladly incorporated in their works this or that feature perfected by the Amasis Painter or felt encouraged to continue conventions that the Amasis Painter had successfully adopted from his elder colleagues. A case in point is the conceit of extending the ornamental border above the panels of amphorae beyond the width of the panel. The Amasis Painter employs it on his amphora in Bonn (*ABV* 151, no. 20), probably following the example set by Lydos on some of his amphorae (see fig. 28).[111] When we meet the same feature on the name piece of the Witt Painter in London (fig. 53),[112] we might at first be tempted to take this as a purely Lydan trait, but as we look at the procession of Athena, Herakles, and Hermes on the obverse of the amphora, we recognize a pronounced kinship with the Amasis Painter in the three-figure composition.

The earliest canonical panel-amphorae in Attic black-figure, by the Gorgon Painter,[113] have no ornamental borders; neither do the many so-called Horse-head Amphorae[114] or the amphora by the KX Painter in Bochum.[115] The change from bare panels to those surmounted by an ornamental frieze occurs with Sophilos: his amphora in the Louvre[116] retains the bare panels, but on the amphora in Jena,[117] a palmette-lotus festoon of five and a half elements appears above each panel. This festoon of heavy palmettes and lotuses is also adopted by the Painter of London B 76 for his amphora in Lyons,[118] while for its companion piece in the Louvre,[119] he gives us another crowning ornament, the chain of addorsed palmettes. Lydos, finally, introduces on his amphora in Naples[120] the chain of addorsed palmettes and lotuses, a pattern the Amasis Painter shuns, though on his Leningrad amphora (*ABV* 151, no. 15) he employs the addorsed palmette chain. Of the other patterns that begin to appear on top of amphora panels in the second quarter of the sixth century, the tongues,[121] the ivy wreath,[122] and the rows of upright ivies[123] do not seem to have appealed to the Amasis Painter as suitable for panels on amphorae, nor did he care for the bud-palmette festoon first introduced by Lydos[124] and later so popular with the Swing Painter.[125]

Hanging buds with or without dots in the interstices are also absent in the preserved amphorae by the Amasis Painter, increasingly common

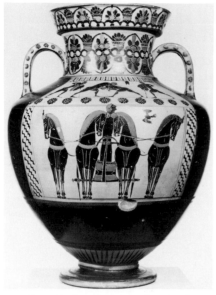

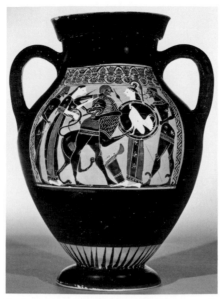

Fig. 49. Neck-amphora (special type). Attributed to the Painter of Cambridge 47. Side B: frontal chariot; on the shoulder, wrestlers. Munich, Staatliche Antikensammlung und Glyptothek, 1468.

Fig. 50. Panel-amphora of type B. Side A: Herakles and the lion. Chicago, Art Institute, 1978.114.

Fig. 51. Panel-amphora of type B. Side A, panel: departure of a warrior. Lent to Madison, Elvehjem Museum of Art.

though they become beginning with the painters of Group E;[126] instead, he reverses the direction and points his buds upward, perhaps being influenced by Lydos, who put upright buds on the side of the mouth of his signed amphora in the Louvre,[127] or by the Camtar Painter, who decorated the mouths of some of his neck-amphorae with the same pattern.[128] That such painters as the Taleides Painter, the Painter of the Nicosia Olpe, and the BMN Painter followed the Amasis Painter in using upright buds above panels[129] is not any more surprising than the buds' occurrence on the contemporary unattributed amphorae in Parma,[130] Naples,[131] and Siena (ex coll. Chigi),[132] all of which share something of the style of the Amasis Painter. The upright buds above amphora panels may thus be counted as an innovation by the Amasis Painter—although it is odd that the Affecter uses the pattern only once,[133] and odd, too, that the Swing Painter—whose painting and potting are not related to Amasis and the Amasis Painter—should try out the pattern on the reverse of his amphora in Brooklyn.[134]

In the Amasis Painter's other favorite pattern, the palmette-lotus festoon, we observe a certain refinement both in general proportions and in the distribution of black and red.[135] With his sense of perfection, he did as much for this pattern as did Exekias for the palmette-lotus chain. In particular, the palmette-lotus festoon became the Amasis Painter's preferred pattern for most of his olpai (Cats. 26 – 32); he thus established a tradition through consistency. Earlier painters, such as the Gorgon Painter,[136] the Ceramicus Painter,[137] and the KX Painter,[138] had experimented, without much conviction, with this pattern on their olpai, but it was the Amasis Painter who brought ornament and figure scenes into more harmonious proportion, both in relation to the vase as a whole and in relation to one another. (An early olpe in the Agora[139] seems to stand halfway between Lydos and the Amasis Painter and shares with the latter the double line between the figures and the surmounting ornament.)

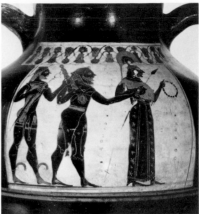

In considering at such length the ornaments on the amphorae by the Amasis Painter, we gain an insight into the artist's approach to the vases he painted and into his endeavors to produce a harmony of shape and decoration that is not easily obtained. We also learn what sets him apart from his colleagues, both friends and rivals.

It is sometimes asserted that the Amasis Painter is not in the "mainstream" of Attic black-figure and that one could draw a straight line from his predecessors to the last great masters of the technique which would barely touch him. Such general observations may make classroom instruction easier for some teachers but do not fully take into account the nature of these artists, who worked without benefit of professional critics and hardly worried about textbooks written two and a half millennia later. An artist, moreover, who, as I believe, was active for almost half a century and who lived in troubled times in a volatile society would have had other things to do than concern himself with posterity. Too young to have played an active role in the days when Attic black-figure began to shake off the filling ornaments and animal friezes of the venerable past, and perhaps too old when red-figure began to replace the very technique that he had applied himself to, he was, all the same, determined to maintain his course and continue what he liked and believed in, yet was not so stubborn as to be blind to changes in style and outlook.

One reason it is difficult to divide the Amasis Painter's long career into easily distinguishable periods is that he was not one to make abrupt changes. The very continuity of his way of drawing and composing, the even flow of his creations, at best allows only such broad distinctions as "(very) early" and "(very) late," with all other works occupying the middle span. To apply this method to vases by the Amasis Painter, it is best to begin with his latest works and to go backward in time. The chronological chart on page 240 provides relative dates for the vases by the Amasis Painter, but the reader should also bear in mind some of the chronological arguments advanced in the entries.

The finest of his late vases is the signed neck-amphora in Boston showing the arming of Achilles and the struggle for the tripod (Cat. 25). Beazley's description cannot be bettered: "The more complex drapery

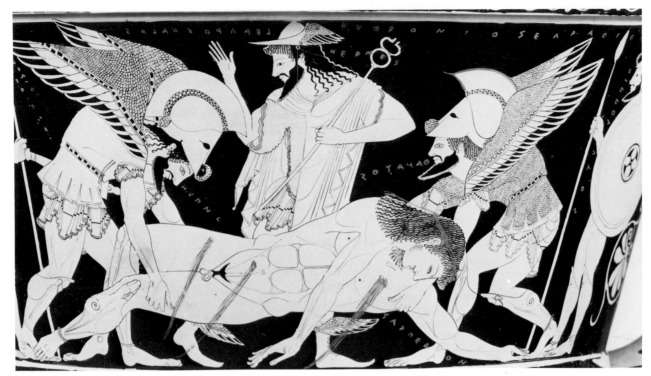

and the more substantial figures show that the Boston neck-amphora is later than that in the Cabinet des Médailles. Indeed, the drawing of the muscular bodies would point to a date not earlier than the twenties or teens of the sixth century, contemporary with the Leagros Group and the red-figured work of Euphronios and his fellows."[140]

As with many of Beazley's brilliant insights, his mention of Euphronios to call forth a general period can now be amplified by specific details, in the light of Euphronios' Sarpedon krater in New York, which was not known to Beazley (see fig. 54).[141] Does not the running figure of Hermes between Apollo and Herakles on the Boston neck-amphora evoke the central figure of Hermes, with his right hand raised, on the obverse of the Sarpedon krater, and are not the scales on the armor of both Apollo and Achilles in Boston to some extent influenced by the corslet worn by Death? Even the very silhouette of Apollo bending over to retrieve his tripod comes astonishingly close to the figure of Hypnos on the New York krater. It is, of course, quite possible that Euphronios also painted a picture of Herakles and Apollo in the struggle over the Delphic tripod and that the Amasis Painter showed the removal of Sarpedon's body by Sleep and Death—vases that have not come down to us. Nevertheless, what is perhaps of some significance is that now, when we speak of the exposure of the Amasis Painter to the Pioneer Group, we can be a little more specific: because of the strong hint provided by the Sarpedon krater, we can suggest that among the many pioneers, it was Euphronios rather than one of the others to whom the Amasis Painter felt drawn.

More than one colleague has asked me why, among the many

Fig. 54. Red-figured calyx-krater. Signed by Euxitheos as potter and Euphronios as painter. Side A, figure scene: Sleep and Death lifting the body of Sarpedon. New York, The Metropolitan Museum of Art, 1972.11.10, purchase, bequest of Joseph H. Durkee, gift of Darius Ogden Mills, and gift of C. Ruxton Love, by exchange, 1972.

excellent vase-painters, the Amasis Painter was selected for an exhibition commemorating the Beazley centenary; and I shall now advance an explanation, even though it is somewhat personal. In the spring of 1939, the completed exchange of cup fragments among Boston, Dorchester, and the Vatican resulted in the two reasonably complete cups now in the Vatican and Oxford (Cats. 62, 63). On that occasion Beazley gave a lecture in the Ashmolean Museum on the Amasis Painter. Beazley was immensely pleased by the physical joins he had brought about, to Oxford's benefit. There was much in the Amasis Painter he admired: his consummate skill, his refinement, his precision, and his humor. As new vases became known in later years, Beazley's comments revealed his delight, a joy I hope will be shared by the visitors to this exhibition. It is fortunate that so many vases by one artist can be shown together: ranging from the second to the last quarter of the sixth century B.C., they were painted by a man who witnessed the flowering of Attic black-figure vase-painting—from Lydos to the Leagros Group— over more than one generation, and who contributed much to its development.

What then, it might be asked, is the contribution of the Amasis Painter to the art of Attic vase-painting in the sixth century? When he began to paint vases, about 560 B.C., much had already been accomplished. Subject matter had become increasingly narrative rather than purely decorative, and the stories, mostly taken from Greek mythology, fired the imagination of vase-painters who tried to render visually what poets had given their public orally. To succeed in this, an artist needed both technique and skill in drawing that were equal to the task. The Amasis Painter had these and, moreover, was fortunate to start painting vases when black-figure was already an established technique with settled conventions—a glossy black silhouette for figures, details rendered by incisions that appear light on dark, and added opaque ceramic colors, such as red and white, to relieve the chromatic monotony. He also benefited from the growing understanding of the human body, its volume, contours, and articulation. The first two generations of black-figure vase-painters had made great strides forward while adhering to a certain discipline, one that required the artist, for instance, to draw figures who stand on a common groundline and rise to an equal height so that their heads line up on the same level (isocephaly). Also enforced was a traditional preference for profile rather than frontal views; but the continual observation of the human body, especially of the body in motion, soon led to modifications of the established formulas, and we note that the elements of perspective were gradually applied to the human body as well as to objects, such as the diskos held by an athlete on a cup by the Heidelberg Painter (fig. 55).[142]

Amid this rapid development, each new convention evolved by an artist was almost at once taken up by his colleagues—especially by the more talented ones. We can best appreciate the Amasis Painter against this background of many excellent artists. In speaking of his style, we must make a distinction between what is shared by others and what is unique to him. Style, in short, is more than a fashion or a trend: it rises to

a level of individual excellence when we assess the difference between two fine painters as no longer one of greater achievement but, rather, one of a personal choice for a different way of drawing. This, the personal style of an artist, becomes so completely integrated in his works that it can be recognized even in the smallest fragments. Sometimes two or more artists are close to one another and paint the same subject using the same scheme of composition; it requires close inspection to recognize the different hands at work, this recognition being akin to that of the music lover who merely upon hearing a recording of a symphony can identify the conductor. The personal touch of a vase-painter manifests itself in many different ways: in the ornaments, the choice of subjects, the scheme of composition, the sense of proportions of the human body, the conventions for incised anatomical details, the use of additional colors—to name but a few of the criteria that establish an attribution.

Unlike the student or scholar working from a distance who consults books and photographs, the visitor to this exhibition will benefit from the cumulative impact of seeing roughly half of one vase-painter's preserved work—all at once and in one gallery, an opportunity no one has ever enjoyed before. The sheer visual impact of over sixty vases painted by a great artist will, it is hoped, leave a memorable impression of his character and style, the scope of his imagination, the precision of his contours and inner markings—and something of the festive spirit that pervades all of his figures.

NOTES

1. *ABV* 39 – 40, no. 16.
2. *ABV* 82, no. 1; 143 – 145, nos. 1, 13.
3. *Monumenti per servire alla storia degli antichi popoli italiani*[2] (Florence 1833) pl. 76,1.
4. *ABS* (1928) 31.
5. *ARV*[2] 368, 400.
6. *ARV*[2] 238, no. 1, 239, no. 16.
7. *Cabinet Durand* 152, no. 411.
8. Cats. 9, 10; *ABV* 151, nos. 10, 11 (here fig. 58), 12 (here fig. 63), p. 153, no. 34.
9. *Beschreibung der Vasensammlung im Antiquarium,* pp. 226 – 229, nos. 1688 – 1692, p. 276, no. 1731.
10. O. Jahn, *Beschreibung der Vasensammlung König Ludwigs in der Pinakothek zu München* (Munich 1854); L. Stephani, *Die Vasensammlung der kaiserlichen Ermitage* (St. Petersburg 1869); H. Heydemann, *Die Vasensammlungen des Museo Nazionale zu Neapel* (Berlin 1872).
11. *Wiener Vorlegeblätter.*
12. *RA,* ser. 3, vol. 18 (1891) 366 – 370.
13. *AA* 1893, 83 – 84.
14. In a letter to Karl Sittl, November 10, 1893.
15. *Unsignierte Vasen des Amasis* (Prague 1895).
16. *JHS* 19 (1899) 135 – 164.
17. See *ABV* 238ff.
18. *Black-figured Vases* 41 – 45.
19. *ABS* (1928) 6.
20. *JHS* 47 (1927) 63.

21. Berkeley and Los Angeles: University of California Press.

22. *JHS* 51 (1931) 256 – 285.

23. *JHS* 49 (1929) 253 – 257.

24. *CVA,* Oxford, fasc. 2 (1931).

25. *BSA* 32 (1931 – 1932, pub. 1934) 18 – 19.

26. *JdI* 44 (1929) 141 – 150; *AM* 59 (1934) 19 – 24.

27. *AM* 56 (1931) 98 – 111.

28. S. Karouzou, *AM* 56 (1931) 26.

29. K. Schefold, *Spätarch. Kunst* (1978) 106.

30. *ABL* (1936) 12, 18.

31. *Ephemeris archaiologike* 1886, cols. 123ff.

32. *The Amasis Painter* (Oxford 1956) 27, 42, appendix 2.

33. *JHS* 78 (1958) 2.

34. *ABV* 109, nos. 25, 29; see R.M. Cook, *JHS* 68 (1948) 148.

35. *ABV* 109, no. 29; see *ABS* (1928) 36, no. 1.

36. See *Paralipomena* 44, no. 29.

37. J.D. Beazley, *JHS* 51 (1931) 277.

38. *ABV* 58, no. 126.

39. *ABV* 83, no. 4.

40. *ABV* 82, no. 1.

41. *ABV* 76, no. 1, handle B/A.

42. E.g., *ABV* 76 – 77, nos. 1, 3, 5, 8, 9.

43. *ABV* 109, nos. 29, 27; see *ABS* (1928) 36.

44. See *ABV* 107 – 110, nos. 1, 5, 6, 27 – 29, 31 – 34; *Paralipomena* 45 (hydria in the Ceramicus Museum).

45. *ABV* 107, no. 1.

46. *Paralipomena* 46.

47. Further examples can be found at *ABV* 150ff., nos. 1 (fig. 57), 3, 10, 14 (fig. 60), 15, 19, 21 (fig. 45), 23 (fig. 56), 33.

48. *ABV* 111, no. 48; New York 1985.11.1 (fig. 25).

49. Further examples can be found at *ABV* 150ff., nos. 23 (fig. 56), 42 (fig. 79), p. 714, under pp. 150 – 158, no. 61 bis (fig. 99); *Paralipomena* 65 (once in Riehen, Hoek collection [here fig. 43]).

50. *ABV* 108, no. 14.

51. *ABV* 107, no. 1.

52. *ABV* 109, nos. 23, 25 (here fig. 28).

53. *ABV* 108, no. 8.

54. R.J. Guy, *Glimpses of Excellence* (Toronto 1984) 7, no. 4.

55. *ABV* 109, no. 29.

56. *ABV* 226, no. 1.

57. *ARV²* (1963) xlvii.

58. *Development* (1951) 57 – 58.

59. For the early panel-amphorae, see *ABV* 144 – 145, nos. 9 – 11; for the later works, see *ABV* 145, nos. 12, 13 (Ajax and Achilles), 14 (fig. 19), 15 – 18.

60. *Paralipomena* 61; D. von Bothmer, *Bulletin du Musée Hongrois des Beaux-Arts* 31 (1968) 17 – 25.

61. *ABV* 39 – 40, no. 16.

62. E.g., *ABV* 69, no. 1 (Athens), 120, top; New York 1978.11.13 (MMA, *Notable Acquisitions, 1975 – 1979* [New York 1979] 14 [here fig. 37]); Athens, Acr. 921 (B. Graef and E. Langlotz, *Die antiken Vasen von der Akropolis zu Athen* 1 [Berlin 1925] 110, pl. 59); Munich 1451 (J.R. Brandt [Institutum Romanum Norvegiae, Rome] *Acta* 8 [1978] pl. 2b).

63. *Paralipomena* 19, no. 16 bis.

64. *ABV* 76, no. 1.

65. Further examples are *ABV* 154, no. 56 (here fig. 64); Warsaw 198552 (*Paralipomena* 66 [here fig. 39]); Athens, Kanellopoulos collection (*Paralipomena* 66 [here fig. 38]).

66. *Paralipomena* 65 (here fig. 40).

67. *ABV* 144, no. 7.

68. Sir Thomas Browne, *Hydriotaphia, Urn-Burial*, ed. C. Sayle (Edinburgh 1927) 3: 37.

69. See K. Schauenburg, *JdI* 79 (1964) 119 – 120.

70. Warsaw 198552 (*Paralipomena* 66 [here fig. 39]).

71. Cats. 26, 54.

72. Cat. 58.

73. Cats. 20, 35, 45; *ABV* 153 – 156, nos. 35, 67, 69, 70, 73, 82.

74. Cyrene, F 13/G 13 (here fig. 42) and D. White, *Libya Antiqua* 9 – 10 (1972 – 1973) pl. 87,f (here fig. 52).

75. *ABV* 151, nos. 17, 18.

76. *ABV* 154, no. 51.

77. *Paralipomena* 65.

78. *ABV* 155, no. 63 bis.

79. *ABV* 156, no. 75.

80. *ABV* 155, no. 62.

81. *ABV* 151, no. 19, 156, no. 78.

82. *ABV* 152, no. 28.

83. *ABV* 156, no. 74.

84. F. B. Visentini, *NSc* 96 (1971) 243 – 244, fig. 60.

85. Cats. 12, 14, 22, 23, 31, 38, 53, 57; *ABV* 150 – 153, nos. 1, 11 (?), 15, 33, p. 156, no. 83.

86. Cats. 24, 25, 40; *ABV* 150 – 153, nos. 3, 14, 43.

87. *ABV* 151, no. 16.

88. E.g., Cats. 5, 9 – 11, 15, 27, 28, 34, 36, 37, 41, 42, 46, 61; *ABV* 151 – 156, nos. 10 – 12, 20, 21, 34, 54, 56, 63, 84.

89. *ABV* 155 – 157, nos. 66, 68, 71, 79, 90 – 92, p. 688, no. 71 bis.

90. *ABV* 155 – 156, nos. 64, 72, p. 714, under pp. 150 – 158, no. 31 bis.

91. *ABV* 155, no. 61 (here fig. 59).

92. Cats. 47, 48; *ABV* 714, under pp. 150 – 158, no. 61 bis.

93. Cat. 49.

94. Athens, Kanellopoulos collection (*Paralipomena* 66 [here fig. 38]).

95. *Paralipomena* 66.

96. For a band-cup fragment from Old Smyrna that recalled the Amasis Painter to Boardman, see *ABV* 688.

97. *ARV*[2] 571, no. 73.

98. E.g., Cats. 1, 2, 3, 6, 7, 10, 11, 13, 21, 23, 28.

99. See also the vase once in Riehen, Hoek collection (*Paralipomena* 65 [here fig. 43.]).

100. *Paralipomena* 27, no. 61.

101. A. Greifenhagen, *CVA,* Brunswick (1940) pl. 6, 2 and 5.

102. R. Lullies, *Sammlung Ludwig* 57 – 60, no. 21.

103. *ABV* 315, no. 3.

104. W.G. Moon in W.G. Moon and L. Berge, *Greek Vase-painting in Midwestern Collections* (Chicago 1979) 52 – 56, nos. 31 – 32.

105. *ABV* 303, nos. 1 – 4 (no. 3 has the cable-pattern).

106. *ABV* 302.

107. Cyrene (D. White, *Libya Antiqua* 9 — 10 [1972 — 1973] pl. 87,f [here fig. 52]); see also *ABV* 150 — 151, nos. 3, 11 (here fig. 58), 12 (here fig. 63), 14 (here fig. 60).

108. See also *ABV* 153, nos. 42 — 44.

109. See also *ABV* 154 — 155, nos. 56 (here fig. 64), 61 (here fig. 59), p. 714, under pp. 150 — 158, no. 61 bis (here fig. 99); *Paralipomena* 66 (Tübingen, Zurich [here fig. 98], Warsaw [here fig. 39], Athens [here fig. 38]).

110. D. von Bothmer, *Antike Kunst* 3 (1960) 77.

111. *ABV* 109, nos. 23, 25 (here fig. 28).

112. *ABV* 313, no. 2.

113. *ABV* 9, nos. 8, 9; *Paralipomena* 7.

114. *ABV* 15 — 17, 679; *Paralipomena* 9 — 10.

115. N. Kunisch, *Jahrbuch der Ruhr-Universität* 1982, 17 — 18, figs. 11, 12.

116. *ABV* 38, no. 5, now cleaned.

117. *ABV* 39, no. 7.

118. *ABV* 87, no. 16.

119. Cp 10586, *Paralipomena* 33, no. 16 bis.

120. *ABV* 109, no. 23.

121. *Paralipomena* 27, no. 61 (Heidelberg Painter); *ABV* 685, no 21 bis (Painter of Vatican 309); *ABV* 125, nos. 35, 36 (Painter of Louvre F 6).

122. *ABV* 125, no. 37, and Erlangen, University, M 231 (both by the Painter of Louvre F 6).

123. *ABV* 125 — 128, nos. 38 — 83 (Painter of Louvre F 6).

124. *ABV* 109, no. 28; London market (*Cat. Sotheby, London, Dec. 13, 1982,* lot 258).

125. E.g., *ABV* 304 — 306, nos. 1, 5, 14, 47; *Paralipomena* 134, no. 23 ter.

126. *ABV* 133, no. 7, 135, no. 42, 140, no. 2 (Munich), 142 (Vatican 354); *Paralipomena* 56, no. 38 bis.

127. *ABV* 109, no. 21.

128. *ABV* 84, no. 4; *Paralipomena* 31, no. 9.

129. *Paralipomena* 73, no. 1 bis, 196, nos. 8 bis and ter, 107, no. 7 bis (here fig. 65).

130. M.P. Rossigniani, *CVA,* Parma, fasc. 1 (1970) III H, pl. 2.

131. A. Adriani, *CVA,* Naples, fasc. 1 (1950) III He, pl. 2,5 — 6.

132. See G. Pellegrini, *Studi e materiali* 1 (1901) 311, no. 215.

133. *ABV* 245, no. 68.

134. *Paralipomena* 133, no. 21 bis.

135. See D. von Bothmer, *Antike Kunst* 3 (1960) 78 — 79, for an outline of the development.

136. E.g., *ABV* 9, no. 11.

137. E.g., *ABV* 19, no. 2.

138. *Paralipomena* 15 (Ceramicus); *ABV* 28, no. 4 (in his manner).

139. *ABV* 445, no. 5.

140. J.D. Beazley, *Development* (1951) 58.

141. N.Y. 1972.11.10.

142. *ABV* 64 — 65, no. 28.

COLOR PLATES

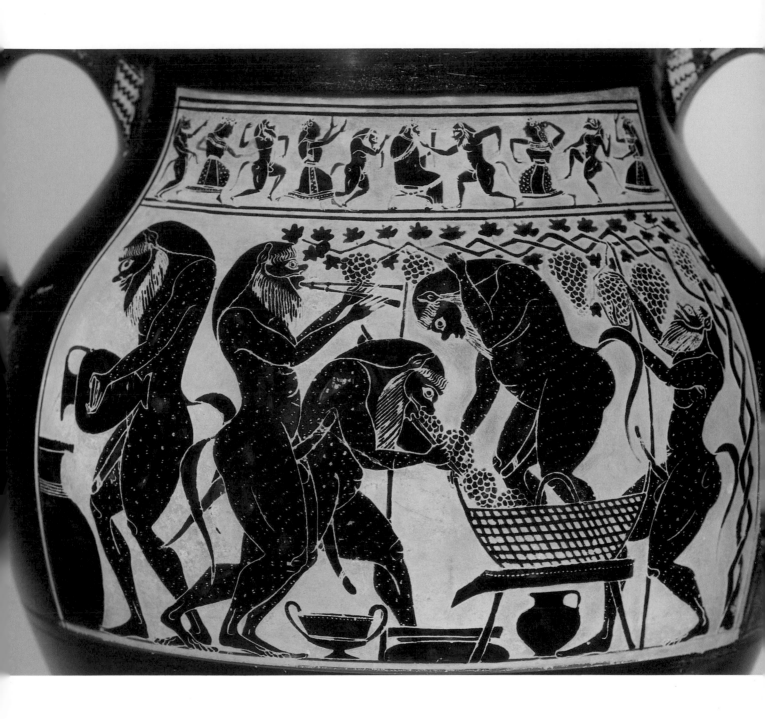

Cat. 19. Panel-amphora (type A). Side B, panel: satyrs making wine. Würzburg, University, Martin von Wagner Museum, L 265 and L 282.

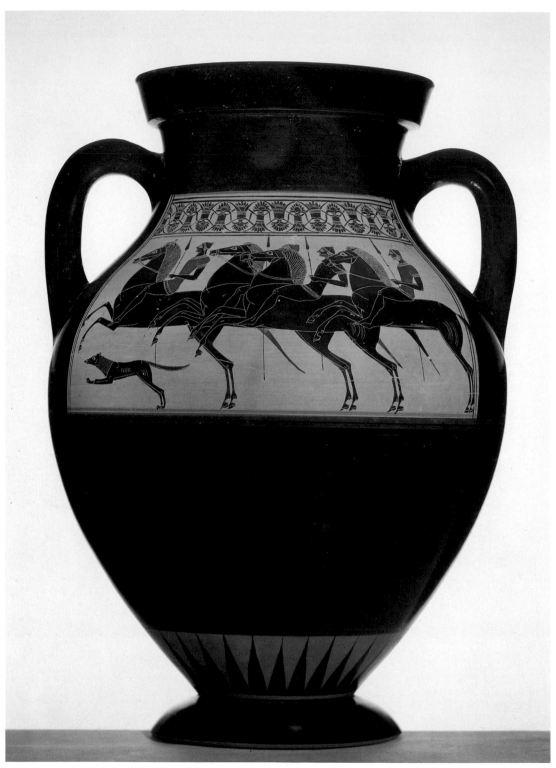

Cat. 4. Panel–amphora (type B). Side B, panel: cavalcade. Munich, Staatliche Antikensammlung und Glyptothek, inv. 8763.

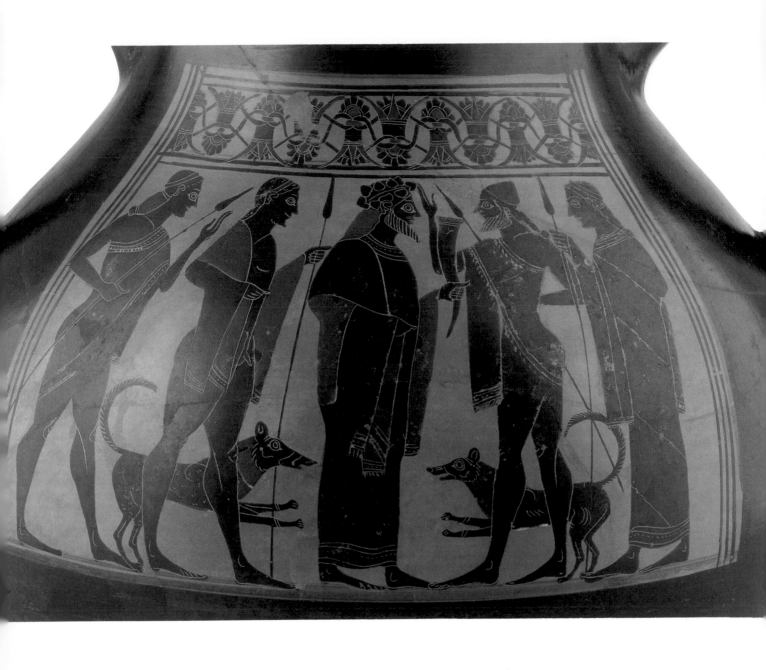

Cat. 2. Panel-amphora (type B). Side A: Dionysos greeted by four youths.
Bloomington, Indiana University Art Museum, 71.82.

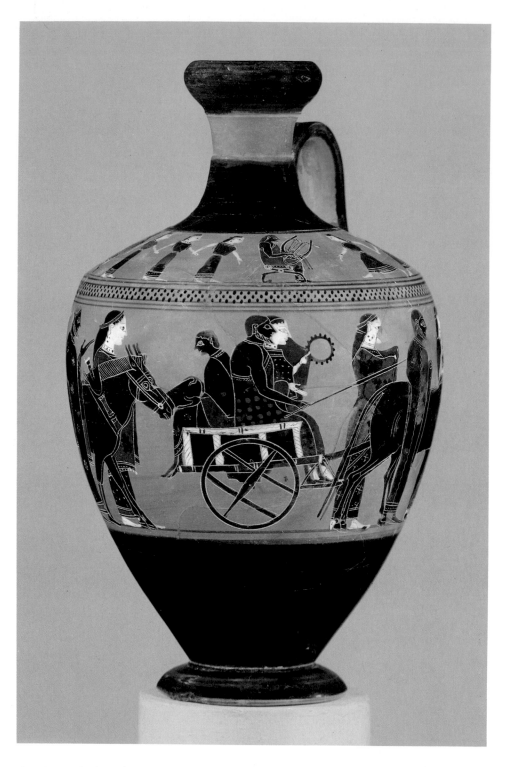

Cat. 47. Lekythos (shoulder type). Detail of wedding procession. New York, The Metropolitan Museum of Art, 56.11.1, gift of Walter C. Baker, 1956.

Cat. 31. Olpe (with round mouth). Perseus, Gorgon, and Hermes. London, British Museum, B 471.

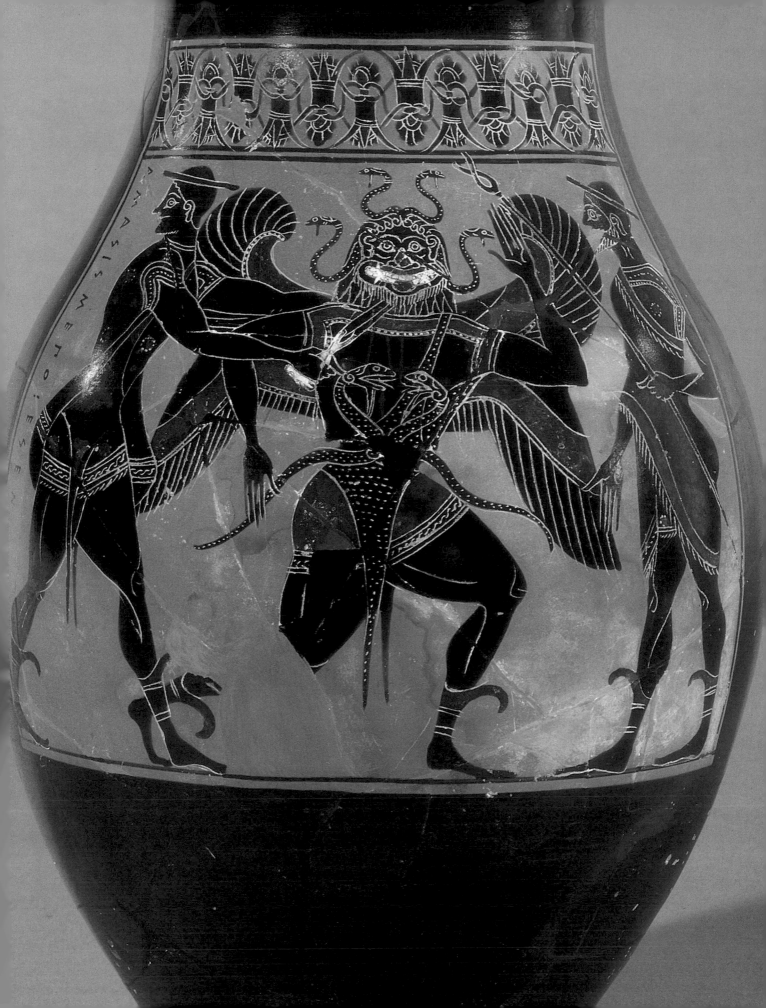

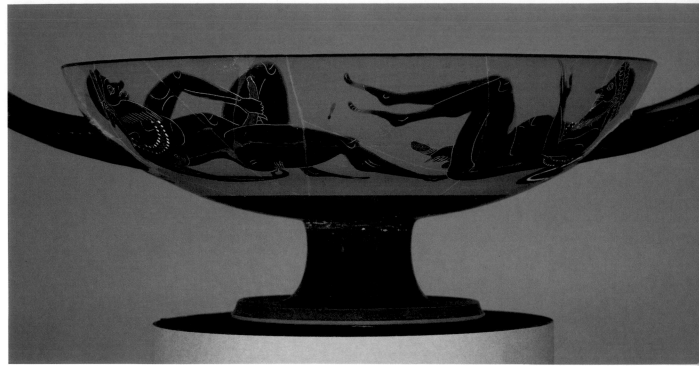

Cat. 61. Cup (variant of type A). Detail of satyrs.
Boston, Museum of Fine Arts, 10.651, gift of E.P. Warren, 1910.

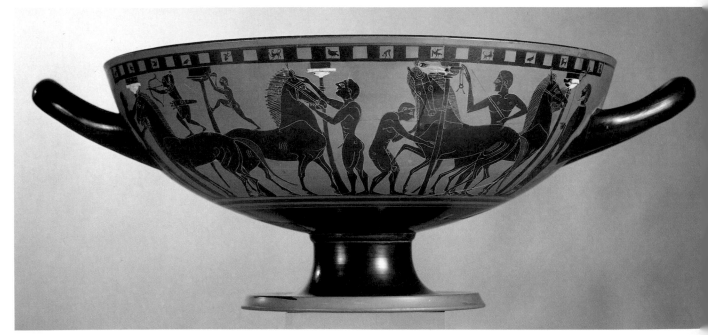

Cat. 60. Cup (type A). Detail of the stable of Poseidon.
Kings Points, New York, Norbert Schimmel.

Cat. 37. Oinochoe (shape I). Detai
of panel: frontal chario
London, British Museum, B 524

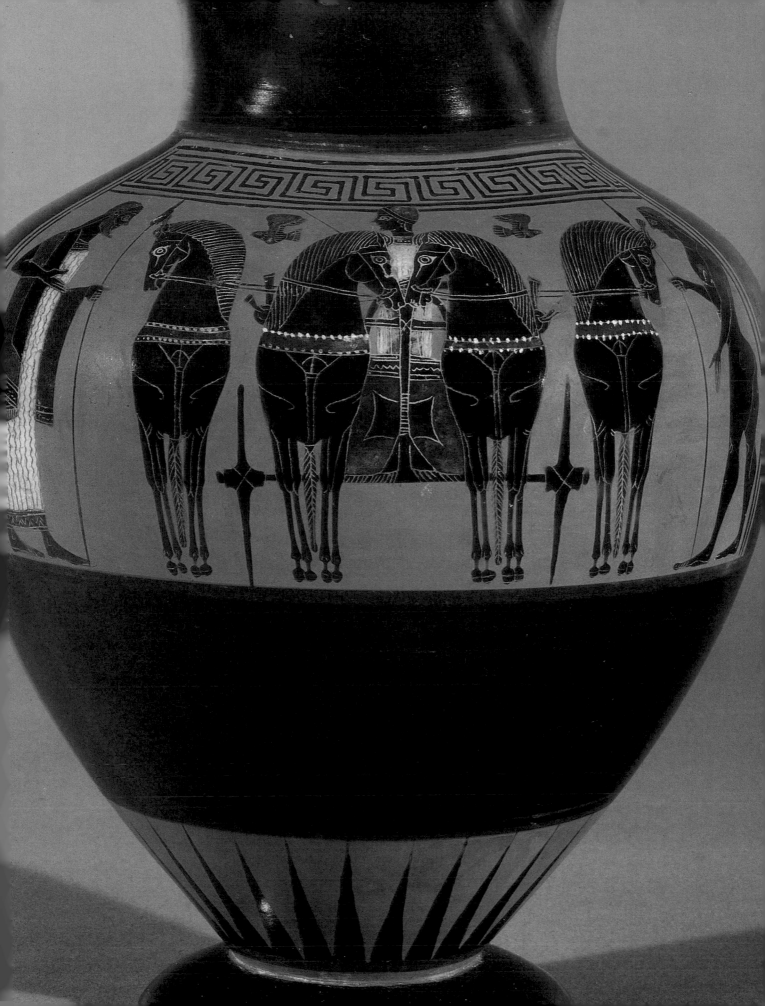

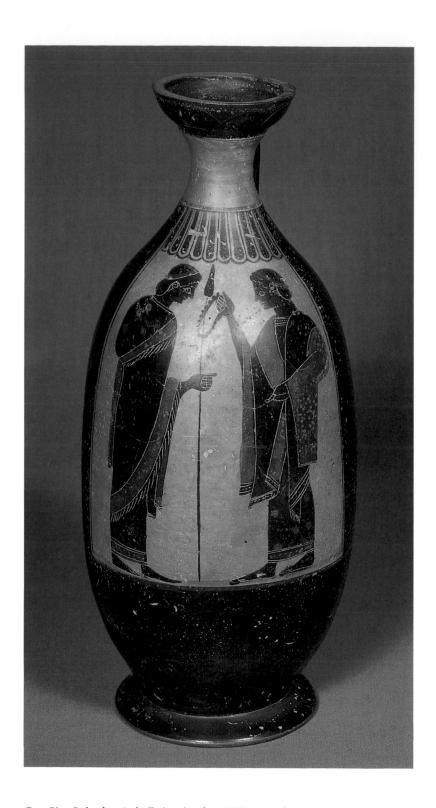

Cat. 51. Lekythos (sub–Deianeira shape). Two youths.
Copenhagen, Danish National Museum, inv. 14067.

Catalogue

1 PANEL-AMPHORA (TYPE B)

THE METROPOLITAN MUSEUM OF ART, NEW YORK, 06.1021.69, ROGERS FUND, 1906.

The subject on each side is an arming scene, a warrior putting on a greave, shown in two successive phases. On the reverse he holds the greave above his left leg, spreading the armor with both hands; on the other side he has slipped it on. On both sides, the other greave is already in place. The warrior wears a fillet in his hair and carries a sheathed sword suspended from a baldric over his left shoulder. On the obverse he faces a woman, clad in a richly decorated peplos and wearing an earring, a necklace, and a bracelet rendered by incised lines, as well as a fillet. In her right hand she holds an aryballos of Corinthian type (see Cat. 52); in her left hand she carries a spear, held tip downward. On the reverse her place is taken by a naked boy carrying a spear in the same manner but holding a wreath in his right hand, perhaps to be placed on the helmet. A Corinthian helmet rests on the ground between the legs of the warrior. On the reverse it has two half-crests and a bull's ear; on the obverse the helmet has a single crest. In each picture, the second figure facing the arming warrior is a youth, as can be seen by the beginnings of a beard at the line of the jaw; he holds the second spear of the warrior and carries a round shield, the devices of which are, on the obverse, the forepart of a boar and, on the reverse, that of a lion. This shield bearer is followed on side A by a naked boy holding a spear, while his counterpart on side B is dressed in a himation. The companions behind the greaving warrior are a youth in a himation and a youth in a chlamys, each holding a spear upright; the two sides differ only in that on the obverse the youth wearing a chlamys extends his left hand in a gesture of greeting. All of the boys and youths wear fillets in their hair.

As Beazley observed more than thirty years ago (*Development* 59), the arming scenes on this amphora are to be compared with an arming scene on a Siana cup in Munich by the Heidelberg Painter (fig. 55; *ABV* 64 – 65, no. 28), to whom he must have been very close at the beginning of his career. The proportions of cup exteriors, especially Siana cups and Little-Master cups, as well as the shoulders of Tyrrhenian neck-amphorae, call for auxiliary figures, those supernumeraries that archaeologists classify as onlookers. This convention of including additional men, usually holding spears, was adopted by the Amasis Painter for his panel-amphorae; it is instructive to look at the outside of the Heidelberg Painter's cup, also showing a warrior greaving, to see which features the Amasis Painter has kept and which he has discarded or modified. The chief figure is more or less the same—a naked, bearded warrior has raised his left leg and bends over, adjusting the greave with both hands—and the Heidelberg Painter has also kept the helmet on the ground facing the same way as its owner. Similar, too, is the boy to the left of the warrior; he wears a chlamys and lifts his left hand in a greeting, while his companion to the right of the warrior brings the shield and holds a spear diagonally in his right hand. Yet on the Munich cup, the remaining four figures, dressed in himatia, stand rather stiffly, holding their spears like staves. The number of participants on the cup exceeds those in each panel of the New York amphora by one. The Amasis Painter has articulated his figures more thoughtfully than the Heidelberg Painter. On each side of this amphora, the first person facing the greaving warrior carries his spear in readiness (rather than using the spear as a staff) by holding it point

downward. The youth immediately behind the spear holder partially overlaps the first figure and carries the shield of the hoplite. There is no sign of a cuirass anywhere: the greaving warrior may well be a figure from Greek mythology, drawn in heroic nudity. (On the much later neck-amphora by the Amasis Painter in Boston [Cat. 25], the arming scene is identified as that of Achilles by the inscriptions.)

Close in time to the New York amphora is the neck-amphora by the Amasis Painter that was formerly in Castle Ashby, now in the Embiricos collection in Lausanne (fig. 56; *ABV* 152, no. 23). It has recently been cleaned, and the owner has kindly allowed the republication of his vase in its new state. The chief subject is again an arming scene, but on this vase the two panels depict different aspects. On the side showing the greaving, probably side B, the warrior strikes the same pose as on the obverse of the New York amphora, but his other leg is still bare, and its greave is standing on the ground between his legs. The bearded warrior wears a leather corslet; the nude youth facing him holds a Corinthian helmet (of the type shown here, on the reverse of the New York amphora) by the nosepiece and carries a spear. As on the New York amphora, the shield (whose blazon is a preening swan) is held by the second person, here a woman. The youth behind the greaving warrior is clad in a chlamys worn on both shoulders; he has raised both arms in a greeting, a gesture that is echoed by the youth behind the shield bearer. The first figure on the left is a true bystander, drawn very much like his counterpart on the obverse of the New York amphora. The other side of the Lausanne vase (probably its obverse, because of

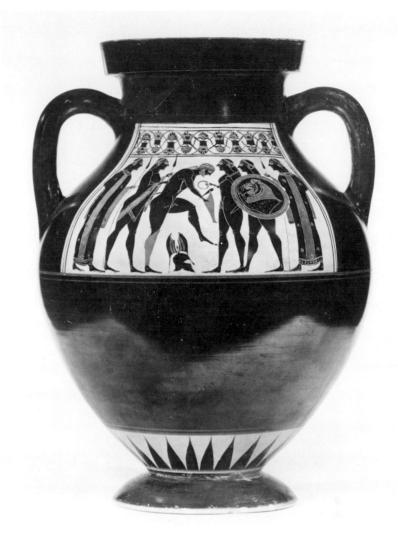

1 Side B.

the more elaborate ornament that serves as the upper frame of the panel) introduces several innovations. The warrior in the center wears a nebris over his tunic (perhaps again a leather corslet) and takes the Corinthian helmet by the nosepiece from the naked youth facing him. Behind the arming warrior stands another naked youth, who is followed by a warrior in a Corinthian helmet and a cloth tunic, armed with sheathed sword and spear, but lacking shield and greaves. On the right side, behind

the youth proffering the helmet, comes a woman who carries a shield with a lion's forepart as a device—like the device on the reverse of the New York amphora, save that the mane is fringed and covers the demarcation of the shoulder. The last figure to the right is another youth dressed in a chlamys slung over both shoulders, like the second and last figures on the other side; in front of him is a dog, also moving to the left.

There are several vases by the Affecter that are clearly influenced by the Amasis Painter (D. von Bothmer, *Journal of the Walters Art Gallery* 38 [1980] 106), and among them are nine that show an arming scene (*ABV* – 247, nos. 1 – 3, 39, 48, 49, 66, 86, 87), always at the same stage: a warrior bending to the right, his left leg bent, in front of him a greave spread apart before being slipped on the leg. On four of the vases (*ABV* 239 – 244, nos. 1, 39, 48, 49), the warrior is nude, as on the New York amphora shown here by the Amasis Painter; on the others, the warrior wears a short chiton, with or without a corslet, and a nebris. Invariably there is a Corinthian helmet at his feet, although there is no consistency in the direction it faces, and in three instances, the helmet rests on a shield lying flat on the ground (*ABV* 244 – 247, nos. 1, 66, 86). Clearly the Affecter took his arming scenes from compositions by the Amasis Painter, either from this amphora or from others like it that have not been preserved. We may therefore conclude (as I did in *RA,* 1969, 5) that the earliest works of the Affecter cannot be later than the arming scenes by the Amasis Painter, which I date about 550 B.C.

Attributed by J.D. Beazley to the Amasis Painter.

DIMENSIONS AND CONDITION
Height, 39.2 – 39.4 cm; width (across handles), 29.0 cm; diameter of body, 28.45 cm; diameter of mouth, 17.6 – 17.8 cm; diameter of foot, 15.9 – 16.02 cm; width of lip, 0.95 – 1.01 cm; width of resting surface, 1.3 cm. Height of panels (without border), 10.8 cm on side A; 11.1 cm on side B. The compass-drawn shields have a radius of 2.27 cm on the

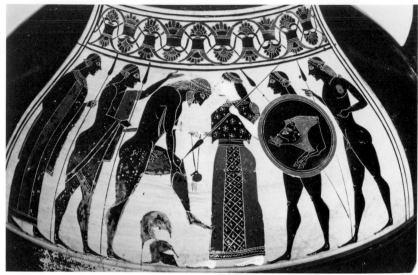

1 Side A, panel.

obverse and 2.36 cm on the reverse. The only breaks are on the mouth and upper part of the neck above handle A/B; the glaze on the reverse has suffered from flaking; there are minor chips and nicks along the edge of the foot.

GRAFFITI

Fig. 55a,b. Siana cup. Attributed to the Heidelberg Painter. Side A: arming scene; side B: diskos thrower. Munich, Staatliche Antikensammlung und Glyptothek, inv. 7739.

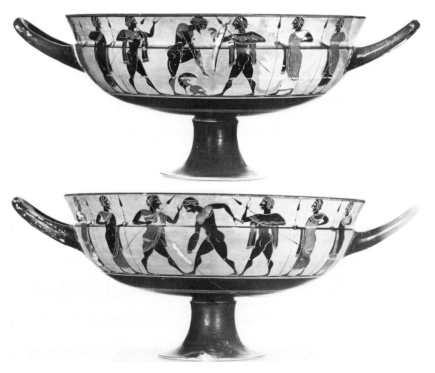

72

SHAPE AND DECORATION

Flaring mouth, sharply offset from the neck. The top of the mouth is flat and glazed; the inside of the neck is glazed to a depth of 1.85 – 2.0 cm. The round handles are glazed on the underside, though the brush has left a few small places uncovered. Echinus foot, glazed on the outside except for the very edge; in the zone above the foot are twenty-five very evenly spaced rays. The reserved panels begin at the height of 20.0 cm (measured from the ground), exactly the "equator" of the amphora. The pictures are framed by two glaze lines on the sides and are surmounted by a festoon of ten palmette-lotuses: on the obverse the artist has continued the festoon and added in the lower right-hand corner part of another lotus; on the reverse the tenth palmette-lotus is trimmed on the right, while part of an extra lotus appears on the upper left-hand corner. The festoons are bordered above and below by two glaze lines. The groundline is rendered in dilute glaze.

ADDED COLORS

Red, line on outer edge of mouth and narrow band below inner edge; two lines directly below panels encircling entire vase; two lines above tips of rays and one line below them; cores and rings of palmettes; outside petals and central pods of lotuses; all twelve fillets in hair of figures; lower part of tied hair of last figure to right on side A and ring of hair around his nipple; all four greaves; rims of shields; neck of boar; muzzle, ear, and parts of mane of lion on shield devices; alternate vertical panels on himatia; lower part of peplos (except for patterned central panel) and shoulder cap of woman; stripes on chlamides; cores of dot-rosettes on himatia; body of aryballos. *White,* female flesh; hilt of sword on side A; rows of dots on crests of helmets; fingernails of boys and youths; tusk of boar; teeth of lion; dots around red cores of dot-rosettes; dots above red chlamys border of second youth on side B; dots along lower border of neckline of himation on side A and on upper edge of bottom border of woman's peplos.

BIBLIOGRAPHY
D. von Bothmer, *CVA,* MMA, fasc. 3 (1963) 4 – 5, pls. 6, 7 (with bibliography to 1963); E.B. Harrison, *Agora* 11 (1965) 42; J.V. Noble, *Techniques* (1966) fig. 189; D. von Bothmer, *RA,* 1969,5; H.A.G.

Brijder, *BABesch* 49 (1974) 108, n. 16; H. Mommsen, *Der Affecter* (Mainz 1975) 33, n. 176; D. Kemp-Lindemann, *Darstellungen des Achilleus in griechischer und römischer Kunst* (Bern 1975) 155; A.W. Johnston, *Trademarks* (1979) 117, type 5D, no. 6; D.L. Carroll, *Patterned Textiles in Greek Art* (Ann Arbor, Mich., 1980) 338, no. 284.

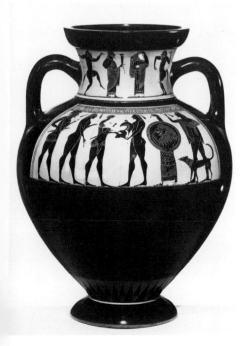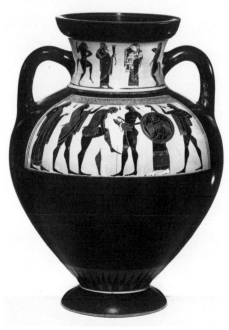

Fig. 56a,b. Neck-amphora. Attributed to the Amasis Painter. Side A: warrior receiving his helmet; side B: warrior greaving. Lausanne, collection of Nicolas Embiricos.

2 Panel-Amphora (Type B)

On each side of the vase Dionysos is shown standing facing right, a drinking horn in his left hand. He wears a long chiton and a mantle draped over his shoulders and arms. In his hair he has an ivy wreath. The god is in the company of mortals. On the obverse he faces a bearded man wearing a fringed chlamys over his left shoulder and a felt cap. He holds a spear in his right hand. The ends of his long hair are tied in a knot. Behind Dionysos are two youths in chlamides, one wearing his over the left shoulder, the other wearing his over both shoulders and arms. Both hold spears, as does the third youth, who stands on the far right wearing a himation and holding a spear. His long hair is tied in a knot like that of the man in the felt cap and that of the youth on the far left. Two snarling dogs in the background complete the picture. One of them wears a collar (there is no leash).

The group on the other side is the earliest of a series that shows Dionysos with boys and youths. Here the dogs are less agitated and both wear collars. The boy facing Dionysos stands still, a spear in his left hand. His right hand is raised in greeting. His mirror image, another boy, is behind Dionysos. These two boys wear wraps on their raised arms. The scene is concluded by two youths, one on each side, who carry their spears in their right hands and wear chlamides over their left shoulders. The youth on the left also carries a sheathed sword in his left hand; it is hidden under the chlamys, but its scabbard protrudes. All the boys and youths on both panels wear fillets in their hair.

The Bloomington amphora is one of the very few on which the Amasis Painter repeated his subject exactly on both sides of the vase. It forms a bridge between the

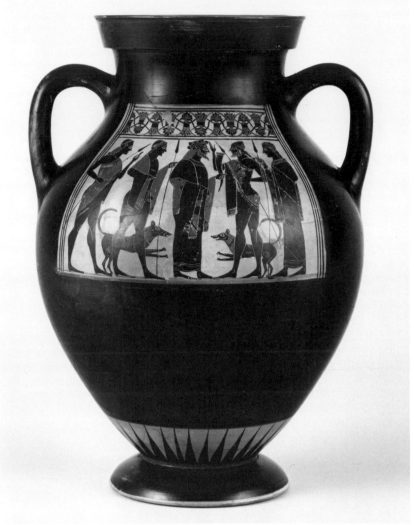

2 Side A.

earliest Dionysiac encounter, on the Guglielmi amphora of the Amasis Painter (fig. 57; *ABV* 150, no. 1), and the later, more finished type that begins with one of the Ludwig amphorae in Basel (Cat. 8). As on the Guglielmi amphora, he has still painted the cuffs of the lotuses black. Very exceptionally, the Amasis Painter has framed his panels here with three lines on the sides rather than two.

Late early period or early middle period. For a discussion of the chronology, see Catalogue 14.

Attributed to the Amasis Painter by R.E. Hecht, Jr.

Dimensions and Condition
Height, 31.5 cm; width (across handles), 23.2 cm; diameter of body, 21.5 cm; diameter of mouth, 14.2 cm; width of lip, 0.7 cm; diameter of foot, 12.3 cm; width of resting surface, 1.4 cm. Height of figures, 9.8 cm on side A, 9.5 cm on side B. The vase is broken and has been repaired with some restorations of the missing portions, notably on the obverse (in the chlamys of the left youth and the folds of the mantle worn by Dionysos; for the condition before res-

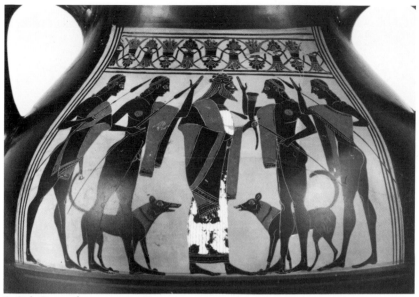

2 Side B, panel.

2 Lid.

toration, see D. von Bothmer, *Antike Kunst* 3 [1960] pl. 11). The lid that appears in the earlier publications does not belong but should be that of the Basel neck-amphora (Cat. 21) that was once owned by the same collector (see D. von Bothmer, *MM* 12 [1971] pl. 30, with the lid).

SHAPE AND DECORATION
Flaring mouth, glazed on top, with a slight overhang. The inside of the mouth is glazed to a depth of 1.5 cm. The round handles are glazed on the underside. Echinus foot, glazed on the outside except for the very edge. Above the foot is a zone of thirty-three rays, of which one, under the right foot of Dionysos on the obverse, is much thinner: this suggests that the painter started painting the rays in the center of the obverse. The pictures are set in panels framed on the sides by three glaze lines,

rather than the usual two. Above the figures is a palmette-lotus festoon, consisting on side A of nine complete elements, with half a lotus-palmette added on each side. On side B the festoon comprises ten complete elements, with half a unit added on the left. The festoon is framed above and below by two glaze lines. The groundlines are drawn in dilute glaze, partially covered by the top red line that encircles the vase. As some of the feet overlap the red line, it is clear that the figures were painted after the body had been glazed and the borders of the panels were drawn.

ADDED COLORS
Red, stripe below inner edge of mouth; two lines below panels encircling entire vase; two lines above rays; cores of palmettes; rings connecting tendrils; outer and central sepals of lotuses; all fillets. On side A, hair on napes of left

youth and Dionysos; chlamys of left youth; folds on chlamys of second youth; folds on mantle of Dionysos and dots on his chiton; necks of dogs and markings behind their shoulders, stripes on their haunches; outside of chlamys of man in felt cap; vertical folds of himation of youth on right side, dots on his himation. On side B, panels on chlamides of flanking youths; dot on nipple of left youth; hair circles around nipples of boys, tied ends of their hair, outsides of their wraps; folds on himation of Dionysos; necks of both dogs and stripes on haunches of right-hand one. *White,* on side B, chiton of Dionysos; chape of scabbard of left youth.

BIBLIOGRAPHY
D. von Bothmer, *Antike Kunst* 3 (1960) 78ff., pl. 11; J.D. Beazley, *Paralipomena* (1971) 65; D. von Bothmer, *MM* 12 (1971) 129; W.G. Moon in W.G. Moon and L. Berge, *Greek Vase-painting in Midwestern Collections* (Chicago 1979) 56 – 57, no. 33.

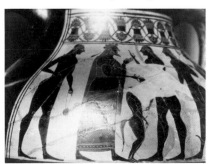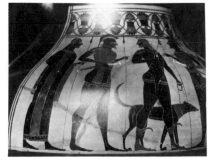

Fig. 57a,b. Panel-amphora of type B. Attributed to the Amasis Painter. Side A, panel: Dionysos and a youth; side B, panel: warriors meeting. Rome, Guglielmi collection.

2bis Fragment.

The fragment preserves the upper right-hand corner of a panel and the trace of the upper attachment of a round handle. All that is left of the figure scene is part of the mane of a horse facing right, most of its ear, and the topknot. The position of the head in relation to the panel suggests that it is not the head of a horse mounted by a rider but rather that of the right trace horse of a quadriga.

The fragment invites comparison with the fragment in Palermo attributed by Beazley to the Amasis Painter (fig. 57 bis; *ABV* 151, no. 19), for the style of drawing and the scale, as well as for the subject. The ornament surmounting the panel is of the early type. The triple line separating the palmette-lotus festoon from the panel recalls the experimental triple lines on the sides of the Bloomington amphora (Cat. 2), with which this vase must be contemporary. For the alleged triple line framing the top of the panel on the reverse of the amphora in Würzburg (Cat. 19), see the comment under Catalogue 18 bis. For the mane and the topknot, compare London B 600.31 (fig. 61; *ABV* 155, no. 67).

Late early period or early middle period.

Attributed to the Amasis Painter by D. von Bothmer.

DIMENSIONS AND CONDITION
Height as preserved, 8.1 cm; width as preserved, 11.71 cm; thickness of wall of sherd, 0.75 cm at top, 0.34 cm at bottom. The inside diameter of the neck at its narrowest level is calculated to have been 13.8 cm, a measurement that suggests a total height of circa 42 cm. The fragment is broken on top at the level of the mouth.

SHAPE AND DECORATION
Round handles. The inside of the mouth may have been glazed to a depth not exceeding the height of the lip. The panel is surmounted by a palmette-lotus festoon that originally had twelve elements, of which the last four and one-half are preserved. The panel is framed on the right by two glaze lines that join, at right angles, the two horizontal glaze lines on top of the floral decoration. The ornamental band is separated from the panel by three glaze lines.

ADDED COLOR
Red, cores of palmettes and cuffs of lotuses; central sepals of lotuses (the last half-lotus does not have a central sepal; instead, the pod is painted red).

BIBLIOGRAPHY
Not previously published.

Fig. 57bis. Fragment of a panel-amphora. Attributed to the Amasis Painter. Palermo, Museo Archeologico Nazionale.

3 PANEL-AMPHORA (TYPE B) WITH LID

VATICAN, MUSEO GREGORIANO ETRUSCO, 17743 (VASE), 390 C (LID).

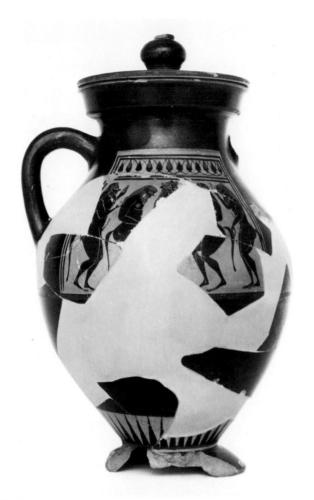

3 Side A.

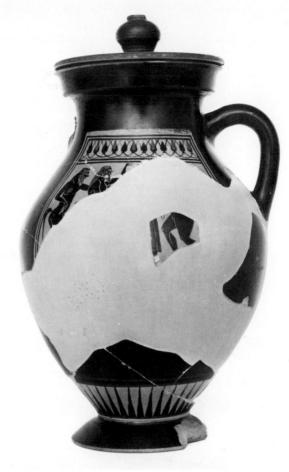

3 Side B.

The pictures are very fragmentary but repeat, with small variations, the same subject. On the better-preserved side (here called the obverse) Dionysos stands amid four satyrs. The god wears a white chiton and has a wreath of red and black ivy leaves in his hair. The satyr behind him looks down, while the one facing him looks up. An ithyphallic satyr flanks the central trio on each side; the one on the left is dancing, as may be the satyr facing Dionysos. There is much variety in the hair and beards: the beards of Dionysos and the flanking satyrs are stippled; that of the satyr behind Dionysos is red, as is

his hair and the hair of the last satyr on the right. The first satyr has a red fillet in his black hair; the hair of the satyr facing Dionysos is black.

On the reverse, which is more fragmentary, only parts of the figures are preserved. On the extreme left is a satyr with black hair crowned by a fillet and red beard. His right arm is akimbo; his left is extended horizontally. The satyr next to him (with red hair and beard) has raised his left arm and appears to touch the ivy wreath of Dionysos, the central figure. The god wears a white chiton and a red himation. He faces an ithyphallic satyr; of the last figure, only a bit of the hair is preserved.

Francesco Roncalli found the fragments of this amphora in a storage area of the Vatican and realized that a stray lid already published by Albizzati (in fasc. 7 of *Vasi del Vaticano*) belonged. This is one of the smallest amphorae by the Amasis Painter and should count among his earliest. The short horizontal strokes below each bud in the ornamental frames above the panels connect the Vatican amphora with Berlin 1690 by the Amasis Painter (fig. 58; *ABV* 151, no. 11). The two vases also share the stippling of the beards, seen on all beards on the obverse of the Vatican piece and on the flanking nude figures on the

3 Lid.

Berlin amphora. For the drawing of the satyrs, compare also the Amasis Painter's fragment from Cyrene (here fig. 52; D. White, *Libya Antiqua* 9 – 10 [1972 – 1973] pl. 87,f, 182, no. 51).

For the zigzag pattern on the brim of the lid, compare the lateral pattern on the New York amphora fragment (Cat. 18), the zigzags on the handle-roots of the Würzburg amphora of type A (Cat. 19), the vertical borders on the lekythoi in London and Montclair (Cats. 49, 50), the very early alabastron in Athens (fig. 34; *ABV* 155, no. 64), and the aryballos in New York (Cat. 52).

Early period, circa 560 – 550 B.C.

Attributed to the Amasis Painter by F. Roncalli.

SHAPE AND DECORATION
Flaring mouth, flat and glazed on top. The preserved handle is round and glazed on the underside. The figure scenes are set in panels framed on the sides by two glaze lines and surmounted by an ornamental band of twelve buds apiece on the obverse and the reverse; every second bud is red. The ornament is framed above and below by two glaze lines. The ground-line is done in black glaze. Echinus foot, glazed on the outside except for the very edge. Above the foot is a zone of forty rays. The lid has a hollow knob in the shape of a pomegranate; the brim is offset by a slight chamfer and is decorated with zigzag lines. In a zone around the knob are thirty-two black and red tongues framed by two glaze lines.

DIMENSIONS AND CONDITION
Height with lid, 24.4 cm; height without lid, 21.2 cm; diameter of body, 14.12 cm; diameter of mouth, 9.47 cm; diameter of foot, 8.25 cm, width of resting surface, 0.988 cm. Height of lid alone, 3.95 cm; diameter of lid, 9.56 cm; outer diameter of flange of lid, 7.06 cm. Height of figures, ca. 6.3 cm. The vase is broken and has been repaired; there have been considerable losses, especially one handle, more than half of the foot, and much of the panels.

3 Profile drawings of lid and foot.

ADDED COLORS
Red, top of pomegranate; line on lid; edge of lid; alternate tongues around knob; edges of lip; line below panels encircling entire vase; two lines above rays; line below rays. In the panels, six of the twelve buds in each ornamental border; fillets of first satyrs on sides A and B. On side A, hair and beard of second satyr, hair circle around his nipple; alternate leaves in wreath of Dionysos, his himation; hair of last satyr. On side B, beard and hair circles around nipple of first satyr; hair and beard of second satyr. *White,* chiton of Dionysos on side A.

BIBLIOGRAPHY
C. Albizzati, *Vasi del Vaticano,* fascs. 1 – 7 (1925 – 1939) 157, no. 369 c, fig. 100 (the lid); F. Roncalli, *Bollettino: Monumenti, musei e gallerie pontificie* 1, 3 (1979) 74 – 75, figs. 19, 20.

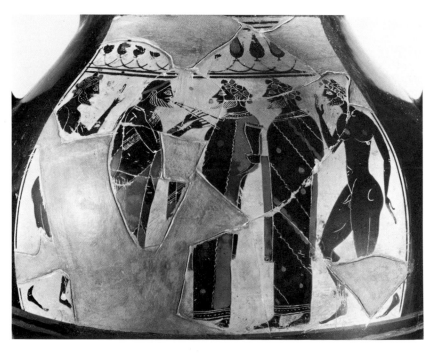

Fig. 58. Panel-amphora of type B. Attributed to the Amasis Painter. Side B, panel: votaries of Dionysos. Berlin, Staatliche Museen, F 1690.

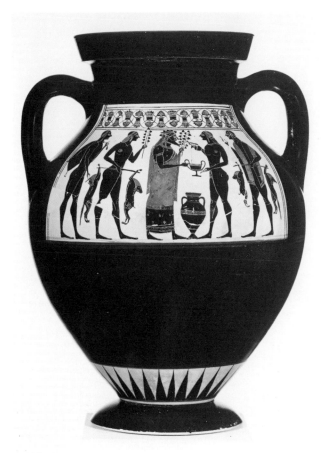

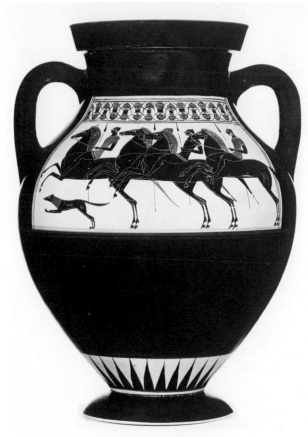

4 Side A.

4 Side B.

The principal picture, on the obverse, gives us Dionysos clad in a black chiton and a red himation, two upright ivy branches in his left hand, holding out his kantharos to be filled. Facing him is a naked youth who fills the kantharos from an oinochoe held very high. The flow of wine is rendered in dilute glaze. Between the feet of Dionysos and the youth stands an ovoid amphora of formidable height — bigger than any of those by the Amasis Painter that have been preserved. Behind the youth pouring wine, another youth approaches. He is wearing a chlamys over both shoulders and upper arms and carries a hare and a fox tied to a pole. The same prey is carried by the naked boy behind Dionysos, who

in his left hand holds up a single ivy branch. The youth behind him, also naked, carries a wineskin over his left shoulder. The boy and youths wear fillets in their hair, while Dionysos wears an ivy wreath.

The other side, the reverse, shows four riders galloping to the left. In his hands each rider holds a spear as well as the reins; the spears are drawn in relief lines that go over the bodies of the horses and riders and were applied before the incisions and added color. Of the riders, the one in the lead is a youth; the face of the second is mostly hidden by the third horse; the third rider has a red beard; and the fourth, an incised beard. All the riders wear short-sleeved chitons and caps with a small point. Below the first horse a lean hound races to the left.

The color scheme of the palmette-lotus festoon follows a convention established by the Amasis Painter early in his career: the cuffs of the lotuses are left black, as on the amphorae New York 06.1021.69 and Bloomington 71.82 (Cats. 1, 2). As on the Bloomington amphora, the top of the mouth is glazed. The Dionysiac subject on the obverse is a common one on amphorae by the Amasis Painter (the chronological sequence of these vases is sketched in the entry on Munich 1383 (Cat. 14) 102 and in the chronology, page 240). For the splendid riders on the reverse, we have, to date, no ready parallels, but their mounts may be compared with the horses of Poseidon on the Schimmel cup (Cat. 60). The odd drawing of the

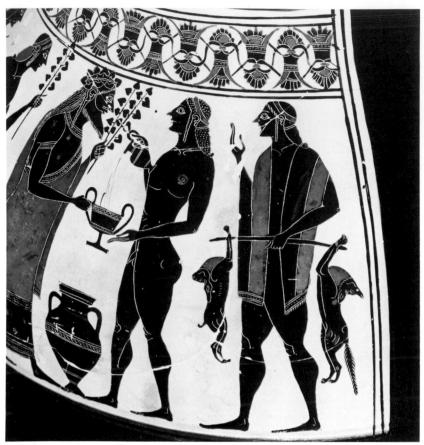

4 Side A, detail of panel.

shoulders on the Schimmel cup differs markedly from the smooth curves in the cavalcade here, and Miss Moore, weighing the evidence of all the characteristics of the Amasis Painter's horses, dates this amphora later than the cup. The coursing hound under the first horse on this work has incised ribs, as does the right-hand dog on the obverse of the Bloomington amphora (Cat. 2).

Middle period, early.

Attributed to the Amasis Painter by W. Bareiss and J.D. Beazley.

DIMENSIONS AND CONDITION
Height, 41.2 cm; width (across handles), 30.0 cm; diameter of body, 28.2 – 29.15 cm; diameter of mouth, 18.8 – 19.05 cm; width of lip, 1.25 cm; diameter of foot, 15.8 cm; width of

resting surface, 1.9 cm. Height of figures, 12.5 cm on side A, 12.3 cm on side B. The vase was broken and repaired in antiquity (there are eight pairs of drill holes and the remains of bronze staples). The figures have no losses other than the right knee of the boy behind Dionysos.

DIPINTO
On the underside of the foot, glaze dipinto:

SHAPE AND DECORATION
Flaring mouth, flat and glazed on top, with slight lip at outer edge; the inside

is glazed to a depth of 2.85 cm. The round handles are glazed on the underside. Echinus foot, glazed on the outside except for the very edge. Above the foot is a zone of thirty-one rays. The figure scenes are set in panels, framed on the sides by two glaze lines, and surmounted by a palmette-lotus festoon. On the obverse the festoon has thirteen complete elements, with half a palmette-lotus added on the left; on the reverse are thirteen complete elements, with half a palmette-lotus added on either side. The ornamental border is framed above and below by two glaze lines. The groundlines are very faintly brushed on in dilute glaze.

ADDED COLORS
Red, line inside of mouth, on outer edges; two lines below panels and two lines above rays, encircling entire vase; line at base of rays; cores of palmettes; rings connecting tendrils; cores of lotuses, their outer sepals. In the pictures, on side A, all fillets; mantle of Dionysos, cores of dot-rosettes on his chiton; circle on shoulder of pictured amphora; necks of foxes and hares, stripes on their haunches; hair on nape of boy; hair circles around nipples of boy and first youth facing Dionysos; panels on chlamys of youth on far right. On side B, chitons of first and fourth riders; dots on chiton of third rider, his beard; cap of second rider; stripes on haunches of third and fourth horses; tails of first and second horses; neck of hound. White, on side A, all fingernails; dots in red cores of dot-rosettes and dots around them.

BIBLIOGRAPHY
D. Ohly and K. Vierneisel, Münchner Jahrbuch der bildenden Kunst, ser. 3, vol. 16 (1965) 232 – 233, fig. 5; H. Marwitz, Pantheon 25 (1967) 207 – 208, fig. 4; D. Ohly, Die Antikensammlung am Königsplatz in München² (Waldsassen, n.d.) 31, pl. 15; J.D. Beazley, Paralipomena (1971) 65; J. Boardman, ABFV (1974) 55 – 56, 77, fig. 91; H. Mommsen, Der Affecter (Mainz 1975) 61, n. 321, 80, n. 395; F.W. Hamdorf, Pantheon 35 (1977) 287 – 294, figs. 1 – 3, 5; M.B. Moore, Horses (1978) 65, A 402, 256, 277, 280, 328, 350, 360, 366, 404, pl. 32,1; A. Schnapp in La cité des images (Lausanne 1984) 71, 74, fig. 106.

5 PANEL-AMPHORA (TYPE B)

PARIS, MUSÉE DU LOUVRE, F 36 (LP 2021; N 3502), ACQUIRED BEFORE 1848.

The obverse shows the combat of Herakles against the brigand Kyknos. Herakles wears a short chiton and over it his lion skin. With his left hand he has seized the crest support of the helmet of his opponent, whom he attacks with a spear. He also carries a sheathed sword suspended from a baldric over his right shoulder. Kyknos is clad in a short chiton, a linen corslet, and a Corinthian high-crested helmet. Besides a round shield, drawn with a compass, that has a roaring lion protome as device, he carries a sheathed sword, defending himself with his spear, held in his raised right hand. Behind him his father Ares approaches, his left foot raised off the ground; the god is not quite ready to join in the battle, for his spear is held at waist level. Ares wears a tunic with short sleeves and a low-crested Corinthian helmet; seen in profile is his round shield, which is emblazoned by a three-dimensional snake. Ares and Kyknos have fillets on their helmets. Behind Herakles Athena stands calmly facing right. She wears a peplos and is adorned with an incised necklace and a double bracelet. In her left hand she holds an upright spear very much in the manner of the Amasis Painter's customary bystanders. She is bareheaded, her hair tied at the nape and crowned with a fillet.

The scene on the reverse is a Dionysiac thiasos. Dionysos, in the center, stands facing right, greeting with his left hand a maenad and a nude man, both dancing. Dionysos wears a long chiton with short sleeves and a mantle over his left shoulder. His hair is tied at the ends, and he is crowned with an ivy wreath. In his right hand he holds a kantharos. The maenad who dances toward him also has an ivy wreath, and her hair is tied behind her ears. She wears a peplos, an earring, a necklace, and bracelets. The nude man wears a fillet in his hair. The

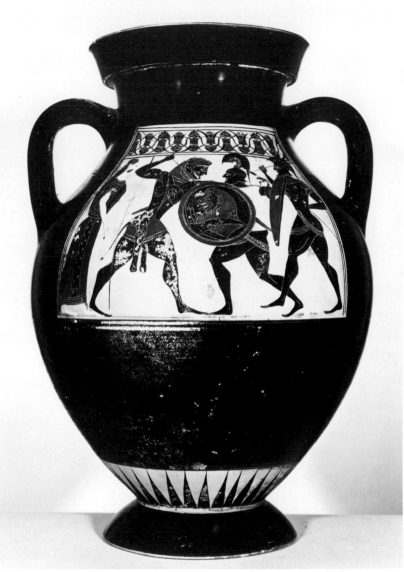

5 Side A.

group on the left, behind Dionysos, consists of a maenad clad in a peplos dancing to the right and looking around at her companion, another nude man. This maenad also wears a large earring, a necklace, and bracelets. Her hair is tied behind her ears, the ends bound in a knot. She does not wear an ivy wreath but merely a fillet, as does the man behind her.

The Amasis Painter's treatment of the Kyknos story on this amphora should be compared with the same painter's fuller treatment on one of the legs of his fragmentary tripod-pyxis in Aegina (Appendix 4). There we see Zeus actively interfering by seizing the right fist of Kyknos, who has raised his spear against Herakles. As on this amphora, Herakles grasps the helmet of Kyknos by the crest support and Ares is directly behind Kyknos,

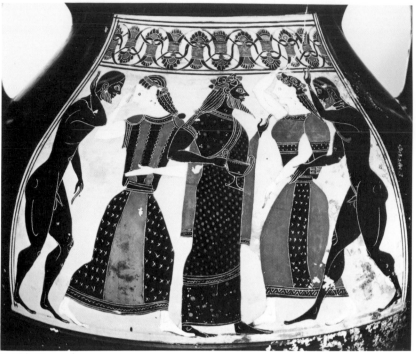

5 Side B, panel.

Dionysos in the midst of dancing couples—men and women on this amphora, or boys and women on the Amasis Painter's amphora Basel Kä 420 (fig. 40; *Paralipomena* 65)—two spheres, those of komoi and thiasoi, seem to intersect; while the fully human males can hardly be confused with satyrs, their female companions look suspiciously like maenads and are called such by Beazley in his *Paralipomena* entry for the Basel amphora. In light of this ambiguity, Mrs. Karouzou's slip in calling the male dancers on this Louvre vase satyrs (*The Amasis Painter* 13) becomes understandable. The ornaments and style of drawing suggest a date in the middle of the painter's middle period.

Attributed to the Amasis Painter by G. Karo.

DIMENSIONS AND CONDITION
Height, 38.2 cm; width (across handles), 26.6 cm; diameter of body, 26.2 – 26.5 cm; diameter of mouth, 16.98 cm; width of lip, 1.165 cm; diameter of foot, 14.86 cm; width of resting surface, 1.35 cm. Height of figures, 12.65 cm; radius of Kyknos' compass-drawn shield, 2.665 cm. The vase is unbroken, but the glaze is worn in places.

SHAPE AND DECORATION
Flaring mouth, unglazed on top. The entire neck is glazed on the inside. The round handles are almost completely glazed on the underside. Echinus foot, glazed on the outside except for the very edge. Above the foot is a zone of thirty-five rays. The pictures are set in panels framed on the sides by two glaze lines and surmounted by a palmette-lotus festoon consisting of nine complete elements, to which half a lotus-palmette has been added at each end. The ornamental border is framed above and below by two glaze lines. The groundlines are drawn in dilute glaze.

his spear poised to fight by the side of his son. On the pyxis in Aegina, the goddess behind Herakles is again Athena, and since the ending of her inscribed name is preserved, we need not doubt (as Schefold did) that the friendly goddess on this amphora is Athena as well, even though (as often happens in black-figure) she does not wear a helmet. The pyxis in Aegina, is likely later than the amphora, but as is often the case on vases by the Amasis Painter, he has remained traditional in his choice of compositional motifs.

The revelers on the reverse are not easily identified. On the Amasis Painter's lekythos stolen from the Ceramicus Museum (fig. 59; *ABV* 155, no. 61), Dionysos is between two naked dancing men, but he is more often in the company of naked youths, as on the amphorae in Geneva (Cat. 15), Bloomington (Cat. 2), and Munich (Cats. 4, 14), and one of the youths may be Oinopion. But when we have

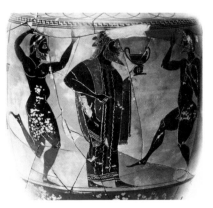 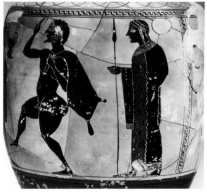

Fig. 59a,b. Lekythos. Attributed to the Amasis Painter. Details of figure zone: Dionysos and dancing men. Once in Athens, Ceramicus Museum, inv. 25.

6 PANEL-AMPHORA (TYPE B)

BASEL, ANTIKENMUSEUM UND SAMMLUNG LUDWIG,
L 19, GIFT OF PETER AND IRENE LUDWIG, 1981.

ADDED COLORS

Red, stripe on inner edge of mouth; lines on upper and lower edge of mouth on outside; two lines each below panels and above rays, encircling entire vase; line at base of rays. Cuffs and cores of lotuses; cores of palmettes; ties at junction of tendrils. In the figure scenes, on side A, chiton of Herakles, neck and muzzle of his lion skin; crest support of Kyknos, his fillet, rim of his shield; ear, pupil, muzzle, and neck of lion device on shield; shield of Ares, dots on his chiton, his fillet; panels of Athena's peplos, her pupil, and her fillet. On side B, all fillets; alternate ivy leaves in wreaths; pendants of earrings and pupils of maenads, parts of their peploi; sparse dots on chiton of Dionysos, dense dots on his himation, the vertical folds of which are solid red; hair stripe on pectoral and abdomen of man on right. *White,* on side A, flesh of Athena; teeth of lions (both on lion skin and on shield device); four groups of two dots on baldric; linen corslet of Kyknos; row of dots on upper border of his chiton and on his crest support; dot-crosses on chiton of Ares, row of dots on his crest support. On side B, flesh of maenads; clusters of three dots on chiton of Dionysos.

BIBLIOGRAPHY

H. Heydemann, *Pariser Antiken* (Halle 1887) 49, no. 29; G. Karo, *JHS* 19 (1899) 139, no. 9; E. Pottier, *Vases antiques du Louvre* 2 (Paris 1901) 92, no. F 36, pl. 66; idem, *Catalogue des vases antiques* 3 (1906) 729; J.C. Hoppin, *Black-figured Vases* (1924) 45, no. 29; E. Pottier, *CVA,* Louvre, fasc. 3 (1925) III He, 12, pl. 15, 5 and 8, pl. 17,3; J.D. Beazley, *ABS* (1928) 32, no. 5; S. Karouzou, *AM* 56 (1931) 108; F. Vian, *REA* 47 (1945) 13, no. 25; J.D. Beazley, *ABV* (1956) 150, no. 6; S. Karouzou, *The Amasis Painter* (Oxford 1956) 13 – 14, pls. 23, 24; K. Schauenburg, *JdI* 79 (1964) 113, fig. 4, 114; P. Ghiron-Bistagne, *Recherches sur les acteurs dans la Grèce antique* (Paris 1976) 291, figs. 148, 149; K. Schefold, *Spätarch. Kunst* (1978) 136 – 137, fig. 177; C. Bérard in *La cité des images* (Lausanne 1984) 126, fig. 179.

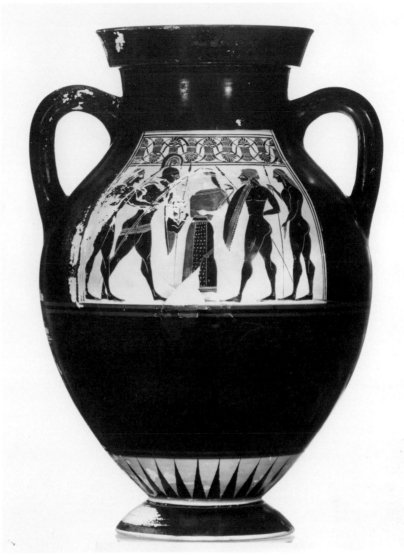

6 Side A.

The pictures are somewhat enigmatic, and it is not even clear which side should be considered the obverse and which the reverse: to avoid confusion I follow Beazley's labeling. In the center of side A, a woman holding an upright spear in her right hand stands facing left. She wears a belted peplos with decorated borders and a central patterned panel on the skirt. In her hair she wears a fillet; a necklace and bracelet are incised. She faces a striding warrior, dressed in a short, patterned chiton and a high-crested Corinthian helmet crowned with a fillet; he carries a round shield on his left arm and a spear held diagonally in his right hand. The device of the shield is the forepart of a rampant lion rendered three-dimensionally. To the right of the woman, another bearded warrior, perhaps the first warrior's squire, wears a fringed cap and carries a round shield with the forepart of a rearing snake, also rendered three-dimensionally, as well as a spear

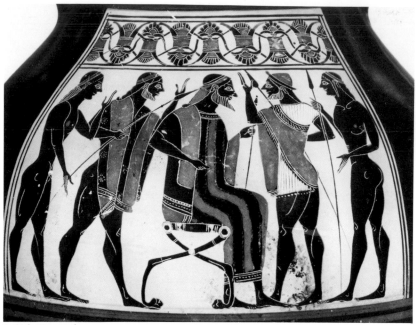

6 Side B, panel.

held at an angle. The painter has mistakenly treated the back of the nude warrior as if it were his front by incising the clavicles and the pectorals, thus making the warrior left-handed. The trio is flanked by a naked youth on each side. Both have fillets in their hair and hold spears: the spear on the left parallels the angle of the hoplite's, while the one on the right is held vertically. This scene cannot be called an arming scene, since the necessary weapons (swords) and additional armor (greaves) are not shown. The woman in the center has been called Athena (see J.D. Beazley, *Paralipomena*), but this is not certain.

The figures on the other side, here called the reverse, also lack clear indications of their identity. The seated man in the center, who wears a long striped chiton, a shawl over his shoulders and arms, and a fillet in his hair, may well be Zeus, since in his left hand he holds a short scepter, but the campstool on which he sits is not very majestic. Of the four figures who surround him, only the man facing him, who is dressed in a petasos, a short chiton, and a chlamys and who is equipped with a spear, could conceivably be one of the Olympians, Hermes. The bearded warrior behind the seated man, wearing a mantle over both shoulders and carrying his spear at an angle, can hardly be a god, and his fillet is not especially significant, since fillets are also worn by the two flanking nude youths, who are completely conventionalized.

The three-dimensional shield device of a lion and the fringed cap of the nude warrior connect this amphora with Louvre F 26 (Cat. 11). In its potting, it is not too far from the Amasis Painter's Faina 40 (fig. 60; *ABV* 151, no. 14), which is not much smaller (height, 31.6 cm; width, 22.4 cm; diameter of body, 21.0 cm; diameter of mouth, 14.05 cm; diameter of foot, 12.1 cm; twenty-eight rays). The amphora Louvre F 26 also has the same ligature in the graffito. The ornaments are of the sturdier early type (phase two of my analysis in *Antike Kunst* 3 [1960] 78), perhaps best represented on the amphora Louvre F 36 (Cat. 5), which also gives us a fine parallel for a three-dimensional snake on a shield seen in profile. The Basel amphora shown here should be placed near in time to these others mentioned. While lion and snake are common devices, it is perhaps not without significance that on Louvre F 36, the snake appears on the shield of Ares and the lion on the shield of Kyknos, and that the tripod-pyxis in Aegina

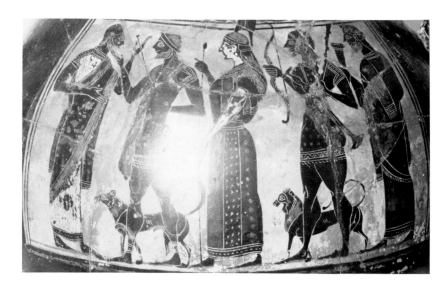

6 Lid.

by the Amasis Painter (Appendix 4) gives us another Ares—his name inscribed—with a snake on his shield.

Middle period.

Attributed to the Amasis Painter by J.D. Beazley.

DIMENSIONS AND CONDITION
Height, 34.6 cm; width (across handles), 24.9 cm; diameter of body, 23.5 cm; diameter of mouth, 15.24 cm; width of lip, 1.06 cm; diameter of foot, 12.42 cm; width of resting surface, 1.14 cm. Height of figures, 10.0–10.2 cm. The vase is broken and has been repaired with a significant loss only in the area of the left foot of the woman on the obverse. The glaze has fired

unevenly and has peeled in many places. When on the Lucerne market in 1961, the amphora still had its lid, which has since disappeared.

DIPINTO AND GRAFFITO
Red dipinto on the base of the vase (four vertical dots [omitted by Lullies, p. 53] and a ligature of heta and rho) and a graffito on the sloping underside of the foot (four vertical strokes and a ligature of heta and rho); reproduced 1:2.

SHAPE AND DECORATION
Flaring mouth, glazed on top. The round handles are completely glazed on the underside. The inside of the mouth is glazed to a depth of 1.8 cm. Echinus foot, glazed on the outside except for the very edge. Above the foot is a zone of twenty-nine rays. The pictures are set in panels framed on the sides by two glaze lines and surmounted by a floral border, a palmette-lotus festoon of seven complete units with a half-unit added on each side. The floral strip is framed above and below by two glaze lines. The groundlines of the pictures are drawn in dilute glaze.

ADDED COLORS
Red, stripe on inner edge of mouth; line on upper outside edge of mouth; two lines below panels encircling entire vase; two lines above rays; line below rays. In the ornaments, cuffs and cores of lotuses; cores of palmettes; rings connecting tendrils at junction of palmette and lotus. In the figure scenes, all fillets; on side A, cap of nude warrior, hair dots on his nipples; background of shield with rampant lion; stripe along rim of shield with snake; lower hair of right-hand flanking youth; upper part of woman's peplos, front panel of its skirt; crest support of hoplite and cores of dot-rosettes on his short chiton. On side B, lower hair of seated man, stripes on his chiton, folds of his mantle, petasos of man facing him, his chlamys; folds and cores of dot-rosettes of bareheaded man behind seated figure; hair dots on nipples of flanking youths. *White,* dots around cores of all dot-rosettes. On side A, flesh of woman; row of dots on shield rim of nude warrior; dots on crest of hoplite. On side B, four cross-and-dot patterns on one panel of chlamys worn by bareheaded man behind seated figure; clusters of three dots on lowest fold or panel of chlamys over bareheaded man's left arm; crinkly borders of red stripes of chiton worn by seated man, row of dots in lower left border of his mantle, hourglass pattern on his campstool; rings at junction of seat and chair legs; hinge of legs; chiton of man facing seated figure.

The incision of the woman's bracelet goes all the way through the black glaze into the clay ground.

BIBLIOGRAPHY
K. Schauenburg, *JdI* 79 (1964) 121–123, figs. 9, 10; R. Lullies, *Aachener Kunstblätter* 37 (1968) 41–43, no. 18 (ill.); J.D. Beazley, *Paralipomena* (1971) 65; F.W. Hamdorf, *Pantheon* 35 (1977) 294, n. 37; R. Lullies in *Sammlung Ludwig* 1 (1979) 52–54, no. 19; A.W. Johnston, *Trademarks* (1979) 117, type 5D, no. 2.

Fig. 60a,b,c. Panel-amphora of type B. Attributed to the Amasis Painter. Side A, panel (p. 84): the introduction of Herakles into Olympus; side B and detail of panel: winged Artemis holding a lion and a fawn. Orvieto, Faina Collection, 40.

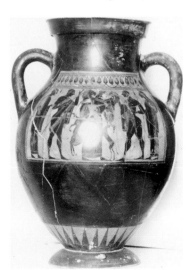

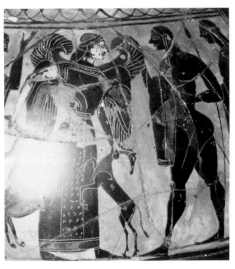

7 PANEL-AMPHORA (TYPE B)

NEW YORK, THE METROPOLITAN MUSEUM OF ART,
56.171.10, FLETCHER FUND, 1950.

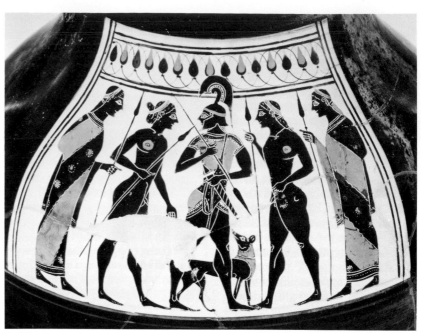

7 Side A, panel.

Both panels show a bearded warrior accompanied by his dog, taking leave from his friends. He is flanked on the obverse by two nude boys; the one on the left is holding the second spear, while the one on the right holds his spear like a staff and carries a wreath in his left hand. Two youths in himatia holding spears complete the scene. The warrior wears a high-crested Corinthian helmet, a tunic, and over it a nebris. In his left hand he holds his sheathed sword and baldric, which he has not yet slung over his right shoulder. His right hand holds a spear tip downward. The boys and youths wear fillets in their hair; there is also a fillet on the helmet.

The reverse repeats the scene with minor variations. Here the warrior is seen from behind and is more fully armed, since he wears greaves and carries a round shield (without blazon) on his left arm; his sword is already suspended from his left shoulder by the baldric. His tunic is of the same cut as the one on the obverse, although the patterning differs; and here his

nebris is fastened over the right shoulder rather than the left, as on the obverse. The friends nearest him are two nude youths (as indicated by the beginnings of a beard on their jaw lines); the one on the left has raised his left arm, over which a small cloak is worn. By way of contrast, the two onlookers in himatia are boys. The fillets are shown as on the obverse. The dog on the reverse faces left, while on the obverse it walks to the right, looking up at its master.

As on the earlier amphora in New York with the arming scene (Cat. 1), the bottoms of the panels on this smaller and somewhat later vase are positioned at the vase's "equator"—at exactly half the height of the amphora. The upright buds—with or without dots in the interstices—are a favorite of the Amasis Painter but are relatively rare as upper borders on vases by other painters, whereas the hanging buds (or lotuses) become a regular feature of late black-figure panel-amphorae. In *ABV* Beazley listed six amphorae

86

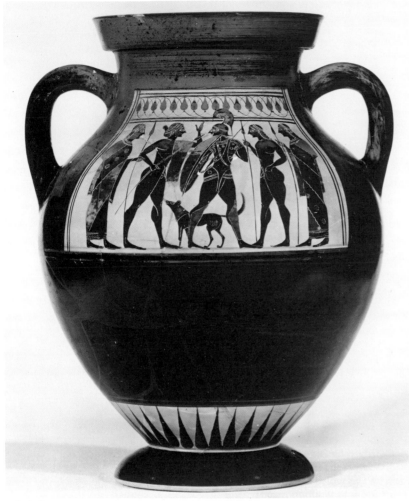

7 Side B.

32.5 cm (Cat. 8). All belong to the painter's middle period and within that range are early rather than late. The New York departure amphora shown here, through its squat proportions, the placement of the panels rather high on the wall of the vase, and the general style, prompts us to date it earlier than the others in this group; additional support is perhaps furnished by the fragmentary amphora from Gravisca that F. B. Visentini (*NSc* 96 [1971] 243 – 245, fig. 60) has attributed to the Amasis Painter and dated 550 B.C. Here the subject is again the departure of a warrior accompanied by his dog, but this time he faces left and confronts a youth who holds the second spear and a sheathed sword; another youth or boy is behind him, nude as on this New York amphora, and the trio is flanked by two bystanders in himatia. Another fragment, not illustrated, is described as giving a handle palmette with red and black grounds—perhaps of the same design as the handle palmette (fig. 32) on the Amasis Painter's Käppeli amphora of type B in Basel (Kä 420, *Paralipomena* 65 [see also fig. 40]).

by the Amasis Painter with upright buds (pp. 150 – 151, nos. 3 [Cat. 7], 5 [Cat. 11], 11 [here fig. 58], 12 [here fig. 63], 13 [Cat. 10], 14 [here fig. 60]) and added two more that have this border in *Paralipomena* (p. 65: the first of the two Ludwig vases [Cat. 8] and the Hoek amphora [fig. 43]), but this total of eight must actually be reduced to seven, since his no. 13 is part of no. 12. To the seven, Roncalli has added a fragmentary amphora in the Vatican (Cat. 3), to which the lid published by Albizzati (*Vasi del Vaticano* [1925 – 1939] 157, fig. 100, no. 369-c) belongs. A fragment of a panel-

amphora with an upright bud pattern found in Cyrene (here fig. 52; D. White, *Libya Antiqua* 9 – 10 [1972 – 1973] pl. 87,f) is surely by the Amasis Painter. The same pattern occurs on the Amasis Painter's fragment London B 600.31 from Naucratis (fig. 61; *ABV* 155, no. 67) that Beazley queried as being perhaps from a chous. I wrongly called it a fragment of an amphora (*Antike Kunst* 3 [1960] 80), but A.J. Clark has persuaded me that the fragment is indeed from a chous.

Of these nine amphorae, eight are reasonably complete, and two even have their original lids. The heights vary between 21.2 cm (Cat. 3) and

Fig. 61. Fragment of a chous. Attributed to the Amasis Painter. London, the British Museum, 1886. 4 – 1.1225 (B 600.31).

8 PANEL-AMPHORA (TYPE B)

BASEL, ANTIKENMUSEUM UND SAMMLUNG LUDWIG,
L 20, GIFT OF PETER AND IRENE LUDWIG, 1981.

Attributed to the "style d'Amasis" by A. Sambon (in *Cat. Hôtel Drouot* [*Paris*], *18 – 20 Mars 1901* 5, no. 16) and to the Amasis Painter by Beazley.

From Orvieto. Ex colls. Alfred Bourguignon, William Randolph Hearst.

DIMENSIONS AND CONDITION
Height, 27.9 – 28.0 cm; width (across handles), 21.84 cm; diameter of body, 20.7 cm; diameter of mouth, 13.8 cm; width of lip, 0.7 cm; diameter of foot, 11.85 – 11.94 cm; width of resting surface, 1.35 cm. Height of figure scenes (without border), 8.2 cm on side A, 8.5 cm on side B. The vase is broken and has been repaired with four small missing pieces restored in terracotta and repainted. The principal areas affected are, on the obverse, parts of both legs of the first boy and of the right leg of the warrior, on the tail of the dog, and on part of the right foot of the right-hand flanking youth. On the reverse, the losses are limited to the fractures and the chin of the left-hand flanking youth. There is a chip on the foot below handle B/A. The glaze has fired unevenly and is mostly reddish brown on the upper part of the vase. This, however, affects the figures only on the reverse.

DIPINTO
Traces of a glaze dipinto on the sloping underside of the foot

SHAPE AND DECORATION
The flaring mouth is undercut slightly at the junction with the neck and has a slight ridge at the upper edge. The top is glazed and flat. The inside is glazed to a depth of 1.6 cm. The round handles are not completely glazed on the underside. Echinus foot, glazed on the outside except for the very edge, which is

reserved. Above the foot is a zone of thirty-three rays, which reach to a level on the body where the diameter is nearly the same as that of the foot. The figure scenes are framed on the sides by two glaze lines and surmounted by a floral border consisting of upright buds, alternately black and red, of which there are fifteen on the obverse and sixteen on the reverse. The floral bands are bordered above and below by two glaze lines. The groundline is rendered in dilute glaze.

ADDED COLORS
Red, upper, lower, and inside upper edges of mouth; two lines encircling vase directly below panels; two circles above rays and one below them; alternate buds in floral bands; all fillets; hair below band of right onlooker on side A and left onlooker on side B; hair circles around nipples of boys on side A and youths on side B; parts of all himatia and cores of their dot-rosettes; tunic of warrior on side A (except for decorated borders); stem of wreath held by right-hand boy on side A; manes of dogs and stripes on their haunches; shield of warrior on side B (except for rim), dots and cores of dot-rosettes on his tunic, wrap of youth greeting him. *White,* all fingernails; hilts of swords, chapes of their scabbards; collars of dogs, stripes on their bellies; dots on crest supports and on patterned border of warrior's tunic on side A; dots of wreaths held by boy (on side A) and youth (on side B) to right of warrior; dots around cores of dot-rosettes.

BIBLIOGRAPHY
D. von Bothmer, *CVA,* MMA, fasc. 3 (1963) 5 – 6, pls. 8, 9 (with bibliography to 1963); D. von Bothmer, *The Metropolitan Museum of Art Guide to the Collections: Greek and Roman Art* (New York 1964) 14 – 15, fig. 18; E.B. Harrison, *Agora* 11 (1965) 42, n. 152; J.D. Beazley, *Paralipomena* (1971) 62, no. 3; A.W. Johnston, *Trademarks* (1979) 4.

It is difficult to determine which of the two panels represents the obverse and which the reverse, but since Schauenburg, Lullies, and Beazley label the side with Dionysos as A, I follow suit. The composition is strictly symmetrical. Dionysos stands in the center facing right. He wears a long white chiton with short sleeves, the crinkly folds of which are indicated by incised lines; over his left shoulder is a red himation. In his hair he has an ivy wreath. His left hand is raised, and in his right hand, he holds a drinking horn (much of his hand and the lower part of the horn are restored). Two nude youths, both with fillets in their hair, approach Dionysos from either side. The one behind Dionysos carries two ivy branches and, in his left hand, a black wreath with tiny round flowers. The youth facing Dionysos holds in his right hand an upright ivy branch. What he once carried in his lowered left hand is hard to tell, since the hand and his thighs are missing and are restored. If he held an ivy branch, as Lullies surmised, it cannot have been so long as the one held by his companion, since the restored area does not go below the level of his knees: I suspect that he held an oinochoe. This trio is flanked on each side by two youths clad in himatia and holding upright spears.

The picture on the reverse features Apollo and Hermes advancing toward the right in the company of three youths; the youth to Hermes' right is naked and holds a spear. The two others are typical bystanders, like their counterparts on the obverse, dressed in himatia and holding upright spears. Apollo and Hermes each wear a nebris over a short chiton. In addition, Hermes wears a petasos and a short wrap over both shoulders. In his left hand he holds his caduceus, while Apollo carries a bow in his left hand and a long arrow in his

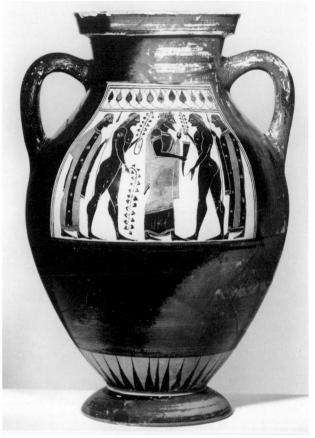

8 Side A.

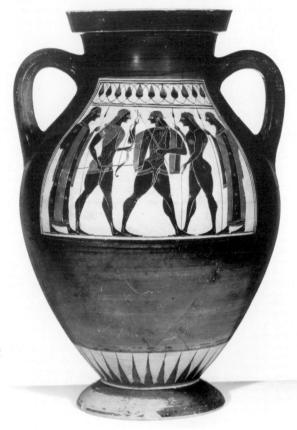

8 Side B.

right. Apollo and the three youths wear fillets in their hair.

Most of the comparisons for the Dionysos picture are discussed by Schauenburg, who also compares the Hermes and Apollo with figures on the reverse of Berlin 1688 (Cat. 9) but does not accept a specific identification of the chief figures. But if the archers on the amphorae in Berlin and Basel are ordinary warriors assembled by a herald, it is surprising that they are shown bareheaded and without quivers (Schauenburg [p. 109, n. 6] misinterprets the tip of Apollo's hair on the Ludwig amphora as a quiver and speaks of the weapon in his right hand as possibly also a spear or staff, although the feathers at the

end of the arrow are clearly marked by incisions).

The ornaments above the panel may help in dating the vase. Three patterns are known from the panel-amphorae of type B by the Amasis Painter: the palmette-lotus festoon (fifteen examples), the addorsed palmette chain (one), and the upright buds (at least ten, possibly eleven). The last group is preserved in several variants: (1) with a short horizontal bar at the junction of the tendrils (Cat. 3, Berlin 1690 [here fig. 58; *ABV* 151, no. 11], and the fragment Oxford G 568 that Beazley related to the Amasis Painter [here fig. 62; *CVA,* Oxford, fasc. 2 (1931) III H, pl. 3, 15, p. 96]); (2) with a dot at the junction of the buds (New York 56.171.10 [Cat. 7], the Ludwig amphora shown here

Fig. 62. Fragment of a panel-amphora of type B. Related to the Amasis Painter. Oxford, Ashmolean Museum of Art and Archaeology, G 568.

[Cat. 8], Faina 40 [here fig. 60; *ABV* 151, no. 14], and the fragment from Cyrene [here fig. 52; D. White, *Libya Antiqua* 9 – 10 (1972 – 1973) pl. 87,f]); (3) with dots at the tendril junctions and in the interstices (Cat. 10); and last, (4) with dots in the interstices only (Cat. 11 and the amphora once in Riehen, Hoek collection [fig. 43; *Paralipomena* 65]). This amphora seems to be slightly later in the painter's middle period than the amphorae in New York (56.171.10 [here Cat. 7]) and Orvieto (Faina 40 [here fig. 60]).

Attributed to the Amasis Painter by K. Schauenburg.

DIMENSIONS AND CONDITION
Height, 32.5 cm; width (across handles), 22.6 cm; diameter of body, 21.9 cm; diameter of mouth, 13.62 – 13.86 cm; width of lip, 1.0 cm; diameter of foot, 12.3 cm; width of resting surface, 1.5 cm. Height of figures, 10.9 cm on side A, 10.85 cm on side B. The vase is broken and has been repaired; some areas are missing and restored: on the obverse there is a big gap comprising part of the himation of Dionysos, most of his right hand with the lower part of his drinking horn and the left wrist, and the hand and thighs of the youth facing him. Another missing and restored area on side A is in the upper part of the right bystander, below his hand, stretching across his chest to his back, and down to the level of his hips. On the reverse, the left arm of Hermes, the left foot of the right bystander, and the genitals of the nude youth are restored. The glaze has misfired in parts.

GRAFFITO

There is a retrograde graffito of lambda and epsilon on the sloping underside of the foot; in black-figure this occurs only one more time, on the foot of a Tyrrhenian neck-amphora wrongly attached to the red-figured bell-krater Louvre G 520 (E. Pottier, *CVA,* fasc. 1 (1923) III Ie, pl. 5,2 – 3).

SHAPE AND DECORATION
Flaring mouth, unglazed on top. The round handles are almost completely glazed on the underside. The entire neck is glazed on the inside. Echinus foot, glazed on the outside except for the very edge. Above the foot is a zone of thirty-two rays. The figure scenes are set in panels framed on the sides by two glaze lines and on top by a band of eleven upright buds bordered above and below by two glaze lines. The figures stand on a glaze groundline on side A; the red line below the panels covers the groundline on side B.

ADDED COLORS
Red, line on inside of neck near upper edge; two lines below panels and another pair above rays, encircling entire vase; line below rays. In the ornaments, the second, fourth, sixth, eighth, and tenth buds on the obverse and the first, third, fifth, seventh, and ninth buds on the reverse. In the pictures all fillets; cores of dot-rosettes on himatia of bystanders; himation of Dionysos, four ivy leaves out of seven in his wreath; chiton of Apollo, knot at end of his hair; vertical panels of Hermes' wrap, top of his petasos; panels of himatia of bystanders. Hair dots on nipples of two youths next to Dionysos; hair circle around nipple of nude youth facing Hermes. *White,* chitons of Hermes and Dionysos; dots around cores of all dot-rosettes.

BIBLIOGRAPHY
K. Schauenburg, *JdI* 79 (1964) 109 – 121, figs. 1 – 3; R. Lullies, *Aachener Kunstblätter* 37 (1968) 44 – 46, no. 19 (ill.); J.D. Beazley, *Paralipomena* (1971) 65; H. Mommsen, *Der Affecter* (Mainz 1975) 36, n. 190; R. Lullies in *Sammlung Ludwig* 1 (1979) 54 – 57, no. 20; A.W. Johnston, *Trademarks* (1979) 141, type 15E, no. 6; D. von Bothmer, *Journal of the Walters Art Gallery* 38 (1980) 102 – 103, fig. 8, 107, nn. 46, 50.

The obverse represents the introduction of Herakles into Olympus. Zeus, on the left, clad in a short white chiton and a fringed and tasseled chlamys over both shoulders and arms, greets the procession, which is led by Hermes. He is dressed like Zeus in a short chiton and chlamys but wears his petasos and carries a short caduceus. By Hermes' side walks a dog that looks up to him. The central figure is a very stately Athena. She wears a high-crested Attic helmet and a belted peplos, a necklace (incised), and bracelets (incised). In her right hand she holds an upright spear. She is followed by Herakles, who, instead of wearing his habitual lion skin, goes bareheaded, dressed in a short chiton and armed with a small club and a bow. A sheathed sword is suspended by a baldric from his right shoulder. The last figure is a youth who wears a short mantle over his right shoulder and, like Zeus, wears a fillet in his hair. In his right hand he holds, like Athena, an upright spear. By his side is a small dog.

The confrontation of Hermes and four figures on the reverse cannot be interpreted with certainty. Hermes, dressed, as on the obverse, in a short chiton and chlamys, holds a caduceus in his right hand; his left hand is raised in a conversational gesture. He strides to the right and looks round at a naked boy who holds a bow in his left hand and an arrow in his right. To his left side is a dog. The boy faces a youth, on the right of Hermes, who is dressed in a fringed chiton (not unlike that of Herakles on the obverse); he holds a bow in his left hand and an upright arrow in his right. A dog looks up to him. This central group of three is flanked on the left by a boy who wears a short mantle over his left shoulder and holds a spear in his left hand. On the far right a youth

appears also holding a spear but dressed like Zeus in a short mantle over his shoulders and arms. The boys and youths wear fillets in their hair.

Robert was the first to speak of the two archers on the reverse as Apollo and Idas, who both claimed Marpessa in a conflict that was settled by Zeus. Though still attractive and accepted by Beazley in *Der Pan-Maler* ([Berlin 1931] 15, 30), this interpretation has become somewhat less certain by the appearance of the Ludwig amphora (Cat. 8) on which "Apollo" as archer faces a naked youth holding an upright spear, again in the company of Hermes. The Berlin amphora shares with amphorae in Copenhagen, Munich, and Geneva (Cats. 13 – 15) the black slanting portion of the underside of the foot and the red line on the neck; the red line also occurs on Louvre F 26 (Cat. 11), where, however, the slanting portion of the underside of the foot is not glazed.

Middle period, about 540 B.C.

Attributed to the Amasis Painter by L. Adamek.

DIMENSIONS AND CONDITION
Height, 29.25 cm; width, 20.25 cm; diameter of body, 19.4 cm; diameter of mouth, 12.78 cm; width of lip, 1.14 cm; diameter of foot, 11.38 cm; width of resting surface, 1.3 cm. Height of figures, 9.7 cm. The vase is broken and has been repaired, with the restorations limited to the fractures.

SHAPE AND DECORATION
Flaring mouth, top flat and unglazed. The neck is glazed on the inside to a depth of 5.7 cm. The round handles are glazed on the underside. Echinus foot, glazed on the outside except for the very edge; the slanting portion of the underside is glazed. Above the foot is a zone of thirty-four rays. The figure scenes are set in panels, framed on the sides by two glaze lines, and surmounted by a palmette-lotus festoon:

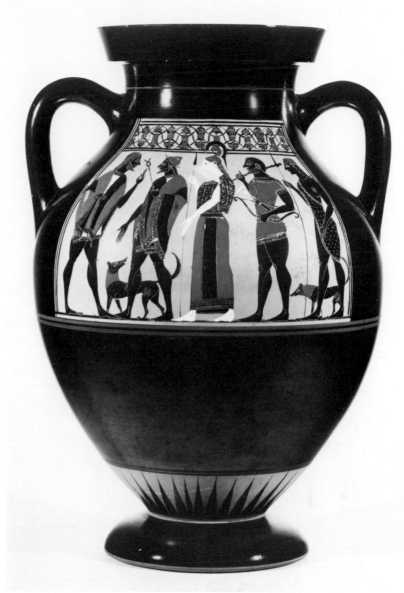

9 Side A.

on side A there are eleven complete elements, to which half a palmette-lotus has been added on the left; on side B there are twelve elements, the ones on the ends trimmed. The festoon is framed above and below by two glaze lines. On the obverse, the groundline is rendered in solid glaze; on the reverse, the line is unevenly applied: it is heavy on the right and thinner on the left.

ADDED COLORS
Red, line on inner edge of mouth; line on neck above upper junction of handles; two lines below panels and two lines above rays, encircling entire vase. Cuffs and cores of lotuses; cores of palmettes; rings connecting tendrils. On side A, chiton of Herakles; panels and neck border of Athena's peplos, her helmet and crest support; petasos of Hermes (except for brim) and panels on his chlamys; panels on mantle of Zeus;

91

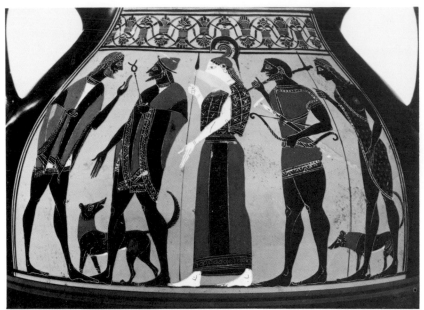

9 Side A, panel.

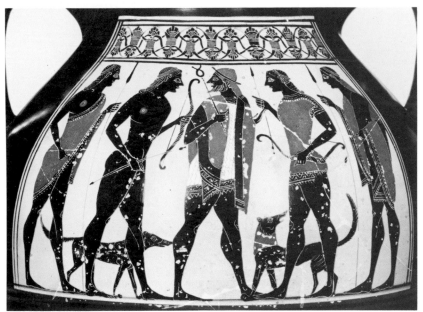

9 Side B, panel.

dots on short mantle of youth on right, hair circle around his nipple; necks of dogs, stripes on their haunches; fillets of Zeus and right-hand youth. On side B, panels on chlamys of Hermes, his hair, his petasos (except for brim); hair circles around nipples of two boys on left, their fillets; short mantle of boy on left; necks of dogs, stripes on their haunches; hair below ribbon of right-hand youth, panels of his chlamys; all fillets. *White,* on side A, flesh of Athena; chitons of Zeus and Hermes; border of crest support (with incised pattern); rows of dots on edges of Herakles' chiton, hilt of his sword; row of dots along edges of short mantle worn by right-hand youth. On side B, chiton of Hermes; rows of dots along borders of right archer's chiton; chlamys of right-hand youth; short mantle of boy on left.

BIBLIOGRAPHY
H. Mommsen, *CVA,* Berlin, fasc. 5 (1980) 15 – 17, pl. 4,4, pl. 6, Beilage B (with bibliography to 1980). Add to the *CVA* bibliography: C. Robert, *Die griechische Heldensage⁴* (Berlin 1920 – 1926) 313, n. 2; *Antikenmuseum, Staatliche Museen Preußischer Kulturbesitz* (Stuttgart 1980) 43, no. 14.

9 Profile drawings of mouth and foot.

10 FRAGMENT OF A PANEL-AMPHORA (TYPE B)

BERLIN, STAATLICHE MUSEEN PREUSSISCHER
KULTURBESITZ, ANTIKENMUSEUM, F 1692,
BEQUEST OF EDUARD GERHARD, 1867.

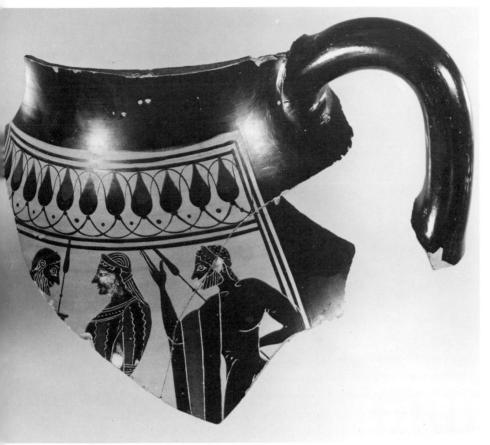

10 Fragment.

Though numbered separately by Furtwängler (*Beschreibung der Vasensammlung im Antiquarium* [Berlin 1885] 229), this fragment belongs to the very fragmentary amphora Berlin F 1691 (fig. 63; *ABV* 151, no. 12, now lost), as I surmised in 1957 (*Gnomon* 27, 541), which on its more complete side has, in a four-figure composition, the introduction of Herakles into Olympus. The subject of the reverse, of which this fragment preserves an important part, is an arming scene. Furtwängler's description of what is ancient on Berlin F 1691, confirmed by Weickert, as quoted by Mrs. Karouzou (*The Amasis Painter* [1956] 30), gives us a fair idea of the four-figure composition of the reverse of the lost vase and confirms the pertinence of this frag-

ment. Of the figure on the extreme left, a youth or man, we know that he wore a long garment; of the second figure, the arming warrior, a bearded bareheaded man holding an upright spear in his left hand, the preserved fragment gives the head, crowned with a fillet, and the left hand with part of the spear. On the lost vase, his left foot and part of his naked lower leg appeared, as did the lower end of a shield in profile, standing or held upright. The arming warrior faces a woman clad in a peplos: she is either his wife or mother. In her hair she wears a fillet and a ribbon. At her ear, a big circular earring with two pendants is visible; it is of the same type as on the cup-skyphos in the Louvre (Cat. 54). Her necklace is incised.

Her lowered left arm may have held the shield by its upper rim. Behind the woman a bearded man moves to the left; he has a wrap around his left shoulder and upper arm and holds a spear diagonally in his right hand. He, too, wears a fillet in his hair. The painter has mistakenly turned his back view into a front view by incising the clavicles and one pectoral.

The height of the lost amphora to which this fragment belongs was given by Furtwängler (p. 229) as 28 cm, which may not be absolutely correct, as the mouth is wrongly restored; the circumference of 55 cm that Furtwängler records may, however, be accurate, as it was taken on the level of the vase that is less affected by the restoration. If the circumference is accurate, the diameter would be 17.5 cm—hence that of a small vase, originally circa 26.2 cm high, on the analogy of Vatican 17743 (Cat. 3).

This is the only arming scene by the Amasis Painter on which occurs a shield seen in profile that is not lying on the ground or carried on the arm by the woman facing the warrior but is standing upright, either held at the top by the hand or leaning against the body (as, for

Fig. 63. Fragmentary panel-amphora of type B. Attributed to the Amasis Painter. Side A: the introduction of Herakles into Olympus (from L. Adamek, *Unsignierte Vasen des Amasis* [Prague 1895] 36, fig. 11). Once in Berlin, Staatliche Museen, F 1691.

11 PANEL-AMPHORA (TYPE B) WITH LID

Paris, Musée du Louvre, F 26 (LP 2873; N 3503), acquired before 1848.

instance, on the Affecter's neck-amphora in Compiègne, *ABV* 239, no. 3).

Middle period.

Attributed to the Amasis Painter by L. Adamek.

DIMENSIONS
Height as preserved, 9.4 cm; diameter of handle, 1.4 cm; thickness of fragment, 0.2 – 0.5 cm. Height of figures (taken from Adamek's drawing of the obverse), 9.1 cm.

SHAPE AND DECORATION
Parts of neck and shoulder and one handle. The panel is framed on the sides by two glaze lines and surmounted by an ornamental band of eleven upright buds, with dots in the interstices. The border is framed above and below by two glaze lines.

ADDED COLORS
Red, second, fifth, eighth, and eleventh bud. In the figure scene, all fillets; vertical stripes of peplos; panel of wrap and dot on nipple; woman's pupil. *White,* flesh of woman.

BIBLIOGRAPHY
H. Mommsen, *CVA,* Berlin, fasc. 5 (1980) 17 – 18, pl. 7,1 (with complete bibliography).

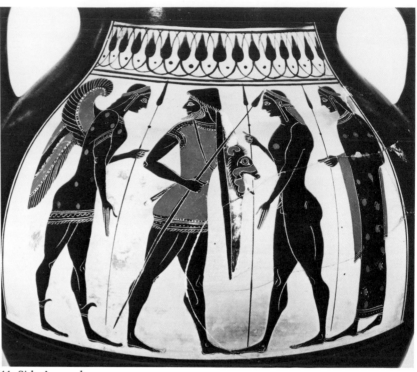

11 Side A, panel.

On the obverse is a light-armed bearded warrior wearing a cap and a short fringed chiton and armed with a round shield seen in profile (the device, a three-dimensional lion head), a spear, and a sheathed sword suspended from his right shoulder by a baldric. He advances toward the right while looking back at a winged youth who wears a short fringed chiton, boots, and a fillet and holds a spear in his left hand. Facing the warrior on the right is a naked youth whose hair is tied behind his ears and is crowned by a fillet; in his right hand he holds an upright spear. Behind him, the scene is completed by another youth, the typical bystander of the Amasis Painter, who wears a himation, a fillet, and—like the winged youth and the naked youth—holds a spear.

On the reverse a naked youth crowned with a fillet holds a hare by the front legs; he approaches a man who is dressed in a chiton and

himation and is also crowned by a fillet. The right arm of the man is covered by the chiton; in his left hand he holds a spear. Behind this man, another man, naked except for a cap and a wrap over his upper left arm, advances to the right, while a dog behind his legs looks at him. The fourth figure, a youth on the right, is again the traditional bystander and is dressed very much like his counterpart on the obverse.

The lid is not certainly the one made for this vase, and its projecting ledge on the underside has been shaved down so as to fit the inside of the mouth: it is hard to tell whether this was done in nineteenth-century Italy or in ancient Etruria to adapt the lid to an amphora for which it had originally not been made, as a replacement. Save for the handles, the Louvre amphora is remarkably close in shape and measurements to Geneva I 4 (Cat. 15), and the possibility is

94

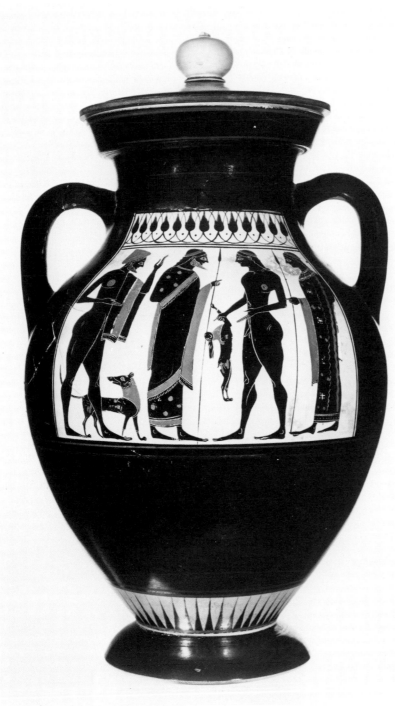

11 Side B.

not to be excluded that the lid of Louvre F 26 actually belongs to the amphora in Geneva.

Winged youths are often encountered on vases by the Amasis Painter, especially in his early period (e.g., Cats. 40, 52, 59; *ABV* 154, no. 56 [here fig. 64]; *Paralipomena* 66 [Warsaw 198552 (here fig. 39); Athens, Kanellopoulos collection (here fig. 38)]), but their name and function escape us. The winged youth on this Louvre amphora is later and more sedate than his ancestors on the very early and early vases: he is no longer in such a mad rush, and there is nothing threatening about him; rather (as is already the case to some extent on the Leningrad lekythos by the Amasis Painter [fig. 64; *ABV* 154, no. 56]), he has joined the rank and file of the onlookers, differing from them only through his wings. The painter has remained faithful to one of his many conventions: the two wings are always deployed in opposite directions, one pointing up and the other drooping.

Middle period.

Attributed to the Amasis Painter by C. Fossey.

DIMENSIONS AND CONDITION
Height with lid, 35.0 cm; height without lid, 30.07 cm; width (across handles), 20.5 cm; diameter of body, 20.3 cm; diameter of mouth, 13.4 cm; width of lip, 1.16 cm; diameter of foot, 11.52 cm; width of resting surface, 1.22 cm. Height of figures, 10.83 cm. The vase is broken and has been repaired; a piece around handle A/B is missing and is restored.

GRAFFITO
Graffito high up on the slanting portion of the underside of the foot, a ligature of heta and rho.

SHAPE AND DECORATION

The lid has an unglazed knob in the shape of a pomegranate, and a reserved circle midway on the glazed upper surface; its brim is offset by a slight ridge. The flaring mouth of the amphora has a slight overhang; its top is unglazed. The round handles are almost completely glazed on the underside. The inside of the neck is glazed to a depth of 2.53 cm. Echinus foot, glazed on the outside except for the very edge. Above the foot is a zone of forty-nine rays; one of them, below the right foot of the winged youth, looks like an afterthought. The figure scenes are set in panels framed on the sides by single (rather than the usual double) glaze lines. The upper ornamental border consists of upright buds with dots in the interstices (fifteen on side A, thirteen on side B). The border is framed by two glaze lines below and only one above: on the reverse, the black of the neck has merged with the line, obscuring both it and the reserved top edge of the panel. The groundline is rendered in dilute glaze.

ADDED COLORS

Red, lines on all three edges of mouth; line on neck above upper junction of handles; two lines below panels and above rays, encircling entire vase; line at base of rays. In the figure-scenes on side A, wing bar of upright wing, wing bow and wing bar of downward wing, dots on chiton of winged youth; chiton of bearded warrior, ear and muzzle of lion on his shield; hair on nape of naked youth, hair dot on his nipple; vertical folds of himation of bystander; cores of dot-rosettes; all fillets. On side B, cap of man on left, hair ring around his nipple, stripe on his wrap; neck of dog, marking on its back, stripe on its haunch; edges and vertical folds of himation of man, horizontal band along lower edge of his chiton, dots on his chiton; neck of hare, two stripes on its haunch; hair circle around nipple of naked youth; stripe on back panel of himation of bystander, cores of dot-rosettes on its front panel, fold over his right forearm; all fillets. *White,* on side A, dot-crosses on winged youth's chiton, rows of dots along wing bow of upward wing and along lower edge of wing bar of lowered wing, lines along lower edge of wing bow and upper edge of wing bar of lowered wing; rows of dots on upper and lower edges of warrior's chiton, his shield (except for rim and device), chape of his scabbard, teeth of lion; dots around cores of dot-rosettes on himation of bystander. On side B, narrow line along red panel of leftmost man's wrap; belly stripe of dog; clusters of three dots on chiton of second man; dots around cores of dot-rosettes; belly stripe and tail of hare; dotted crosses on front panel of bystander's himation, fold behind his back, row of dots along edge of upper border of himation.

BIBLIOGRAPHY

C. Fossey, *RA,* ser. 3, vol. 18 (1891) 366 – 370; L. Adamek, *Unsignierte Vasen des Amasis* (Prague 1895) 22 – 23; G. Karo, *JHS* 19 (1899) 138, no. 7; E. Pottier, *Vases antiques du Louvre* 2 (Paris 1901) 90, no. F 26, pl. 65; idem, *Catalogue des vases antiques* 3 (1906) 722; J.C. Hoppin, *Black-figured Vases* (1924) 44 – 45, no. 27; E. Pottier, *CVA,* Louvre, fasc. 3 (1925) III He, 11, pl. 14, 1 and 4, pl. 18,2 – 3; J.D. Beazley, *ABS* (1928) 32, no. 4; S. Karouzou, *AM* 56 (1931) 104, no. 12; J.D. Beazley, *ABV* (1956) 150, no. 5; S. Karouzou, *The Amasis Painter* (Oxford 1956) 30, no. 17; K. Schauenburg, *JdI* 79 (1964) 114 – 122, figs. 6, 7; A.W. Johnston, *Trademarks* (1979) 117, type 5D, no. 4.

Fig. 64a,b,c. Lekythos. Attributed to the Amasis Painter. Leningrad, Hermitage, inv. 2635.

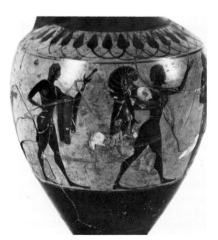
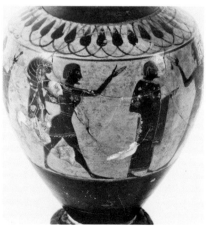
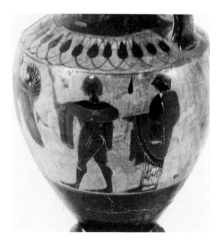

12 PANEL-AMPHORA (TYPE B)

PARIS, MUSÉE DU LOUVRE, F 25 (MNB 1688),
ACQUIRED IN 1879.

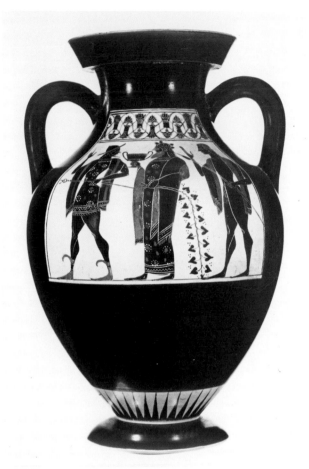

12 Side A.

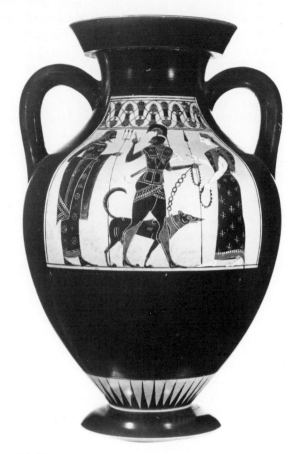

12 Side B.

On this small and slender vase the painter has abandoned his normal five-figure composition and reduced the number to three. On the obverse Hermes leads Dionysos and a young god, perhaps Apollo, with all the deities moving to the left. Hermes is clad in a richly embroidered short chiton, a wrap over both shoulders, a petasos, and boots. He turns his head round to face the company and gestures with a raised index finger. In his left hand he holds his caduceus nearly horizontally. Dionysos takes a somewhat smaller step. In his hair he has an ivy wreath; he wears a long chiton, patterned like the short one worn by Hermes, and over it a himation that covers his shoulders and both arms. In his right hand

he carries a kantharos (presumably filled with wine), and in his left hand is a long, trailing ivy branch with triple corymbs, or berries, between the leaves. The last god (Apollo?) wears a chlamys over his shoulders and upper arms and carries a spear in his left hand; with his right hand he appears to be greeting Hermes.

On the reverse, a hoplite (perhaps Ares) takes leave of Poseidon and a goddess who, if the hoplite is Ares, may be Aphrodite. Poseidon is dressed in a decorated chiton and a mantle that has slipped from his shoulders and is held up by his forearms. In his left hand he holds the trident. Ares wears a short fringed chiton, a leather cuirass

with pteryges, a Corinthian high-crested helmet, and greaves. A sheathed sword is suspended by a baldric from his right shoulder. With his left hand he holds a wreath and the chain leash of a big dog. He turns his head to Poseidon and points with the index finger of his raised right hand. Aphrodite (or perhaps Athena) completes the scene on the right, clad in a peplos and wearing an earring, a necklace, and bracelets. In her left hand she holds a wreath with dot-flowers like the one held by Ares; in her right hand she holds a spear, which balances the upright trident of Poseidon in the composition.

Lenormant was the first to propose that the hoplite leading a dog was

Pandareos stealing the Golden Hound, and he was followed in this conjecture by Pottier; but Pfuhl rejected this interpretation. Another dog on a leash occurs on the Amasis Painter's amphora that was once in the collection of the Marchese Giorgio and the Marchesa Isabella Guglielmi in Rome (fig. 57; *ABV* 150, no. 1). More than fifty years ago Beazley (in *JHS*) expressed the difficulty of interpreting the picture perfectly: "it seems likely that the Paris picture is primarily 'a warrior leaving home': — soldier, father or counsellor, mother or wife. But the painter has spiced it with a trident and, if the purchaser calls the figures Ares, Poseidon, and Aphrodite, will not complain." In *ABV*, however, he reverted to his earlier description given in *ABS* ("warrior [Ares?] with Poseidon and Athena") by describing the scene as "warrior (Ares?) leaving home, with Poseidon and a goddess (Athena?)," and his last words on the subject (in *Paralipomena*) were, "If the warrior is Ares, the woman may be Aphrodite." For the chain leash, compare the obverse of the Leningrad amphora (*ABV* 151, no. 15).

With its pinched neck and slender figures, this amphora should be dated late in the painter's middle period.

Attributed to the Amasis Painter by G. Karo.

Found at Vulci in 1832. Ex colls. Edmé-Antoine Durand, Narcisse Revil, Charles Paravey.

DIMENSIONS AND CONDITION
Height, 18.2 cm; width (across handles), 11.6 cm; diameter of body, 11.42 cm; diameter of mouth, 7.5 cm; width of lip, 1.05 cm; diameter of foot, 6.3 cm; width of resting surface, 0.75 cm. Height of figures, 6.7 cm. The vase is unbroken.

SHAPE AND DECORATION
Flaring mouth with a pronounced overhang, unglazed on top; the neck is glazed to depth of 1.15 cm. The round handles are glazed on the underside. Echinus foot, glazed on the outside except for the very edge. Above the foot is a zone of thirty-nine rays. The figure scenes are set in panels framed by a single glaze line on the sides and surmounted by a floral band, a palmette-lotus festoon composed of eight complete elements, with half a unit added on the left. This border is framed above and below by two glaze lines. The groundline is rendered in glaze.

ADDED COLORS
Red, lines on all three edges of mouth; line above rays; dots in cores of palmettes and lotuses and on rings connecting tendrils. In the panels, dots and cores of dot-rosettes on all chitons; boots of Hermes, brim of his petasos, stripes on his chlamys; beard of Dionysos, part of folds of his mantle; fillet in hair of the young god (Apollo?), panels on his chlamys; fillet and beard of Poseidon, stripes on his mantle, broad stripe along edge of his chiton; outer pteryges of Ares, his greaves, his crest support; neck of dog, marking on its back, stripe on its haunch; pupil and pendants of earring and necklace of the goddess, her fillet, stripes on upper part of her peplos, broad band along its lower edge. *White,* dots around cores of all dot-rosettes; row of dots on upper edges of chitons of Hermes and Dionysos; above red border of goddess's peplos; along edge of Poseidon's mantle; belly stripe of dog; sword hilt and chape of Ares, groups of two dots on his baldric; flesh of goddess, dots in quadrants of incised crosses on her peplos.

BIBLIOGRAPHY
C. Lenormant in J. de Witte, *Cabinet Durand* (1836) 84 – 85, no. 262 (bought by N. Révil for 550 francs); *Vente Paravey, Hôtel Drouot [Paris], 26 février 1879,* no. 11; G. Karo, *JHS* 19 (1899) 138 – 139, no. 8; E. Pottier, *Vases antiques du Louvre* 2 (Paris 1901) 90, no. F 25, pl. 65; idem, *Catalogue des vases antiques* 3 (1906) 722; E. Pfuhl, *MuZ* 1 (1923) 262; J.C. Hoppin, *Black-figured Vases* (1924) 44, no. 26; E. Pottier, *CVA,* Louvre, fasc. 3 (1925) III He, 11, pl. 14, 2 and 5, pl. 16,4 – 5; J.D. Beazley, *ABS* (1928) 32, no. 3; idem, *JHS* 51 (1931) 259; idem, *ABV* (1956) 150, no. 4; S. Karouzou, *The Amasis Painter* (Oxford 1956) 12, 30, no. 18, pl. 22; K. Schauenburg, *JdI* 79 (1964) 139 – 140, fig. 23; J.D. Beazley, *Paralipomena* (1971) 62, no. 4; A. Delivorrias in *LIMC* 2 (1984) 124, no. 1292; P. Bruneau in *LIMC* 2 (1984) 486, no. 96, pl. 368, Ares 96.

13 PANEL-AMPHORA (TYPE B) WITH LID

COPENHAGEN, DANISH NATIONAL MUSEUM, INV. 14347,
GIFT OF THE NY CARLSBERG FOUNDATION, ACQUIRED IN 1960.

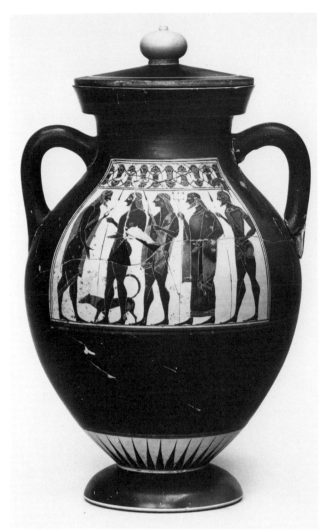

13 Side A.

13 Side B.

The subjects of the panels are not easily interpreted. On the obverse a bearded man or god, who wears a short mantle over his left shoulder, greets with both hands a procession of four figures. Two youths are in the lead: the first is naked, while the second wears a chlamys over his shoulders and upper arms; both youths carry spears, the first holding his upright, the second holding his at an angle. In addition, the first youth has a small fillet over his wrist. The youths are accompanied by a dog with a black collar. Behind the two youths are Poseidon with trident, clad in chiton and himation over his shoulders and both arms, followed by Ares, who is dressed in a short-sleeved short chiton, a nebris, and a high-crested Corinthian helmet. Ares holds an upright spear in his right hand and a fillet in his left. Beazley (in *Paralipomena*) speaks of "two youths (Polydeukes and Castor?) received by a king (Zeus?)."

The reverse gives us another scene of five figures, but three are bystanders. A bearded hero in the center dressed in a short pleated chiton and a nebris approaches Athena. The man has both arms bent at the elbows, his hands open; the goddess wears a peplos and a high-crested Attic helmet; much of her body is covered by her compass-drawn round shield, which is emblazoned with an eagle. In her right hand she holds a spear; with her left hand she appears to stroke the beard of the man, a gesture not unlike that of Hermes touching the beard of Zeus on the Amasis Painter's amphorae in Berlin (F 1691, *ABV* 151, no. 12 [here fig. 63])

13 Top.

and Orvieto (here fig. 60; *ABV* 151, no. 14). Of the three onlooking youths, the two at the ends are naked. The one on the left holds a glaze wreath in his right hand; his opposite carries a fillet in his left hand and holds an upright spear in the other. The third youth, directly behind the bearded hero, also carries an upright spear, but he is dressed in a long, richly ornamented chiton. Beazley (in *Paralipomena*) thought of "Herakles (?)" for the man facing Athena, but his long hair would seem to be a difficulty. All male figures on both sides wear fillets on their heads or helmet.

A. Hermary has reinforced Beazley's tentative identification of the two youths on the obverse as the Dioskouroi, and Schefold has accepted his arguments. Hermary cites a line in Pindar (*Nemean Odes* 10.84), where Zeus invites Polydeukes to live with Athena and Ares in Olympus, and since on the Copenhagen amphora the proces-

sion of the Dioskouroi, Poseidon, and Ares is welcomed by a stately bearded man on the left, that figure can only be Zeus. A passage in Alcaeus (fr. 109), also adduced by Hermary (p. 62), refers to the Dioskouroi as going on their speedy horses across the wide earth and the entire sea; their function on land and at sea thus associates them with Ares and Poseidon. Finally, a contemporary amphora in Boston by the BMN Painter (Boston 60.1, here fig. 65; *Paralipomena* 107, no. 7 bis; Hermary, *BCH* 102 [1978] 55, fig. 5) shows the Dioskouroi on horseback between Poseidon and their father Tyndareos, behind whom stands a naked boy with a wreath in his left hand, reminiscent of the bystanders on the Copenhagen amphora.

This is not the only time the Amasis Painter has painted the Dioskouroi, for Tyndareos and Kastor (both names inscribed) appear at the left end of one leg of the fragmentary tripod-pyxis in Aegina (Appendix 4). Here Kastor, bearded and wearing a Corinthian helmet, is shown walking beside his horse with two spears held over his right shoulder, as he is doing on the black-figured amphora of type A in Brescia that Langlotz attributed to Psiax (fig. 66; *ABV* 292, no. 1). Hermary (p. 70) follows Arias and Vos in taking the Brescia departure to mean that of the Dioskouroi; the inscribed tripod-pyxis by the

Amasis Painter does, indeed, favor this interpretation. The Thracian costume worn by the Dioskouroi on the amphora in Brescia is no serious obstacle, as Shefton (in his revised translation of P.E. Arias and M. Hirmer, *Greek Vase Painting* [1962] 304 – 305) explains. There remains, however, the puzzling meeting of Athena and a bearded hero on the reverse of the Copenhagen amphora shown here. Inspired by Boardman's bold political interpretation of the popularity enjoyed by Herakles in Attic art at the time of Peisistratos (*RA*, 1972, 57 – 72; *JHS* 95 [1975] 1 – 12), Hermary concludes his interpretation of the Copenhagen amphora by asking himself whether the painter did not have Hippias and Hipparchos in mind when he showed the Dioskouroi, and think of Peisistratos when he portrayed Herakles: "la question vaut, semble-t-il, au moins la peine d'être posée" (p. 76). The question is as intriguing as the answer elusive, but if the equation of Herakles and the Dioskouroi with Peisistratos and his sons hinges on the bearded hero next to Athena on the reverse of this amphora, more than ordinary caution is in order, for we would first have to establish with certainty that Athena's friend is indeed Herakles. The only other male figure wearing a chitoniskos and a nebris, but without arms or armor, who appears in the company

Fig. 65. Panel-amphora of type B. Attributed to the BMN Painter. Side A, detail of panel: the Dioskouroi on horseback. Boston, Museum of Fine Arts, 60.1.

Fig. 66. Panel-amphora of type A. Attributed to Psiax. Side B, detail of panel: youths with horses. Brescia, Museo Civico.

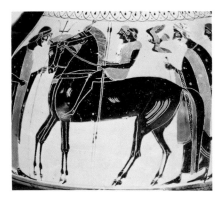

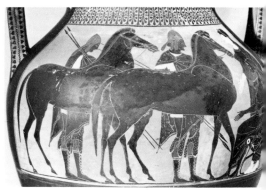

of Athena on vases by the Amasis Painter is the person behind Athena on the fragmentary olpe in Oxford (Cat. 29), of whom Beazley said, he "may be Herakles (compare the Amasis oinochoe in the Louvre, F 30), but he has no club to characterise him, or none remains" (*CVA,* Oxford, fasc. 2 [1931] 97). Unfortunately, his neck and head are missing on the olpe, and thus we cannot even tell whether or not he was bearded. The nebris is red, as on the Copenhagen amphora; the right forearm is upright, close to the body, and his missing right hand may have been open in the gesture of greeting that is employed by the left flanking youth on the Copenhagen reverse.

To date, twelve certain representations of Herakles by the Amasis Painter are known. In his fight with the Nemean lion (Cat. 34), he is shown naked; four times he wears the lion skin (Cats. 5, 55; *ABV* 153, no. 33, and the Aegina pyxis [Appendix 4]); in the remaining seven pictures of Herakles (Cats. 9, 27; *ABV* 151, nos. 10 [twice], 12 [here fig. 63], 14 [here fig. 60], p. 156, no. 79), he is bareheaded, wears a chiton, and has either a club or a bow, or both. He invariably wears his hair short. Thus, there is no iconographical reason to take the friend of Athena on the Copenhagen reverse and Athena's companion on the Oxford olpe as Herakles, and a political explanation of the subjects in Copenhagen must be argued differently or—perhaps better still—be ignored. The eagle device on Athena's shield, though common to black-figured vases, occurs on other vases by the Amasis Painter only one more time, on the shield of Kyknos on the Aegina pyxis (Appendix 4).

Middle period, late.

Attributed to the Amasis Painter by R.E. Hecht, Jr.

DIMENSIONS AND CONDITION

Height with lid, 35.9 cm; height without lid, 31.5 cm; width (across handles, one of which is alien), 21.92 cm; diameter of body, 21.0 cm; diameter of lid, 13.56 cm; diameter of mouth, 13.785 cm; diameter of foot, 12.255 cm; width of lip, 1.38 cm; width of resting surface, 1.41 cm. Width of original handle, 1.75 cm. Height of lid alone, 5.15 cm. Height of figures, 10.48 cm. The vase is broken and has been repaired, but other than handle A/B, an ancient replacement, there are no restorations. Two small areas on the obverse are missing: a triangle in the left thigh of the naked youth and a fragment with part of his left arm and the middle portion of his companion to the right.

SHAPE AND DECORATION

Flaring mouth, reserved on top; the entire neck is glazed on the inside. Handle A/B is alien, probably from an amphora by the Affecter; it was attached to the body in antiquity as a replacement for a broken handle. The figure scenes are set in panels framed on the sides by two glaze lines and surmounted by ornaments bordered above and below by two glaze lines. The ornaments consist of palmette-lotus festoons; on each side there are nine

13 Profile drawings of lid, mouth and of foot.

complete elements, with half a palmette-lotus added in the available space at the left end. The groundline is rendered in glaze. There are thirty-five rays in the zone above the echinus foot, which is glazed on the outside except for the very edge, as well as on the slanting surface of the underside. The rays end at the level of 5.73 cm (measured from the ground), at the height where the diameter of the vase very nearly equals that of the foot. The lid, which fits but is a trifle too small, has a reserved knob in the shape of a pomegranate; at the junction of knob and lid proper is a fillet. A reserved line, 0.14 cm wide, is placed 1.02 cm from its edge. The underside of the lid is reserved.

ADDED COLORS

Red, fillet on lid and its edge; line on inner edge of mouth; line on neck above handles; two lines below panels and two above rays, encircling entire vase; cores of palmettes; rings connecting tendrils; cuffs and cores of lotuses. On side A, all fillets on heads; hair circle around nipple of naked youth and fillet on his wrist; neck (except for collar) of dog, two stripes on its haunch; folds of Zeus' short himation, eight dots on it; two folds of chlamys of second youth, dots on other folds; parts of Poseidon's mantle; chiton of Ares and fillet in his left hand. On side B, back panel of chiton of youth and fold hanging down from his left arm; nebris of bearded hero; helmet and crest support of Athena, rim of her shield, wing bar and tail bar of eagle, ten dots apiece in front and back panels of her peplos; hair circles around nipples of naked youths; fillet in left hand of youth behind Athena. *White,* flesh of Athena; chitons of Poseidon and bearded hero; rows of dots along chlamys border of central youth on side A, along chiton border of second youth on side B, and along upper border of Zeus' mantle.

BIBLIOGRAPHY

D. von Bothmer, *Antike Kunst* 3 (1960) 80; K.F. Johansen, *CVA,* Copenhagen, fasc. 8 (1963) 247 – 248, pl. 313,2, pl. 314; J.D. Beazley, *Paralipomena* (1971) 65; A. Hermary, *BCH* 102 (1978) 55 – 56, fig. 6, 63 – 64, 75 – 76; K. Schefold, *Spätarch. Kunst* (1978) 173, fig. 228.

14 PANEL-AMPHORA (TYPE B)
MUNICH, STAATLICHE ANTIKENSAMMLUNG
UND GLYPTOTHEK, 1383 (J.75), ACQUIRED
WITH THE CANDELORI COLLECTION IN 1841.

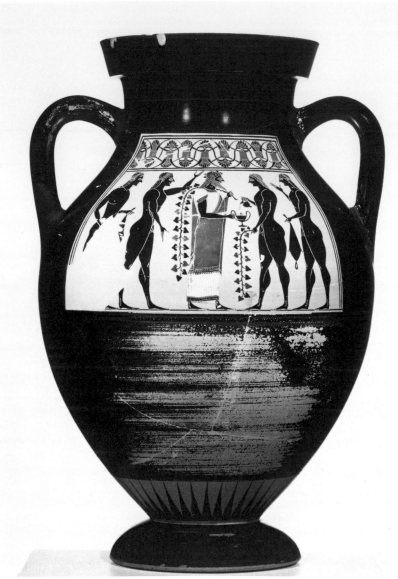

14 Side A.

The obverse shows Dionysos sur-
rounded by three naked youths and
a naked boy. The god stands facing
right, clad in a long white chiton
whose crinkly folds are indicated
by incised lines; over it is a red hi-
mation draped over his left shoulder.
In his hair he wears an ivy wreath,
and in his left hand he holds a long
vine of ivy over his left shoulder. In
his right hand he holds a kantharos,
which is being filled with wine,
rendered in dilute glaze, from a
small oinochoe held by the youth
facing him; in his left hand he holds
another ivy vine. The boy behind
Dionysos has extended both arms
in a salutation. The two flanking
youths at either end of the panel
each carry a wineskin in one hand.
All the youths and the boy wear
fillets in their hair.

The recovery of Helen is shown

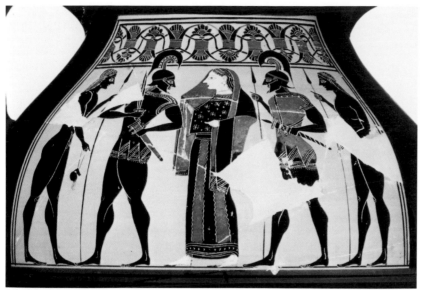

14 Side B, panel.

on the reverse. The wife of Menelaos occupies the central position; she wears a belted peplos and has pulled her himation over the back of her head. The earring on her left ear is a circle with two visible pendants; her necklace is rendered with a wavy incised line. In front of her, looking back, is her husband Menelaos, who wears a short chiton and a high-crested Corinthian helmet. With his left hand he grasps the scabbard that is suspended from a baldric over his right shoulder; in his right hand he holds his sword upright in a menacing position; behind Helen another Greek warrior follows the procession. He is dressed like Menelaos and, like him, grasps his scabbard; his sword is sheathed, and in his right hand he holds an upright spear. The trio is flanked by two youths, the famous bystanders of the Amasis Painter, whom Beazley once dubbed Guildenstern and Rosincrantz (*JHS* 51 [1931] 259); the one on the left holds a spear and an aryballos; the one on the right holds only a spear. All the figures on both sides wear fillets either in their hair or on their helmets.

We now know of five amphorae by the Amasis Painter on which we see Dionysos in the company of four youths or boys. On the earliest, the amphora in Bloomington (Cat. 2), Dionysos appears on both sides of the amphora: on the obverse, with a man, three youths, and two dogs; on the reverse, more symmetrically, with four youths and dogs. I take the Bloomington amphora to be earlier than the others because of the shape of the vase, its ornamentation (there are black cuffs on the lotuses), and the horn in the left hand of Dionysos. Not much later is the amphora in Basel (Cat. 8); here Dionysos still holds the drinking horn rather than the kantharos, but a mantle worn over both shoulders and arms has given way to the new fashion of a himation worn over the left shoulder. Two of the youths go without any garments and carry ivy vines; the ivy vines and nudity of some of the youths recur, together with the himation of Dionysos, on Munich inv. 8763 (Cat. 4). On this, the earlier of the two Munich amphorae, Dionysos already holds a kantharos for refilling, and two of the youths arrive with game, each carrying a fox and a hare on poles. The Amasis Painter has painted the ivy leaves black; on the amphora in Geneva (Cat. 15) the game is reduced to a single hare carried from a stick on the shoulder, and some of the ivy leaves are now painted red. Dionysos holds a kantharos of the same shape as on Munich inv. 8763 (Cat. 4). Of the five amphorae, the one pictured here does not differ much from the amphora in Geneva. Looking at all five together, we can appreciate the criteria for dating.

The picture of Helen, on the reverse of this amphora, was taken by Lilly Kahil to be not the recovery of Helen after the capture of Troy and her return with Menelaos to the Greek ships, but, rather, her abduction by Paris, an interpretation that has not been generally accepted.

Middle period, late.

Attributed to the Amasis Painter by A. Furtwängler (*Führer durch die Vasen-Sammlung König Ludwigs I* [Leipzig 1895] 28).

From Vulci.

DIMENSIONS AND CONDITION
Height, 34.6 cm; width (across handles), 21.9 cm; diameter of body, 21.9 cm; diameter of mouth, 14.4 cm; width of lip, 1.0 cm; diameter of foot, 12.5 cm; width of resting surface, 1.4 cm. Height of figures, 10.1 cm on side A, 10.0 cm on side B. The vase is broken and has been repaired with some conspicuous losses: on side A, right hand, groin, bottom of wineskin, and most of legs and feet of left youth; part of lower right leg of boy; on side B, back of left boy, parts of his arms; right shoulder and parts of upper right arm of Menelaos; portions of peplos of Helen; knees and parts of thighs of second warrior; middle and part of left arm and hand of right youth.

14 Side A, detail of youth (enlarged).

GRAFFITO

SHAPE AND DECORATION
Flaring mouth, flat and unglazed on top. The inside of the neck is glazed to a depth of 6.7 cm. The round handles are entirely glazed. Echinus foot, glazed on the outside except for the very edge; the slanting portion of its underside is also glazed. Above the foot is a zone of forty rays. The figure scenes are set in panels framed on each side by two glaze lines and surmounted by a palmette-lotus festoon, which consists, on the obverse, of eight complete elements with half of one added on the left, and, on the reverse, of eight complete ones with half of one added on each side. The ornamental border is framed above and below by two glaze lines. The groundlines are drawn in somewhat thinner glaze.

ADDED COLORS
Red, line on inner edge of mouth; line on neck slightly above upper junction of handles; two lines below panels and two more above rays, encircling entire vase; line below rays. Cores of palmettes; rings connecting tendrils; cuffs and cores of lotuses; all fillets. On side A, mantle of Dionysos; alternating leaves of ivy vines; on side B, crest supports of helmets; parts of Helen's mantle, two vertical stripes on lower part of her peplos, her pupil; chiton of warrior behind Helen; cores of dot-rosettes on chiton of Menelaos, his scabbard. *White,* chiton of Dionysos; flesh of Helen, dotted crosses on black panels of her lower peplos; dots around cores of dot-rosettes on chiton of Menelaos, row of dots on his crest support, chape of his scabbard, hilt of his sword; edge of crest support of second warrior, row of dots along upper border of his chiton, two transverse stripes of his scabbard, hilt of his sword.

BIBLIOGRAPHY
R. Lullies, *CVA,* Munich, fasc. 1 (1939) 18, pls. 21 – 23 (with bibliography to 1939). Add to the *CVA* bibliography: C. Dugas, *BCH* 60 (1936) 164, no. 20; Y. Béguignon, *L'Iliade illustré* 84; F. Magi, *Annuario della R. Scuola Archeologica di Atene e delle missioni italiane in Oriente,* n.s. 1 – 2 (1939 – 1940) 68 – 69, fig. 6; E. Buschor, *Satyrtänze und frühes Drama* (Munich 1943) fig. 30; B. Neutsch, *Marburger Jahrbuch für Kunstwissenschaft* 15 (1949 – 1950) 57, fig. 24; L. Ghali-Kahil, *Les enlèvements et le retour d'Hélène dans les textes et les documents figurés* (Paris 1955) 50, no. 6; J.D. Beazley, *ABV* (1956) 150, no. 7; S. Karouzou, *The Amasis Painter* (Oxford 1956) 3, 29, no. 5, pl. 3, pl. 6,1; D. von Bothmer, *Gnomon* 29 (1957) 540; A.W. Johnston, *Trademarks* (1979) 84, type 29A, no. 1.

15 PANEL-AMPHORA (TYPE B)

GENEVA, MUSÉE D'ART ET D'HISTOIRE, I 4,
GOSSE COLLECTION, ACQUIRED IN 1867.

The subject on the obverse is Dionysos surrounded by four naked boys. The god, clad in a white chiton and a himation draped over his left shoulder, stands facing right. In his left hand he holds a very long, wavy ivy vine tendril; in his right hand he holds a kantharos. The boy facing him holds a drooping ivy vine in his left hand and raises his right hand to greet the god. His companion behind him holds in his left hand a similar vine and in his right hand a short branch with small blossoms or buds. The boys flanking the god on the left are very similar: the one directly behind Dionysos carries an upright ivy vine and a wineskin in his left hand, while the one on the extreme left holds a yokelike stick over his left shoulder, from which a dead hare is suspended. All the boys have long hair and wear fillets in their hair; the first, third, and fourth also have a sidelock in front of their ears. The ends of the second boy's hair are gathered into a knot. Dionysos wears a wreath of ivy leaves in his hair.

The reverse shows a departure scene. On the left, a warrior dressed in a short-sleeved chiton and a high-crested Corinthian helmet walks to the right; in his left hand he holds an aryballos by a cord, the tassels of which are shown below the mouth of the aryballos. Over his right shoulder he carries a sheathed sword, in his right hand, a spear. The warrior is preceded by a youth in a long chiton who holds a spear in his left hand; this youth turns his head back to face the warrior. In the center of the figure scene, a young horseman wearing a short chiton pulls the reins of his horse with hands that also hold a vertical spear on his left side; behind his horse is a void horse with a lowered head. In front of the horses stands a boy facing left; in his right

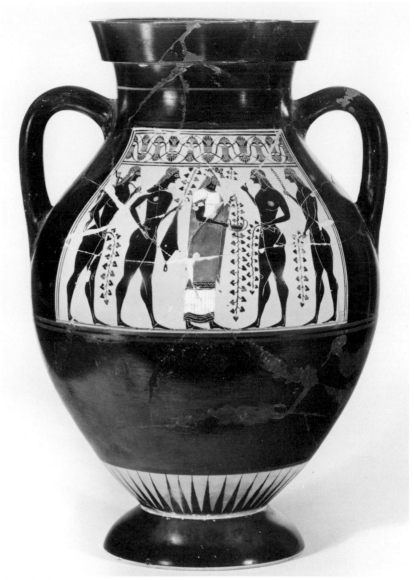

15 Side A.

hand he holds an upright spear and carries an aryballos by the thong; in his left hand he holds a fillet with white dots. The youth in the chiton and the boy on the right wear fillets in their hair.

Beazley has called the rider on the Geneva reverse the mounted squire leading "his master's horse." For the aryballoi so conspicuously carried by the warrior and the boy on the

right, we may compare the arming scenes on New York 06.1021.69 (Cat. 1) and on the Amasis Painter's Guglielmi amphora (fig. 57; *ABV* 150, no. 1). On New York 56.171.10 (Cat. 7), the youth behind the warrior on the obverse holds something from a cord in his left hand; I suspect that it may also have been an aryballos. These early aryballoi are rather small; later, on

105

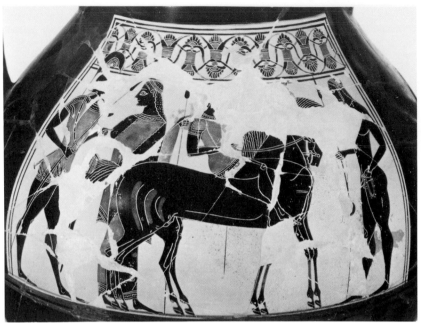

15 Side B, panel.

the Louvre cup-skyphos (Cat. 54), they become as big as on the Geneva amphora shown here, on Munich 1383 (Cat. 14), and on the tripod-pyxis in Aegina. The latest aryballos depicted by the Amasis Painter, on the very late cup in Oxford (Cat. 63), is truly gigantic.

This amphora, the one in Copenhagen (Cat. 13), and Munich 1383 (Cat. 14) are very close in style and period. They also share an unusual feature of the slanting underside of the foot being glazed, and—equally rare in amphorae by the Amasis Painter—of having a red line on the neck above the upper junction of the handles. The wineskin on the Geneva obverse recurs two more times on the obverse of Munich 1383, and the kantharos held by Dionysos appears to be the same model on both vases, so that it is hard to tell which of the two amphorae is a shade earlier and which is a bit later. (For a full discussion of the dating, see Cat. 14.)

Middle period, late.

Attributed to the Amasis Painter by T.B.L. Webster.

DIMENSIONS AND CONDITION
Height, 31.2 cm, width (across handles), 21.8 cm; diameter of body, 20.7 cm; diameter of mouth, 13.47 cm; width of lip, 0.85 cm; diameter of foot, 11.33 cm; width of resting surface, 1.205 cm. Height of figures, 9.8 cm on side A, 9.3 cm on side B. The vase is broken and has been repaired, with many missing portions restored. The major losses comprise, on side A, much of face of Dionysos, fingers of boy greeting him; on side B, much of helmet and entire face of warrior, portions of his left leg, half of his aryballos, and cord by which it is held; most of tails, left front legs, and heads of horses; head of rider; much of face of boy on right, a good portion of his chest, most of his aryballos.

SHAPE AND DECORATION
Flaring mouth, flat and unglazed on top. The entire neck is glazed on the inside. The round handles are glazed on the underside. Echinus foot, glazed on the outside except for the very edge, and glazed on the slanting portion of the underside. The figure scenes are set in panels framed on the sides by two glaze lines and surmounted by a palmette-lotus festoon, which consists, on the obverse, of nine complete elements, with half a palmette-lotus added at each end, and, on the reverse, of ten complete elements, with half of one added on the left. The ornamental border is framed by two glaze lines above and two below. Above the foot is a zone with forty-five rays. The groundlines are drawn in thinner glaze.

15 Profile drawings of mouth and foot.

ADDED COLORS
Red, line on inside edge of mouth, line on neck above upper junction of handles; two lines below panels and two lines above rays, encircling entire vase; line at junction of foot and body; cores of palmettes; rings at junction of tendrils; cores and cuffs of lotuses. In the figure scenes, on side A, all fillets; hair circles around nipples of second and third boys; mantle of Dionysos; some ivy leaves of vines; on side B, all fillets; chitons of warrior and rider; some folds on long chiton of youth and dots on its black folds; three stripes on haunch of

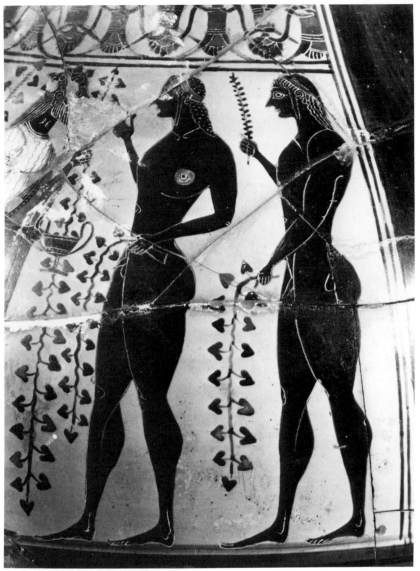

15 Side A, detail of panel (enlarged).

near horse. *White,* on side A, chiton of Dionysos; on side B, dotted crosses on chiton of youth; dots on baldric of warrior, chape of his scabbard, hilt of his sword; row of dots on edge of rider's chiton; dots along outer edge of hand-held fillet of last figure on right.

BIBLIOGRAPHY
S. Karouzou, *The Amasis Painter* (Oxford 1956) 3 – 4, 30, no. 6; pls. 4, 5; D. von Bothmer, *Antike Kunst* 3 (1960) 78, no. 82, 80; K. Schauenburg, *JdI* 79 (1964) 114 – 115, fig. 5; *Dionysos: Griechische Antiken* (Ingelheim 1965) no. 8, pl. 3; C. Dunant and L. Kahil, *CVA,* Geneva, fasc. 2 (1980) 13 – 14, pl. 44,1 – 4, pl. E, no. 2.

16 FRAGMENT OF A PANEL-AMPHORA (TYPE B)

BASEL, HERBERT A. CAHN COLLECTION, 814.

16 Fragment.

The fragment portrays a flanking nude youth with short hair rendered by incisions; spiral curls frame his forehead, and a long sidelock passes in front of his ear.

The youth resembles in some ways, as the owner has observed, the flanking youth on the right of the reverse of Munich 1383 (Cat. 14), who also has stippled hair, though of normal length. The right hand must have held a spear, and the left arm must have been somewhat pulled back, since there is no incised overlap of the shoulder, as, for instance, in the youth with a hare on an amphora in the Louvre (Cat. 11). Short hair for youths is rare for bystanders but occurs on the Amasis Painter's amphora in Orvieto, Faina 40 (fig. 60; *ABV* 151, no. 14). For the clavicles, compare the flanking youth behind Poseidon on the olpe in Oxford (Cat. 29).

Attributed to the Amasis Painter by Herbert A. Cahn.

DIMENSIONS
Height as preserved, 3.03 cm; width as preserved, 4.57 cm; thickness of wall of sherd, 0.36 cm above, 0.29 cm below. Estimated height of figure, 10.4 cm.

SHAPE AND DECORATION
The fragment comes from the upper right-hand corner of the figure scene. The panel is framed on the right by two glaze lines.

BIBLIOGRAPHY
Not previously published.

17 FRAGMENT OF A PANEL-AMPHORA (TYPE B?)

NEW YORK, THE METROPOLITAN MUSEUM OF ART, 1985.11.2, GIFT OF NICHOLAS S. ZOULLAS, 1985.

17 Fragment.

On the left is the lower part of the body of a man (or a god) clad in a long chiton and a fringed chlamys; he is holding a spear (or a trident). To his right is the lower leg of a warrior wearing a greave and facing right. Between the figures is the end of a signature. On the analogy of the other signatures, it should be

[ΜΕΠΟΙΕѕ]ΕΝ
[ΑΜΑѕΙѕ]

written in two lines, as on the olpai in the Louvre and Würzburg (Cats. 27, 28), where the name is in the first line, separated from the verb by the spear or trident.

The large scale of the figures (estimated height, ca. 13 cm) and the estimated diameter of the vase (ca. 23.5 cm) suggest an amphora of type B of considerable height. The subject may have been the arming of Achilles, with Phoenix on the left and Achilles in the center. There may have been another figure behind Phoenix. The double incised outline for the greave is rare.

The fringe on the chlamys and the tiny white dots around the red cores of the dot-rosettes suggest a date in the late period—not too far from that of two of the Boston neckamphorae (Cats. 24, 25).

18 FRAGMENT OF A PANEL-AMPHORA (TYPE A)

NEW YORK, THE METROPOLITAN MUSEUM OF ART,
1984.313.2, ANONYMOUS GIFT, 1984.

Attributed to the Amasis Painter by
D. von Bothmer.

DIMENSIONS
Height as preserved, 5.54 cm; thickness
of wall of sherd, 0.39 cm.

ADDED COLORS
Red, line below panel; folds of chlamys;
cores of dot-rosettes on chiton; greave.
White, dots around cores of dot-
rosettes.

BIBLIOGRAPHY
Not previously published.

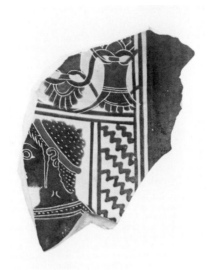

18 Fragment.

The preserved portion gives the
upper right-hand corner of a
panel with the last two members
of a palmette-lotus festoon and the
head, neck, and part of the chest and
shoulder of a youth standing facing
left. He wears a fillet in his short
hair and is clad in a himation.

Among the works of the Amasis
Painter, compare, for the stippled
incisions in the hair of the youth,

Fig. 67. Fragment of a panel-amphora
of type A. Attributed to the Amasis
Painter. Satyrs and maenads. Samos,
Museum.

the youths on Munich 1383 (Cat.
14); for the sidelock, compare the
amphora in Geneva (Cat. 15) and
Munich 8763 (Cat. 4). The short
hair is unusual in a flanking figure,
but it occurs on the Faina amphora
(fig. 60; *ABV* 151, no. 14). The two
incised hooks on the neck, also a
rare detail, are known from Munich
1383 (Cat. 14), the Samos fragment
(fig. 67; *ABV* 151, no. 18), and the
Basel amphora Kä 420 (fig. 40;
Paralipomena 65). Quite unknown
otherwise, however, is the zigzag as
a lateral panel border of amphorae.
Zigzags are encountered in the
work of the Amasis Painter on the
roots of the handles of Würzburg
265 (Cat. 19), as vertical borders
on the lekythoi in London and
Montclair (Cats. 49, 50), on the
New York aryballos (Cat. 52), on
the Agora alabastron (fig. 34; *ABV*
155, no. 64), and on the flange of
the lid of Vatican 17743 (Cat. 3).

The fragment shown here should
be from an amphora of type A
rather than of type B, since to date,
among the works of the Amasis
Painter, lateral frames of panels are
known only from the amphora of
type A (special model) Berlin inv.
3210 (fig. 45; *ABV* 151, no. 21). The
scale of the figure on the fragment
is 11¼ percent smaller than the
scale of the Berlin figures, and the
height of the complete amphora
may therefore, on the analogy of
Berlin inv. 3210, have been circa 39
cm. Another argument in favor of
an amphora of type A is the glazing
of the neck on the inside all the way
down to the slope of the shoulder,
as was done on the Würzburg
amphora (Cat. 19).

As to a relative date, the red and
black alternations in the lotus pods,
together with the red cuffs of the
lotus cuffs, are shared by Basel
Kä 420 (fig. 40; *Paralipomena* 65), a
vase that is roughly contemporary
with Berlin inv. 3210 and the two

18 BIS FRAGMENTS OF A PANEL-AMPHORA (TYPE A?)

NEW YORK, THE METROPOLITAN MUSEUM OF ART, 1985. 57,
ANONYMOUS GIFT, 1985.

lekythoi in London and Montclair (Cats. 49, 50): middle period, early, about 550 – 540 B.C.

Attributed to the Amasis Painter by D. von Bothmer.

DIMENSIONS

Height as preserved, 6.03 cm; width as preserved, 4.89 cm; thickness of wall of sherd, 0.905 cm above, 0.305 cm below. Estimated height of panel, 14.2 cm.

DECORATION

The fragment is glazed inside to the level corresponding to the middle of the floral ornament. The rest of the body on the inside is covered with dilute glaze. The panel is framed above by a palmette-lotus festoon, separated from the figure scene by two glaze lines, and framed on the side by diagonal zigzags ("pipe cleaners") that are set off from the figure scene by two glaze lines. Two additional glaze lines frame the reserved area on the right.

ADDED COLOR

Red, cores of palmettes; cuffs of lotuses and three petals; fillet in hair of youth.

BIBLIOGRAPHY

Not previously published.

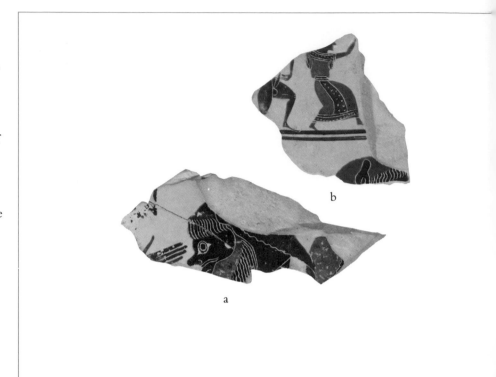

18bis Side A. The fragments are positioned to approximate their location on the panels.

18bis Side B. The fragments are positioned to approximate their location on the panels.

110

d

c

g

h

The eleven fragments—of which three are joined into one and two into another—are from the obverse and the reverse. Both pictures are thematically connected, as on the amphora in Würzburg (Cat. 19). Four of the fragments are of a vintage scene not unlike that of the Basel amphora Kä 420, on the side Beazley called the obverse (fig. 40; *Paralipomena* 65). In such scenes, much space is taken up by the trough on three legs, the basket of grapes, and the satyr treading them, with the result that Dionysos is not in the center but on the left. The first of the New York fragments (a), from the obverse of the amphora, gives the nose, mouth, and beard of Dionysos and his left hand. He faces a satyr, who wears a fillet in his hair and whose head is slightly inclined. This satyr stands back to back with a second satyr, who faces right. The second satyr is partly preserved on fragments a and b; fragment a shows his long red hair covering his nape, and fragment b preserves the crown of his head, his ear, and the incised fringe of his brushed-up hair. Fragment c furnishes the back of a third satyr and the neck, beard, chest, shoulder, back, upper right arm, left forearm, and hand (holding a beaker or tumbler) of a fourth satyr. Fragment c also preserves part of the body of a fifth satyr, whose head appears on fragment d; he is dancing with his head thrown back and his left arm raised. Of the subsidiary frieze above this panel, parts of two dancing trios can be made out on fragments b and d. The group on b consists of the remaining two figures of a trio, a naked ithyphallic satyr and a maenad clad in a peplos dancing to the right. The other trio, on fragment d, dances to the left. Here a satyr, his legs slightly bent and his feet held close together, is between two dancing maenads, the second only indicated by her preserved foot.

The four fragments on the reverse, e, f, g, and h, are somewhat easier to interpret. The head on fragment e, drawn in outline, is that of a maenad facing right. Her hair is tied in a ribbon behind her ears, and an incised line in her hair above reveals that she wears an ivy wreath. A big circular earring with three decorative projections adorns her ear. Her chest and arms appear on fragment f, which is composed of three pieces. She wears a belted peplos and has a bracelet on her raised left wrist; of the lowered right arm, only the elbow is preserved. In front of her, on the same fragment (f), an ithyphallic satyr moves to the right. Both of his arms are raised, as in the fluting satyrs on the Würzburg and Basel amphorae (Cat. 19 and Kä 420, *Paralipomena* 65 [here fig. 40]). Overlapped by his abdomen are three small fingers of another figure, perhaps a diminutive satyr, like the one on the obverse of the Guglielmi amphora (fig. 57; *ABV* 150, no. 1). The third fragment of the reverse (g) comes from the center of the scene: Dionysos, clad in a chiton and himation, faces a maenad (or Ariadne) who wears a peplos and a mantle that covers her right arm, which holds a wreath. Her hair is tied in a ribbon, as is the first maenad's, and her earring is the same shape as that of her companion. The necklace is painted in a zigzag line of somewhat thinner glaze. Of the last figure, on fragment h, a satyr dancing to the left, only the small of his back, his buttocks, part of his tail and thighs, and his left hand and forearm are preserved. The perpendicular line behind his tail is that of the lateral frame.

The subject of these fragments is more readily understood in comparison with the complete vases in Würzburg (Cat. 19) and Basel (Kä 420, *Paralipomena* 65 [here fig. 40]). The beaker or tumbler held by the third satyr on the obverse recurs on the Basel amphora; the incisions on the bodies of the satyrs in pairs of short strokes representing hair are familiar from eight of the nine Würzburg satyrs and from the Kavala fragments (fig. 70; *Paralipomena* 65); the hair above the foreheads of the satyrs on these fragments, brushed back *en brosse,* recurs on the amphora of type A in Berlin (fig. 45; *ABV* 151, no. 21) and on the Würzburg amphora (Cat. 19); the incised semicircle on the haunch of the first satyr on the reverse of this fragmentary amphora can be matched by that of the left satyr of the Berlin amphora just cited and that of the first satyr on the obverse of the Basel amphora (Kä 420; *Paralipomena* 65 [here fig. 40]). The earrings of the maenads are all of the big hoop type known from the Basel and Berlin amphorae.

The small frieze above the panel of the obverse is closer to the corresponding frieze above the arming panel of the Berlin amphora (fig. 45) than to the dancers on either side of the Würzburg amphora (Cat. 19), and I suspect that the dancers may originally have numbered ten or more. Their movements from left to right and from right to left suggest a central figure—no doubt Dionysos, either seated, as on the obverse of the Würzburg amphora (Cat. 19), or standing, as on the obverse of the Berlin amphora and on the reverse of the amphora in Würzburg. The maenads in the small frieze, incidentally, are not drawn in outline, as are those in the panel, but in the standard black-figure technique.

Middle of the painter's middle period.

Attributed to the Amasis Painter by J.R. Guy on February 16, 1984, before the fragments came to New York.

DIMENSIONS AND CONDITION
Preserved height of biggest fragment, 7.2 cm; estimated height of figures: 15.5 cm in the panels, 2.66 cm in the small frieze above. Estimated height of vase, 40–41 cm. The insides of some of the fragments are flaked.

SHAPE AND DECORATION
The amphora was probably of type A rather than of type B, since in the vases by the Amasis Painter, the subsidiary frieze is known, to date, only from amphorae of type A (Berlin inv. 3210, *ABV* 151, no. 21 [here fig. 45], Würzburg 265 [Cat. 19]) and the fragments from Samos, which Beazley (*ABV* 151, no. 18 [here fig. 67]) has classed "type A rather than type B." The panels are framed by single lines on the sides, as on the amphora Würzburg 265 (Cat. 19). The small frieze is separated from the principal figure scene below by two glaze lines. A guideline in dilute glaze below these two glaze lines can be seen on fragment d, and I ask myself whether the faint line below the two glaze lines on the Würzburg amphora, which Wolfgang Züchner (in *Neue Beiträge zur klassischen Altertumswissenschaft,* ed. R. Lullies [Stuttgart 1954] 107–108, n. 16, pl. 17,1) restored as a third glaze line, was not, as on these New York fragments, a mere guideline. The inside of the amphora of which these fragments are preserved is painted with streaky dilute glaze.

ADDED COLORS
Red, on side A, fillet in hair and beard of first satyr; hair of second satyr; in the subsidiary frieze, upper part of peploi of maenads and two panels in their lower part. On side B, panels on peplos of first maenad; tail of first satyr; dots on chiton of Dionysos, stripe on his himation; mantle over right arm of maenad or Ariadne facing Dionysos, stripe on neckline of her peplos. *White,* on side A, flesh of maenads in small frieze; rows of dots along base and near rim of beaker or tumbler. One side B, crosses and dots on chiton of Dionysos, row of dots along upper edge of his himation; row of dots on lower border of maenads' necklines.

BIBLIOGRAPHY
Not previously published.

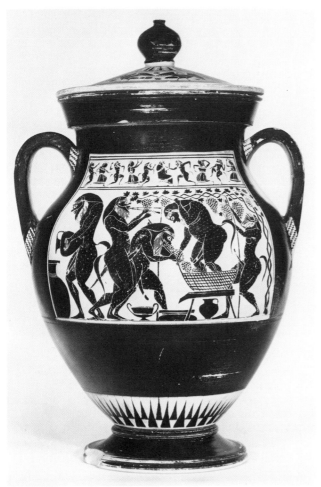

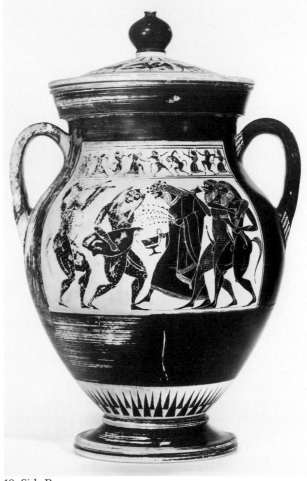

19 Side A.

19 Side B.

The figure scenes on the obverse and reverse are thematically connected. In the main picture, on side A, five satyrs are shown making wine. On the left, a hairy satyr pours water from a hydria, held by the side handles, into a storage vessel that is partially buried in the ground. Back to back with him stands another hairy satyr playing the flutes for the three fellow satyrs who are hard at work: the one on the far right harvests grapes from vines that are propped up by two poles; the satyr in the middle empties a shallow bowl filled with plucked grapes into a three-handled basket set on a raised trough. In it

the fifth satyr stands slightly bent over, treading the grapes. With his left hand he holds onto the trellis above his head, while with the right hand he has grasped one of the handles of the basket to balance himself. The pressed juice of the grapes flows from a spout in the trough into a pithos that is almost completely buried in the ground. A big globular oinochoe stands below the trough, and the kantharos of Dionysos is on the other side of the pithos, between the legs of the third satyr. Dionysos himself appears in the small frieze in the panel above, seated in the center on a campstool with a drinking horn in his left hand, while four maenads and five

satyrs perform a dance. The satyrs are naked, whereas the maenads wear belted peploi and have, like Dionysos, ivy wreaths in their hair.

On the reverse, Dionysos appears in the big panel dancing toward a satyr, who, for comic effect, turns his head frontally to the spectator. In his right arm and hand he carries a full wineskin, from which he fills the kantharos held out by Dionysos. The god wears a long chiton and a himation over both shoulders and arms. His head is crowned with an ivy wreath, and in his left hand he holds several ivy branches. He moves in step with the two satyrs behind him, who dance

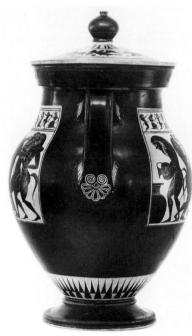

19 Handle B/A.

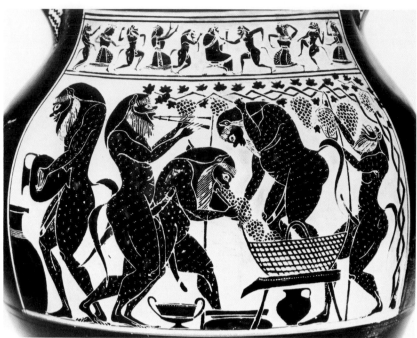

19 Side A, panel.

side by side, their arms around one another's shoulders. In their free hands they carry drinking horns, the farther satyr having raised his to his lips. The satyr on the left of the panel faces Dionysos and his companions while playing the flutes, a dot-fillet suspended from the crook of his right arm. In the small frieze above, five satyrs and four maenads are shown in a dance. The maenads again wear belted peploi and ivy wreaths; of the satyrs, the first on the left carries a wineskin and the second plays the flutes. Some of the satyrs are hairy, like their comrades in the main scenes.

The animals and monsters on the lid are grouped heraldically, four on the left and four on the right, with a siren in the center. This siren is flanked on the left and on the right by a seated sphinx between two lions. The procession is concluded on the left by a swan and on the right by another siren, this time turning its head. Between the last two figures, almost as if to accentu-

ate the suture, the artist has aligned two rosettes vertically. Seven other rosettes are placed most regularly: one each under the forward wing of the swan and the siren, another pair under the belly of each of the lions in the rear, and the remaining three, more irregularly, one under the lion to the right of the principal siren, another under the forward wing of the siren, and the last between the lion behind the siren and the sphinx.

The pertinence of the lid Würzburg L 282 was first proposed by Züchner. Erika Simon (in *Die griechischen Vasen*) has recently argued against this, reverting to Langlotz's categoric statement in his Würzburg catalogue (*Griechische Vasen* 53), "Der Deckel [L 282] gehört nicht zur Amasisamphora." Miss Simon adds that Langlotz was right, "da Deckel von Bauchamphoren dunkel sind." This argument no longer holds, however, for on the lids of two panel-amphorae signed by Exekias as pot-

ter, Louvre F 53 (here fig. 68; *ABV* 136, no. 49; *Paralipomena* 55) and Toledo 80.1022A (here fig. 69; C.G. Boulter and K.T. Luckner, *CVA*, Toledo, fasc. 2 [1984] pls. 81–83), siren and stags, or panthers and stags already appear in circular friezes between ornamental bands. Thus the Würzburg lid is in good company and need not be considered a unicum. Moreover, since Züchner's recognition of the pertinence of the lid, his stylistic arguments can be reinforced by newly attributed vases. For vertical rows of rosettes that serve as a punctuation mark, we have the Amasis Painter's Kanellopoulos lekythos in Athens (fig. 38; *Paralipomena* 66) and Louvre Cp 10520 (Cat. 43); the Louvre lekythos also gives us good comparisons for the lions and siren, as well as for the rosettes placed below the forward wings of the siren. The swan on the Würzburg lid is not too far from the cygnet on the Louvre cup-skyphos (Cat. 54) or the shield devices on the Amasis

114

19 Side B, detail of satyr.

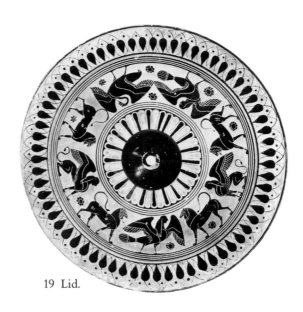

19 Lid.

Painter's Embiricos neck-amphora (fig. 56; *ABV* 152, no. 23) and the neck-amphora in the Cabinet des Médailles (Cat. 23). A final argument is the excellent fit of the lid on the vase.

The vintage scene on the obverse has been much discussed and admired for over a hundred years, and the subject was considered a rarity for the Amasis Painter. In the last thirty years, however, this aspect of the Amasis Painter has been considerably strengthened by the appearance of the splendid Basel amphora (Kä 420, *Paralipomena* 65 [here fig. 40]), the fragmentary amphora in Kavala, attributed to the Amasis Painter by François Salviat (here fig. 70; *Paralipomena* 65, now partly published by D. Lazarides in *Deltion* 17 [1961 – 1962] pl. 283), and the new fragment from Samos, attributed by Helmut Kyrieleis (here fig. 71; *AA* 1980, 341, fig. 7), all of which bear on the Würzburg amphora. The Samos fragment gives us legs of hairy satyrs with a metal hydria. The Kavala scene

repeats the treading of the grapes, the three-handled wicker basket, the trough, and the oinochoe placed under it, as well as the supporting post of the vines. The Kavala satyrs are hairy, and Dionysos appears twice, once in the vintage scene and again, dancing in the company of maenads and satyrs on the other side of the vase. Like the Würzburg amphora, the Kavala panels are framed on the sides by single lines; a palmette with alternating red and black fronds was under the handle, and the grape juice flowing from the trough is rendered in dilute glaze. Clearly all of these vintage vases are interconnected. The Samos fragment and the Kavala fragment are, in all probability, from amphorae of type A, but as the

Fig. 68. Lid of a panel-amphora of type B signed by Exekias as potter and attributed to a painter of Group E. Paris, Musée du Louvre, F 53.

Fig. 69. Lid of a panel-amphora of type B signed by Exekias as potter. Toledo Museum of Art, 80.1022 A, B.

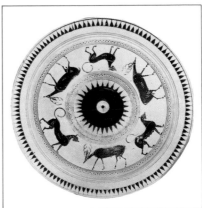

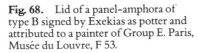

115

feet are not preserved, it is hard to tell whether or not they are of the same model as the Würzburg vase. In the grape-plucking scenes by the Amasis Painter on the Würzburg amphora and on the Kavala fragments, one detail should be singled out as rarely shown on vases: the charakes, or vine props, that support the vines. Pritchett has discussed the literary evidence (W.K. Pritchett, *Hesperia* 25 [1956] 305 – 306), and Sparkes has stressed their presence on the Kavala fragments and the Würzburg amphora (in *BABesch*, pp. 49 – 50) but does not cite other examples; we can add the earliest example, Louvre AM 1008 (here fig. 72; E. Pottier, *CVA*, fasc. 4 [1926] III He, pl. 29,3 and 6, pl. 30, 3 and 4), an amphora in Altenburg, related to the Antimenes Painter (*Paralipomena* 123), the fragments of a black-figured lekanis in Istanbul from Xanthos (H. Metzger, *Fouilles de Xanthos* 4 [Paris 1972] 120 – 122, no. 241, pls. 56, 57) that Beazley has attributed to the Antimenes Painter (*ABV* 691, no. 137), as well as the skyphos fragment Athens, Agora P 26652.

On this amphora, the pressed grape juice flows directly into the pithos, without passing through a strainer, as on the Amasis Painter's Basel amphora (Kä 420, *Paralipomena* 65 [here fig. 40]), and the wine will thus be red: the skins, the stalks, and the pips, which contain most of the red coloring agents of the wine, are thus not filtered out, as for white wine, but will instead ferment along with the grape juice and determine the color of the wine.

Sparkes (in *BABesch*) takes the Würzburg amphora to be "about ten years later" than the Basel amphora Kä 420 and the Amasis Painter's Kavala fragments (fig.

Fig. 70. Fragments of a panel-amphora of type B. Attributed to the Amasis Painter. Vintage scene with satyrs making wine. Kavala, Museum, 983.

70; *Paralipomena* 65). I should have thought that all of the three vases are contemporary, datable to the middle of the Amasis Painter's middle period.

Attributed to the Amasis Painter by F. Dümmler, in a letter to K. Sittl, November 10, 1893 (see J.D. Beazley, *JHS* 51 [1931] 274, n. 29).

Perhaps from Vulci, as are most of the vases from the Feoli collection.

DIMENSIONS AND CONDITION
Height with lid, 42.15 cm; height without lid, 34.5 – 34.8 cm; width (across handles), 27.0 cm; diameter of body, 24.4 cm; diameter of mouth, 19.1 – 19.2 cm; width of lip, 1.2 cm; diameter of foot, 15.3 cm; width of resting surface, 1.2 cm; width of handle A/B, 3.512 cm; width of handle B/A, 3.45 cm; diameter of lid, 19.55 cm; height of lid alone, 8.3 cm. Height of principal pictures in panels, 12.4 cm. The vase and the lid are unbroken, but the surface has fretted away.

SHAPE AND DECORATION
Flaring mouth, unglazed on top, with a slight lip on the outside at the upper edge. The entire neck is glazed on the inside to a depth of 9.5 cm. The handles are flanged, and at their attachments to the neck and shoulder of the vase, they are decorated with zigzag lines on the outsides (cf. the zigzags on Cats. 3, 18, 49, 50, 52). Below each handle is a seven-frond palmette. The flaring foot is in two degrees and is glazed on the outside except for the very edge. The foot is joined to the body of the vase by a fillet. In the zone above the fillet, fifty-eight rays are drawn in two tiers. They extend to the level of the vase at which its diameter equals exactly that of the foot. The figure scenes are set in panels framed on the sides by single glaze lines; the groundlines are also rendered in glaze, but applied more thinly, especially on the reverse. Each principal scene is surmounted by a small subsidiary frieze of figures framed above and below by two glaze lines.

The lid of this vase is preserved. Its knob is in the shape of a pomegranate,

19 Profile drawings of lid, mouth, and of foot.

and the lid proper is decorated by a zone of animals and monsters framed above and below by four glaze lines. Between the figure-zone and the knob is a tongue-pattern of forty-one alternately black and red tongues, beginning and ending with two contiguous black tongues above the siren that is the last figure on the right of the zone. On the flange are sixty-five linked upright buds with dots in the interstices.

ADDED COLORS
The surface has fretted away, and the added colors have all but disappeared. I have not been able to verify all the traces, but G. Beckel has kindly identified most of them, here recorded. *Red,* on the lid, alternate tongues, painted not over black but directly on the clay ground; manes and stripes on haunches of lions; fillet in hair of central siren between heraldic lions. In the panels, on side A, himation of seated Dionysos; parts of peplos of dancing maenads; two stripes on pithos; line at junction of neck and shoulder on oinochoe below

trough. On side B, stripes in mantle of Dionysos; hair and tail of last dancing satyr. *White,* on the lid, faces and chests of sirens and sphinxes and their wing bows. In the panels, on side A, (probably) flesh of dancing maenads and (perhaps) hinges of Dionysos' campstool, as well as his chiton. On side B, (probably) flesh of dancing maenads.

Züchner has restored some of the added colors and the worn glaze in two photographs (pls. 17, 18), but the third glaze line that he has restored under the small frieze of side B was probably only a guideline in dilute glaze, as on one of the New York fragments (Cat. 18 bis, fragment d), not a third glaze line, as on the New York fragment Catalogue 2 bis.

BIBLIOGRAPHY
H. Brunn, *Bullettino dell'Instituto di Corrispondenza Archeologica* (1865) 48; K.L. von Urlichs, *Verzeichniss der Antikensammlung der Universität Würzburg* 3 (1872) 78 – 79, no. 334; A. Furtwängler, *Der Satyr aus Pergamon* (Berlin 1880) 23, n. 2; H. Bulle, *Die Silene in der archaischen Kunst der Griechen* (Munich 1893) 16 – 17, no. 23; K. Sittl, *Dionysisches Treiben und Dichten* (Würzburg 1898) 29, n. 1, pls. 2, 3; G. Karo, *JHS* 19 (1899) 134 – 138, fig. 1, pl. 5; E. Fölzer, *Die Hydria* (Leipzig 1906) 12, 101; G. Perrot in G. Perrot and C. Chipiez, *Histoire de l'art dans l'antiquité* 10 (Paris 1914) 189 – 191, figs. 121, 122; J.D. Beazley, *JHS* 34 (1914) 190, n. 10; E. Buschor, *Griechische Vasenmalerei*[2] (Munich 1914) 135, fig, 96; E. Pfuhl, *MuZ* (1923) vol. 1, 258 – 262, vol. 3, pl. 54, fig. 222; J.C. Hoppin, *Black-figured Vases* (1924) 45, no. 31; A. Gotsmich in *Epitymbion: Heinrich Swoboda dargebracht* (Reichenberg 1927) 58ff., fig. 3; J.D. Beazley, *ABS* (1928) 22, 32, no. 2; B. Schweitzer, *JdI* 44 (1929) 114, n. 1; W. Kraiker, ibid., 144 – 145, n. 2; P. Cloché, *Les classes, les métiers, le trafic* (Paris 1931) 11; J.D. Beazley, *JHS* 51 (1931) 274; E. Langlotz, *Griechische Vasen* (Munich 1932) 50 – 51, no. 265 (vase), 53, no. 282 (lid), pls. 73, 74, 86; F. Brommer, *Satyroi* (Munich 1937) 26, 54, n. 20, no. 3; E. Buschor, *Griechische Vasen* (Munich 1940) 121 –

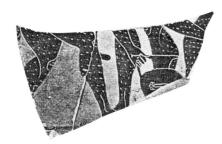

Fig. 71. Fragment. Attributed to the Amasis Painter. Satyrs. Samos, Museum.

Fig. 72. Panel-amphora of type B. panel: men and boys picking grapes (G. Perrot and C. Chipiez, *Histoire de l'art dans l'antiquité* 10 [Paris 1914] 127, fig. 91). Paris, Musée du Louvre, AM 1008.

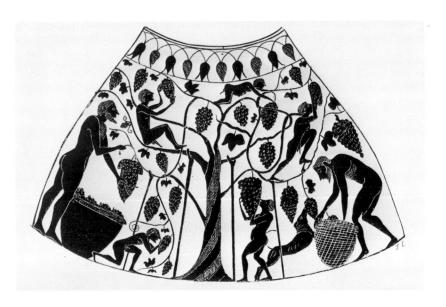

20 NECK AND MOUTH OF A LIDDED VASE

BOSTON, MUSEUM OF FINE ARTS, 86.616 (N 184),
GIFT OF THE EGYPT EXPLORATION FUND, 1886.

123, fig. 139; J.D. Beazley, *Development* (1951) 60, 112, n. 51, pl. 23,2; E. Buschor, *Bilderwelt griechischer Töpfer* (Munich 1954) 24; W. Züchner in *Neue Beiträge zur klassischen Altertumswissenschaft,* ed. R. Lullies (Stuttgart 1954) 103 – 108, pls. 15 – 18; S. Karouzou, *The Amasis Painter* (Oxford 1956) 14, 17 – 18, 29, no. 1, pl. 25,1, pl. 28,2, pl. 29; J.D. Beazley, *ABV* (1956) 151, no. 22; B.A. Sparkes, L. Talcott, and M.A. Frantz, *Pots and Pans of Classical Athens* (Princeton, N.J., 1958) fig. 14; A. Bruckner, *Antike Kunst* 1 (1958) 35 – 36; M. Robertson, *JHS* 78 (1958) 167 – 168; D.A. Amyx, *Hesperia* 27 (1958) 244 – 250, no. 2; P.E. Arias and M. Hirmer, *Greek Vase Painting,* translated and revised by B. Shefton (1962) pl. 55, 299 (commentary); J. Dörig in J. Boardman, J. Dörig, W. Fuchs, and M. Hirmer, *Die griechische Kunst* (Munich 1966) 100, pl. 97; W.A. Younger, *Gods, Men, and Wine* (London 1966) 128 – 129 (ill.); E. Simon, *Die Götter der Griechen* (Munich 1969) 286, fig. 278; J.D. Beazley, *Paralipomena* (1971) 63, no. 22; J. Boardman, *ABFV* (1974) 55 – 56, 76, fig. 88; H. Mommsen, *Der Affecter* (Mainz 1975) 30, n. 158, 33, n. 177, 46, n. 226, 48, n. 250, 52, n. 281, pl. 139, Beilage U; M. Robertson, *A History of Greek Art* (London 1975) 135 – 136, 638, n. 134, pl. 41a; E. Simon, *Führer* (1975) 95, pl. 25; B.A. Sparkes, *BABesch* 51 (1976) 49 – 50, 58, fig. 5; E. Simon and M. Hirmer, *Die griechischen Vasen* (Munich 1976) 82 – 83, pl. 68; R.J. Charleston, ed., *Masterpieces of Western and Near-Eastern Ceramics* 2: R.M. Cook and R.J. Charleston, *Greek and Roman Pottery* (Tokyo 1979) fig. 32; H. Kyrieleis, *AA* 1980, 341; M. Robertson, *A Shorter History of Greek Art* (n.p., 1981) 34 – 37, fig. 56.

20 Fragment.

The scene on the neck is a boxing match of two men, flanked on the right by a youth shouldering a staff—a judge or trainer? Of the boxer on the left, only the fist is preserved; of his bearded opponent, we have the head, the left shoulder, flank, buttock, and his flexed left arm. The judge or trainer wears a himation. In his right hand he holds a staff that crosses his body on its left side.

The fringes on the himation of the youth and the drawing of the ears and eyes show this fragment of a vase by the Amasis Painter to be an early work. For the boxing scene the best comparisons are furnished by the boxers on the neck of London B 191 (Cat. 22) and the wrestlers on the obverse of the London vase and on both sides of the neck of Basel BS 497 (Cat. 21); both of these are early vases, not necessarily potted by Amasis. The treatment of the mouth here resembles that of the red-figured psykter by Euthymides in Turin (*ARV*² 28, no. 11), which has a lid. This fragment may well be from an early psykter, equipped with handles like

the one in Rhodes in the manner of Lydos (*ABV* 115, no. 3) and having a neck set off from the body—just as there are early neck-pelikai that may well antedate the canonical one-piece pelikai.

Middle period.

Attributed to the Amasis Painter by J.D. Beazley.

From Naucratis.

DIMENSIONS AND CONDITION
Height as preserved, 7.3 cm. Estimated diameter of mouth, 12 cm inside, 15 cm outside. The glaze has misfired, and the neck has been imperfectly burnished on the outside.

SHAPE AND DECORATION
The mouth has a raised ledge on the inside, which suggests that it was pro-

20 Profile drawing of mouth.

21 PANEL NECK-AMPHORA (SPECIAL SHAPE)

BASEL, ANTIKENMUSEUM UND SAMMLUNG LUDWIG, BS 497, ACQUIRED IN 1984.

filed in this fashion to accommodate a lid. The side of the mouth, its top, and the inside are glazed.

ADDED COLOR

Red, band on inside of lip very near edge, a narrower stripe at a depth of 4.8 cm; outside of ledge; hair of boxer and youth; beard of boxer and a dot (not a circle) denoting hair on his nipple; stripes on himation of youth.

BIBLIOGRAPHY

H. Hoffmann, *CVA,* Boston, fasc. 1 (1973) 43, pl. 58,1 (with bibliography to 1973). Add to the *CVA* bibliography: J.D. Beazley, *Development* (1951) 112, n. 60; B. Legakis, *Antike Kunst* 26 (1983) 76, n. 27.

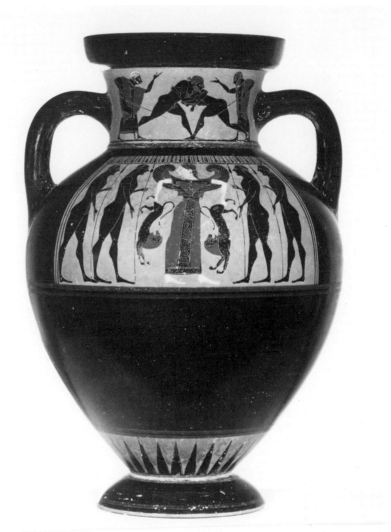

21 Side A.

The scenes on the neck represent nude men wrestling, flanked by judges or trainers. The pose of the wrestlers on the reverse is the typical beginning of the match and almost duplicates the similar composition on the obverse of London B 191 (Cat. 22); the wrestlers on the obverse show a more advanced phase of the match, a headlock. The judges or trainers wear chitons and himatia and hold staves. The left-hand one on the obverse has a white beard and white hair and is thus differentiated from his colleague.

The pictures on the body show the same subject on both sides— Artemis as πότνια θηρῶν, the mistress of the wild beasts, holding two lions: on the obverse she has seized them by the hind legs and holds them upside down; on the reverse she pulls them up by the scruff. Her companions are, on side A, four nude boys holding upright spears. On side B, the second and fourth boys wear mantles, and the second and third hold wreaths; only the spears of the first and the second are held upright; that of the fourth is

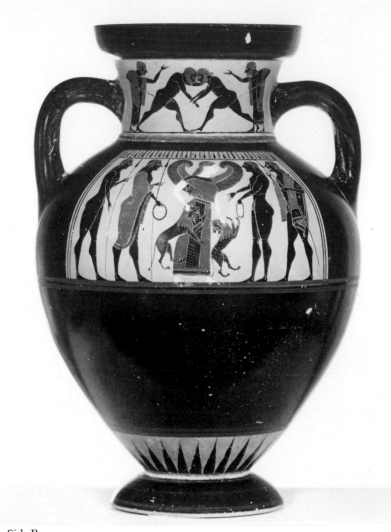

21 Side B.

held off the ground and at an angle. The goddess wears a belted peplos and has an incised necklace and incised bracelets. Her wings grow not from the back but from her sides and seem to emerge from her belt. On the reverse she is shown in profile facing right; on the obverse the upper part of her body is in frontal view, while the head is seen in profile turned toward the left, and the lower part of her body is seen in profile facing right. All figures, except the last boy on side A, have a fillet in their hair.

A winged goddess, once without animals, occurs in the oeuvre of the Amasis Painter three more times: on the alabastron in the Agora (fig. 34; *ABV* 155, no. 64), on the Louvre lekythos F 71 (Cat. 41), and on the panel-amphora in Orvieto (fig. 60; *ABV* 151, no. 14). On the lekythos and the panel-amphora she holds animals—lions in Paris, lion and fawn in Orvieto. Twice, in Athens and Orvieto, she has four wings, which on the alabastron do not interfere with the movement of her arms but accentuate her speedy motion, while on the Orvieto amphora,

they produce something of a clutter. For the obverse of the neck-amphora shown here, the painter has wisely reverted to the heraldic scheme first encountered on his Louvre lekythos F 71, and as one compares the two, one is struck by the strong similarity between the two versions of the frontal goddess, a closeness that even extends to the way the wings grow from her belt and to the antithetical lions. Since the lekythos in the Louvre is considered early and this neck-amphora is surely later, the question arises whether the two almost identical pictures of Artemis as πότνια θηρῶν do not reflect a freestanding statue or a relief that remained visible for a long time. As for the Artemis in profile on the reverse, she has less in common than does the goddess on the obverse with the Amasis Painter's Artemis in Orvieto, even if we make allowances for elimination of the second pair of wings and the way in which the Orvieto Artemis appears to choke the fawn.

The profile of the Basel neck-amphora shown here, as Mrs. Mommsen has noted (p. 11), comes closest to that of a panel neck-amphora in Munich, "probably a rough work by the painter [of Acropolis 606] himself" (fig. 73; *ABV* 81, no. 1, Munich 1447). (The potting of this Basel neck-amphora is unusually heavy, and I do not believe that it is the work of the potter Amasis.)

As often in the work of the Amasis Painter, certain unusual details of drawing recall similar conventions he employs elsewhere. For the spiral pattern on the peplos of his Artemis on the obverse, we can compare the same pattern on Artemis' peplos on the lekythos in London (Cat. 49) and on the peplos of the girl holding out a lip-cup on the mastoid in Paris (Cat. 53). By the same token, the manner in which the frontal wings of the Basel

120

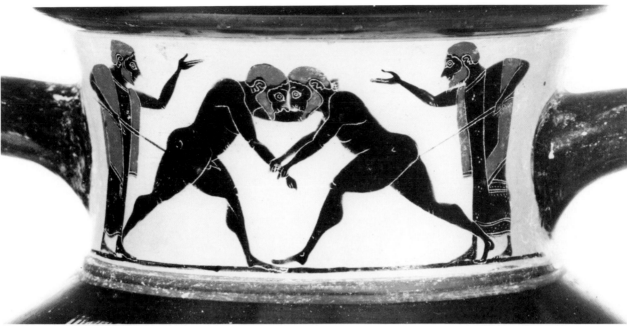

21 Side B, neck (enlarged).

Artemis shown here are linked by a palmette that almost serves as a clasp has found its way into shield devices by the Amasis Painter—on the shoulder of the neck-amphora in the Cabinet des Médailles (Cat. 23) and on the oinochoe in Oxford (Cat. 29).

Middle period.

Attributed to the Amasis Painter by K. Schauenburg.

DIMENSIONS AND CONDITION
Height, 30.95–31.15 cm; diameter of body, 21.6 cm; diameter of mouth, 13.63–13.67 cm; width of lip, 1.02 cm; diameter of foot, 11.46 cm; width of resting surface, 1.2 cm. Height of figures, 4.5 cm on neck, 8.94 cm on body. The vase is unbroken but no longer has its lid, which was sold to Bloomington with *another* vase by the Amasis Painter that had once been in the same collection (Cat. 2). If, as I believe, the lid now in Bloomington is the original lid of the vase now in Basel, we gain the following additional measurements: height with lid, 35.5 cm; diameter of lid, 14.0 cm above, 13.965 cm below; height of lid alone, 5.4 cm.

SHAPE AND DECORATION
Echinus mouth, glazed on top. The entire neck is glazed inside. The round handles are almost entirely glazed on the underside. Fillet between neck and shoulder. Echinus foot, glazed on the outside except for the very edge. Above the foot is a zone of twenty-nine rays. The pictures on the neck have a groundline but are not framed; the pictures on the body are framed on the sides by two glaze lines and are bordered above by black and red tongues (thirty-nine on the obverse, thirty-six on the reverse). There is a faint groundline of dilute glaze on the obverse; on the reverse, the red line below the panel, drawn while the vase was spinning on the wheel, has inadvertently gone slightly askew and thus covers the bottom edge of the panel. The panels do not reach up to the fillet but stop 1.08 cm short of it, allowing for a neat separation of neck and body figure scenes, as on the similar neck-amphora by the Amasis Painter now in the Embiricos collection in Lausanne (fig. 56; *ABV* 152, no. 23) and the neck-amphora London B 191 (Cat. 22). The effect is similar to that of the reverses of black-figured panathenaic amphorae.

Fig. 73. Panel neck-amphora. Near the Painter of Acropolis 606. Side B: cock and a plant. Munich, Staatliche Antikensammlung und Glyptothek, 1447.

121

ADDED COLORS

Red, inner edge of mouth; line on inside of neck 3.25 cm below top; stripe near bottom of mouth on outside; fillet between neck and shoulder; alternate tongues above panels (on side A, first tongue is black; on side B, red); two lines below panels and two lines above rays, encircling entire vase; line on outside of foot and another near its edge. In pictures on neck: on side A, hair and beards of wrestlers and of judge on right; on side B, hair and beards of all four men. In the panels, all fillets; wing bows of Artemis, her peplos (except for ornamented central panel of skirt); chlamys of second boy on side A; folds on chlamys of last boy; manes and muzzles of lions on both sides and stripes on haunch of one lion on each side (right-hand lion on side A, left-hand lion on side B). Cores of dot-rosettes on chiton of right-hand judge or trainer on neck of side B and on chlamys of last boy in panel. On the lid, disk on top of knob; edge of knob; line at junction of knob and lid; edge of flange. *White,* hair and beard of left judge or trainer on neck of side A; flesh of Artemis; dots around cores of all dot-rosettes; dot-clusters on chiton of white-haired old judge on side A, of both judges on side B. Rows of dots above incised zigzag border of peplos on side A, along stripe with incised spiral pattern on same peplos; along edges of wing bars; teeth of lions; rows of dots along edge of chlamys of second boy on side B.

BIBLIOGRAPHY

K. Schauenburg, *JdI* 79 (1964) 131 – 135; J.D. Beazley, *Paralipomena* (1971) 66; D. von Bothmer, *MM* 12 (1971) 126, n. 18, pl. 30; H. Mommsen, *Der Affecter* (Mainz 1975) 10 – 11, n. 36, 26, n. 135, 46, n. 218, pl. 134, middle, left.

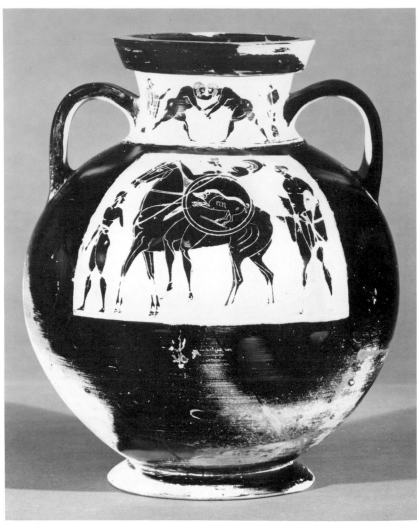

22 Side A.

The small figure scenes on the neck contain athletic scenes, as on the Basel neck-amphora (Cat. 21) and the fragment in Boston (Cat. 20). On the obverse of the neck, a pair of nude bearded wrestlers are shown between two judges or trainers, bearded men dressed in chitons and himatia. On the reverse of the neck, between two similar men, dressed as their counterparts on the other side, two nude boxers exchange blows, as on the Boston fragment.

In the panel on the body of the obverse, a warrior with greaves, a high-crested Corinthian helmet, and a shield (the device, a boar at bay) dismounts from his horse, holding onto the top of its head with his right hand; his squire, a youth holding a spear, is mounted on the horse next to that of the hoplite. A little naked boy walks ahead, looking round behind, and a bearded man with a fillet in his hair and a chlamys over both forearms and lower back walks behind the horses. The man holds a spear upright in his right hand; his beard is stippled.

On the reverse, the painter has joined Poseidon, Ares, and Hermes in one of the loose groupings that he favored. Poseidon, who stands

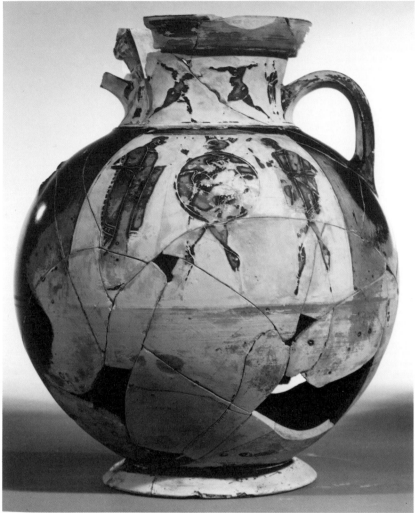

22 Side B.

on the left, has a fillet in his hair, which, like his beard, is stippled. He is clad in a long chiton and a mantle worn over his shoulders and left arm. In his left hand he holds a trident. Ares, in the center, advances toward the left. He is equipped with greaves, a big round shield with a centaur hurling a pine branch as device, a spear, and a Corinthian helmet with two half-crests and an ear on top. Hermes, concluding the scene, walks behind Ares. He wears boots, a short chiton, a chlamys over his shoulders and upper arms, and a petasos. In his left hand he holds a rather long caduceus; his right hand is raised in salutation.

For the paunchy wrestlers, the bearded athletes on the neck of the neck-amphora in Basel (Cat. 21) and the heavyset wrestling youths on the aryballos in New York (Cat. 52) give us good comparisons. The paunchy youths of the aryballos reappear as boxers on the narrow frieze above the Dionysiac thiasos on the reverse of the Amasis Paint- er's Berlin amphora of type A (fig. 74; *ABV* 151, no. 21), and similar boxers (although bearded), are also shown on the fragment in Boston (Cat. 20). The wrestlers on the Lon- don and Basel neck-amphorae can trace their descent from such wrest- lers by Lydos as those on the frag- mentary band-cup in Oxford (*ABV* 113, no. 80) signed by Nikosthenes as potter or, earlier still, from figures on the Siana cup in the manner of the Heidelberg Painter in Paris (*ABV* 67, no. 2), which also gives us a judge and a pair of boxers on either side of the wrestlers. The iconogra- phy of the Amasis Painter's athletes tells us much about his beginnings, and we are not surprised to find other echoes of Lydos on this vase: the two horses on the obverse of this neck-amphora are not too dis- tant from those in Naples by Lydos (*ABV* 109, no. 23), although they are painted in mirror reverse.

Fig. 74. Panel-amphora of type A (special model). Attributed to the Amasis Painter. Side B: detail showing boxers. Once in Berlin, Staatliche Museen, inv. 3210.

Fig. 75. Fragmentary red-figured cup. Signed by Kleophrades, son of Amasis, as potter and attributed to the Kleophrades Painter. Detail showing the shield device of an Amazon. Paris, Bibliothèque Nationale, Cabinet des Médailles, 535.

As for the shield device, we note that the Amasis Painter has put a short groundline under the hind legs of the boar to make sure that its rearing action is fully appreciated. He used the same device for one of the hoplites on the shoulder of the neck-amphora in the Cabinet des Médailles (Cat. 23). The centaur hurling a pine branch on the shield of Ares on the reverse of this vase is the most ambitious device drawn by the Amasis Painter; it anticipates the device of the chief Amazon on the red-figured cup by the Kleophrades Painter in the Cabinet des Médailles (fig. 75; ARV^2 191, no. 103)—a cup, incidentally, that is signed by Kleophrades, son of Amasis, as potter (cf. Appendix 2).

Middle period, fairly early.

Attributed to the Amasis Painter by J.D. Beazley.

From Vulci. Ex coll. Campanari, 1839.

DIMENSIONS AND CONDITION
Height, 30.5 cm; diameter of body, 25.6 cm; diameter of mouth, 14.04 cm; width of lip, 1.2 cm; diameter of foot, 14.24 cm; width of resting surface, 1.6 cm; width of handle, 3.0 cm. Height of figures on body, 12.5 cm; radius of Ares' compass-drawn shield, 2.3 cm. The vase is broken and has been repaired. The surface is very damaged. One handle is missing and has been restored. The glaze has misfired on the reverse.

SHAPE AND DECORATION
This neck-amphora has a flaring mouth, reserved on top, of amphorae of type A or type B; the inside of the mouth and neck are glazed. The neck is reserved and has figure scenes on both sides. The strap handles (one is modern) are glazed on the outside only. Between neck and body is a fillet. The rather globular body is decorated with scenes set in panels framed on the sides by single faint glaze lines; the groundline is also rendered in dilute glaze. These panels do not rise all the way to the top of the shoulder but, as on the Amasis Painter's Basel neck-amphora (Cat. 21) and Embiricos neck-amphora in Lausanne (fig. 56; ABV 152, no. 23), they stop short of the fillet. Unlike these two vases, however, the London neck-amphora shown here has no rays above the echinus foot.

ADDED COLORS
Red, top of mouth, band along its inner and outer edges; band on inside of neck halfway down; fillet between neck and shoulder; lines along edges of angular handles; two lines encircling entire vase below panels; edge of foot. On neck of side A, hair and beards of wrestlers and judges or trainers; hair on chest of wrestler on left; stripes on himatia of judges or trainers; on neck of side B, dots on chiton of judge or trainer on left, himation of judge or trainer on right; hair, beards, and hair circles around nipples of boxers. On the body, on side A, fillet on head of boy in front of horses, hair circles around his nipples; fillet in hair of rider and dots on his chitoniskos; greaves and crest support of dismounting warrior, two stripes on haunch of his horse, rim of his shield, neck of boar in his device, stripes on its flank and haunch; hair circles around nipples of right-hand man, fillet in his hair, dots on his chlamys; on side B, cores of dot-rosettes on Poseidon's himation, fillet in his hair; edges of crest of Ares, rim of his shield, part of centaur's shoulder in his device, his greaves; petasos of Hermes (except for brim), alternate folds of his chlamys, top of his boots. White, on side A, tusks of boar; on side B, dots around cores of dot-rosettes on Poseidon's himation, rows of dots on crest of Ares; chiton of Hermes.

BIBLIOGRAPHY
H.B. Walters, *Catalogue* 2 (1893) 127 – 128, no. B 191; E.N. Gardiner, *JHS* 25 (1905) 267, n. 17, 270, n. 28; H.B. Walters, *CVA*, British Museum, fasc. 3 (1927) III He, 9, pl. 44,5; J.D. Beazley, *ABS* (1928) 34, no. 21; S. Karouzou, *The Amasis Painter* (Oxford 1956) 32, no. 26, pl. 21,1 – 2; J.D. Beazley, *ABV* (1956) 152, no. 24, 325, no. 1; D. von Bothmer, *Antike Kunst* 3 (1960) 80; K. Schauenburg, *JdI* 79 (1964) 132; D. von Bothmer, *MM* 12 (1971) 126; H. Mommsen, *Der Affecter* (Mainz 1975) 26, n. 135, 61, n. 321, pl. 134; M.B. Moore, *GettyMusJ* 2 (1975) 47, fig. 25, 48, n. 55; eadem, *Horses* (1978) 65, 242, 327, 362, 404.

23 Neck-Amphora (Special Model)

Paris, Bibliothèque Nationale, Cabinet des Médailles, 222,
acquired with the donation of the Luynes collection in 1863.

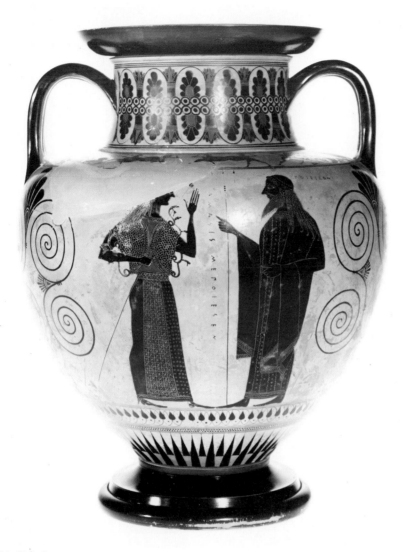

23 Side A.

The shoulder of this vase, in a frieze framed above and below by two glaze lines, represents a battle of nineteen hoplites, composed of four groups on the obverse and five on the reverse. In the spaces under the handles the painter has placed, under handle A/B, a runner blowing a horn to sound the alarm and, under handle B/A, an archer escaping to the right while looking back. The part of the battle that rages on the shoulder of the obverse is more com-plex than that on the reverse: the group on the left shows a hoplite on the defensive, turning to the left and looking round at his opponent, whose shield device is a star. The next two groups present two duels; the devices of the warriors on the right of each group are a prancing goat and a collapsing stag. The scene concludes with a trio—a hoplite lunges at a warrior who has sunk onto one knee (his device, a swan), while a comrade rushes up to defend him; his device is a rearing boar, the hind legs on a groundline.

On the shoulder of the reverse, the battle continues with five duels. In the first, the hoplite on the left holds his spear at waist level; the device of his opponent is the pro-tome of a lion. In the second group, the warrior on the left turns tail, looking round behind him; his opponent has a winged palmette as a device. The next three groups, which conclude the battle scene, are very much alike, save for the shield devices of the right-hand hoplites: the protome of a ram, a frontal pan-ther head, and the protome of a horse. The painter has been most attentive to symmetry: on this side of the battle, the shields in the first and last groups barely touch, while the shields in the three groups be-tween them overlap.

All warriors are dressed and armed very much alike; they wear Corinthian helmets with high crests (except for the fourth hoplite on the obverse), linen corslets with pteryges, greaves, round shields, and spears. In the central group on the reverse, both warriors carry sheathed swords, as do, on the ob-verse, the two in the second group, the right-hand warrior in the third group, and the last warrior in the final group. The shields of all the warriors to the left of each group are seen from the inside, and since their devices are not shown, the painter, on the obverse, has lavished much distinguishing detail on the shields' straps and staples, whereas on the re-verse, he has used a simpler model for all five shields. The fleeing archer wears a pointed oriental cap, a short belted chiton with fringes, and greaves; he has lost his bow, but in his quiver, carried at waist level, he still has three arrows. The horn blower on the opposite side wears a cap with a visor and a short fringed chiton.

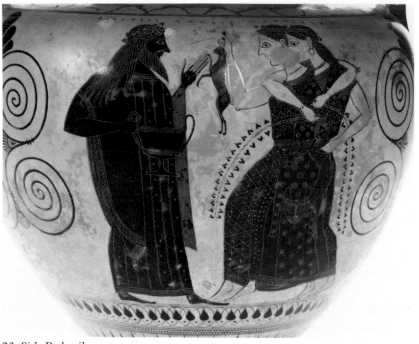

23 Side B, detail.

23 Handle A/B.

In contrast to the fierce battle on the shoulder, the chief pictures are in a serene mood. On the obverse Athena and Poseidon face one another. The goddess, on the left, moves toward Poseidon. She wears a richly decorated belted peplos and, over both shoulders, her aegis with four snakes on each side. Of her helmet, only the nape guard is preserved. Her left arm is raised in a greeting; in her right hand, she holds her spear diagonally. Poseidon (whose name is inscribed ΓΟSΕΙΔΟΛ) stands facing left. He wears a fillet in his hair and a ribbon, below which six long tresses fall over his left shoulder. He is clad in a long chiton with crinkled pleats and a himation over his shoulders and arms; in his right hand he holds his trident. Between the two deities, the potter Amasis has written his signature in a straight line parallel to the pronounced vertical of the trident: ΑΜΑSΙS ΜΕΓΟΙΕSΕΝ

On the reverse, Dionysos (his name inscribed ΔΙΟΛVSΟS)

welcomes two maenads who dance toward him, each with an arm around the other's shoulder. The god is drawn very much like Poseidon, and like Poseidon wears a long chiton with crinkled pleats and a himation over his shoulders and left arm. An ivy wreath crowns his head. In his right hand he holds a big kantharos apparently filled with wine, and his left hand is raised in the familiar gesture of greeting. His hair is not tied in a ribbon behind his ears, as is Poseidon's. Instead, the hair below the ivy wreath falls in eight long tresses over his shoulders. The flesh of the maenads is drawn in outline. Both are wreathed with ivy and each wears a bracelet on one wrist; the preserved earring of the closer maenad has pendants; the necklaces are drawn in crinkled lines. The farther maenad, on the left, whose body is overlapped by the one on the right, wears a belted peplos, while her companion wears the skin and head of a leopard over her peplos. The maenads bring gifts to Dionysos: one holds a hare by the ears, the other a small stag by the front legs; in her other hand, each carries an ivy branch. Above the hare and the maenads' heads, the potter Amasis has signed this vase a second time in a horizontal line, parallel to the two groundlines of the shoulder: ΑΜΑSΙS ΜΕΓΟΙΕSΕΝ

The alien lid, which disfigures the splendid vase in even the most recent publications (of Hirmer's photographs), has now been removed, being much too small to have been made for this vase. The alien lid, however, was on the vase when the Duc de Luynes bought it at the Durand sale of 1836 (see D. von Bothmer, *Berliner Museen* 14 [1964] 40, n. 5). There are other instances of lids in the Durand collection having been sold with the wrong vases (e.g., the lid of *ABV* 136, no. 49 [here fig. 68]: see also D. von Bothmer, *Berliner Museen* 14 [1964] 40, n. 2), and one day we may find the correct

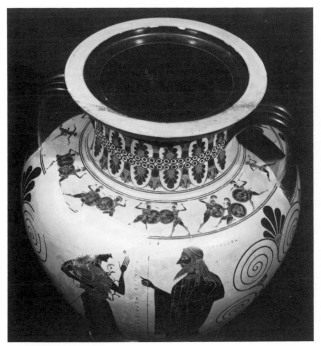

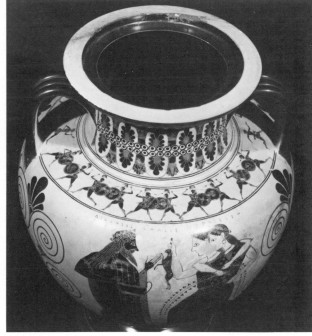

23 Side A, shoulder.

23 Side B, shoulder.

amphora for the lid formerly placed on the Amasis neck-amphora.

The pattern-work below and around the handles on this vase was later modified by the Amasis Painter for his Boston neck-amphora that shows Achilles receiving his armor from Thetis (Cat. 25). This vase, in

the Cabinet des Médailles, is clearly earlier. Its rather squat proportions and the decorative scheme, with eight spirals, palmettes in the spandrels, and strips of hanging triangles below the triple handles, connect it with the neck-amphorae of the Botkin Class, first recognized by

Beazley in 1931 and later enlarged (*JHS* 51 [1931] 284; *ABV* 169, nos. 1 [here fig. 81], 2, 3 [here fig. 76], 4, 5, 6 [here fig. 82]; *Paralipomena* 71, no. 4 bis [here fig. 77]; see also fig. 78 for a later addition to this class). The figure-work on vases of the Botkin Class is not only earlier

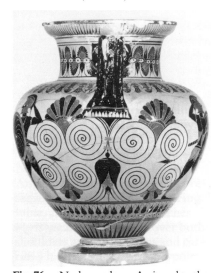

Fig. 76. Neck-amphora. Assigned to the Botkin Class. Side view. Boston, Museum of Fine Arts, 98.923.

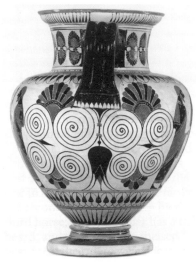

Fig. 77. Neck-amphora. Assigned to the Botkin Class. Side view. New York, The Metropolitan Museum of Art, 64.11.13.

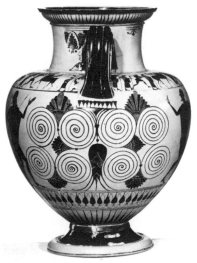

Fig. 78. Neck-amphora. Assigned to the Botkin Class. Side view. New York, private collection.

than the figure-work on the neck-amphorae signed by Amasis as potter but is not even stylistically close to the vases attributed to the Amasis Painter. Beazley attributed one neck-amphora of this class to the Phrynos Painter (*ABV* 169, no. 1) and considered four more (*ABV* 169, nos. 2, 3, 4; *Paralipomena* 71, no. 4 bis) as probably by the Phrynos Painter, with the remaining two (nos. 5 and 6) as "less careful, but bear[ing] a distinct resemblance" to the first five (*Paralipomena* 71).

The interesting question now arises—who potted the vases in the Botkin Class? The potter Phrynos signed two lip-cups (*ABV* 168), for which a parallel cannot easily be found. Should we not consider the neck-amphorae of the Botkin Class as early works by the potter Amasis? The potter, as I have long believed, must have had a say in the ornamental decoration of the vases that he created. It used to be assumed that all vases signed by Amasis as potter were decorated by the same man, the Amasis Painter, but the lekythos in Malibu, attributed to the Taleides Painter yet signed "Amasis made me" under the foot, now proves that this may not always be correct (see Appendix 1). If the lesson of the Malibu lekythos by the Taleides Painter, *signed* by Amasis as potter, is extended to *unsigned* vases that were potted by Amasis but with pictures painted by painters other than the Amasis Painter, we may learn more about the development of the potter Amasis and his influence in the Ceramicus.

The pair of dancing maenads on the reverse shares the outline technique for the flesh with five other vases by the Amasis Painter, the amphora of type A in Berlin (fig. 45; *ABV* 151, no. 21), the fragments in Samos (fig. 67; *ABV* 151, no. 18), the fragments in Kavala (fig. 70;

Paralipomena 65), the Basel amphora Kä 420 (fig. 40; *Paralipomena* 65), and New York 1985.57 (Cat. 18 bis). On the Berlin amphora, Dionysos is surrounded by two dancing trios, a naked maenad and a naked satyr, their arms around each other's necks and shoulders, followed by a maenad in a belted peplos; on the Samos amphora the embrace is somewhat more advanced in the first couple, since the satyr has put his other arm around the naked maenad's waist, while in the couple behind this group, a naked maenad is carried by a satyr who, with his lips pursed, is about to kiss her. On the Kavala fragments the position of the two maenads is not clear, nor can we tell whether both were dressed. The dancing pair on the Basel amphora is that of a maenad in a peplos and a naked satyr; this pair is somewhat more harmonious, since both raise their right feet in step. The same has been observed about the Paris neck-amphora shown here, where the two maenads dressed in belted peploi dance toward Dionysos. These maenads, however, do not clasp the wrist of their companion, as do the maenads in Berlin, Basel, and Samos, because all hands are busy holding animals and ivy vines. Also in step, but in a less lively dance, are the two satyrs behind the dancing Dionysos on the Würzburg amphora of type A (Cat. 19). Here, too, the right hand of the figure on the plane nearest the spectator does not clasp the wrist of his companion.

Middle period, possibly a little later than the amphorae in Berlin, New York, Würzburg, Basel, and Kavala discussed above.

Signed twice by Amasis as potter and hence attributed to the Amasis Painter (see J.D. Beazley, *ABS* [1928] 31).

From Vulci. Ex colls. Edmé-Antoine Durand and Honoré-

Théodoric-Paul-Joseph d'Albert, Duc de Luynes (acquired at the Durand sale of 1836 for 3,200 francs, being the fifth most expensive vase in that sale).

DIMENSIONS AND CONDITION
Height, 32.5 cm; diameter of body, 25.4 cm; diameter of mouth, 16.99 cm; width of lip (which is slanted), 1.48 cm; diameter of foot, 14.66 cm; width of resting surface, 0.74 cm. Height of figures on shoulder, 3.2 cm; height of figures on body, 15 cm. The vase is unbroken, but the surface is damaged on the obverse. The upper part of the head of Athena, most of the tip of her spear, and her inscribed name, as well as part of the faces of the two maenads, were formerly repainted, but they have now been cleaned.

SHAPE AND DECORATION
Echinus mouth, glazed on the outside; the unglazed top of the mouth slants

23 Profile drawing of mouth, neck, and shoulder.

23 Profile drawing of foot.

outward. The neck, set off from the mouth by a slight fillet, is glazed on the inside; it is decorated on each side with a palmette-lotus chain of eleven complete elements, to which the painter has added in the available space, on the left on each side, half of a double lotus and, only on side A, the tip of a lotus on the upper right. This floral ornament is framed above by three glaze lines and below by two. The handles are formed by three rolls of clay joined together, the middle one somewhat shorter than the others; the three joined strips flare out at the attachments to the neck and shoulders of the vase. Beneath each lower handle attachment is a narrow strip of hanging black triangles (seventeen on A/B, eighteen on B/A) framed by glaze lines. A slight fillet joins the neck to the body.

The figures on the body of the neck-amphora take up less space than do the elaborate ornaments under each handle. On each side of a small upright palmette that is connected with a hanging flower (a stylized rose), a single tendril forms four spiral volutes, arranged in two tiers; the ones above are larger than the ones below. In the spandrels between the spirals in the top tier are five-frond upright palmettes, and there are smaller, horizontal palmettes in the spandrels on the inside of the flanking spirals of both tiers. Another small palmette hangs between each pair of spirals in the bottom tier. Two more palmettes, even smaller, appear in the two spandrels between small volutes that emerge from where the flower is suspended from the upright palmette in the very center. These central palmettes have only three fronds; those in the spandrels of the spirals have seven or eight. Three short horizontal lines mark the root of each spandrel palmette; these are comparable to the more random three or two lines in the tendrils of the Oxford cup (Cat. 63) or the neck-amphora Boston 01.8027 (Cat. 25). Below the figure-zone is an ornamental band of upright buds with dots in the interstices, bordered above by three glaze lines, and below by a band of dicing framed above and below by three lines. Above the foot is a zone of sixty-eight rays in two tiers, framed on the bottom, just above the fillet, by three lines. Between the body and the foot is a fillet. The foot is in two degrees, not unlike the feet of amphorae of type A. Its diameter agrees exactly with the diameter of the vase at the level where the rays stop. The foot is completely glazed on the outside as well as on the underside, except for the resting surface.

ADDED COLORS

Red, cores of palmettes; cuffs, central sepals, and alternate petals of lotuses; fillet between body and foot. On the shoulder, all greaves, crest supports, and shield staples; caps of archer and horn blower; chiton of horn blower; dots on chiton of archer; in the combats, on side A, hand grips of first, third, fifth, and seventh warriors; alternate rays on star in device of second warrior; neck of goat in device of fourth hoplite; part of corslet of fifth hoplite, neck of stag in device of his opponent; wing bars and body behind wings of swan in device of eighth hoplite; neck and haunch of boar in device of ninth hoplite. On side B, hand grips of first, fifth, seventh, and ninth hoplites; mane of lion in device of second hoplite; central pteryx of third hoplite; core of palmette and wing bows in device of fourth hoplite; part of cuirass of fifth hoplite; central pteryx of sixth hoplite; key-shaped marking on panther head on device of eighth hoplite; part of cuirass of ninth hoplite. On the body, on side A, upper part of peplos of Athena, dense dots on front panel of peplos below her belt; ribbon in hair behind ears of Poseidon, row of dots in vertical pleats of his chiton, alternately sparse and dense; on side B, panel of himation hanging from left arm of Dionysos, dots in alternate pleats of his chiton; ivy leaves in wreaths of Dionysos and maenads; upper part of peplos of closer maenad, dense dots in its front and back pleats, ears, forehead, and nose of her leopard skin, dots on neck of little stag she carries; dots on upper part of peplos worn by farther maenad. *White,* flesh of Athena (almost all gone).

BIBLIOGRAPHY

S. Lambrino, *CVA,* Bibliothèque Nationale, fasc. 1 (1928) 28 – 29, pls. 36, 37 (with bibliography to 1927). Add to the *CVA* bibliography: J.D. Beazley, *ABS* (1928) 33, no. 18; A. Merlin, *Vases grecs du style géométrique au style à figures noires* (Paris 1928) pl. 36; M.H. Swindler, *Ancient Painting from the Earliest Times to the Period of Christian Art* (New Haven, Conn., 1929) 148, figs. 230, 231; H. Schaal, *Griechische Vasen,* pt. 1: *Schwarz-figurig* (Bielefeld 1930) 11, pl. 23, fig. 42; S. Karouzou, *AM* 56 (1931) 109 – 111, no. 25; R. Nierhaus, *JdI* 53 (1938) 108 – 109, fig. 9; E. Buschor, *Griechische Vasen* (Munich 1940) 117, fig. 133; F. Magi, *Annuario della R. Scuola Archeologica di Atene e delle missioni italiane in Oriente* 1 – 2 (1939 – 1940) 66 – 67, fig. 4; A. Lane, *Greek Pottery* (London 1948) pl. 42; W. Schmalenbach, *Griechische Vasen-bilder* (Basel 1948) pl. 52; B. Neutsch, *Marburger Jahrbuch für Kunstwissenschaft* 15 (1949 – 1950) 56, fig. 20, 69; J.D. Beazley, *Development* (1951) 57 – 60, 112, n. 41; F. Villard, *Les Vases grecs* (Paris 1956) 63, 65 – 67, pl. 17; S. Karouzou, *The Amasis Painter* (Oxford 1956) 19, 31, no. 22, pls. 31, 32; J.D. Beazley, *ABV* (1956) 152, no. 25; L.A. Stella, *Mitologia greca* (Turin 1956) 141; W. Kraiker, *Die Malerei der Griechen* (Stuttgart 1958) 45, pl. 19; S. Stucchi in *Enciclopedia dell'arte antica, classica e orientale* 1 (Rome 1958) 298 – 300, fig. 431; M. Robertson, *Greek Painting* (Geneva 1959) 63, 65, 67 – 68; R.M. Cook, *Greek Painted Pottery* (Chicago 1960) 82 – 83, pl. 23; P.E. Arias and M. Hirmer, *Greek Vase Painting,* translated and revised by B. Shefton (1962) pls. 56, XV, 57, pp. 297 – 300 (commentary); P.E. Arias, *Storia della ceramica...arcaica e classica* (1963) pls. 48, 49; G. Becatti, *L'età classica* (Florence 1965) 91, fig. 80, 94; J. Dörig in J. Boardman, J. Dörig, W. Fuchs, and M. Hirmer, *Die griechische Kunst* (Munich 1966) 102, pls. XIV, 99; E. Simon, *Die Götter der Griechen* (Munich 1969) 83, 285, figs. 79, 277; F. Villard in J. Charbonneaux, R. Martin, and F. Villard, *Archaic Greek Art* (London 1971) 88 – 89, fig. 97; M. Robertson, *Antike Kunst,* supp. 9 (1973) 83, pl. 29, fig. 5; J. Boardman, *ABFV* (1974) 55, 75, fig. 85; H. Mommsen, *Der Affecter* (Mainz 1975) 23, n. 115, 124, n. 125, 28 – 30, n. 146, 38; E. Simon and M. Hirmer, *Die griechischen Vasen* (Munich 1976) pls. 72, XXIII.

24 NECK-AMPHORA

BOSTON, THE MUSEUM OF FINE ARTS, 01.8026,
H.L. PIERCE FUND, 1901.

24 Side A, detail.

The picture on the obverse is very fragmentary: a male divinity, of whom only the head, left shoulder, and both feet are preserved, faces an armed goddess. Between the two figures appears the signature of the potter Amasis: [AM]ASIS [M]EПOIESEN

The goddess is surely Athena clad in a peplos; in her right hand she holds a spear, and with her left arm she carries a big round shield that bears an elaborate gorgoneion as a device. The gorgoneion is equipped with three pairs of snakes: one on top of the head, the second behind the ears, and the third below the chin. On her forehead the Gorgon has three tilka-like dots. The god facing Athena, probably Poseidon, on the analogy of the neck-amphora in the Cabinet des Médailles (Cat. 23), has a fillet in his hair and wears a long chiton and a mantle; the staff held in his right hand crosses his left shoulder diagonally and should be the staff of a trident. The spacing of the inscription in two lines suggests that his left arm was bent at the elbow, with the left hand raised in a gesture of greeting.

The picture on the reverse shows two warriors setting out. The one on the left wears a Corinthian helmet with a high crest, greaves, a short chiton, and a belted leather

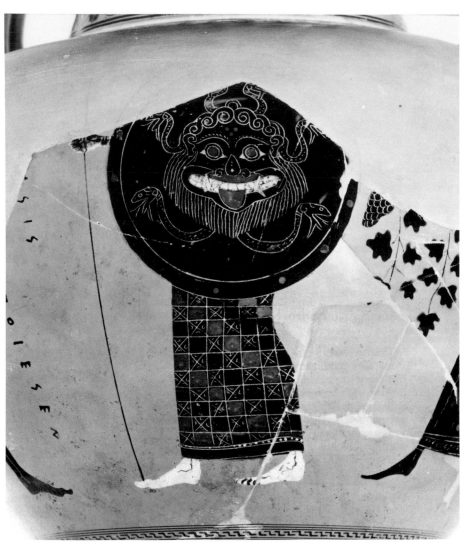

24 Side A, detail.

corslet; in his left hand he carries a sheathed sword, not yet slung over his right shoulder; in his right hand he holds a spear. The right shoulder-flap of his corslet is decorated with the head of a panther. He looks back at his companion, who wears a Corinthian helmet with two half-crests, greaves, a scale cuirass, and a short chiton. His sword is suspended from a baldric (which the artist has omitted to show on his right shoulder), and he carries a spear and Boeotian shield with a device of two butting rams. Between the two warriors, placed

carefully without interruption, is the one-line signature of the potter Amasis: AMASIS MEПOIESEN
Under each handle, in a smaller scale, Dionysos is walking to the left while looking behind him to the right. The god is wearing a chiton and mantle and is holding branches. Under handle A/B (where the figure is better preserved), these branches are grapevines and ivy vines; on the other side, under handle B/A, only the grapevines in the right hand are preserved. The god wears an ivy wreath in his hair.

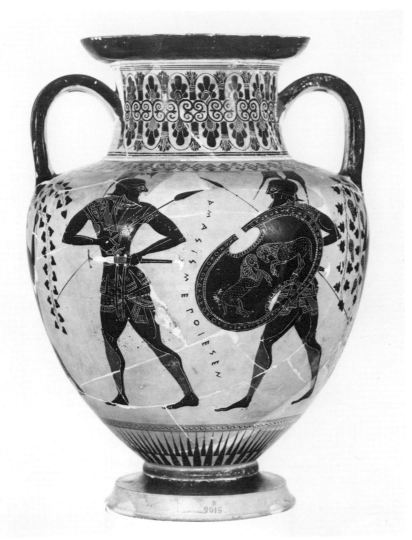

24 Side B.

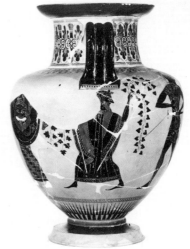

24 Side A/B.

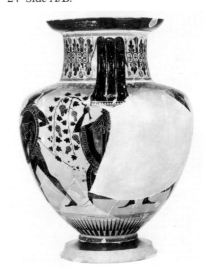

24 Side B/A.

The picture of Poseidon and Athena is in the tradition of the confrontation of the deities on the neck-amphora in the Cabinet des Médailles (Cat. 23) and, earlier, on the Amasis Painter's chous in Florence (fig. 79; *ABV* 153, no. 42), and the olpe in Oxford (Cat. 29). Normally Poseidon is on the left and Athena is on the right, but on the neck-amphora in the Cabinet des Médailles, their positions are reversed. The extra figures on the chous (Hermes and a man) and on the oinochoe (Herakles [?] and a youth) somewhat diminish the majestic aspect of the confronta-

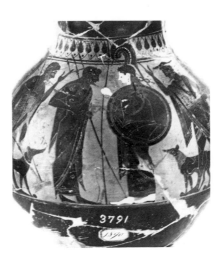

Fig. 79. Chous. Attributed to the Amasis Painter. Detail of Athena and Poseidon. Florence, Museo Archeologico, 3791.

tion. The two warriors on the other side of this vase may well be heroic but should not be taken as Hector pursued by Achilles, as Mrs. Karouzou proposed (*The Amasis Painter* 21). Schefold and Kossatz-Deissmann follow her, but I do not recall any pursuit—military or amorous —that is quite so sedate (if not phlegmatic), and Beazley's caption "warriors setting out" (*ABS* 34, no. 34; *ABV* 152, no. 26) need not be abandoned. As for the two Dionysoi under the handles, the conceit of putting figures, sometimes on a smaller scale, under the handles, is not unique: it goes with such mid-sixth-century neck-amphorae as Oxford 1965.135, by a painter of Group E (fig. 80; *ABV* 137, no. 59); Leningrad inv. 2365, which Gorbunova has attributed to the Painter of London B 174 (K.S. Gorbunova, *Hermitage* [1983] 29, no. 13), and Naples 2498, by a painter of the Group of London B 174 (*ABV* 141, no. 5), and becomes almost the rule on neck-amphorae by the Affecter (see Mommsen, pls. 26, 31, 32, 35, 42, 43, 45, 47, 48, 53, 54, 56, 57, 59, 61 – 63, 65, 67, 68, 78, 80, 82, 84, 85, 92, 94, 96, 100 – 102, 106, 107, 109, 111, 114 – 116, 118,

120 – 122, 124, 125). In general shape and scheme of decoration, the Boston neck-amphora shown here and its companion (Cat. 25) are descendants of the Botkin Class (*ABV* 169 – 170); these two vases continue the reduction of the figure heights by the ornamental band on the shoulder and share with the Botkin Class the sawlike ornamental strip below the handles. In the Botkin Class, figures below the handles occur on Brussels A 714 (fig. 81; *ABV* 169, no. 1), Berlin 1713 (*ABV* 169, no. 5), and Berlin 1714 (fig. 82; *ABV* 169, no. 6): it is perhaps no coincidence that the foot of Leningrad inv. 4469 (*ABV* 169, no. 4), which, pace Beazley, is not alien, is of the same shape as the foot of the neck-amphora here. We do not know the potter of the Botkin Class, but I do not exclude the possibility that he was Amasis or an associate of Amasis (see discussion at Cat. 23).

The two neck-amphorae in Boston are among the latest vases painted by the Amasis Painter. (On the question of the date, see Cat. 25.)

Signed twice by Amasis as potter and hence attributed to the Amasis

Painter: "the signed pieces are evidently all by one hand" (J.D. Beazley, *ABS* [1928] 31).

Found in Orvieto in 1877. Ex coll. Alfred Bourguignon.

DIMENSIONS AND CONDITION
Height, 25.8 cm; diameter of body, 20.3 cm; diameter of mouth, 12.5 cm; width of lip, 1.16 cm; diameter of foot, 10.9 cm; width of resting surface, 1.2 cm. Height of figures, 14.2 cm; radius of Athena's compass-drawn shield, 3.24 cm. The vase is broken and has been repaired; the many missing portions are restored in plaster and terracotta. The restorations have been colored, for the most part, in neutral tones, but there is some repainting, notably on the bottom of Athena's shield, part of her peplos, the right foot of the right-hand warrior on side B, the right foot of Dionysos behind him, part of the step-pattern above the rays, and parts of the rays. Among the misleading restorations are the left shoulder of the left-hand warrior and part of the right crest of the right-hand warrior (both on side B). Half of the mouth is restored (in the area over handle A/B).

SHAPE AND DECORATION
Echinus mouth, unglazed on top; the neck is set off from the mouth and the shoulder by fillets; triple handles, unglazed on the underside. Flaring

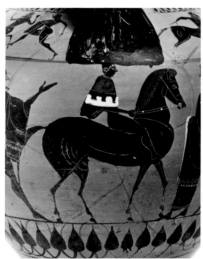

Fig. 80. Neck-amphora. Attributed to a painter of Group E. Detail of horseman below handle. Oxford, Ashmolean Museum of Art and Archaeology, 1965.135.

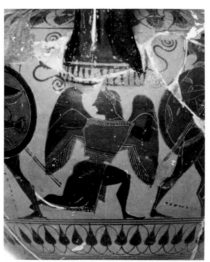

Fig. 81. Neck-amphora. Assigned to the Botkin Class. Detail of figure below handle. Brussels, Musées Royaux d'Art et d'Histoire, A 714.

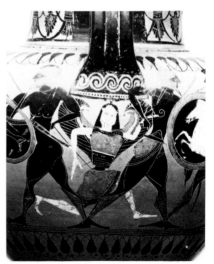

Fig. 82. Neck-amphora. Assigned to the Botkin Class. Detail of figure below handle. Berlin, Staatliche Museen, F 1714.

24 Profile drawings of mouth and foot.

foot connected with body by a fillet; the sloping surface of the underside is glazed; the concave edge of the foot is reserved. The ornament on the neck is a palmette-lotus chain consisting, on each side, of seven addorsed palmettes alternating with six and one-half addorsed lotuses, bounded above, by three glaze lines, and below by two. Instead of the traditional tongues, the shoulder ornament is a chain of twenty-five addorsed palmettes on each side, flanked on the obverse by preening swans in silhouette (the swans face the center) and bordered by two glaze lines above and below. The root of the handles is ornamented by a strip of hanging black triangles (sixteen under handle A/B, only fourteen preserved under handle B/A). Below the triangles are two glaze lines. The figure decoration extends very far down the wall of the vase. There is no groundline. Between the fillet and the figure-zone are two tiers of eighty stacked rays, bordered above by a step-pattern moving left that is framed by three glaze lines above and below. Between the rays and the fillet are two glaze lines.

ADDED COLORS
Red, line on inner edge of mouth, another line 1.2 cm below on inside of neck; fillet above foot; cores of palmettes on neck; cuffs, cores, and central sepals of lotuses; dots in cores of palmettes on shoulder; fillet of Poseidon; dots on rim of Athena's shield; tilka-like dot on forehead, pupils, mustache, and tongue of gorgoneion; squares in four diagonal rows on Athena's peplos; alternate ivy leaves in wreaths of Dionysoi, folds on their mantles, dots and cores of dot-rosettes on chitons of Dionysoi; all greaves of warriors, parts of their corslets; dots on chiton of first warrior; alternate folds of chiton of second warrior; crest support of first warrior, top of his scabbard; alternate tongues in borders of cutouts of Boeotian shield. *White,* dots on lower cuffs of lotuses; flesh of Athena, dots along lower border of her peplos; teeth and tusks of gorgoneion. Dots along bottom edges of chitons of warriors; dots on crest support of left warrior; chapes of scabbards; hilt of sword; four circular attachments for baldric on scabbard; dots on rim of Boeotian shield; dots around cores of dot-rosettes on chitons of Dionysoi.

The (unpainted) groundline of the figures was lightly sketched, to serve as a guideline.

BIBLIOGRAPHY
H. Hoffmann, *CVA,* Boston, fasc. 1 (1973) 19−21, pl. 26, pl. 28,1−2, profile drawing no. 25 (with bibliography to 1970). Add to the *CVA* bibliography: F. von Duhn, *Bullettino dell'Instituto di Corrispondenza Archeologica* 1878, 206−220; W. Klein, *Meistersignaturen*[2] (1887) 44, no. 3; L. Adamek, *Unsignierte Vasen des Amasis* (Prague 1895) 12, no. 2; G. Karo, *JHS* 19 (1899) 140; G. Nicole, *RA,* ser. 5, vol. 4 (1916) pt. 2, 377, no. 3; E. Langlotz, *Zeitbestimmung* (1920) 15; G.S. Korres, *Ta meta kephalon krion krane* (Athens 1970) 235, pl. 85a; J.D. Beazley, *Paralipomena* (1971) 63, no. 26; K.P. Stähler, *JOAI* 49 (1968−1971) 112; P.C. Cechetti, *Studi Miscellanei* 19 (1972) 26, no. 122, 27, no. 130, pls. 43, 45; J. Boardman, *ABFV* (1974) 52, 55, fig. 86; H. Hoffmann in *Ancient Art: The Norbert Schimmel Collection,* ed. O. Muscarella (Mainz 1974) under no. 56; D. Callipolitis-Feytmans, *Les plats attiques à figures noires* (Paris 1974) 48, n. 52, 104, n. 45; H. Mommsen, *Der Affecter* (Mainz 1975) 16, 30, 33, n. 179, 47, n. 239; J. Hurwit, *AJA* 81 (1977) 16, n. 75; K. Schefold, *Spätarch. Kunst* (1978) 231−232, fig. 310; A. Kossatz-Deissmann in *LIMC* 1 (1981) 133−134, no. 559, 137, 199, pl. 114, Achilleus 559; B. Legakis, *Antike Kunst* 26 (1983) 73, n. 6, 74, n. 7; H. Hoffmann in *Antidoron...Jürgen Thimme* (Karlsruhe 1984) 65.

25 NECK-AMPHORA

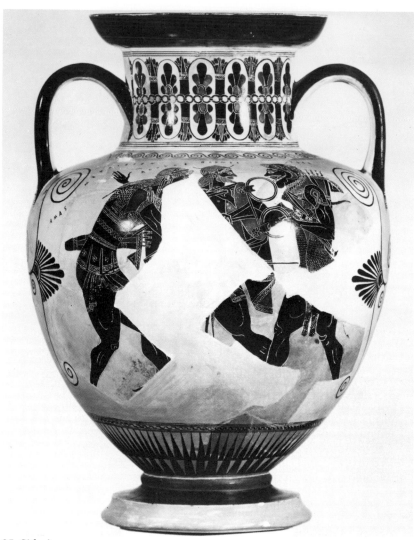

25 Side A.

The picture on the obverse shows
Apollo (ΑΓΟΛΟΝ) trying to take
back the Delphic tripod that
Herakles ([ΗΕΡ]ΑΚΛΕS) clutches
by one of the three legs and one of
the two upright rings; behind the
struggling pair, Hermes (ΒΕΡΜΕS)
rushes to the left while looking
round. Apollo is clad in a short
chiton, over which he wears an
elaborate leather corslet with scales
on the upper parts and pteryges
below the waist. Under the right
armpit is an incised palmette. The
god also carries a quiver with four
arrows by his left side. Herakles is
dressed in a short chiton and his
lion skin; a double baldric on his
right shoulder supports a sheathed
sword and a quiver with four
arrows and a bow. Hermes wears
a petasos tied below his chin by a
strap, a chlamys over his shoulders
and upper arms, a chiton, and a
nebris. Enough is preserved of his
right foot to tell that he wore boots.
Both Apollo and Hermes wear fil-
lets in their hair. The right hand of
Hermes is raised in a gesture of
greeting; his left hand (now miss-
ing) held the caduceus, of which
only the staff is preserved in part.

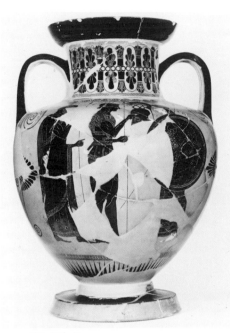

25 Side B.

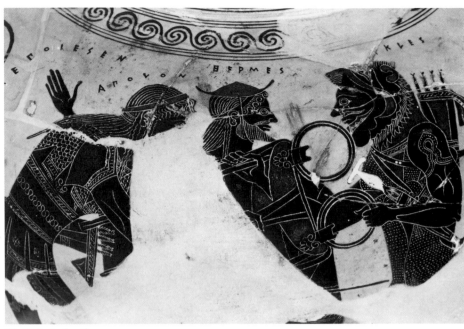

25 Side A, detail.

This side of the vase is signed by Amasis as potter in an undulating line in the upper left portion of the scene (AMAS[IS] MEΓOIESEN).

The reverse also represents a mythological subject, the arming of Achilles. Achilles (A+IVEVS) stands in the center of the scene, dressed in a short chiton, greaves, and a leather corslet with pteryges, similar to the corslet of Apollo on the other side; in his left hand he holds an upright spear. A sheathed sword is on his left side (the baldric, however, is not shown), and with his right hand he takes by the nosepiece a Corinthian helmet that his mother, Thetis, offers him. The helmet has an elaborate crest support in the shape of a snake. Thetis (ΘE[T]IS) faces Achilles, much of her body— from the neck to the knees— covered by the very big round shield that bears as device a lion attacking a stag, whose incised antlers are visible in the lion's mane. In her left hand Thetis carries a second spear, and with her right hand she holds the Corinthian

helmet by the nape guard. Thetis wears a long, richly ornamented peplos, an incised necklace, an earring, and a spiked diadem. Her hair is tied with a fillet beind the ears. Phoenix (ΦOINI+S), dressed in a long chiton and a mantle, stands behind Achilles. In his left hand he holds a spear, and his right forearm is raised in greeting (the hand is missing). There are wrinkles on his bald forehead, and both he and Achilles wear fillets on their heads.

The subject of the obverse is well known from the pediment of the Siphnian Treasury at Delphi and from more than a hundred and eighty vase-paintings, almost all of which follow the composition of the pediment, in that the tripod is off the ground. The intervention of Hermes, in lieu of Zeus, is not unique, for it also occurs on a black-figured hydria in Dijon (J. de Witte, *Description des vases peints et des bronzes antiques formant la collection de M. de M[agnoncourt]* [Paris 1839] 34 – 35, no. 44; D. von Bothmer, p. 57, no. 117).

The arming scene on the reverse is that of Achilles, since the Amasis Painter has gone to the trouble of naming his figures, but there are *two* armings of the hero, one when he left Phthia and another when he needed a replacement for his armor, which he had lent to Patroklos, from whom it was taken by Hector. On the second arming occasion, Thetis secured a new panoply from Hephaistos in record time, and when Achilles was slain by Paris, his body was recovered with his armor. At the funeral games of Achilles, the armor was awarded to Odysseus, and it was Odysseus who handed it over to Neoptolemos, the son of Achilles, who had been fetched from Skyros for the final assault on Troy.

Hauser implied in his first publication of the Boston vase (pp. 4, 7) that the arming shown here was the second arming, and he observed that the shield device of a lion felling a stag recurs with only slight modifications on the shield that Odysseus holds for Neoptolemos

135

on the Douris cup in Vienna (*ARV*[2] 429 – 430, no. 26; D. Williams, *Antike Kunst* 23 [1980] 138ff., pl. 33,8; pl. 34,1 – 2). Another, perhaps even stronger, argument for placing the scene of the Boston arming in the Greek camp at Troy is the presence of Phoenix, who accompanied Achilles to Troy and led Ajax and Odysseus in the embassy to the tent of Achilles (*Iliad* 9, lines 168ff.). While the old tutor of Achilles did not succeed at that time in persuading Achilles to take up his arms again against the Trojans, his presence at the second arming of Achilles, following the death of Patroklos, served to recall at once to the Amasis Painter's contemporaries who saw the vase the major role played by Phoenix, both at the embassy and at the funeral games for Patroklos. Johansen therefore came out strongly for the second arming at Troy (K.F. Johansen, *Iliaden i tidlig graesk Kunst* [Copenhagen 1934] 71), in which he has been followed by me (*Bulletin of the Museum of Fine Arts, Boston* 47 [1949] 89: misunderstood by Hoffmann in the Boston *CVA*, fasc. 1, p. 22). Beazley (*Development* [1951] 58) emphatically labelled the Boston scene the first arming, and Johansen, in the English translation of a revised version of his book cited above (*The Iliad in Early Greek Art* [Copenhagen 1967] 123), more cautiously than in 1934, admits, "it is doubtful where the scene should be localised." But in this author's opinion, the second arming is perhaps the more probable one in the context of the iconography of the period.

Both Boston neck-amphorae, while not, strictly speaking, a pair, are late works by the Amasis Painter, and their date should be, as Beazley put it, "not earlier than the twenties or teens of the sixth century, contemporary with the

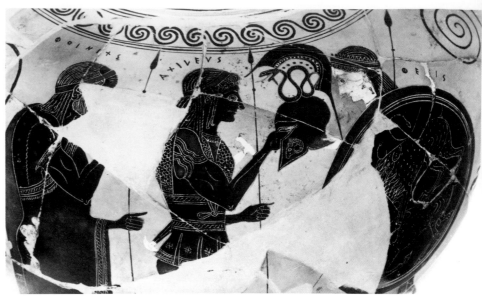

25 Side B, detail.

Leagros Group and the red-figured work by Euphronios and his fellows" (*Development* [1951] 58; see also here, p. 53 and fig. 54). Though both neck-amphorae in Boston share some ornamentation with the neck-amphora in the Cabinet des Médailles (Cat. 23), the one in Paris must be earlier, judging by the folds of the drapery and the somewhat stiffer poses struck by its figures. Closer in date to the Boston vases are the oinochoe in the Vatican (Cat. 38) and the cups in Oxford and the Vatican (Cats. 63, 62).

Signed by Amasis as potter on the obverse and hence attributed to the Amasis Painter (see J.D. Beazley, *ABS* [1928] 31).

Found in Orvieto shortly before 1896 (the joining Philadelphia fragments were found in the summer of 1896). Ex coll. Alfred Bourguignon.

DIMENSIONS AND CONDITION
Height as restored, 30.4 cm; diameter of body, 21.7 cm; diameter of mouth, 14.0 cm; width of lip, 1.41 cm. Height of figures, 16.6 cm; radius of Thetis' compass-drawn shield, 3.85 cm. The vase

is broken and has been repaired, with many missing fragments restored and repainted. The modern foot has been modeled on that of Boston 01.8026 (Cat. 24). In the fall of 1935, Humfry Payne discovered more fragments of this vase among the Orvieto fragments of the University Museum in Philadelphia, and they have since been given to the Boston Museum of Fine Arts and have been incorporated. One more joining fragment of the rosebud under handle A/B was spotted in Philadelphia (MS 4861) by Heide Mommsen and is now in Boston (1972.228). For an appreciation of what Payne's discovery added to the figures, compare Hauser's drawings (not Bourguignon's, as is wrongly stated in *CVA*) in *JOAI* 10 (1907) pls. 1 – 4, often reproduced, with the plates in *CVA*.

SHAPE AND DECORATION
Echinus mouth, unglazed on top; the neck is set off from the mouth and the shoulder by fillets; triple handles, unglazed on the underside. The ornament on the neck is a conventional palmette-lotus chain of six addorsed palmettes alternating with six addorsed lotuses, to which, on the obverse, the painter has added a half double lotus on the left, while on the reverse, he has put such a half-lotus on each side. The

25 Side B/A.

palmette-lotus chain is bounded above and below by three glaze lines. On top of the shoulder, directly below the slight fillet, is a spiral pattern running to the left all the way around the vase; it is bordered above and below by three glaze lines. Below the flaring root of each handle is a strip of eleven hanging black triangles framed above by one glaze line in a reserved band, and below by three glaze lines. Below each handle is a configuration of three palmettes (two horizontal, one upright), an elaborate hanging bud (a rose rather than a lotus), and eight volutes. Below the figure-zone, which lacks a groundline, are eighty-five stacked palmettes bordered above by a step-pattern running left, which is framed above by three glaze lines. The foot and the fillet below the rays are modern.

ADDED COLORS
Red, line on inner edge of mouth; two lines on inside of neck, one at a depth of 2.47 cm, the other at a depth of 4.69 cm; central sepals of lotuses; cores and alternate fronds of palmettes on neck; cores of handle palmettes. On the body, on side A, Apollo's fillet, alternate folds and shoulder of his chiton, central stripe on his quiver, bowl of the tripod; Hermes' petasos, some folds of his chiton and chlamys, cores of dot-rosettes on his

chlamys, his right boot; chiton of Herakles, dots on his shoulder, central panel of his quiver, ear, neck, and part of muzzle of his lion skin. On side B, fillets of Phoenix and Achilles; some folds on himation of Phoenix, dots and cores of dot-rosettes on his chiton; chiton of Achilles, his greaves; diadem, pupil, and earring of Thetis, border of her peplos and some of the incised squares on it; rim of shield, neck of stag in its device, stag's scrotum, stripes on haunches of stag and lion, last row of locks of lion's mane. *White,* rows of dots on cuffs of lotuses; dots around cores of all dot-rosettes; dots along lower edges of horizontal borders of corslets of Apollo and Achilles and along ornamented edges of all chitons; dots on quiver of Herakles, his baldric, teeth of his lion skin; hilts and chapes of sheathed swords of Herakles and Achilles; dots on crest support of helmet, divisions of crest; flesh of Thetis, row of dots on edge of her peplos.

BIBLIOGRAPHY
H. Hoffmann, *CVA,* Boston, fasc. 1 (1973) 21 – 22, pl. 27, pl. 28,3 (with bibliography to 1970). Add to the *CVA* bibliography: G. Karo, *JHS* 19 (1899) 134, n. 1, 141; G. Nicole, *RA,* ser. 5, vol. 4 (1916) pt. 2, 377, no. 3; E. Langlotz, *Zeitbestimmung* (1920) 15; A. Gotsmich in *Epitymbion: Heinrich Swoboda darge-*

bracht (Reichenberg 1927) 67; W. Kraiker, *JdI* 44 (1929) 150; M.-Th. Picard, *Collection Latomus* 28 (1957) 369, pl. 51,1; G.S. Korres, *Ta meta kephalon krion krane* (Athens 1970) 71, 79, pl. 11, 235; J.D. Beazley, *Paralipomena* (1971) 63, no. 27; K.P. Stähler, *JOAI* 49 (1968 – 1971) 112; F. Hölscher, *Die Bedeutung archaïscher Tierkampfbilder* (Würzburg 1972) 138, n. 614; J. Boardman, *ABFV* (1974) 52, 55, 203, fig. 86; H. Mommsen, *Der Affecter* (Mainz 1975) 23, n. 115, 30, 33, n. 179, pl. 136; D. von Bothmer in *Festschrift für Frank Brommer* (Mainz 1977) 57; K. Schefold, *Spätarch. Kunst* (1978) 142 – 143, fig. 189, 198, fig. 270; A. Kossatz-Deissmann in *LIMC* 1 (1981) 123 – 124, no. 508, 127, 199, pl. 109, Achilleus 508; E. Böhr, *Der Schaukelmaler* (Mainz 1982) 39 (with n. 376 on p. 69); B. Legakis, *Antike Kunst* 26 (1983) 73 – 74, nn. 6, 7.

26 OLPE (WITH TREFOIL MOUTH)

LONDON, THE BRITISH MUSEUM, B 52 (1867. 5-6.38), ACQUIRED IN 1867.

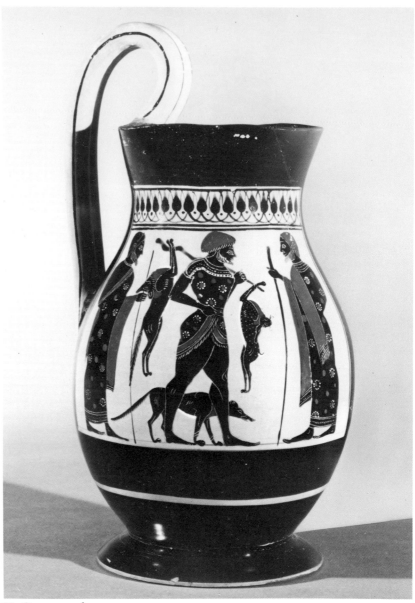

26 Center panel.

The subject of the olpe is the return of a bearded hunter and his dog. He wears a fringed leather cap and a short belted chiton, also fringed. His prey—a fox and a hare—is tied to a lagobolon, or yokelike stick, carried on his left shoulder. The dog by his side is sniffing. The hunter walks up to a bearded man with short red hair who holds a staff in his right hand. His left arm is akimbo under his long himation. Behind the hunter, another man, again with short hair, stands facing right. His staff is held in the left hand, while his bent right arm and hand are held close to the body under his chiton; his himation is worn over his left shoulder.

Hare and fox carried on a lagobo-lon, hunter with hound (held short

on a leash), epitomize the return of a successful hunter, as on a contemporary cup in London signed by Tleson as potter (fig. 83; *ABV* 181, no. 1, London B 421). The Amasis Painter shows these two animals carried on sticks by two hunters in Dionysiac contexts on amphorae in Munich (Cat. 4) and Geneva (Cat. 15), where a flanking youth carries a hare over his left shoulder on a hunting stick, and a single hare is held in the right hand of the hunter in Eastern costume on the Amasis Painter's chous in Bristol (fig. 84; *ABV* 153, no. 44). His hare is certainly dead, but when a naked boy on an amphora in the Louvre (F 26, Cat. 11) holds just such a hare by the forelegs, the question arises whether that hare is not living—"a gift from an admirer," as Beazley put it (*JHS 51* [1931] 261). The leather cap with fringes worn by the hunter on the London olpe shown here recurs on other vases by the Amasis Painter: the Louvre amphora just mentioned and one of the Ludwig amphorae in Basel (Cat. 6).

This olpe stands somewhat apart from the others painted by the Amasis Painter and may well be the earliest. Middle period, early to middle.

Fig. 83. Lip-cup. Signed by Tleson as potter and attributed to the Tleson Painter. Interior: return of the hunter. London, the British Museum, B 421.

Attributed to the Amasis Painter by C. Fossey.

From Rhodes.

DIMENSIONS AND CONDITION
Height to top of handle, 25.415 cm; height to rim, 20.675 cm; diameter of body, 13.4 cm; diameter of foot, 10.6 cm; width of resting surface, 0.88 cm; width of handle, 2.475 cm. Height of figures, 9.8 cm. The vase is unbroken.

GRAFFITO
Several scratches on top of the handle could be remnants of a graffito.

SHAPE AND DECORATION
Echinus foot, glazed on the outside except for the very edge. After the vase was turned on the wheel and before the handle was attached, the potter pinched the mouth in three places to produce the trefoil shape. The lip is glazed on top,

26 Profile drawing of foot.

and the insides of the mouth and neck are glazed to a depth of 4 cm. The handle is made of two coils of clay and arches high above the mouth. It is left unglazed but is decorated with four longitudinal glaze lines. The figure scene is set in a panel on one side of the vase, beginning to the right of the handle and ending opposite the handle. The panel is framed on the sides and on top by a single glaze line and is surmounted by an ornamental strip of seventeen upright black buds with dots in the interstices. The groundline is drawn in dilute glaze. Between the bottom of the panel and the foot, between the levels of 3.85 cm and 4.21 cm measured from the ground, a reserved band encircles the body. On the side to the left of the handle are two reserved spandrels, which, when taken with the black disk between them, suggest an apotropaic eye.

ADDED COLORS
Red, edge of rim; fillet in hair of left man; upper edge, two vertical folds, and dots and cores of dot-rosettes on himation of left man; necks of fox and hare; cap of hunter, lower edge of his chiton, dots and cores of dot-rosettes on it; neck of dog, stripe on its haunch; hair of man on right, dots and cores of dot-rosettes on his himation, two vertical folds. *White,* dots around cores of all dot-rosettes; belly and neck stripes of fox and hare; belly stripe of dog; row of dots on upper edge of hunter's chiton.

BIBLIOGRAPHY
C. Fossey, *RA,* ser. 3, vol. 18 (1891) 366 — 370, fig. 2; H.B. Walters, *Catalogue* 2 (1893) 65, no. B 52; L. Adamek, *Unsignierte Vasen des Amasis* (Prague 1895) 22 — 23; G. Karo, *JHS* 19 (1899) 43, no. 19, 138 — 139, no. 14; J.D. Beazley, *ABS* (1928) 34, no. 24; P. Cloché, *Les classes, les métiers, le trafic* (Paris 1931) pl. 15,1; S. Karouzou, *AM* 56 (1931) 104 — 106, Beilage 52; J.D. Beazley, *JHS* 51 (1931) 261; E. Langlotz in H. Schrader, *Die archaischen Marmorbildwerke der Akropolis* 1 (Frankfurt am Main 1939) 38, n. 35; A. Rumpf, *Malerei und Zeichnung der klassischen Antike* (Munich 1953) 50 — 51, pl. 12,10; S. Karouzou, *The Amasis Painter* (Oxford 1956) 10, pl. 32, no. 30, pl. 15,2; J.D. Beazley, *ABV* (1956) 153, no. 31; D. von Bothmer, *Antike Kunst* 3 (1960) 75, 80; F.L. Bastet, *BABesch* 41 (1966) 84 — 85, fig. 5; A. Schnapp in *La cité des images* (Lausanne 1984) 71, 73, fig. 105.

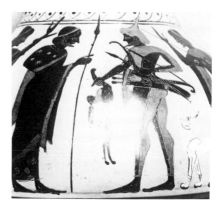

Fig. 84. Chous. Attributed to the Amasis Painter. Detail showing the return of the hunter. Bristol, City Museum, H 803.

The scene on the olpe shows the introduction of Herakles into Olympus, but with a surprising variation. The god on the left, who faces the procession of Hermes, Athena, and Herakles, is not Zeus but Poseidon. He wears a chiton and, over his left shoulder, a fringed mantle. His right arm is tucked into his garment, and with his left hand he holds an upright trident. A broad fillet is placed on his head. Hermes wears boots, a short chiton, a chlamys over both shoulders and upper arms, and a petasos. In his left hand he holds the caduceus horizontally, and with his right hand he signals Athena and Herakles, toward whom he turns his head.

Between Hermes and Athena the potter Amasis has signed this work in two lines intended to be read from the bottom line to the top line,

ΜΕΓΟΙΕS[Ε]Ν

ΑΜΑSIS

the two lines of the signature are separated by the spear held by Athena. The goddess wears a high-crested Attic helmet and a peplos; much of her body, from her chin to mid-thigh, is covered by a compass-drawn round shield that bears her personal device of the owl. Herakles responds to the gesture of Hermes by raising his right hand. For the festive occasion of his arrival on Mount Olympus, he has shed the lion skin. Instead, he wears a short chiton and carries a sheathed sword and a quiver with four arrows, both suspended from a holsterlike double baldric that passes over his right shoulder and under his left armpit. In his left hand he holds his bow.

The reception of Herakles by Poseidon rather than Zeus recurs, as Beazley has seen, on a neck-amphora by the Antimenes Painter in the Museo Nazionale in Tarquinia (RC 1871, *ABV* 270, no. 64;

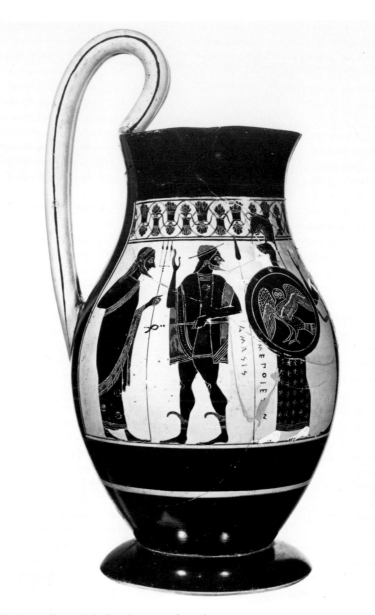

27 Right profile, with left and center of panel.

G. Jacobi, *CVA,* Tarquinia, fasc. 1 [1955] III H, pl. 7) on which Herakles walks toward Poseidon and looks back at Hermes. Pottier (in *RA,* p. 37) made much of the blend of Ionian and Doric cults started by Peisistratos in Athens and saw in the Louvre olpe an echo of the introduction of the new cult of Herakles in Athens: "présenté au plus ancien possesseur de l'Acropole par sa protectrice Athéné et par l'introducteur ordinaire des ambassades divines, Hermès." But there are other introductions of Herakles into Olympus in which Poseidon is just one of the gods present, such as seen on the panel-amphora of type B by the Painter of Berlin 1686, Basel 103.4 (published by K. Schefold, *Spätarch. Kunst* [1978] 39, fig. 37), or London B 166 by the same painter (here fig. 85; H.B. Walters,

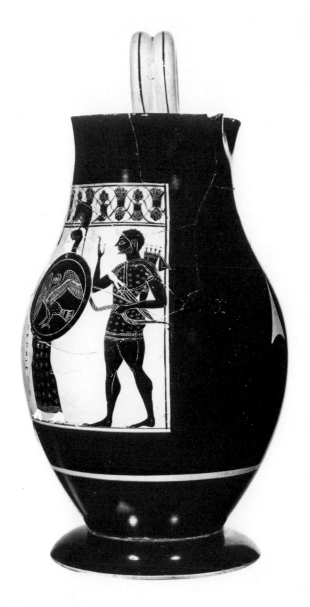

holds a spear (on no. 10), and once he appears in a short chiton and a wrap (on no. 9). A fifth figure on three of the four amphorae (nos. 9, 10, and 14) is twice Dionysos (nos. 10 and 14) and once a youth, who hardly qualifies as a god (no. 9). On the fragmentary vase (no. 12), as on the Louvre olpe (no. 29), there are only four figures, the same number that appears on the lost Canino olpe by the Amasis Painter (*ABV* 153, no. 33). There, Herakles and Zeus, whose hand Herakles shakes, are in the center, flanked by a light-armed youth on the left and a bearded hoplite (Ares?) on the right.

The lion walking beside Herakles on the Amasis Painter's Orvieto amphora Faina 40 (fig. 60; *ABV* 151, no. 14) may be Hera's, but what are we to make of the dogs next to Hermes on the Orvieto vase or on Berlin 1688 (Cat. 9—with a second dog next to a flanking youth on the right) and Berlin 1691 (fig. 63; *ABV* 151, no. 12)? Surely the painter liked dogs and put them into as many scenes as he could, even into such solemn events as Herakles' entry into Olympus.

The date, like that of most of the vases signed by Amasis as potter, should be in the painter's middle period.

Signed by Amasis as potter and hence attributed to the Amasis Painter (see J.D. Beazley, *ABS* [1928] 31).

27 Front, with right side of panel.

CVA, British Museum, fasc. 3 [1927] III He, pl. 30,3) that shows on one side Herakles turning away in alarm to Poscidon. Similarly, on the amphora by the Mastos Painter in Amiens (fig. 86; *ABV* 691, no. 5 bis, under pp. 257 – 262), a frightened Herakles turns to Dionysos. In this connection it is worth noting that on the first five of the Amasis Painter's six introductions of Herakles into Olympus (*ABV* 150 – 153, nos. 9 [Cat. 9], 10, 12 [here fig. 63], 14 [here fig. 60], 29 [Cat. 27], 33), the procession moves from right to left, and its inviolate center is formed by the trio Hermes, Athena, and Herakles. The host on the left thus becomes a less prominent person, who only twice (nos. 12 and 14) receives the friendly gesture of Hermes' touching his beard and chin; once he

DIMENSIONS AND CONDITION
Height to top of handle, 26.4 cm; height to rim, 21.5 cm; diameter of body, 13.05 cm; diameter of foot, 10.32 cm; width of resting surface, 1.37 cm. Height of figures (from groundline to lower border of festoon), 9.48 cm; radius of Athena's compass-drawn shield, 2.25 cm. The vase is broken and has been repaired. There are only minor losses along the break, through the top line of the signature and the adjacent peplos of Athena.

27 Left profile.

SHAPE AND DECORATION
Echinus foot. The flaring mouth (with an original diameter of 9.07 cm) is glazed to an inside depth of 3.33 cm. After the vase was turned on the wheel and before the handle was attached, the potter pinched the mouth in three places to produce the trefoil shape. The handle, made of two rolled strips of clay, arches high above the mouth. It is left unglazed but is decorated with four longitudinal glaze lines. The picture is set in a panel framed on the sides by a single glaze line and surmounted above by a palmette-lotus festoon of thirteen complete elements, to which half a unit has been added in the available remaining space on the left. The border is framed above by one glaze line and below by two. The groundline is drawn

in somewhat thinner glaze. Below the panel and above the foot, a reserved band encircles the entire vase at a level where the diameter of the vase is very nearly that of the foot, suggesting that the painter, in sketching out this decorative detail, held an instrument at right angles to the edge of the foot and spun the vase around its axis. The panel is not centered in relation to the handle but confined to the area to the right of the handle, common practice on most of the earlier trefoil olpai. On the side to the left of the handle are two reserved spandrels, which, when taken with the black disk between them, suggest an apotropaic eye.

27 Profile drawing of foot.

ADDED COLORS
Red, edge of mouth; central sepals of lotuses; cores of palmettes; ring connecting tendrils. Edges of himation of Poseidon, dots and cores of dot-rosettes on his chiton and on short chiton of Hermes; fillet in hair of Poseidon; top of Hermes' petasos, tongues of his boots, parts of folds of his chlamys; crest support of Athena's helmet, twelve dots on rim of her shield, wing bars and tail stripe of owl of her device; dots on chiton of Herakles. *White,* dots around cores of all dot-rosettes; flesh of Athena; row of dots along upper edge of wing bars of owl (the dot effect produced by the painter's first drawing a solid line, then

slicing it by incisions); chape and hilt of sword of Herakles, row of dots on upper band of edge of his chiton.

BIBLIOGRAPHY
W. Klein, *Meistersignaturen*[2] (1887) 45, no. 5; E. Pottier, *RA,* ser. 3, vol. 13 (1889) pt. 1, 31 – 37, pl. 4; F.A.O. Benndorf in *Wiener Vorlegeblätter, 1889,* pl. 4,3; A. Furtwängler in W.H. Roscher, *Ausführliches Lexicon der griechischen und römischen Mythologie* 1 (Leipzig 1884 – 1890) col. 2220; L. Adamek, *Unsignierte Vasen des Amasis* (Prague 1895) 12, 23, 31 – 32; E. Pottier, *Vases antiques du Louvre* 2 (Paris 1901) 91, no. F 30; idem, *Catalogue des vases antiques* 3 (1906) 725 – 728; G. Perrot in G. Perrot and C. Chipiez, *Histoire de l'art dans l'antiquité* 10 (Paris 1914) 187 – 189, figs. 119, 120; E. Langlotz, *Zeitbestimmung* (1920) 16; J.C. Hoppin, *Black-figured Vases* (1924) 36 – 37; J.D. Beazley, *ABS* (1928) 34, no. 22; S. Karouzou, *AM* 56 (1931) 104, no. 10, Beilage 51; *Encyclopédie photographique de l'art* 2 (Paris 1936 – 1937) 283; Q. van Ufford, *BABesch* 17 (1942) 51; J.D. Beazley, *Development* (1951) 58 – 59, 112, n. 48; idem, *ABV* (1956) 152, no. 29; S. Karouzou, *The Amasis Painter* (Oxford 1956) 9, 32, no. 31, pl. 16,1, pl. 17; P.E. Arias and M. Hirmer, *Greek Vase Painting,* translated and revised by B. Shefton (1962) pl. 54, 298 – 299 (commentary); P.E. Arias, *Storia della ceramica . . . arcaica e classica* (1963) pl. 47,1.

Fig. 85. Panel-amphora of type B. Attributed to the Painter of Berlin 1686. Side A: the introduction of Herakles into Olympus. London, the British Museum, B 166.

Fig. 86. Panel-amphora of type B. In the manner of the Lysippides Painter. Attributed to the Mastos Painter. Side A, panel: the introduction of Herakles into Olympus. Amiens, Musée de Picardie, 3057.179.40.

28 OLPE (WITH TREFOIL MOUTH)

WÜRZBURG, UNIVERSITY, MARTIN VON WAGNER MUSEUM,
L 332 (HA 531), ACQUIRED WITH THE FEOLI COLLECTION IN 1872.

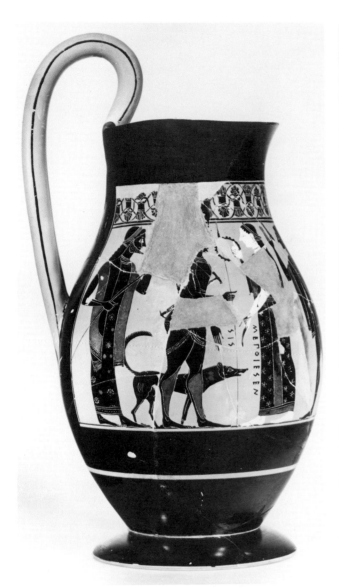

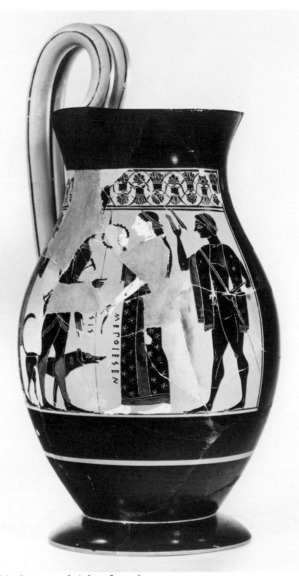

28 Right profile, with left and center of panel.

28 Center and right of panel.

The subject may be interpreted as the return rather than the departure of a warrior and his dog. On the left, a man clad in a long chiton and a mantle over his shoulders holds a staff or spear diagonally in his right hand. The left hand, now missing, was raised. The warrior in front of him wears a short belted chiton, greaves, and a high-crested Corinthian helmet. On his left side he carries a sheathed sword, and in his

left hand he holds an upright spear. A rather lean dog is at his side. The warrior is greeted by a woman who wears a belted peplos. Her left arm and hand are extended downward; in her raised right hand she holds a wreath with dots, rendered in glaze. Her hair, like that of the bearded man on the left, is tied with a ribbon behind and below the ears. An incised line on her neck stands for her necklace, and she wears a hoop earring with two visible pendants.

Between her and the warrior the potter's signature appears vertically:

ΜΕΠΟΙΕϹΕΝ

[AMA]ϹΙϹ

in two lines, with the verb in the upper line, as on Louvre F 30 (Cat. 27); as on the Louvre olpe, the spear of the woman separates the two lines of the signature. The last figure, on the right end of the panel, is a youth wearing a chlamys over his shoulders and upper arms. He holds a spear in his lowered left hand and

143

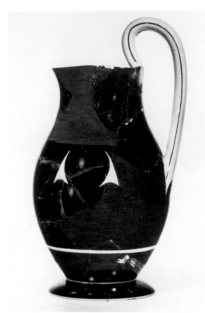

28 Left profile.

greets the warrior with his raised right hand. In his short hair he wears a fillet.

This signed olpe is very close to the Amasis Painter's signed olpe in the Louvre (Cat. 27), and the two have often been considered a pair. Compositionally even closer to this Würzburg vase is the small amphora in the Louvre (Cat. 12). Poseidon, Ares, his dog, and the goddess on the Louvre reverse find their closest counterparts in the man, the warrior, his dog, and the woman on the Würzburg olpe—and does not the youth, on the right in Würzburg, look as if he had been taken from the Louvre obverse? Especially telling are the position of the dog and even its breed. In scale, the figures on the Louvre amphora are smaller than the figures on the olpe, but the three vases compared here, the two signed olpai and the small Louvre amphora, must be quite close in date. Langlotz (in Schrader, p. 38, n. 35) has dated the Würzburg olpe 560 B.C., but I take it to be considerably later.

Middle period, late.

Signed by Amasis as potter and hence attributed to the Amasis Painter (see J.D. Beazley, *ABS* [1928] 31).

From Etruria. Ex coll. Agostino Feoli.

DIMENSIONS AND CONDITION
Height to top of handle, 26.625 cm; height to rim, 21.63 cm; diameter of body, 12.1 cm; diameter of foot, 10.6 cm; width of resting surface, 1.1 cm. Height of figures, 10.2 cm. The vase is broken and has been repaired. There are some losses in the figures, notably the left arm of the left-hand man, the head and shoulders of the warrior, the middle of his body, parts of his arms, and the chest, upper left arm, and lower back and buttocks of the woman.

SHAPE AND DECORATION
Echinus foot, glazed on the outside except for the very edge. The flaring mouth (with an original diameter of 9.36 cm) is glazed on the inside to a depth of 4.0 cm. After the vase was turned on the wheel and before the handle was attached, the potter pinched the mouth in three places to produce the trefoil shape. The handle, formed of two rolled strips, rises well above the level of the mouth and is left unglazed, but has on the sides and on top four longitudinal glaze lines. The picture is in a panel framed on the sides and bottom by single glaze lines. It is surmounted by a palmette-lotus festoon

28 Profile drawing of foot.

that must have contained thirteen complete elements, to which the painter added half an element on the left. The ornamental border is framed below by two glaze lines and above by one. Between the panel and the foot, a re-

served band encircles the entire vase at the level where the diameter of the vase equals that of the foot. The panel begins near the right side of the handle and ends opposite the handle. On the side to the left of the handle are two reserved spandrels, which, when taken with the black disk between them, suggest (as Jacobsthal observed [p. 16]) an apotropaic eye.

ADDED COLORS
Red, edge of mouth; central sepals of lotuses; cores of palmettes; rings connecting tendrils; line below panel encircling entire vase. In the figures, all fillets; folds of himation of left-hand man, cores of dot-rosettes on his chiton; chiton of warrior above his belt, dots below his belt, his greaves; neck of dog, stripes on its haunch; central panel and bottom of woman's peplos; woman's pupil, pendants of her earring; stripe of chlamys on right arm of right-hand youth, cores of dot-rosettes on chlamys over his shoulders. *White,* flesh of woman; dots around cores of dot-rosettes; hilt and chape of warrior's sheathed sword.

BIBLIOGRAPHY
K.L. von Urlichs, *Verzeichniss der Antikensammlung der Universität Würzburg* 3 (1872) 97, no. 97; W. Klein, *Meistersignaturen²* (1887) 45, no. 7; F.A.O. Benndorf in *Wiener Vorlegeblätter, 1889,* pl. 4,2; L. Adamek, *Unsignierte Vasen des Amasis* (Prague 1895) 12, no. 6, 30; E. Langlotz, *Zeitbestimmung* (1920) 15 – 16; J.C. Hoppin, *Black-figured Vases* (1924) 38 – 39, no. 7; P. Jacobsthal, *Ornamente griechischer Vasen* (Berlin 1927) 15 – 16, pl. 4; J.D. Beazley, *ABS* (1928) 34, no. 23; W. Kraiker, *JdI* 44 (1929) 142, n. 3; S. Karouzou, *AM* 56 (1931) 104, no. 9; E. Langlotz, *Griechische Vasen* (Munich 1932) 64 – 65, no. 332; idem in H. Schrader, *Die archaischen Marmorbildwerke der Akropolis* (Frankfurt am Main 1939) 38, n. 35; S. Karouzou, *The Amasis Painter* (Oxford 1956) 9, 33, no. 32, pl. 16,2, pl. 18; J.D. Beazley, *ABV* (1956) 152 – 153, no. 30; D. von Bothmer, *Antike Kunst* 3 (1960) 75, 80; E. Simon, *Führer* (1975) 95 – 96.

29 FRAGMENTARY OLPE

OXFORD, ASHMOLEAN MUSEUM OF ART AND ARCHAEOLOGY, 1929.19,
GIFT OF J.D. BEAZLEY, 1929.

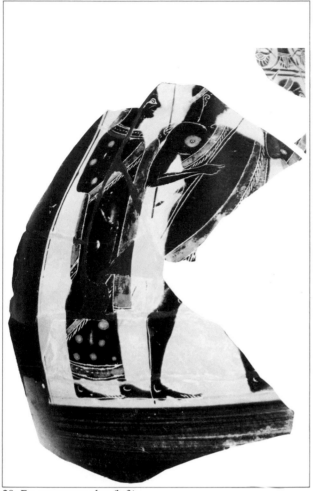

29 Fragmentary olpe (left).

29 Fragmentary olpe (right).

The scene consists of five figures. On the left, a youth wearing a long chiton and, draped over his left shoulder and arm, a fringed himation, holds a spear in his left hand. His hair is tied in a ribbon below and behind his ears. He is preceded by a boy who wears a fringed chlamys over his left shoulder and upper arm; in his right hand the boy holds a spear diagonally, and in his hair he wears a fillet. This youth advances toward the central figure, Poseidon, of whom only the upper face and head, his right elbow under his himation, part of his chest, and the left forearm and hand, holding the trident, remain.

The fringed himation was worn over the left shoulder and the left arm. Athena, to the left, faces Poseidon. The high crest of her Attic helmet extends into and partly obscures the palmette-lotus festoon, which, however, was fully drawn before parts of it were covered by the crest and the crest support. A big round shield carried on the left arm covers her body from the shoulders to above the knees. The device is a thunderbolt that terminates below in a palmette and is equipped with two pairs of wings. Athena wears a long, presumably belted, peplos and holds an upright spear. The figure behind her can hardly be Herakles, since he

wears a short chiton and a nebris over it. His head and shoulders are missing, and of the right arm, we have only a bit of the forearm, which was raised but need not have held anything. The painter ran out of space: the last figure is very close to the lateral frame, and the back of his upper left arm is actually drawn over the glaze line.

The identity of the last figure to the right, labeled "male (Herakles?)" by Beazley (in *ABV*), is almost certainly not Herakles, as is explained in the discussion of the iconography of the Copenhagen amphora (Cat. 13). Five figures make for a

145

29 Additional unattached fragments.

rather crowded composition, and we ask ourselves whether the painter did not conflate a scene such as the introduction of Herakles by Hermes and Athena to Poseidon (as on the Louvre olpe F 30 [Cat. 27]) with another subject, and discovered too late the limitations of space. I suspect that he began his picture on the left side and that the problem did not become acute until he had finished with Poseidon.

Middle period, late (contemporary with the Amasis Painter's fragmentary olpe in Athens from the Olympieion [fig. 87; *Paralipomena* 66]).

Attributed to the Amasis Painter by J.D. Beazley.

From Greece.

DIMENSIONS
Height as preserved, 18.4 cm. Height of figures, 12.2 cm.

SHAPE AND DECORATION
The fragment is broken off on top at just the level where one could have determined whether the vase had a trefoil mouth or a round one. Unpublished nonjoining fragments of the lower body, however, have parts of the reserved band that is typical of olpai and unknown for choes by the Amasis Painter. The neck is glazed on the inside. The picture is set in a panel framed on each side by a glaze line and surmounted by a palmette-lotus festoon, of which only five elements are preserved. The ornament is framed above and below by two glaze lines. The groundline is drawn in dilute glaze.

ADDED COLORS
Red, cores of palmettes and lotuses; one central sepal of lotus, above head of Poseidon (other preserved lotuses do not have central sepals); fillets of boy and Poseidon; dots on chiton of youth and its lower border, vertical folds and upper and lower border stripes on his

Fig. 87. Fragments of an olpe. Attributed to the Amasis Painter. Athens.

himation and that of Poseidon; hair circle around nipple of boy, upper and lower border stripes and vertical fold of his chlamys; dot on chiton of Poseidon; face of Athena, central vertical panel of her peplos, horizontal stripe at its lower border; rim of Athena's shield, wing bows of its device, crest support of her helmet, nebris of male figure behind her. *White,* row of dots on upper border of chiton of male figure behind Athena.

The hand and feet of Athena are black; for her red face with an incised male eye, compare the chous in the Louvre (Cat. 34).

BIBLIOGRAPHY
J.D. Beazley, *ABS* (1928) 35, no. 3; idem, *CVA,* Oxford, fasc. 2 (1931) 97, III He, pl. 3, no. 28; G. van Hoorn, *Choes and Anthesteria* (Leiden 1951) 162, no. 780; S. Karouzou, *The Amasis Painter* (Oxford 1956) 34, no. 45; J.D. Beazley, *ABV* (1956) 153, no. 38; Oxford University, Ashmolean Museum, Dept. of Antiquities, *Select Exhibition of Sir John and Lady Beazley's Gifts to the Ashmolean Museum, 1912 – 1966* (London 1967) 42, no. 111.

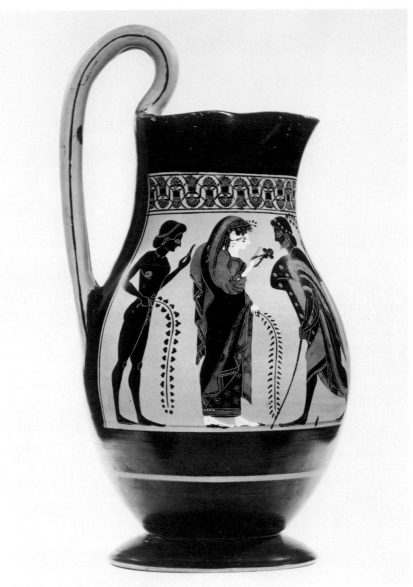

30 Right profile, with left and center of panel.

The scene shows an amorous encounter of a woman (or goddess) and a man (or god), flanked by two youths holding ivy branches. The youth on the left is naked and has a fillet in his hair; his companion wears a fringed chlamys and has a wreath of round leaves on his head. The woman is dressed like a bride, in a sleeved chiton and a very big himation that is pulled up over the back of her head. She is crowned with a myrtle wreath and in her left hand holds a bough of myrtle, while with her right hand she proffers a rose to the man facing her. She also has a necklace (rendered by an incised line) and earrings—the visible one is composed of three red globules. The man facing her is clad in a richly fringed himation and wears a wreath in his hair. He is taller than the other figures, but his

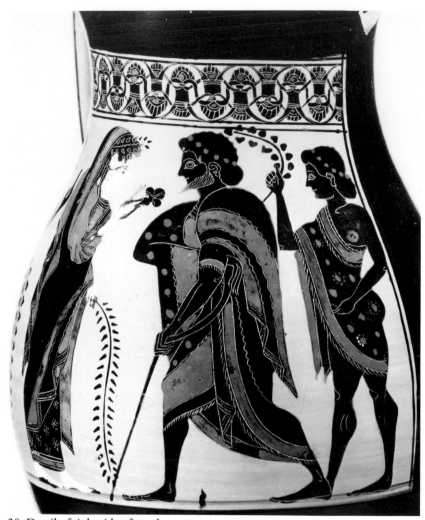

30 Detail of right side of panel.

30 Left profile.

head is on the same level as those of the company: the artist has clung to the old-fashioned principle of iso-cephaly but has managed to convey the greater size of the man by show-ing him with bent knees, leaning on a curiously shaped staff that resembles a crutch. In amorous encounters, taller men are often shown with the knees bent in something of a half-crouch to bring their heads to the level of their partners (e.g., the kissing scenes on a black-figured neck-amphora at Amherst College, Massachusetts, by a painter of the Medea Group [ABV 321, no. 1],

or the man leaning on a staff on a neck-amphora by the same hand in New York [fig. 88; ABV 321, no. 2]). While most such meetings of lovers on black-figured vases are taken from the human sphere and depict the ladies as professionals, this olpe brings an air of solemnity to the scene by the bridal aspect of the woman and the presence of the two youths; thus, the possibility of a heroic or divine meeting cannot be excluded.

For the linear decoration of the unglazed handle, compare the

trefoil olpe by the Gela Painter in the Louvre (F 322, C.H.E. Haspels, ABL 214, no. 197), which must be the latest olpe with the picture panel on the left side of the vase rather than centered. The New York olpe shown here is, among those by the Amasis Painter, closer to the frag-mentary olpe from the Athenian Agora (fig. 89; ABV 714, under pp. 150 – 158, no. 31 bis): the New York olpe shares with the Agora olpe the diameter, the height of the panel, and the ornamental border above the figure scene; the two must have been made and painted at about the same time.

Late period, about 520 B.C.

At first, only tentatively attributed by J.D. Beazley (in ABV) to the Amasis Painter (on the strength of a tiny photograph) and thought, if by the Amasis Painter, to be "a late work." Independently attributed by D. von Bothmer to the Amasis Painter when the olpe appeared on the London art market in 1959.

Ex coll. James Christie (Framing-ham Pigot, Norwich).

DIMENSIONS AND CONDITION

Height to top of handle, 32.9 cm; height to rim, 26.94 – 27.12 cm; diameter of body, 16.54; diameter of foot, 13.03 cm; width of resting surface, 1.4 cm. Height of figures, 12.8 cm. The capacity, when the vase is filled to the lower edge of the glaze inside the neck, is 2.8 liters. There is a small chip at the mouth, which has been repaired with plaster and repainted.

SHAPE AND DECORATION

Echinus foot. The flaring mouth (with an original diameter of 12.41 cm) is glazed inside to a depth of 4.54 cm. After the vase was turned on the wheel and before the handle was attached, the potter pinched the mouth in three places to produce the trefoil shape. The handle, which rises well above the level of the mouth, is made of two rolled strips of clay, flattened and stretched at the upper and lower joins. The handle is unglazed but is decorated with four longitudinal glaze lines. The figure scene is set in a panel surmounted by a festoon of fifteen palmette-lotuses, of which the first and the last are not complete. The floral border is framed above and below by glaze lines, and the lateral edges of border and panel are also framed by glaze lines. The groundline of the panel is drawn in dilute glaze. Below the panel, a reserved band encircles the entire vase at roughly the level where the diameter of the body equals the diameter of the foot. The panel is not centered opposite the handle but is moved to the right side of the handle, thus giving the reclining banqueter an almost complete view of the picture when the wine is poured from the olpe into a drinking cup by a right-handed attendant. On the side to the left of the handle are two reserved spandrels, which, when taken with the black disk between them, suggest an apotropaic eye.

ADDED COLORS

Red, line on edge of mouth; cores of palmettes and lotuses; wreaths; hair circles around nipples of youths; woman's pupil, earring, alternate folds and stripes on her garments; cores of dot-rosettes on mantles of man and youth behind him, alternate stripes on their garments. *White,* flesh of woman; dots around cores of dot-rosettes on garments of man and youth behind him.

BIBLIOGRAPHY

J.D. Beazley, *ABV* (1956) 698, under p. 445, no. 3 bis; *Cat. Christie, Manson & Woods, London, March 23, 1959,* lot 171 (ill.); *MMA Bulletin* 18 (1959 – 1960) 36 (ill.); D. von Bothmer, *Antike Kunst* 3 (1960) 75, 80, pl. 8,1 – 2; J.D. Beazley, *Paralipomena* (1971) 66; F. Brommer, *Hephaistos: Der Schmiedegott in der antiken Kunst* (Mainz 1978) 210, A.

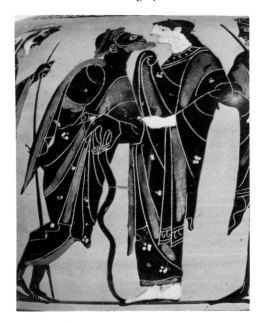

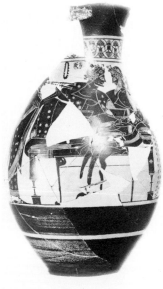

30 Drawing of profile.

Fig. 88. Neck-amphora. Attributed to a painter of the Medea Group. Side B: detail showing a man courting a woman. New York, The Metropolitan Museum of Art, 56.171.21.

Fig. 89. Fragmentary olpe (with trefoil mouth). Attributed to the Amasis Painter. Symposion. Athens, Agora Museum, P 24673.

The subject is neatly centered opposite the handle (and not relegated to one side, as on the Amasis Painter's trefoil olpai). Perseus, on the left, his head averted, plunges his sword into the neck of a frontal Gorgon. On the right is Hermes. The young hero wears winged boots, a short fringed chiton, a nebris, and a petasos; his kibisis is slung over his left shoulder. The bearded Hermes on the right also wears boots, a short fringed chiton, and a petasos; instead of a nebris he wears a chlamys over the right shoulder. In his left hand he holds a very long caduceus. The fierce Gorgon is equipped with two pairs of wings, one going up, the other pointing down; in addition, she wears the same boots as Perseus and Hermes. Her short peplos is belted; over it she wears a nebris with two serpents as a clasp. Four more snakes issue from her hair. Blood flows in three streams from the wound in her throat. The signature of Amasis as potter appears vertically between Perseus and the left frame of the panel: AMASISMEΓOIESEN , in one line.

The Gorgon Medusa is very much the chief figure on this olpe. Not only does she take up more space than either Perseus or Hermes, she is placed exactly in the center. Her bent knees, however, should not mislead us into thinking that she is collapsing from her wound, for in this respect the Amasis Painter merely follows the traditional scheme of her flight combined with a fast run, the "knielauf," as archaeologists have dubbed it. In archaic Attic art, beginning with the proto-Attic neck-amphora in Eleusis, the preferred moment in the story is normally the flight of Perseus after the accomplished feat, the severed head of Medusa safely in his kibisis and the surviving Gorgons in hot pursuit. The Amasis Painter, however, has selected the actual

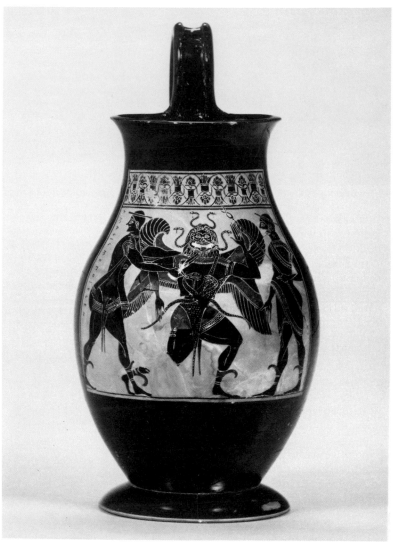

31 Front.

decapitation for his scene, in a rendering not unlike that known from a bronze shield strap found at Olympia (E. Kunze, pl. 57, no. 44), which bears a strong resemblance not only in the position of the figures but even in such details as the hornlike snakes on Medusa's head. The shield strap in Olympia is contemporary with this olpe, and behind both representations may be imagined a sculpture with the same subject, such as the somewhat later metope from Selinus (fig. 90;

G. Lippold *Die griechische Plastik* [Munich 1950] pl. 29,1).

Many of the details of the head of Medusa on this olpe were kept by the Amasis Painter for his truly terrifying device on the shield of Athena in Boston (Cat. 24): the shape of the nose, the red stripe above the teeth, and the snakes on the head. The beard on the shield device, however, is that of a "normal" full beard, while on the Medusa killed by Perseus on this olpe, the beard's contour resembles that of the mane of a lion, as on the

name piece of the Nettos Painter (fig. 91; *ABV* 4, no. 1). The Amasis Painter's other three gorgoneia, the center of the Boeotian shield in the Berlin arming scene (fig. 45; *ABV* 151, no. 21), the tondo of the cup in the Vatican (Cat. 62), and the top of a standlet in Athens (fig. 92; *ABV* 157, no. 90), conform to the tradition of gorgoneion tondos. This tradition begins with the gorgoneion by Kleitias and Ergotimos in New York (fig. 93; *ABV* 78, no. 12) and introduces white for the ears as early as the plate by Lydos in Munich (*Paralipomena* 46). Note also that this is the only known vase of the Amasis Painter on which blood is shown.

The date of this olpe is not much different from those given to the signed olpai with trefoil mouths in the Louvre and Würzburg (Cats. 27, 28): middle period, late.

Signed by Amasis as potter and hence attributed to the Amasis Painter (see J.D. Beazley, *ABS* [1928] 31).

Found in Vulci 1828/29. Ex colls. Lucien Bonaparte, Prince of Canino; W.W. Hope.

DIMENSIONS AND CONDITION
Height to top of handle, 25.77 cm;

height to rim, 20.92 cm; diameter of body, 13.255 cm; diameter of mouth, 9.22 cm; diameter of foot, 10.255 cm; width of resting surface, 1.28 cm. Height of figures, 10.22 cm. The vase is broken and has been repaired. There are minor losses in the panel, limited to the right lower leg and knee of the Gorgon.

SHAPE AND DECORATION
The flaring mouth has a flat, glazed top. Mouth and neck are glazed on the inside to a depth of 1.5 cm. The high handle is flanged and rises well above the level of the mouth. Echinus foot, glazed on the outside except for the very edge. The figure scene is set in a panel framed on each side by a glaze line and surmounted by a palmette-lotus festoon of twelve complete elements, with half an element added on the left. The ornamental band is framed above by a single glaze line and framed below by two. The groundline is drawn in thinner glaze.

ADDED COLORS
Red, cuffs and central sepals of lotuses; cores of palmettes; rings connecting tendrils; brims of petasoi; tops of boots; upper lip, nose, tongue and wrinkle on forehead of Gorgon; wing bows of upper wings; wing bars of lower wings; upper border and skirt of Gorgon's peplos; blood; markings on nebris of Perseus, cores of dot-rosettes on his chiton; dots and cores of dot-rosettes on chiton of Hermes, edges of his chlamys. *White,* teeth and tusks of Gorgon; rows of dots on lower border

31 Drawing of profile.

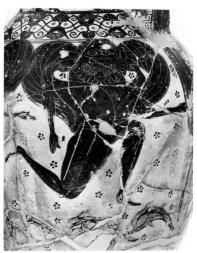

Fig. 90. Metope from Selinus (from a cast), ca. 520 B.C. Perseus and Medusa. Palermo, Museo Archeologico Nazionale.

Fig. 91. Neck-amphora. Attributed to the Nettos Painter. Side A: detail showing a Gorgon. Athens, National Museum, 1002.

of wing bows of upper wings and on upper border of her peplos; dots around cores of all dot-rosettes.

BIBLIOGRAPHY

Museum Etrusque de Lucien Bonaparte, Prince de Canino: Fouilles de 1828 à 1829 (Viterbo 1829) 11, no. 21; O. Gerhard, *Annali dell'Instituto di Corrispondenza Archeologica* 3 (1831) 178, no. 702; L.J.J. Dubois, *Notice d'une collection de vases antiques en terre peinte, provenante des fouilles faites en Entrurie par feu M. Le Prince de Canino. Vente... [Paris,] rue des Jeûneurs 16 (salle no. 3). Le mardi 4 avril 1843 et jours suivants* 16 – 17, no. 62; idem, *Notice... vente, 22 avril 1845 et jours suivants, heure de midi, [Paris,] rue des Jeûneurs 16,* 13 – 14, no. 32 bis; D. Raoul-Rochette, *Lettre à M. Schorn: Supplément au catalogue des artistes de l'antiquité grecque et romaine* (Paris 1845) 31 – 32; T. Panofka, *Archäologische Zeitung* 4 (1846) cols. 236 – 237; J. de Witte, *Revue de philologie* 2 (1848) 391; *Cat. Christie, London, June 14 – 16, 1849: William Williams Hope, Esq., Partly from Rushton Hall, Northamptonshire,* no. 12; S. Birch, *Archäologische Zeitung* 7 (1849) col. 99; S. Birch and C.T. Newton, *A Catalogue of the Greek and Etruscan Vases in the British Museum* 1 (London 1851) 172, no. 641 bis; H. Brunn, *Geschichte der griechischen Künstler* 2 (Stuttgart 1885) 656; *Corpus inscriptionum graecarum* 4 (Berolini 1877) 183, no. 8126; G. Loeschcke, *Archäologische Zeitung* 39 (1881) col. 30, n. 3; J. Six, *JHS* 6 (1885) 282 – 283; W. Klein, *Meistersignaturen*[2] (1887) 44 – 45, no. 4; F.A.O. Benndorf in *Wiener Vorlegeblätter, 1889,* pl. 4, 1a – c; H.B. Walters, *Catalogue* 2 (1893) 238, no. B 471; F. Knatz, *Quomodo Persei fabulam artifices graeci et romani tractaverint* (Bonn 1893) 14, no. 3; L. Adamek, *Unsignierte Vasen des Amasis* (Prague 1895) 12, no. 3; G. Karo, *JHS* 19 (1899) 138; J.E. Harrison, *Prolegomena to the Study of Greek Religion* (Cambridge 1903) 225; H.B. Walters, *History of Ancient Pottery* 1 (New York 1905), 382 – 383, fig. 97; E. Langlotz, *Zeitbestimmung* (1920) 16; E. Pfuhl, *MuZ* (1923) 259, pl. 51, fig. 215; J.D. Beazley, *ABS* (1928) 34, no. 25; idem, *Greek Vases in Poland* (Oxford 1928) 4, n. 4; W. Kraiker, *JdI* 44 (1929) 143 – 144; S. Karouzou, *AM* 56 (1931) 106 – 107, Beilage 54,1; A. Merlin in *Mélanges Gustave Glotz* 2 (Paris 1932) 606, n. 5; R. Hampe, *AM* 60 – 61 (1935 – 1936) 292, no. 9; J.M. Woodward, *Perseus: A Study in Greek Art and Legend* (Cambridge 1937) 50 – 52, fig. 13; E. Langlotz in H. Schrader, *Die archaischen Marmorbildwerke der Akropolis* (Frankfurt am Main 1939) 38, n. 35; E. Kunze, *Olympische Forschungen* 2 (Berlin 1950) 136 – 138; S. Karouzou, *CVA,* Athens, fasc. 2 (1954) III Hg, 9; eadem, *The Amasis Painter* (Oxford 1956) 10, 33, no. 35, pl. 15,1; J.D. Beazley, *ABV* (1956) 153, no. 32; S. Stucchi in *Enciclopedia dell'Arte Antica, classica e orientale* 1 (Rome 1958) 298, fig. 430; K. Schauenburg, *Perseus in der Kunst des Altertums* (Bonn 1960) 22 – 23; D. von Bothmer, *Antike Kunst* 3 (1960) 80; J.D. Beazley, *Paralipomena* (1971) 64, no. 32; J. Boardman, *ABFV* (1974) 73, fig. 80; K. Schefold, *Spätarch. Kunst* (1978) 83, fig. 95; O. Stumpfe, *Die Heroen Griechenlands: Einübung des Denkens von Theseus bis Odysseus* (Münster 1978) 63.

Fig. 92. Standlet. Attributed to the Amasis Painter. Top: gorgoneion. Athens, National Museum, Acr. 2481.

Fig. 93. Standlet. Signed by Ergotimos as potter and Kleitias as painter. Top: gorgoneion. New York, The Metropolitan Museum of Art, 31.11.4.

32 Olpe (with round mouth, low handle)

Würzburg, University, Martin von Wagner Museum, L 333 (H 574), acquired with the Margaritis collection in 1892.

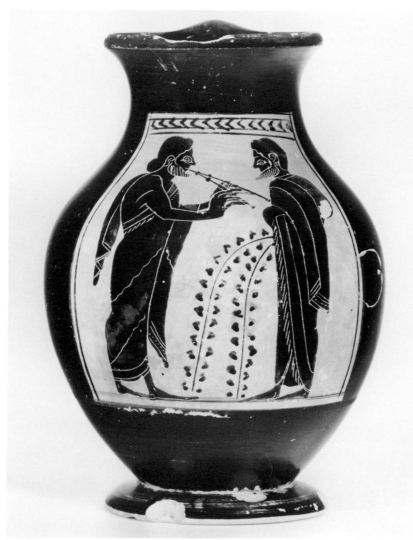

32 Front.

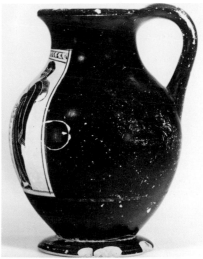

32 Left profile.

flute player facing a singer whose mouth is open.

Late period.

Attributed to the Amasis Painter in 1931 by J.D. Beazley (in *JHS*, p. 261, DD); Langlotz had noted independently that the stylization of the himatia reminded him of the Amasis Painter.

Perhaps found in Boeotia, as were most of the Margaritis vases.

DIMENSIONS AND CONDITION
Height to top of handle, 16.025 cm; height to rim, 15.66 cm; diameter of

The subject of the vase is two men in fringed himatia, facing one another; the one on the left plays the flutes, while his listener holds two long ivy vines in his right hand. The man to the right has a fillet in his hair.

Langlotz called the listener Dionysos, and Mrs. Karouzou claimed that both the flute player and the other man were "singing in Dionysos' honour, to judge by the ivy-branches they hold" (p. 24), but it is hard to sing and play the flutes at the same time, and only one of

them holds ivy branches. Beazley (in *ABV*) labeled the group "komos?," having already compared it (in *JHS*, p. 265) with the Amasis Painter's fragmentary lekythos of sub-Deianeira shape in the Villa Giulia in Rome (fig. 94; *ABV* 155, no. 63) that shows a

32 Profile drawing of foot.

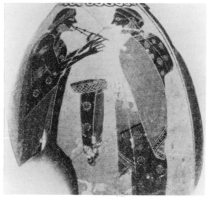

Fig. 94. Lekythos (sub-Deianeira shape). Detail. Attributed to the Amasis Painter. Rome, Museo Nazionale Etrusco di Villa Giulia, Castellani Collection.

body, 11.035 cm; diameter of mouth, 7.035 cm; diameter of foot, 7.27 cm; width of resting surface (which is slightly convex), 1.05 cm. Height of figures, 9.05 cm. The bottom and foot are broken off and reattached. The mouth and foot are chipped.

SHAPE AND DECORATION

This olpe is somewhat squatter than the trefoil olpai by the Amasis Painter (Cats. 26 – 30; *ABV* 152 – 153, nos. 29 – 31, 714, under pp. 150 – 158, no. 31 bis [here fig. 89]) or his olpai with flat, round mouths (*ABV* 153, no. 32 [Cat. 31], nos. 33, 34). The lip is not flat on top but is, instead, ridged and glazed. The inside of the mouth is glazed to a depth of 1.1 cm. The convex handle is completely glazed. Echinus foot. The figure scene is set in a panel framed on each side by a glaze line. The ground-line is done in two brushstrokes, a heavier one beginning on the right and a lighter one tapering from the left to the center. Above the figure scene are fourteen chevrons, framed above and below by two lines; the top line above is partially obscured by the black glaze of the neck. The black handle is rounded.

ADDED COLORS

Red, line encircling vase below panel; fillet in hair of right-hand man; alternate folds of himatia; line along edge of himation thrown over left shoulder of flute player, two blotches in lowest stripe of his himation. *White,* crosses on one fold of himation of man on right; seven clusters of three dots in top stripe of flute player's himation, four more such clusters in lowest stripe.

Note that the contours of the left feet are incised.

BIBLIOGRAPHY

J.D. Beazley, *JHS* 51 (1931) 261, DD, 165; E. Langlotz, *Griechische Vasen* (Munich 1932) 65, no. 333; S. Karouzou, *The Amasis Painter* (Oxford 1956) 24, pl. 33, no. 37, pl. 42,4; J.D. Beazley, *ABV* (1956) 153, no. 36; E. Simon, *Führer* (1975) 96.

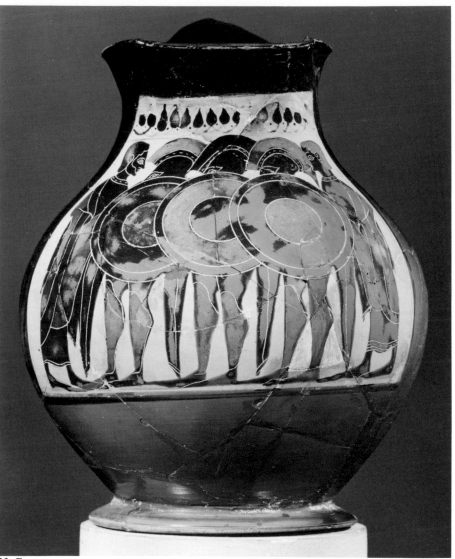

33 Front.

The figure scene is in a panel surmounted by fifteen upright buds with dots in the interstices. Between two onlookers dressed in himatia, a man and a youth, are three hoplites wearing Corinthian low-crested helmets, greaves, and cloaks; they stand facing left, as if in formation. Their shield devices are disks.

As A.J. Clark has demonstrated, this is the earliest chous by the Amasis Painter and may be dated

to around 560 B.C. In the composition of the scene, it still follows some of the conventions of the second quarter of the sixth century, namely, the compass-drawn disks that serve as shield devices and the absence of spears—features that recur on vases by the Camtar Painter and on some Tyrrhenian neck-amphorae. Among the choes attributed to the Amasis Painter (and to the potter Amasis), this is closest to Louvre F 37 (Cat. 34),

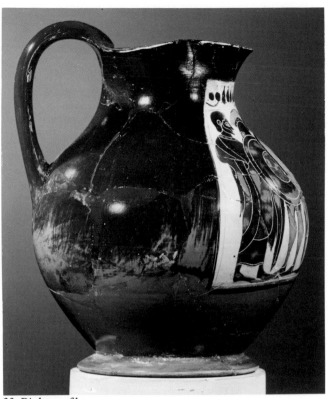

33 Right profile.

33 Drawing of profile.

both in outline and in measurements, including the capacity (the New York chous holds 1.350 liters, the Paris chous, 1.44 liters).

Attributed to the Amasis Painter by D. von Bothmer.

Said to have been found in Orvieto in the late nineteenth century.

DIMENSIONS AND CONDITION
Height to top of handle, 18.6 cm; height to rim, 17.5 cm; diameter of body, 14.6 cm; diameter of foot, 9.65 cm; width of mouth, 8.39 cm; width of resting surface, 0.95 cm; width of handle, 1.94 cm. Height of figures, 10.02 cm; radius of compass-drawn shields, 2.28 cm. The vase is broken and has been repaired; small missing portions (mostly on the body) are restored. The glaze has misfired red in parts.

SHAPE AND DECORATION
Trefoil mouth (with an original diameter of 9.0 cm), flat on top; after the vase was turned on the wheel and before the handle was attached, the potter pinched the mouth in three places to produce the trefoil shape. Ridged handle, glazed inside to a depth of 2.8 cm. Echinus foot.

ADDED COLOR
Red, top of mouth; hair of right-hand youth; alternate stripes on himatia; crests of first and third hoplites and disk devices of their shields; zone between rim of shield and its disk on shield of second hoplite; greaves of all three hoplites; band below panel encircling entire vase.

BIBLIOGRAPHY
Cat. Sotheby Parke Bernet, New York, December 14, 1978, lot 233 (ill.); A.J. Clark, *MMA Journal* 15 (1981) 35ff., figs. 1 − 4, 24.

34 OINOCHOE (SHAPE III: CHOUS)

PARIS, MUSÉE DU LOUVRE, F 37 (Cp 3237),
ACQUIRED WITH THE CAMPANA COLLECTION IN 1861.

The subject is Herakles wrestling the Nemean lion, flanked and aided by Iolaos on the left and Athena on the right. Iolaos wears a short fringed chiton under a bronze cuirass and a sheathed sword suspended from a baldric slung over his right shoulder; in his right hand he shoulders a club, while with his left hand he holds a bow and one arrow. Herakles is nude and carries a scabbard; with both hands he forces the lion's mouth open. The lion braces itself with its left hind leg against the left shin of Herakles and attacks the right shoulder and upper arm of the hero with the paws of its forelegs. Athena is clad in a belted peplos. Her right arm is raised in the familiar gesture of friendly greeting; in her left hand she holds a spear diagonally. Her hair is tied with a ribbon below and behind her ears, and the top of her head is crowned with a fillet. Note that her face and neck are painted red and that her eye has the shape of a male eye.

For the red face and neck of Athena and her "male" eye, here and on Oxford 1929.19 (Cat. 29), compare the eye-siren on the Boston cup (Cat. 61). *Black* flesh for women is known from many black-figured lekythoi (see C.H.E. Haspels, *ABL* [1936] 10, 19, 21, 27, 30–31, 37, 89, 91, 98, 149) and also occurs on vases by the Taleides Painter (see D. von Bothmer, MMA *Bulletin,* n.s. 5 [1946–1947] 226). Red faces for men and monsters are known from the time of the Nettos Painter on (e.g., *ABV* 4–5, nos. 1 [here fig. 91], 2), but the red-faced Athena on this chous is very unusual (see also H.R.W. Smith, *The Hearst Hydria* [Berkeley, Calif., 1944] 270, n. 36, and J. Boardman, *ABFV* [1974] 198).

Though the Nemean lion, the first labor of Herakles, was immensely popular in Attic black-figure, this vase is the only representation

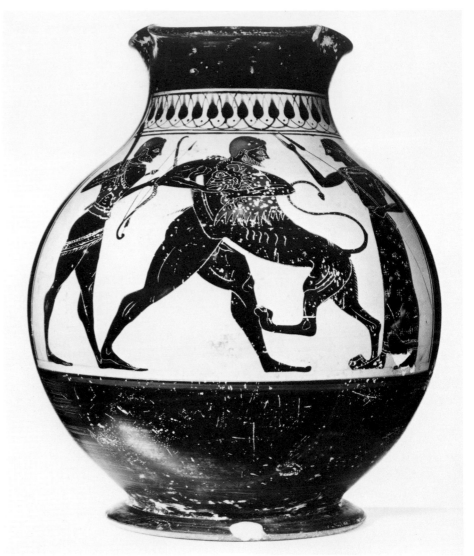

34 Front.

of the subject by the Amasis Painter that has come down to us. The curious double line employed for the left foreleg of the beast, a mistake of incision, reveals that the painter's mind was on something else: the two-dimensional shield device of a rampant lion protome, of which he has left us ten splendid examples—on four amphorae (Cats. 1, 5, 6; *ABV* 151, no. 21 [here fig. 45]), two neck-amphorae (Cat. 23; *ABV* 152, no. 23 [here fig. 56]), a chous (*ABV* 153, no. 42 [here fig. 79]), a lekythos (*ABV* 714, under

pp. 150–158, no. 61 bis [here fig. 99]), a band-cup (Cat. 55), and a cup of type A (the Schimmel cup, Cat. 60) on which the forepart of a roaring lion is shown with both forelegs raised. As we compare the shield device on the Amasis Painter's Embiricos neck-amphora (fig. 56; *ABV* 152, no. 23) with the forepart of the Nemean lion on the Louvre chous shown here, we observe the following astonishing agreements: the mane of both lions not only has a serrated edge on its

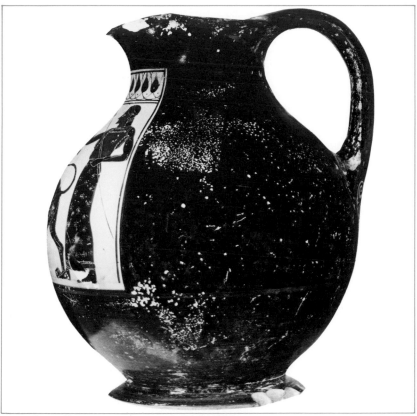

34 Left profile.

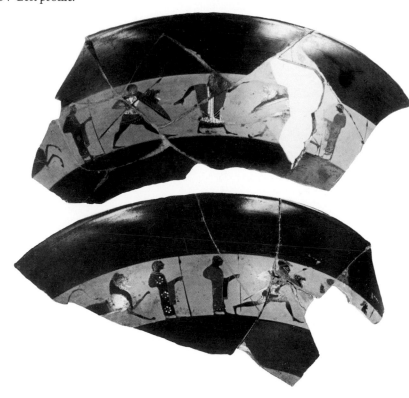

ruff but also has one on the shoulder, while all the other lion protomai have an incised shoulder line instead of the fringe. The fringed, or serrated, edge of the mane is also shown on the ambitious device of Boston 01.8027 (Cat. 25), which gives us a complete lion felling a stag, and on the living lions held by Artemis on the Basel neck-amphora (Cat. 21). In contrast, note that on Faina 40 (fig. 60; *ABV* 151, no. 14), which has Artemis holding a lion and a lion walking beside Herakles on the other side, the manes end at the shoulder incision, as they do on the lions held by Artemis on a lekythos in the Louvre (Cat. 41). The lionesses attacking a youth on the Amasis Painter's Vogelsanger lekythos in Zurich (fig. 98; *Paralipomena* 66) obviously cannot be considered, since manes of lionesses are not so developed as those of lions. The manes of two heraldic lions on the early lekythos in the Louvre, newly attributed to the Amasis Painter (Cat. 43), also stop at the shoulder line, differing in this respect in no way from those of the lions around the handles on the hybrid lip-cup in the Louvre (Cat. 58), on the Amasis Painter's band-cup in Tel Aviv (fig. 95; *Paralipomena* 67), or the lions attacking their prey on the New York aryballos (Cat. 52).

A.J. Clark has demonstrated that the Louvre chous shown here is very close in potting, shape, and size to the choes in New York (Cat. 33) and Orvieto (*ABV* 153, no. 43) and that it is earlier than the somewhat bigger choes in Florence,

Fig. 95a,b. Fragmentary band-cup. Attributed to the Amasis Painter. Sides A and B. Tel-Aviv, Museum Ha'aretz, 90458 and 90558.

Bristol, and Oxford (*ABV* 153 – 154, nos. 42, 44, 45 [Cat. 36]). He has also found a fragment of the handle of a chous and adjacent parts of the wall of the vase in one of the storerooms of the Louvre, which, alas, does not join the Florence chous, although it belongs to the Florence Sub-Section (the core of its twelve-fronded palmette being red).

The date of this chous, a sturdy vase, should be shortly after the middle of the sixth century, early in the Amasis Painter's middle period.

Attributed to the Amasis Painter by J.D. Beazley.

Ex coll. Marchese Giampietro Campana.

DIMENSIONS AND CONDITION
Height to top of handle, 18.25 cm; height to rim, 17.9 cm; diameter of body, 14.975 cm; diameter of foot, 9.31 cm; width of resting surface, 0.89 cm; width of handle (at narrowest level), 1.93 cm. Height of figures, 9.8 cm. Capacity, 1.44 liters. The vase is unbroken, but there is a small hole, which is restored, in the area of the left foot of Athena. The edge of the foot is chipped in two places, and the glaze has peeled in parts. The oinochoe was placed in the kiln in a horizontal position and rested on a skyphos or bowl with a diameter of 9.5 cm at the opening; this has left a circular contact mark, half of which goes from the paw of the right hind leg of the lion to the right foot of Iolaos. It has protected the glazed area thus covered from being discolored, as is most of the rest of the vase.

SHAPE AND DECORATION
Trefoil mouth (with an original diameter of 8.75 cm); after the vase was turned on the wheel and before the

handle was attached, the potter pinched the mouth in three places to produce the trefoil shape. The mouth is glazed entirely on the inside to the beginning of the shoulder; the ridged handle is glazed on the underside; at its root, in silhouette, is an eleven-fronded palmette. Shallow echinus foot, glazed on the outside except for the very edge. The figure scene is set in a panel framed on the sides by a single line and surmounted by fourteen upright buds, with dots in the interstices. The ornament is bordered below by two glaze lines and separated above from the black of the rest of the body by a single glaze line. The groundline on which the figures stand is drawn in very dilute glaze. The panel extends on either side to the meridian marked by the highest level of the lateral lobes of the mouth.

ADDED COLORS
Red, edge of mouth; line below panel encircling entire vase; line on foot; hair of Iolaos and Herakles; ear, mane, muzzle of lion, two stripes on its haunch; neck and face of Athena (except her eye and ear), fillet in her hair, upper part of her peplos; flare of Iolaos' cuirass and arch above its abdominal cavity, stripe along its upper edge; short sleeves of Iolaos' chiton, row of nine dots above its decorated lower border. *White,* dots on baldric of Iolaos, chape of his and Herakles' scabbards; nails of right front paw of lion, two of its teeth, its belly stripe; row of dots along inner edges of border of Athena's peplos.

BIBLIOGRAPHY
Cataloghi del Museo Campana, sers. 4 – 7 (Rome 1857) Sala D, no. 1085; E. Pottier, *Vases antiques du Louvre* 2 (Paris 1901) 92, F 37, pl. 67; J.D. Beazley, *ABS* (1928) 35, no. 29; G. van Hoorn, *Choes and Anthesteria* (Leiden 1951) 166, no. 809; J.D. Beazley, *ABV* (1956) 153, no. 41; S. Karouzou, *The Amasis Painter* (Oxford 1956) 12 – 13, 33, no. 39, pl. 10,2; K. Schefold, *Spätarch. Kunst* (1978) 91, fig. 108; A.J. Clark, *MMA Journal* 15 (1981) p. 40, figs. 12 – 14, pp. 44 – 45, fig. 24, p. 48.

34 Drawing of profile.

35 FRAGMENT OF AN OINOCHOE (SHAPE III: CHOUS)

OXFORD, ASHMOLEAN MUSEUM OF ART AND ARCHAEOLOGY, G 137.52,
GIFT OF D.G. HOGARTH, 1903.

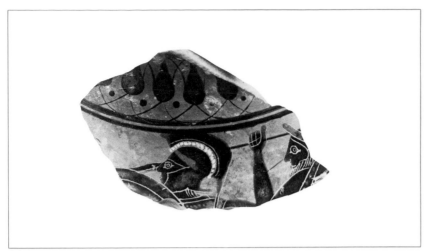

35 Fragment.

Preserved are the upper parts of two hoplites fighting facing left. The first hoplite wears a low-crested Corinthian helmet and possibly a chiton. On his left arm he carries a shield; his right arm is raised and holds a spear poised for attack. His companion, who is bearded, wears a petasos and carries a shield shown in profile; a thin glaze line that crosses his face and the right arm of the first hoplite are all that remain of his spear, which he held at a sharper angle.

It is not entirely certain that this fragment comes from a chous rather than an amphora of type B, since the upper break occurs below the neck. The glaze on the inside is no reliable criterion, for the Basel amphora L 20 (Cat. 8) has the entire neck glazed on the inside. If the fragment comes from a chous, it would have had a four-figure composition, with two more combatants on the left.

Low-crested helmets are comparatively rare on pots by the Amasis Painter (e.g., Rome, Guglielmi collection, *ABV* 150, no. 1 [here fig. 57]; once in Riehen, Hoek collection, *Paralipomena* 65 [here fig. 43]; Louvre F 36 [Cat. 5]; Berlin inv. 3210, *ABV* 151, no. 21 [here fig. 45]; Lausanne, Embiricos collection, *ABV* 152, no. 23 [here fig. 56]; New York 1978.11.22 [Cat. 33]; Athens 19163, *ABV* 714, under pp. 150 – 158, no. 61 bis [here fig. 99]), since the artist could show the more spectacular helmets with high crests, in spite of the compositional principle of isocephaly, by letting the crests go into the pattern-work above. On cups, by contrast (e.g., Berlin 1795, *ABV* 156, no. 83 [here fig. 110]; Tel Aviv 90458 and 90558, *Paralipomena* 67 [here fig. 95]; Malibu [Cat. 55]; and the Schimmel cup [Cat. 60]), there was no such leeway, since the black band above the picture-zone on band-cups or the rim on cups of type A limited the height of the figures.

Middle period.

Said by J.D. Beazley to be in the "style of the Amasis Painter" (*CVA,* Oxford, fasc. 2 [1931] 96); later (in *ABV*) attributed to the painter himself.

From Naucratis.

DIMENSIONS
Height as preserved, 4.33 cm; width as preserved, 5.93 cm.

SHAPE AND DECORATION
The fragment preserves part of the floral ornament above the panel, six upright buds with dots in the interstices. Two glaze lines separate the floral ornament from the panel; a single glaze line frames the buds above. The inside is glazed to the level halfway down the ornament on the outside.

ADDED COLORS
Red, helmet (except for crest); rim of shield of left warrior; brim of petasos of right warrior, dots on rim of his shield. *White,* crest support of helmet, with incised slanted lines giving a corded effect: the same technique is used in the white wing bar of the owl on Athena's shield on the olpe Louvre F 30 (Cat. 27) and on the edge of the cap of the left–hand warrior on the amphora fragment London B 600.31 (fig. 61; *ABV* 155, no. 67).

BIBLIOGRAPHY
J.D. Beazley and H.G.G. Payne, *JHS* 49 (1929) 264, under no. 41; J.D. Beazley, *CVA,* Oxford, fasc. 2 (1931) 96, III H, pl. 3,17; G. van Hoorn, *Choes and Anthesteria* (Leiden 1951) 162, no. 779; J.D. Beazley, *ABV* (1956) 154, no. 46; M.S. Venit, *Painted Pottery from the Greek Mainland Found in Egypt* (Ann Arbor, Mich.: University Microfilms International, 1984) 310, no. B 321.

36 Oinochoe (shape III: chous)

Oxford, Ashmolean Museum of Art and Archaeology, 1965.122,
acquired with part of the Spencer–Churchill collection in 1965.

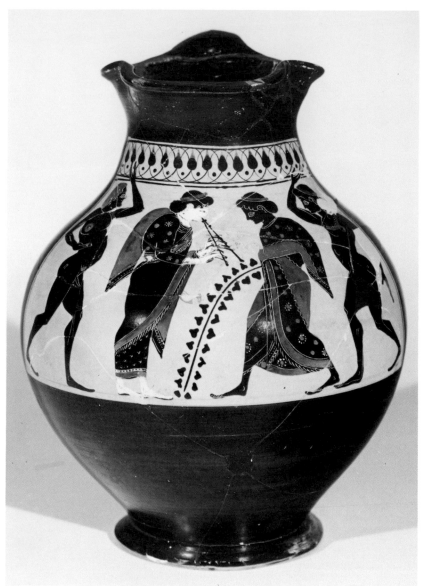

36 Front.

The subject is a revel, or komos, of a naked boy on the left and a naked youth on the right, both dancing and sticking out their stomachs. Each of them raises an arm with the hand intruding into the pattern above; the other arm is lowered. The boy on the left and the youth have short hair, but only the youth wears a fillet on his head and a garland around his neck, the so-called hypothymis. In the center a woman plays the flutes; she is dressed in a chiton with long sleeves and a voluminous himation draped over her left shoulder. One fold of the mantle falls over her left arm, while another forms a big hump on her back. In her hair she wears a fillet. Her earring is rendered by a single dot below the lobe; her necklace is incised in a wavy line. The youth facing her, slightly bent over, treads the beat. The artist has given him, by mis-

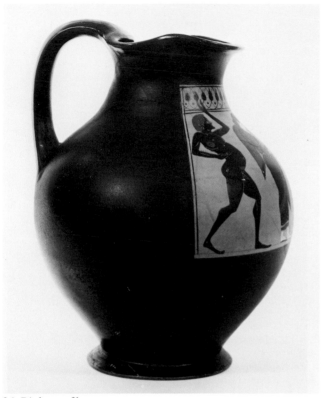

36 Right profile. 36 Back.

take, two left feet. The youth wears a fillet in his hair and a big hima tion that covers both arms: it is not made clear whether the big ivy vine is held in his left or in his right hand.

When it was first connected by Beazley with the Amasis Painter (in *ABS*), he spoke of the vase as a "school-piece?"; later (in *JHS*, p. 262) he modified his stricture and said, "I believe it to be by the painter himself, in his laxer later style," for in the meantime, Beazley had come to know the Acropolis fragment of a very similar, though finer, vase by the Amasis Painter (fig. 96; *ABV* 153, no. 39). This vase, at least in its preserved part— dancing youth or boy with raised left hand crossing into the pattern-work above, head and shoulders of a woman fluting—repeats the com-

position of the Oxford chous. Even in the details of drawing (the hair-line of the dancer, the ear, earring, eye, and necklace of the musician) there is much agreement between the two vases. The Acropolis sherd is finer, and earlier, and since the vase must have been on view on the Acropolis, as was not the case with the vases that were exported to Etruria and other faraway places, the Amasis Painter for once may have refreshed his memory of what he had done before by looking again at his earlier version of the scene.

The Acropolis fragment is unusual in that the ornament above the figures is not a band of upright buds but a triple-net pattern with dots in the spaces between the knots. The group of the youth facing the musician on the Oxford chous antici-pates to some extent the trefoil olpe in New York (Cat. 30), which also shows a sleeved chiton.

Beazley has remarked (*ABV* 154) that the potter-work is not by Amasis, and as Clark (p. 44) has demonstrated, there are, indeed, differences that set this chous somewhat apart. On the other hand, its measurements agree so closely to the Amasis Painter's choes in Florence and Bristol (*ABV* 153, nos. 42, 44), which together with the chous shown here form a sub-group, that we cannot exclude the Oxford chous from the products of the potter Amasis with any really persuasive arguments. Note also that on both the Bristol chous and the one in Oxford, the volutes above the palmette beneath the handle are connected by two short strokes.

Middle period, very late, or early late period.

Attributed to the Amasis Painter by J.D. Beazley.

Ex colls. C.W. Rycroft, E.G. Spencer-Churchill.

DIMENSIONS AND CONDITION
Height to top of handle, 24.325 cm; height to rim, 23.255 cm; diameter of body, 18.59 cm; diameter of foot, 10.415 cm; width of resting surface, 0.86 cm; width of handle, 2.785 cm. Height of figures, 10.3 cm. The vase is broken and has been repaired; there are some losses in the figures, namely, the nape of the right-hand dancing youth and parts of his left arm and thighs.

SHAPE AND DECORATION
Trefoil mouth, flat on top; after the vase was turned on the wheel and before the handle was attached, the potter pinched the mouth in three places to produce the trefoil shape. The inside of the mouth and neck is glazed to a depth of 5.1 cm. The ridged handle is glazed on the underside. Below the handle, in silhouette, is a hanging palmette with thirteen fronds. Echinus foot, slightly warped, glazed on the outside except for the very edge.

36 Profile drawing of foot.

The figure scene is set in a panel framed on the sides by single glaze lines and surmounted by an ornamental band of sixteen upright buds with as many dots in the interstices. The pattern is framed below by two glaze lines and above by one. The very faint ground-line is done in dilute glaze.

ADDED COLORS
Red, top of mouth; core of palmette under handle, two lines connecting volutes of palmette. In the panel, hair of dancing boy, hair circle around his right nipple, spot of hair on right contour of his chest, his pubic hair; fillet of fluting woman, her earring, dots and cores of dot-rosettes on her chiton, its lower edge, folds of her himation, her pupil; fillet of youth facing woman; dots and cores of dot-rosettes on his himation, its lower border and three folds; fillet of right-hand dancing youth, hair circle around his left nipple, his garland. *White,* female flesh; dots above red stripe of woman's chiton and along red edges of her himation; dots around cores of dot-rosettes, both on her chiton and on himation of youth in front of her; dots along upper edge of garland worn by dancing youth.

BIBLIOGRAPHY
J.D. Beazley, *ABS* (1928) 35, no. 33; idem, *JHS* 51 (1931) 261 – 264, figs. 6 – 8, pl. 8,2; G. van Hoorn, *Choes and Anthesteria* (Leiden 1951) 161, no. 768; S. Karouzou, *The Amasis Painter* (Oxford 1956) 24, 34, no. 42, pl. 42,3; J.D. Beazley, *ABV* (1956) 154, no. 45; Oxford University, Ashmolean Museum, *Exhibition of Antiquities and Coins Purchased from the Collection of the Late Captain E.G. Spencer-Churchill* (Oxford 1965) pl. 8, no. 55; A.W. Pickard-Cambridge, *The Dramatic Festivals of Athens*[2] (Oxford 1968) fig. 61 (facing p. 200); J.D. Beazley, *Paralipomena* (1971) 64; M. Robertson, *Antike Kunst,* supp. 9 (1973) 82, n. 16; H. Mommsen, *Der Affecter* (Mainz 1975) 33, n. 179; M.J. Vickers, *Greek Vases* (Oxford 1978) 81, fig. 20; A.J. Clark, *MMA Journal* 15 (1981) 42 – 45, figs. 20 – 23; M.J. Vickers, *Greek Vases*[2] (Oxford 1982) 81, fig. 20; idem in *Image et Céramique grecque (Actes du Colloque de Rouen, 25 – 26 novembre 1982)* (Rouen 1983) 32 – 35, n. 26.

Fig. 96. Fragment of an oinochoe. Attributed to the Amasis Painter. Athens, National Museum, Acr. 1882.

37 OINOCHOE (SHAPE I)

LONDON, THE BRITISH MUSEUM, B 524 (1842. 7-28.785), ACQUIRED
WITH THE BURGON COLLECTION IN 1842 (COLOR PLATE 8).

The scene in the panel represents a frontal four-horse chariot; in the box, the charioteer, a youth, holds the reins and a goad. He wears a long white chiton and a cap; his head is turned to his right. Two birds fly in opposite directions between and above the pole horses and the trace horses. The quadriga is flanked on the left by a man clad in a long white chiton and a short mantle that covers his shoulders and his left arm. In his left hand he holds an upright spear; on the right of the quadriga a naked boy facing left holds a spear.

The vase is the name piece of Beazley's Class of London B 524 (assembled in *Paralipomena* 179), a loosely connected class of oinochoai of shape I that is characterized by the echinus foot, the trefoil mouth, a black neck without collar, and a low handle. This Class is related to the Class of the Oxford Siren-jug (*ABV* 420, 696; *Paralipomena* 178), which, however, differs by its vases having a collar. The best vase in the Class of London B 524 is its name piece, the oinochoe by the Amasis Painter shown here, and though the vase is not signed, it is not to be excluded that the potter Amasis created this special model. There is much in shape and scheme of decoration that recalls the panel-amphorae of type B by the Amasis Painter: the two lines that frame the panel and its upper ornamental border on the sides, as well as the double lines that frame the border above and below.

The painter must have painted his figures before he applied the lateral frames but after he had drawn the horizontal lines of the frame above, for the glaze line of the lateral frame goes over the back of the figure on the right, and the head of the charioteer goes over the lower line at the top of the panel; his red cap is also

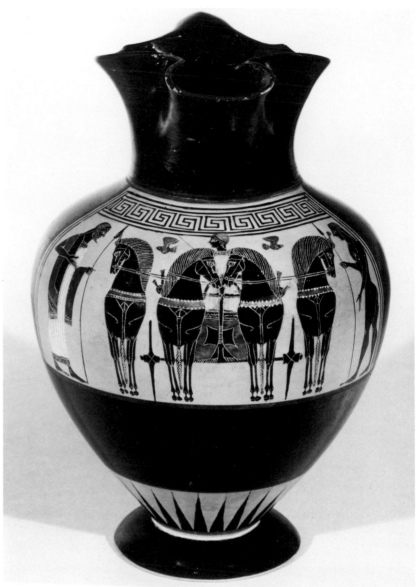

37 Front.

painted over the same line, reaching to the upper line. The painter must have started the continuous maeander pattern on the right, paying close attention to the distortion of the shoulder until nearly the middle, when the straight lines and right angles of the maeander no longer adjust to the curved surface but become tilted, resulting in an incongruous ending above the shoulder of the man on the left.

The continuous maeander above the panel brings to mind the upper border on the reverse of the Amasis Painter's Embiricos neck-amphora (fig. 56; *ABV* 152, no. 23), on which, however, the left end of the maeander is better adjusted to the curvature of the shoulder and the meridians of the left frame.

Robertson has gone at length into the charming panther head

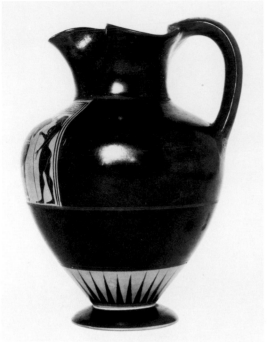

37 Left profile.

37 Detail of panther head below handle (enlarged).

below the handle: to the frontal panther heads of the Amasis Painter he has collected (p. 83), add two more shoulder-flaps, on the amphora of type A in Berlin (fig. 45; *ABV* 151, no. 21) and on Boston 01.8026 (Cat. 24), as well as the shield device on the shoulder of the neck-amphora in the Cabinet des Médailles (Cat. 23) and on the signed band-cup in Malibu (Cat. 55).

There are two more vases with frontal chariots by the Amasis Painter: the fragmentary amphora (type A?) in Bonn (fig. 44; *ABV* 151, no. 20) and the fragment of a small mastoid (?) in Palermo (*ABV* 156, no. 78). The Bonn amphora has figures as big in scale as those on the Berlin amphora of type A (fig. 45; *ABV* 151, no. 21). The vase in Bonn is unusual, in that the palmette-lotus festoon above the pictures

extends beyond the lateral frame of the panel (see fig. 27), as do the ornaments on the amphora of type B in Naples by Lydos (*ABV* 109, no. 23) and his fragmentary amphora in a private collection in Basel (fig. 28; *ABV* 109, no. 25): this is a rare feature. Possibly Lydan, too, is the conceit of eagles flying in opposite directions, seen both on the Bonn amphora (where only one eagle is preserved) and on this Lon-

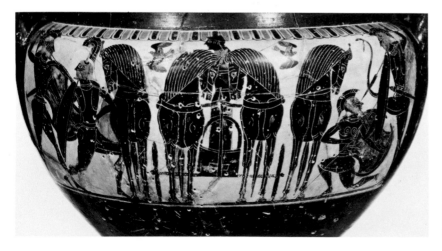

Fig. 97. Column-krater. Attributed to Lydos. Detail of side A: frontal chariot. Cambridge, Massachusetts, Fogg Art Museum, 1925.30.125.

don oinochoe. A particularly close parallel to this vase is, perhaps, the Lydan column-krater in the Fogg Museum (fig. 97; *ABV* 108, no. 9), which displays a similarity that also extends to the head of the charioteer and his hat. The horses by the Amasis Painter are, however, of a different breed. The amphora in Bonn is clearly earlier than the oinochoe shown here and may be contemporary with another fragment in Palermo (fig. 57 bis; *ABV* 151, no. 19) that shows Dionysos in his chariot.

Middle period, early.

Attributed to the Amasis Painter by J.D. Beazley.

From Italy. Ex coll. Thomas Burgon.

DIMENSIONS AND CONDITION
Height to top of handle, 21.04 cm; height to rim, 20.465 cm; diameter of body, 14.5 cm; diameter of foot, 7.735 cm; width of resting surface, 1.12 cm; width of handle, 1.93 cm. Height of figures, 7.6 cm. The vase is intact.

SHAPE AND DECORATION
Echinus foot, glazed on the outside except for the very edge; ovoid body; flaring trefoil mouth glazed inside. After the vase was turned on the wheel and before the handle was attached, the potter pinched the mouth in three places to produce the trefoil shape. The ridged handle is completely glazed and does not rise noticeably above the top of the mouth. The figure scene is set in a panel framed on the sides by two glaze lines, as on most of the Amasis Painter's amphorae of type B. Above the panel is a border of continuous maeanders running to the left and consisting of nine complete elements; the ornamental border neither begins nor ends flush with the lateral frames but continues with truncated parts of maeanders beyond the complete pattern on both sides. The border is framed above and below by two glaze lines. In a zone above the foot are twenty-nine rays. Below the handle is a panther head in front view.

ADDED COLORS
Red, edge of mouth; lateral ends of handle attachment on lip; line at junction of neck and shoulder; line below panel encircling entire vase; line above rays; line below rays. In the figure scene, breastbands of horses; parts of chariot box; top of hair of flanking man and boy; panels on mantle of man; hair circle around nipple of boy; chevrons in ears of panther under handle. *White,* chitons of man and of charioteer; dots on brim of cap; rows of dots along edges of breastbands; ears of panther under handle. Some of the charioteer's chiton pleats are in white painted over red that covers the black background.

BIBLIOGRAPHY
S. Birch and C.T. Newton, *A Catalogue of the Greek and Etruscan Vases in the British Museum* 1 (London 1851) 169 – 170, no. 633; H.B. Walters, *Catalogue* 2 (1893) 250, no. B 524; J.D. Beazley, *ABS* (1928) 22, n. 1, 35, no. 28; idem, *BSA* 32 (1931 – 1932, pub. 1934) 19; G. Hafner, *Viergespanne in Vorderansicht* (Berlin 1938) 4, no. 16, 22; J.D. Beazley, *Development* (1951) 61; S. Karouzou, *The Amasis Painter* (Oxford 1956) 7, 33, no. 38; J.D. Beazley, *ABV* (1956) 154, no. 47; D. von Bothmer, *Antike Kunst* 3 (1960) 80; J.D. Beazley, *Paralipomena* (1971) 179, Class of London B 524, no. 1; M. Robertson, *Antike Kunst,* supp. 9 (1973) 81 – 84, pl. 29,1,3 – 4; idem, *A History of Greek Art* (London 1975) 136, pl. 32c; H. Mommsen, *Der Affecter* (Mainz 1975) 7, n. 28, 21, n. 102, pl. 133; M.B. Moore, *Horses* (1978) 65, 236, 248 – 249, 277, 346, 349, 397, 414, A 406, pl. 32,3.

37 Drawing of profile.

38 OINOCHOE (SHAPE I)

VATICAN, MUSEO GREGORIANO ETRUSCO, 17771.

"Not gods (Apollo, Zeus, Artemis, Ares), but simple mortals. Musician, and judge or other authority," is how Beazley (in *JHS,* p. 264) characterized the scene. On the left, a woman, dressed in a belted peplos and a mantle over her shoulders, stands facing right. Her hair is tied up in a krobylos by a ribbon. Two incised lines mark her bracelets, a wavy incised line renders her necklace, and three red dots represent the pendants of an earring. In front of her, a small deer walks toward a youth crowned with an ivy wreath and dressed in a himation. He holds a lyre and an ivy branch in his left hand and a longer, trailing ivy vine in his right hand. He faces a bearded man, also clad in a himation and crowned with an ivy wreath, who is seated on a campstool that has a cushion. In his left hand the man holds a staff; his right hand fingers a blossom. Behind him stands another youth holding a pointed staff (rather than a spear). He wears a chlamys over his left shoulder; at his side a small dog looks up at its master.

Though Beazley came out categorically against a divine interpretation of the subject, the resemblance of the figures to those on the lekythos in London (Cat. 49) is strong enough to demand a reexamination. It must be remembered that Beazley had not yet attributed the London lekythos to the Amasis Painter at the time (in 1931) when he said "not gods." It was Miss Haspels, in 1936, who first related the London lekythos to the Amasis Painter and saw the connection with this oinochoe: "it has the same deer and the same diphros with cushion" (*ABL* 18). In addition, we may draw attention to the hair of Artemis worn on the lekythos in a krobylos that can be matched on the Vatican oinochoe. Now, the London lekythos (Cat. 49) is close to the

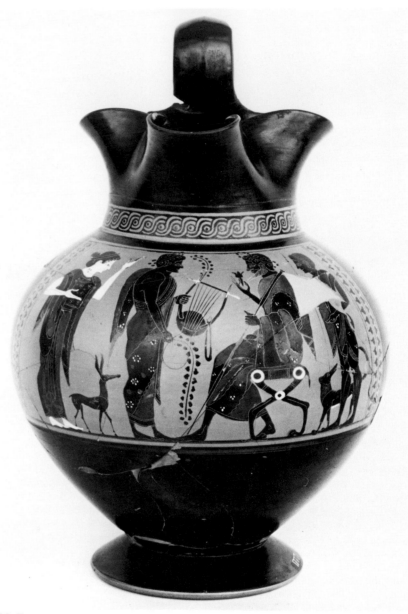

38 Front.

Dusenbery one (Cat. 50), which has a seated youth holding a scepter, and this figure can also be compared with the seated man on the oinochoe shown here. Even if the Amasis Painter did not draw the chief figures on the oinochoe unmistakably as Artemis, Apollo, and Zeus, he must have had these divinities in mind, and must have remembered the lekythos now in London when he painted this scene.

The black band between the panel and neck recalls the placement of the panel on the neck-amphora in Basel (Cat. 21); the black palmette below the ridged handle is in the tradition of the palmettes below the handles of most of the Amasis Painter's choes (Cats. 34, 36; *ABV* 153 – 154, nos. 42 – 44).

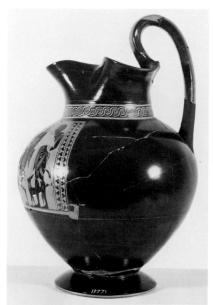

38 Left profile.

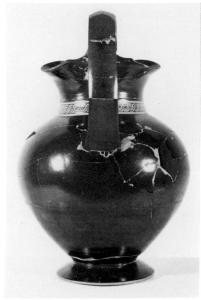

38 Back.

body is set in a panel framed on each side by an ivy branch (twenty-one leaves on the left, nineteen on the right), bordered by lines in thinned glaze. A thinned glaze line on top and another serving as a groundline serve as horizontal frames for the panel. Under the handle are the remains of a palmette in silhouette. Echinus foot, glazed on the outside except for the very edge.

ADDED COLORS
Red, top of mouth; line encircling vase below panel. In the figures, ribbon of woman, pendants of her earring, her pupil, some folds of her peplos and himation, dots on her himation; alternate folds of musician's himation; dots and cores of dot-rosettes; plectrum; neck of deer; alternate folds on himation of seated man; neck of dog; dot and stripes on youth's chlamys, leaves in his hair. *White,* female flesh; dots around cores of dot-rosettes of musician; parts of lyre; clusters of dots on himation of man; hinges of campstool; belly stripe of dog; triple dots on chlamys of youth.

BIBLIOGRAPHY
Museum Etruscum Gregorianum[2] (Rome 1842) pl. 1,2 (= second edition, pl. 9,2); J.D. Beazley, *JHS* 51 (1931) 264, HH, pl. 9; C.H.E. Haspels, *ABL* (1936) 18, 38; C. Albizzati, *Vasi del Vaticano,* fasc. 7 (1939) 199 – 201, no. 432, figs. 145 – 147, pl. 60; S. Karouzou, *The Amasis Painter* (Oxford 1956) 24, 34, no. 46, pl. 41; J.D. Beazley, *ABV* (1956) 154, no. 48; M.A. Levi, *La Grecia antica* (Turin 1963) 22; J.D. Beazley, *Paralipomena* (1971) 64; F. Roncalli, *Bollettino: Monumenti, musei e gallerie pontificie* I,3 (1979) 75 – 77, figs. 21 – 23.

For the red dots, the painter's shorthand for an earring, we should compare the dots under the ears on the Louvre mastoid (Cat. 53), which also furnishes us with good parallels for the lyre and the ivy branch. Other single dots for earrings are known from the late chous in Oxford (Cat. 36) and from the Acropolis fragments of a chous (*ABV* 155, no. 66). The three-dimensional folds on the peplos of the woman hint at a rather late date for this oinochoe, making it contemporary with the two neck-amphorae in Boston (Cats. 24, 25).

Connected with the Amasis Painter by J.D. Beazley and attributed to the painter himself by T.B.L. Webster, with whom Beazley agreed.

Found at Vulci in 1828/29.

DIMENSIONS AND CONDITION
Height to top of handle, 31.5 cm; height to rim, 25.6 cm; diameter of body, 21.0 – 21.9 cm; width of mouth, 14.17 cm; diameter of foot, 12.04 cm; width of resting surface, 0.78 cm; width of handle, 3.05 cm. Height of figures, 10.7 cm. The vase is broken and has been repaired. The only serious loss in the picture is a triangular gap sloping from the shoulders of the seated man to the left elbow of the youth behind him, across the middle of the youth to the area of the man's left elbow, and up toward the end of the staff. (The "concave handle" mentioned by Beazley in *ABV* [p. 154] and figuring in the old illustrations of the vase was seen by Roncalli to be alien and has been replaced by the original, ridged handle, which lacks only the lower part, now restored in plaster.)

SHAPE AND DECORATION
Globular shape, trefoil mouth; after the vase was turned on the wheel and before the handle was attached, the potter pinched the mouth in three places to produce the trefoil shape. The high handle, completely glazed, is ridged. The neck is separated from the body by a collar decorated with a cable-pattern; the collar has a slight ridge above and a groove below. The figure scene on the

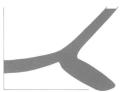

38 Profile drawing of foot.

39 LEKYTHOS (SHOULDER TYPE)

TÜBINGEN, UNIVERSITY, ARCHÄOLOGISCHES INSTITUT 7434 (O.Z. 234),
BEQUEST OF OTTO ZABERER, 1949.

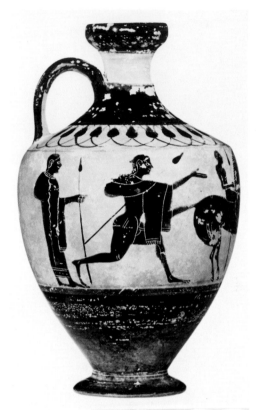

39 Right profile.

39 Front.

There are six figures on the body of the vase. In the center a boy on horseback holding a spear gallops to the right, preceded and followed by a boy running to the right. Each boy wears a fillet in his hair and a chlamys that covers his shoulders and one upper arm; each carries a spear diagonally. The boy in front of the rider looks round. This central trio is flanked, on the left, by one boy and, on the right, by two more. These bystanders wear himatia and hold spears.

The group of a rider between two runners also occurs on the hybrid lip-cup in the Louvre (Cat. 58) and the cup of type A in Mayence (Cat. 59). Oddly enough, on the lip-cup in the Louvre, the Amasis Painter has made the same mistake in the incised anatomy of the runner in front of the horse as on the lekythos seen here: by incising the groin line and the genitals, he has given that part of the body a front view, which is vitiated by the position of the wrap over both shoulders. Of his three treatments of this subject, only the runner on the Mayence cup is correctly drawn.

Early period—one of the earliest vases by the Amasis Painter.

Attributed to the Amasis Painter by E. Simon.

DIMENSIONS AND CONDITION
Height, 16.8 cm; diameter of body, 9.94 cm; diameter of mouth, 3.76 cm; diameter of foot, 5.14 cm. Height of figures, 6.0 cm. The vase is unbroken, but there is a chip on the foot, and the glaze has flaked off in places.

SHAPE AND DECORATION
Rounded mouth, glazed inside. The

39 Left profile.

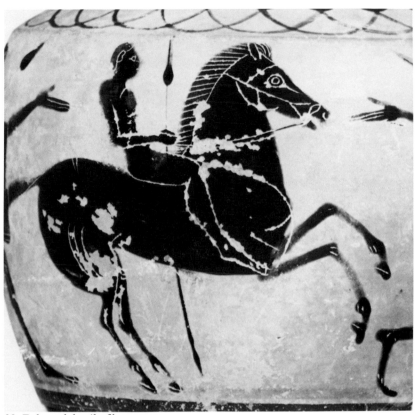

39 Enlarged detail of horseman.

neck is unglazed and is set off from the shoulder by a chamfer rather than a drip-ring. The shoulder is divided by a slight chamfer into an upper, black zone and a lower zone decorated with upright buds. The strap handle is unglazed on the underside; the outside of the handle is slightly concave. The figure-zone appears on the upper part of the body; its groundline is drawn in dilute glaze. Echinus foot, set off from the body by a narrow fillet.

ADDED COLOR
Red, lines on inside of mouth, below chamfer on neck, below figure-zone. In the figures, fillet of running boys; patch of hair on chest of rider; panels on wraps; vertical folds of himatia of bystanders; dots on himatia of bystanders on right.

BIBLIOGRAPHY
J. Burow, *CVA,* Tübingen, fasc. 3 (1980) 50, pl. 38,5 − 7 (with complete bibliography).

40 LEKYTHOS (SHOULDER TYPE)

PHILADELPHIA, UNIVERSITY OF PENNSYLVANIA,
UNIVERSITY MUSEUM, MS 4849, ACQUIRED IN 1896.

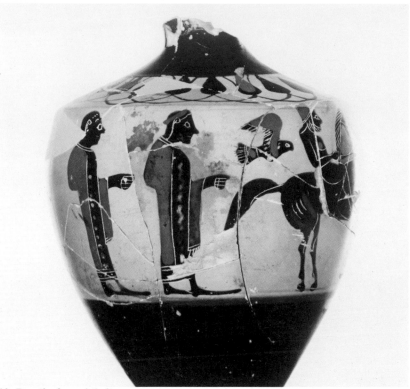

40 Detail of panel (left).

On the body, a bearded rider wearing a petasos gallops toward a winged male genius clad in a short chiton and boots. Behind the rider an eagle flies to the right. This group is flanked on the left by a pair of youths in himatia who look on, their left arms bent at the elbow and extended as if holding spears (which the painter has omitted to draw). Behind the winged youth, a male figure (his face is missing), dressed in a chlamys, runs up. Behind him is another youth, who, like his companions on the left side of the scene, is dressed in a himation and faces left.

The convention of dividing the shoulder into a black upper and an ornamented lower zone also occurs in the late period of the C Painter, who has left us three lekythoi (*ABV* 58 nos. 126 [here fig. 20], 127; Athens, N.P. Goulandris Museum

[*Cat. Christie, London, December 10, 1981,* lot 245]) that have, in the lower zone, an upright lotus-pattern with dots in the interstices. His three lekythoi should be contemporary with those by the Amasis Painter, and there are also some resemblances in the figure style: it is not that the Amasis Painter was taught by the C Painter—in the sense that he was his pupil—but there are enough similarities to reveal that the Amasis Painter was acquainted with these late lekythoi by the older painter.

Early period.

Attributed by J.D. Beazley to the Amasis Painter as a "very early" work.

Found in Orvieto in 1896.

DIMENSIONS AND CONDITION
Height as preserved, 10.25 cm; diameter of body, 9.35 cm. Height of figures,

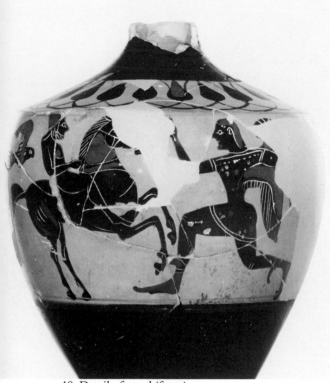

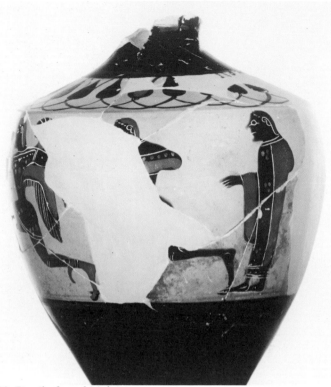

40 Detail of panel (front).

40 Detail of panel (right).

4.5 cm. The vase is broken and has been repaired. The neck and mouth are missing, and the lower part of the vase and foot are restored.

SHAPE AND DECORATION
The lekythos lacks its mouth, neck, handle (except for the stub on the shoulder), and base, but the figure-zone is almost complete. As on the other early lekythoi by the Amasis Painter, the shoulder is divided into an upper zone, glazed black, with a slight chamfer at the lower edge, and a lower one that is ornamented. In the zone on the lower part of the shoulder are nineteen upright buds, every fourth of which is opened; they are connected by tendrils. The shoulder is broken at the level of the traditional drip-ring. The lower part of the body, beneath the figure-zone, is glazed.

ADDED COLORS
Red, second, sixth, tenth, fourteenth, and eighteenth buds on shoulder; parts of himatia of three bystanders; fillet in hair of second bystander; wing bow and part of tail of eagle; petasos of rider

and hair dot on his nipple; neck of horse, two stripes on its hindquarters; hair of winged youth, his boots, wing bow, single dots on his short chiton; hair of running youth to right of winged youth, part of his chlamys.
White, row of dots on himation of first bystander; wavy line on himation of second bystander; clusters of three dots on chiton of winged youth; row of dots along red stripe on chlamys of runner; triple dots on himation of last figure.

BIBLIOGRAPHY
S.B. Luce, *University of Pennsylvania, University Museum, Catalogue of the Mediterranean Section* (Philadelphia 1921) 67, no. 68; J.D. Beazley, *ABV* (1956) 154, no. 50; D. von Bothmer, *Antike Kunst* 3 (1960) 72, pl. 4,4 – 6; idem, *MM* 12 (1971) 128, 130.

41 LEKYTHOS (SHOULDER TYPE)

PARIS, MUSÉE DU LOUVRE, F 71 (Cp 3411), ACQUIRED
WITH THE CAMPANA COLLECTION IN 1861.

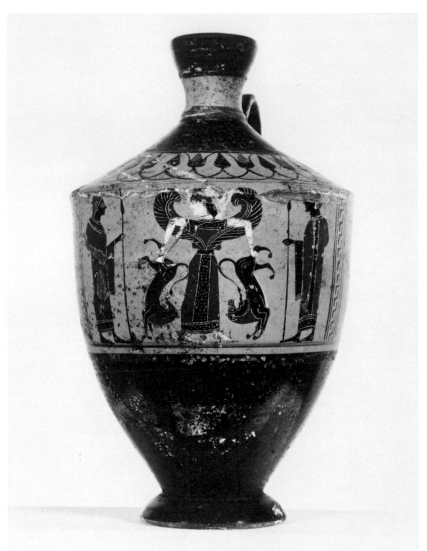

41 Front.

Artemis holds two lions upside
down by their hind legs; she stands
toward the right; her chest and
arms are rendered frontally, and her
neck and head are turned left. She
wears a belted peplos and has a fillet
in her hair; the two upright wings
are attached to her waist. On either
side of the goddess stands a youth
clad in a himation holding an
upright spear.

This is the earliest of the Amasis
Painter's representations of a
winged Artemis, the Artemis of

the Wild Beasts ($\pi\acute{o}\tau\nu\iota\alpha\ \theta\eta\varrho\tilde{\omega}\nu$),
of which there are not many Attic
examples. Sophilos was the first
to show the goddess holding two
lions upside down by their tails
(G. Bakir, *Sophilos* [Mainz 1981]
pl. 33, fig. 58), following perhaps
an Eastern tradition (see also the
early-sixth-century gem in Berlin
[L. Kahil, *LIMC* 2 (1984) pl. 445,
Artemis 36]). Kleitias shows this
winged Artemis twice on the han-
dles of the François vase (fig. 23;
ABV 76, no. 1). She is once seen

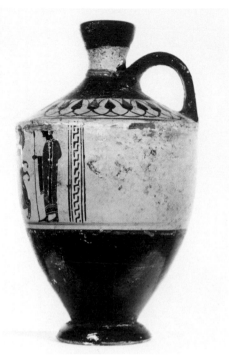

41 Left profile.

holding two lions by the scruff, the
other time holding a panther and a
stag by the neck. The earliest repre-
sentation of Artemis holding two
lions by the hind legs is known
from the neck of a Melian am-
phora from Rheneia in Mykonos
(L. Kahil, *LIMC* 2 [1984] pl. 443,
Artemis 22), a refinement that
the Amasis Painter obviously
preferred, since he used the same
scheme on the obverse of the neck-
amphora in Basel (Cat. 21—not
listed by Kahil in *LIMC*), while on
the reverse he followed Kleitias. On
the Amasis Painter's amphora in the
Faina collection in Orvieto (fig. 60;
ABV 151, no. 14), he repeated the
upside-down lion of this Louvre
lekythos and of the Basel neck-
amphora, and placed it in the right
hand of Artemis; for the deer on
Faina 40, however, which is almost
choked by her left hand, he relied
on such models as handle A/B
of the François vase (fig. 23a).
The step-pattern lateral borders
recur on the top and sides of the

Ceramicus lekythos (fig. 59; *ABV*
155, no. 61). Beazley (in *ABV*)
called the Louvre lekythos "early,"
which should be interpreted as
before the middle of the sixth cen-
tury rather than the "third quarter
of the sixth century," as Kurtz
(p. 198) writes.

Attributed to the Amasis Painter by
J.D. Beazley.

Ex coll. Marchese Giampietro
Campana.

DIMENSIONS AND CONDITION
Height, 14.4 cm; diameter of body, 8.42
cm; diameter of mouth, 2.66 cm; diam-
eter of foot, 4.32 cm; width of resting
surface, 0.52 cm; width of handle, 1.42
cm. Height of figures, 4.26 cm. The
vase is broken and has been repaired;
the losses are limited to the crown of
Artemis' head and the upper part of
the right bystander's head.

SHAPE AND DECORATION
The mouth is rather straight and has a
rounded edge; the inside is entirely
glazed. The flat strap handle is glazed
streakily on the underside; there is a
drip-ring between the shoulder and
unglazed neck. The shoulder has a
slight chamfer above and below the
black zone. On the lower half of the
shoulder is a zone of twenty-six
blossoms and buds; the buds are all
black, while the half-opened blossoms
have red centers. The panel begins un-
der the ninth bud and ends under the
twentieth bud. It occupies the upper
part of the body and is framed on the
sides by a vertical step-pattern set
between double glaze lines. Echinus
foot.

ADDED COLORS
Red, top of mouth; stripe inside mouth;
line below drip-ring; alternate buds;
line below figure-zone; line at base; line
on edge of foot; hair of bystanders; en-
tire himation of left youth; fillet of
Artemis, her wing bows, part of her
peplos; manes of lions, markings be-
hind their shoulders, stripes on their
haunches; parts of himation of right
youth. *White,* flesh of Artemis, row of
dots above ornamental lower border of

her peplos; teeth and belly stripes of
lions; row of dots above lower border
of left youth's himation; vertical step-
pattern on central panel of himation
worn by right bystander.

The necklace and bracelets of
Artemis are incised, and an incised
fringe appears on the fold of the hima-
tion over the arm of the right-hand
youth.

BIBLIOGRAPHY
E. Pottier, *Vases antiques du Louvre*
2 (Paris 1901) 98, no. F 71, pl. 69;
G. Radet, *REA* 10 (1908) 137, fig. 45;
J.D. Beazley, *ABS* (1928) 35, no. 34;
C.H.E. Haspels, *ABL* (1936) 10 – 11,
pl. 3,2; E. Vanderpool, *Hesperia* 8 (1939)
251 – 252, fig. 9; J.D. Beazley, *ABV*
(1956) 154, no. 49; S. Karouzou, *The
Amasis Painter* (Oxford 1956) 7, 35, no.
52; K. Schauenburg, *JdI* 79 (1964) 132,
fig. 17; D.C. Kurtz, *Athenian White
Lekythoi: Patterns and Painters* (Oxford
1975) 7, 77, n. 9, 198; L. Kahil in *LIMC* 2
(1984) 626, no. 34, pl. 445, Artemis 34.

42 Lekythos (Shoulder Type)

Paris, Musée du Louvre, F 192 (Cp 3262), acquired with the Campana collection in 1861.

The composition shows a naked boy running to the right between two sphinxes that face toward the center; the right sphinx has raised its right front leg. This trio is flanked, on the left, by another running youth or boy (his face is missing) and, on the right, by a bystander—a male figure (his head is gone) clad in a himation and holding an upright spear. The youth or boy on the left wears a chlamys over his shoulders and his left upper arm; his right arm is held under his cloak.

This picture shares much with the compositional scheme of the Amasis Painter's Vogelsanger lekythos in Zurich (fig. 98; *Paralipomena* 66), which instead of two sphinxes has two lionesses. The Vogelsanger lekythos has upright blossoms and buds on the shoulder and must be a bit later. Welcome synchronisms for the runners are furnished by the lekythos in Tübingen (Cat. 39) and the cup in Mayence (Cat. 59), and all three vases are from the nucleus of what might be styled the earliest vases by the Amasis Painter, around 560 B.C.

Connected by C.H.E. Haspels with the Amasis Painter and attributed to the painter himself by J.D. Beazley.

Ex coll. Marchese Giampietro Campana.

Dimensions and Condition
Height, 14.76 cm; diameter of body, 9.34 cm; diameter of mouth, 3.02 cm; diameter of foot, 3.78 cm; width of resting surface, 0.53 cm; width of handle, 1.63 cm. Height of figures, 5.1 cm. The vase is broken and has been repaired; there are some losses, notably the face of the runner on the left and the head, neck, and chest of the bystander on the right.

Shape and Decoration
The mouth is rounded on top; its inside and that of the neck are entirely glazed.

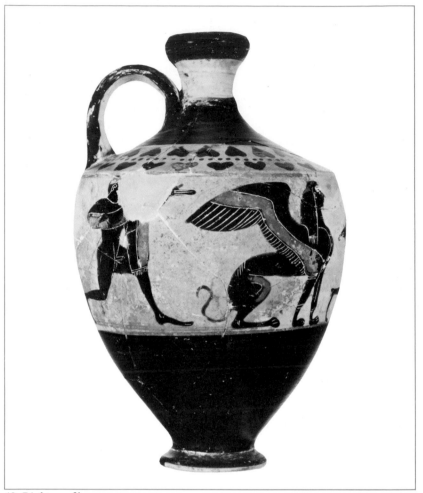

42 Right profile.

The underside of the flat strap handle is unglazed. The shoulder, set off from the unglazed neck by a ridge, is divided by a chamfer into an upper black zone and a lower one decorated with a two-row ivy "wreath" with nineteen leaves on the top and twenty-two on the bottom; between the leaves is a row of seventy-one glaze dots; in each row of leaves, five are red, the others black. The figure-zone appears on the upper part of the body and has a faint double ground-line drawn in dilute glaze. The lower part of the body and the outside of the foot, except for its very edge, are glazed.

Added Colors
Red, lines on edge of mouth and top of shoulder at junction of neck; ten of ivy leaves; half of chlamys of left runner;

his hair; fillets; pupils; wing bars; stripes along contours of hind legs of sphinxes; hair and hair circle around nipple of naked running boy; back panel and fold over arm of bystander's himation. *White,* face, neck, and chest of sphinxes, lower borders of their wing bars; inner edge of red on vertical panel of chlamys of left runner; line running down middle of front panel of bystander's himation.

The necklaces of the sphinxes are rendered by two incised lines.

Bibliography
C.H.E. Haspels, *ABL* (1936) 12; J.D. Beazley, *ABV* (1956) 154, no. 52; D. von Bothmer, *Antike Kunst* 3 (1960) 72 and n. 16; J.-M. Moret, *Oedipe, la sphinx et les Thébains* (Geneva 1984) 90, n. 11, pl. 64,1–2.

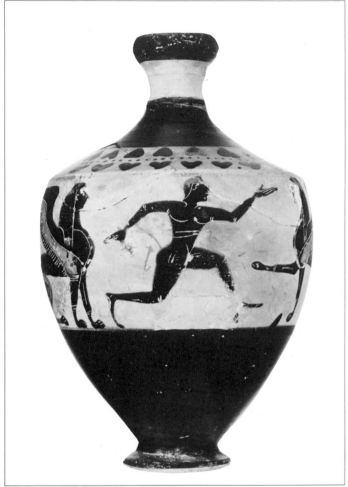

42 Front.

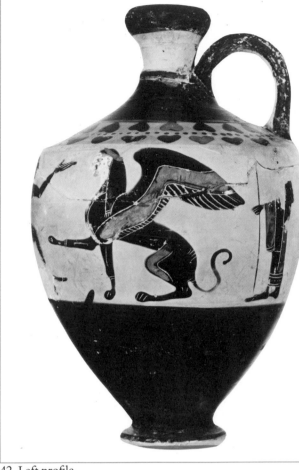

42 Left profile.

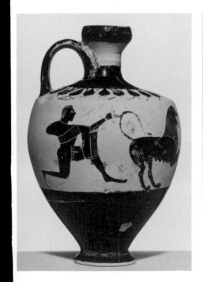
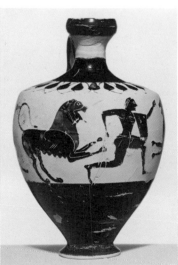
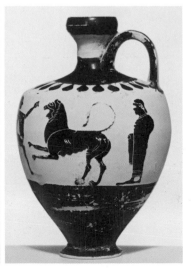

Fig. 98a,b,c. Lekythos (shoulder type). Attributed to the Amasis Painter. Zurich, collection of R. Vogelsanger.

43 LEKYTHOS (SHOULDER TYPE)

PARIS, MUSÉE DU LOUVRE, Cp 10520, ACQUIRED
WITH THE CAMPANA COLLECTION IN 1861.

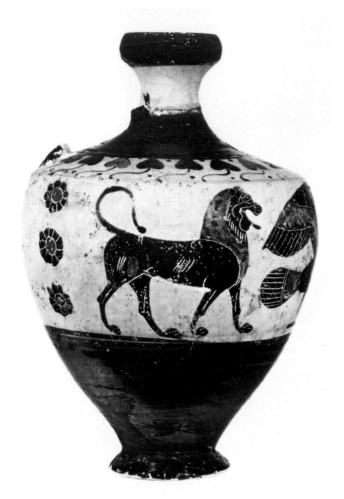

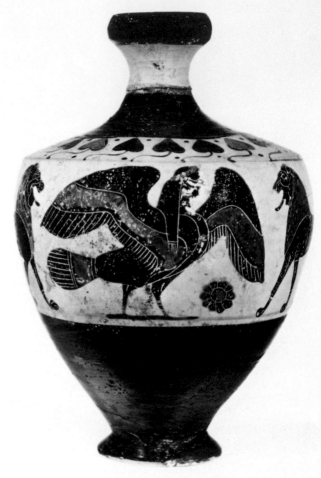

43 Right profile.

43 Front.

The subject is a siren, her wings spread, who stands facing right, flanked by a roaring lion on each side. She wears a fillet in her hair; below her left wing is a rosette. The lions are somewhat sturdier than the lionesses on the Amasis Painter's Vogelsanger lekythos in Zurich (fig. 98; *Paralipomena* 66).

This Louvre lekythos is among the earliest by the Amasis Painter; the hair of the siren and the contours of her right wing are very close to the corresponding details in the sphinxes on the lekythos Louvre

F 192 (Cat. 42), which Beazley (in *ABV*) has called "very early."

Attributed to the Amasis Painter by D. von Bothmer.

Ex coll. Marchese Giampietro Campana.

DIMENSIONS AND CONDITION
Height, 13.62 cm; diameter of body, 9.13 cm; diameter of mouth, 3.195 cm; diameter of foot, 3.8 cm; width of resting surface, 0.66 cm; width of handle (at stub), 1.55 cm. Height of figures, 4.64 cm. The vase is broken and has been repaired; half of the foot is restored. The handle is missing. The glaze is pitted in places.

SHAPE AND DECORATION
The rounded mouth, glazed inside to a depth of 2.34 cm, comes to an edge on top; the neck is unglazed and is set off from the shoulder by a chamfer rather than a drip-ring. The shoulder is divided into an upper zone, glazed black, and a lower one, decorated with sixteen ivy leaves on curving stems, with dots between the points of the leaves and the stems. For the curvilinear stems of the ivy leaves, compare the lekythos in Centre Island (Cat. 44). A seventeenth stem, near the handle, has no leaf, as the handle (now missing) was joined to the shoulder at that point. The upper and lower zones of the shoulder are separated by a chamfer. Of the

176

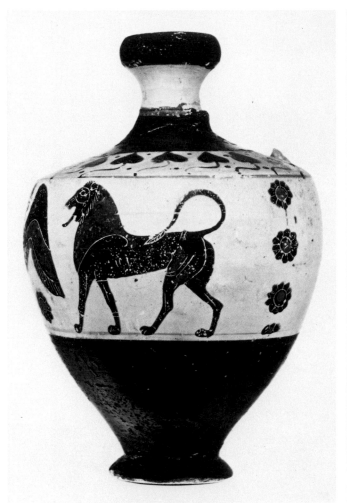

43 Left profile.

43 Back.

sixteen drawn leaves, the third, seventh, eleventh, and fourteenth are red. The figure scene appears on the upper part of the body, loosely framed on the sides by vertical rows of rosettes, three on the left and three and a half on the right. These rows of rosettes bring to mind the right-hand border of the Kanellopoulos lekythos in Athens by the Amasis Painter (fig. 38; *Paralipomena* 66) and the panel borders of the rather globular neck-amphora London B 49 (*ABV* 326, 715; M. Robertson, *A History of Greek Art* [London 1975] pl. 35d). The groundline is drawn in dilute glaze.

ADDED COLORS
Red, edge of mouth; line on top of shoulder; four of sixteen ivy leaves; manes of lions, stripes on their haunches

(one on left lion, two on right lion); wing bars and tail bar of siren, fillet in her hair; cores of all rosettes. *White,* face, neck, and chest of siren; border stripes below red bands on wing bars; belly stripes and teeth of lions.

BIBLIOGRAPHY
Not previously published.

The subject on the body of this vase is a youth running to the right, a chlamys over his extended left arm; his raised right hand holds a spear diagonally, with which he menaces a fleeing man, nude except for a chlamys over his shoulders and upper arms. The left hand of the man is clenched in a fist and may have held a spear. On his head he wears a petasos. To the right of him, an unarmed youth rushes to the left; he is nude except for a chlamys slung over his upper left arm. The trio is flanked by two onlookers: on the left, a man clad in a himation and chiton holding a spear; on the right, a youth, also equipped with a spear or staff, who wears only a himation.

This lekythos, as Beazley has noted (in *ABV*), belongs to the Amasis Painter's "very early" group. Its composition is a forerunner of the separated combat on the lekythos from Vari in Athens (fig. 99; *ABV* 714 under pp. 150 – 158, no. 61 bis; *Paralipomena* 64, no. 61 bis). The curved stems of the ivy leaves also occur on Louvre Cp 10520 (Cat. 43), but there the leaves are single, not connected to a wreath, and the painter has placed glaze dots between each leaf on top and placed flanking dots beside each root of the stems below. In shape, this lekythos is already more developed than the earlier lekythos Louvre F 71 (Cat. 41).

Attributed by J.D. Beazley to the Amasis Painter as a very early work.

Ex coll. Mirko Ros, Baden (near Zurich).

DIMENSIONS AND CONDITION
Height, 16.3 cm; diameter of body, 9.9 cm; diameter of mouth, 3.27 cm; diameter of foot, 4.46 cm; width of resting surface, 0.73 cm. The vase is chipped and flaked in places. The unpainted surface is much eroded, so

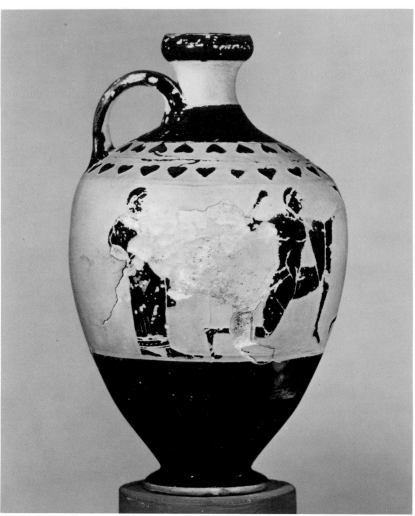

44 Right profile.

that the glazed parts stand out in low relief. The glaze has fired a reddish brown in places.

SHAPE AND DECORATION
Convex mouth, coming to an edge on top; flat strap handle; slight chamfer on shoulder at lower edge of black glaze zone and at neck on its upper edge; the inside of the mouth is glazed to a depth of 2.25 cm. The lower part of the body, below the figure-zone, is glazed, as is the outside of the echinus foot, except for the very edge. The lower zone on the shoulder is decorated with an ivy "wreath" running left and consisting of eighteen leaves above and twenty-one below; they are alternately red and black and are connected to the main branch by curved stems.

ADDED COLORS
The accessory colors are almost completely gone. *Red*, alternate ivy leaves; himatia; stripes on chlamides; hair circles around nipples of attacking youth; circle on inside of edge of mouth. *White*, chiton of left onlooker and (perhaps) folds on chlamides of fleeing man and youth on right.

BIBLIOGRAPHY
J.D. Beazley, *ABV* (1956) 154, no. 55; D. von Bothmer, *Antike Kunst* 3 (1960) 73, 80, pl. 5, figs. 4, 5; *Auktion Galerie Fischer, Lucerne, December 5, 1963*, 23, no. 389; *Münzen und Medaillen A.G., Basel, Sonderliste G: Attische schwarzfigurige Vasen* (Basel, November 1964) 16, no. 22 (with illustrations, p. 17); J.D. Beazley, *Paralipomena* (1971) 64, no. 55.

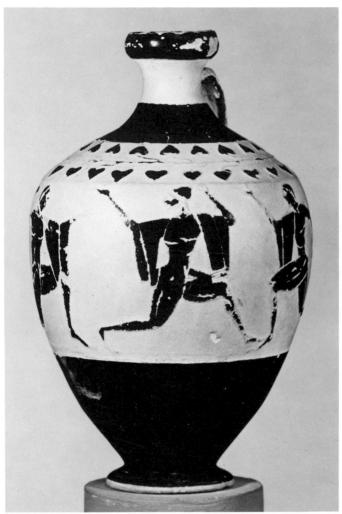

44 Front.

44 Left profile.

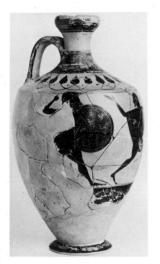
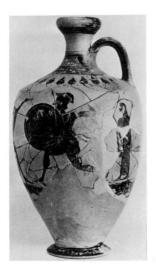
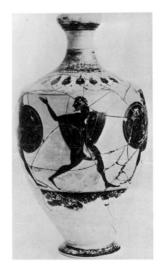

Fig. 99a,b,c. Lekythos (shoulder type).
Attributed to the Amasis Painter. Athens,
National Museum, 19163.

45 Fragment of a Lekythos (Shoulder Type)

BOSTON, MUSEUM OF FINE ARTS, 86.594 (N. 187),
GIFT OF EGYPT EXPLORATION FUND, 1886.

46 Lekythos (Shoulder Type)

PARIS, MUSÉE DU LOUVRE, E 718 (Cp 540; S 3965),
ACQUIRED WITH THE CAMPANA COLLECTION IN 1861.

45 Fragment.

All that is left are the head and left forearm with part of a chlamys of a youth, facing left.

Of the many lekythoi by the Amasis Painter, the Boston fragment is closest in scale and composition to such lekythoi as Leningrad inv. 2635 (fig. 64; *ABV* 154, no. 56; *Paralipomena* 64, no. 56; K.S. Gorbunova, *Hermitage* [1983] 32 – 34, no. 15), and the preserved head and arm of a youth must belong to the second figure from the right in a scene that comprised at least five figures converging toward the center from both sides.

Early Period.

Attributed to the Amasis Painter by J.D. Beazley.

From Naucratis.

DIMENSIONS
Height as preserved, 3.43 cm; width as preserved, 4.43 cm; thickness of wall of sherd, 0.475 cm.

SHAPE AND DECORATION
The shape is that of the Amasis Painter's standard lekythos. The lower part of the shoulder is decorated with a frieze of upright buds—whether with or without dots in the interstices cannot be ascertained, as the fragment is broken off below the area where such dots might occur.

ADDED COLOR
Red, fillet.

BIBLIOGRAPHY
E. Robinson, *Museum of Fine Arts Catalogue of Greek, Etruscan, and Roman Vases* (Boston 1893) 233, no. N 187; A. Fairbanks, *Museum of Fine Arts Catalogue of Greek and Etruscan Vases* (Boston 1928) 128, no. 356,2, pl. 39; J.D. Beazley, *JHS* 51 (1931) 265 – 267, fig. 10; C.H.E. Haspels, *ABL* (1936) 11; J.D. Beazley, *ABV* (1956) 155, no. 60; D. von Bothmer, *Antike Kunst* 3 (1960) 72.

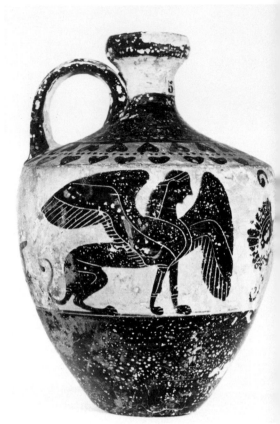

46 Right profile.

In the figure-zone of this vase, two sphinxes are placed heraldically around a palmette-lotus cross. The sphinx on the left has a fillet in its hair.

While the sphinxes do not differ much from those on Louvre F 192 (Cat. 42), the attenuated palmette-lotus cross gives the vase a somewhat later look, as does the separation of neck and shoulder, which is less pronounced than in his earlier lekythoi. Still "very early," as Beazley said, but not among the earliest.

Connected by C.H.E. Haspels with the Amasis Painter and attributed by her to the same hand as Louvre F 192 (Cat. 42).

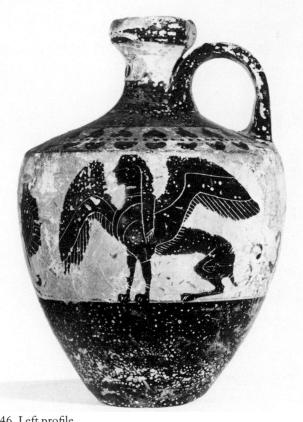

46 Front.

46 Left profile.

Attributed by J.D. Beazley to the Amasis Painter himself.

Ex coll. Marchese Giampietro Campana.

DIMENSIONS AND CONDITION
Height as preserved, 12.8 cm, diameter of body, 8.91 cm; diameter of mouth, 2.92 cm; width of handle, 1.49 cm. Height of figures, 4.745 cm. The base of the lekythos and its foot are missing. The glaze has suffered from erosion.

SHAPE AND DECORATION
Convex mouth coming to an edge on top. The inside of the mouth and neck are glazed; the underside of the flat strap handle is reserved. The neck is not set off very markedly from the shoulder, and the drip-ring of the earlier lekythoi has all but disappeared; the shoulder is divided by a chamfer into an upper black zone and a lower one that is

ornamented. As on Louvre F 192 (Cat. 42) and the lekythos in Mykonos (*ABV* 154, no. 51), the floral shoulder ornament is formed by a two-row ivy "wreath" of nineteen leaves above and twenty-three below, separated by seventy-eight dots that are meant to simulate the central stem of a wreath. The groundline of the figure-zone is drawn in dilute glaze.

ADDED COLORS
Red, six ivy leaves in top row and probably eight in bottom row (the first two red ones and the last are certain). Fillet in hair of left sphinx; wing bars of both sphinxes. *White,* face, neck, and chest line on each sphinx.

BIBLIOGRAPHY
C.H.E. Haspels, *ABL* (1936) 12;
J.D. Beazley, *ABV* (1956) 154, no. 53;
K. Schauenburg, *JdI* 79 (1964) 126.

47 LEKYTHOS (SHOULDER TYPE)

NEW YORK, THE METROPOLITAN MUSEUM OF ART, 56.11.1,
GIFT OF WALTER C. BAKER, 1956 (COLOR PLATE 4).

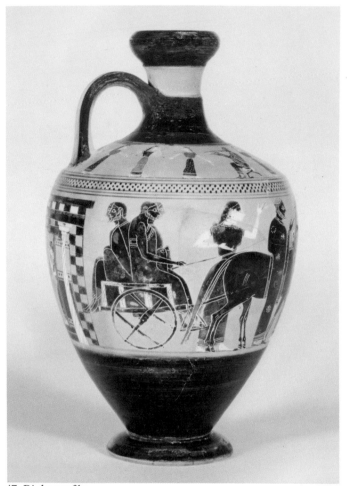

47 Right profile.

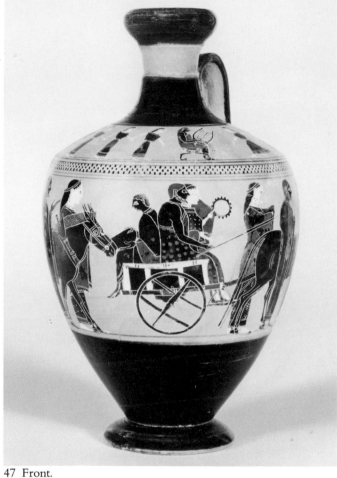

47 Front.

The lower part of the shoulder is painted with scenes of a dance. On the left, three girls hold hands and approach a flute player seated on a campstool. The first girl looks round at her companions. Behind the flute player another trio walks toward a lyre player seated on a campstool; he faces the third group of three girls, who approach him rapidly with long strides. All the girls wear peploi, earrings, and fillets in their hair; the musicians wear himatia.

The main scene, on the body, represents a wedding procession of the bride and groom and the best man, the parochos; they are seated

in the lead cart, drawn by two donkeys, and are followed by a mule cart with four guests likewise seated. Beside each team two women and a man walk in the wedding procession, with the women on the left side of the team and the man on the right. The woman in the lead, next to the yoke of the team of donkeys, holds two torches, which indicates that the procession takes place after nightfall. Their destination is the house of the bridegroom, shown in summary fashion directly below the handle. Its two doors are open, and through them we catch a glimpse of the interior, in which another woman (drawn on a smaller scale and half hidden by

the wall) approaches to the left, a torch in her left hand, her right hand raised in a gesture of greeting. She must be the mother of the groom.

The wedding procession on this lekythos by the Amasis Painter stands in marked contrast to most other wedding scenes known from Attic black-figure. Starting with the nuptials of Peleus and Thetis and the cortege of Olympian wedding guests—as on the François vase in Florence (*ABV* 76, no. 1) and the Sophilos dinos in London (*Paralipomena* 19, no. 16 bis)—the bridal vehicle is not a mule or donkey cart,

182

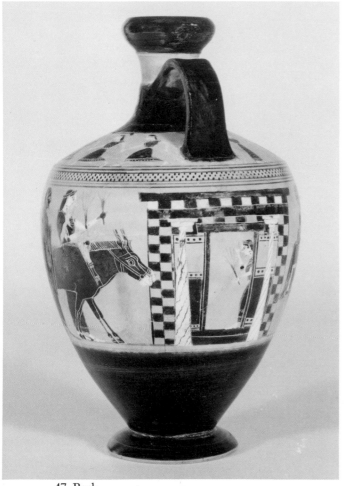

47 Back.

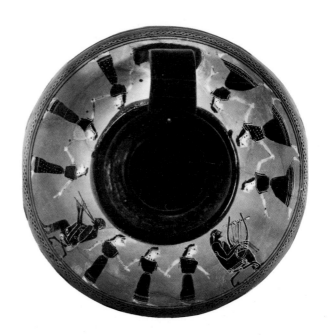

47 Shoulder from above.

but a four-horse chariot. Even if the identity of the couple often eludes us, sixth-century processions are normally accompanied by gods. The chariots are driven by the groom, who holds the reins: on the lekythos shown here, however, there are no reins, and the drivers merely hold long goads. Since the drawing is exceptionally careful in every detail, the absence of reins cannot be an oversight but must reflect an actual practice, and it is not without interest that we recall that the ancient lexicographers are quite explicit about the bridal chariot in which the bride, the groom, and the parochos sat. The lekythos

gives not only our earliest, but also our fullest representation of an Attic wedding, which probably took place in the country rather than in the city. The white columns on the porch of the bridegroom's house may well be wooden columns, and the incised spirals are sheer decoration, as opposed to the spiral fluting on the shaft of a column on the Heidelberg Painter's cup in Taranto (*ABV* 66, no. 55). For a later mule cart with two women seated back to back and greeted by a man on foot, compare the lekythos by the Gela Painter in Giessen (fig. 100).

Middle period.

Attributed by D. von Bothmer to the Amasis Painter.

DIMENSIONS AND CONDITION
Height, 17.3 cm; diameter of body, 10.6 cm; diameter of mouth, 3.7 cm; diameter of foot, 5.2 cm; width of resting surface, 0.875 cm. Height of figure-zone on body (without frame), 5.96 cm. The vase is broken and has been repaired; there are only insignificant losses along the fractures. Part of the white in the columns of the porch has been retouched.

SHAPE AND DECORATION
Convex mouth, rounded on top; flat strap handle. There is a slight chamfer on the shoulder at the lower edge of the

black glaze zone and on the neck at its upper edge; the inside of the mouth is glazed to a depth of 2.7 cm. The lower part of the body, below the figure-zone, is glazed, as is the outside of the echinus foot, except for the very edge. The figure scene on the lower part of the shoulder is separated from the scene on the body by a band of dicing, bordered above and below by three glaze circles; the band goes all the way around the vase.

ADDED COLORS
Red, on the shoulder, fillets in hair of dancing girls, parts of their peploi; short hair of flute player; long hair of lyre player; stripes on folds of himation of flute player; entire himation of lyre player. On the body, hair of two men accompanying carts on foot; hair of groom and best man; peploi of women walking beside teams; lower part of peplos of bride, the inside of her veil; dots on himation of groom; stripe on himation of best man and cores of dot-rosettes on his himation; dots on stripes on himatia of two nearer men in second cart; part of himation of man walking beside donkeys drawing leading cart; overfold, horizontal border, and center of dot-rosettes on himation of man

walking beside mules. Part of harness of team of mules; tails of mules; peplos and diadem of mother of groom; fillets in hair of walking women. *White,* on the shoulder, all female flesh; dots on himation of flute player; roundels on two campstools; horizontal protrusions of crossbar of lyre; on the body, columns of porch and alternating squares in "metopes" of entablature of house; muzzles of donkeys; frames of two carts; round fastenings of halters of both teams; dots around red cores of dot-rosettes on himatia of men.

BIBLIOGRAPHY
MMA Bulletin 15 (1956 – 1957) 54 – 55 (ill.); D. von Bothmer, *Gnomon* 29 (1957) 538; G.M.A. Richter, *A Handbook of Greek Art* (London 1959) 323 – 324, fig. 437; D. von Bothmer, *Antike Kunst* 3 (1960) 73 – 74, 80, pl. 7,1 – 3; A. Greifenhagen, *JdI* 75 (1960) 84, n. 2; E. Simon, *Antike Kunst* 6 (1963) 16, n. 57; H. Metzger, *Recherches sur l'imagerie athénienne* (Paris 1965) 63, n. 4; L. Beschi, *Annuario della Scuola Archeologica di Atene e delle missioni italiane in Oriente* 47 (1969) 92, fig. 2; F. Villard in J. Charbonneaux, R. Martin, and F. Villard, *Archaic Greek Art* (London 1971) 87, figs. 94, 95; J.D. Beazley,

Paralipomena (1971) 66; D. von Bothmer, *MMA Bulletin,* ser. 2, vol. 31 (1972 – 1973) 22 – 23, no. 8 (ill.); V. Karageorghis in *Excavations in the Necropolis of Salamis* 3 (Nicosia 1973) 75, fig. 14,2; J. Boardman, *ABFV* (1974) fig. 77,1 – 2; J. Macintosh, *RM* 81 (1974) pt. 1 text, 30, pl. 16,2; G.A. Christopoulos, *The Archaic Period* (Athens 1974) 457, fig. 242; R. Bianchi-Bandinelli, *L'arte dell'antichità Classica: Grecia* (Turin 1976) fig. 291; I. Krauskopf, *AA* 1977, 25, n. 26; E.A. Carmean and E.E. Rathbone, *American Art at Mid-century: The Subjects of the Artist* (Washington, D.C., 1978) 235, fig. 29; S.R. Roberts, *The Attic Pyxis* (Chicago 1978) 18, 180 – 181, fig. 98,1; P. Oliver-Smith, *Architectural Elements on Greek Vases before 400 B.C.* (Ann Arbor, Mich.: University Microfilms International, 1980) 49, n. 41; H. Ebertshäuser and M. Waltz, *Antiken* 1 (1981) 79, fig. 92; R.F. Sutton, *The Interaction between Men and Women Portrayed on Attic Red-figure Pottery* (Ann Arbor, Mich., 1982) pl. 9, fig. 111; C. Bérard in *La cité des images* (Lausanne 1984) 96, fig. 137.

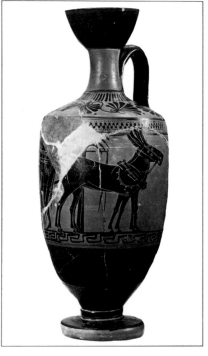

Fig. 100a,b. Lekythos. Attributed to the Gela Painter. Giessen, University.

48 LEKYTHOS (SHOULDER TYPE)

NEW YORK, THE METROPOLITAN MUSEUM OF ART,
31.11.10, FLETCHER FUND, 1931.

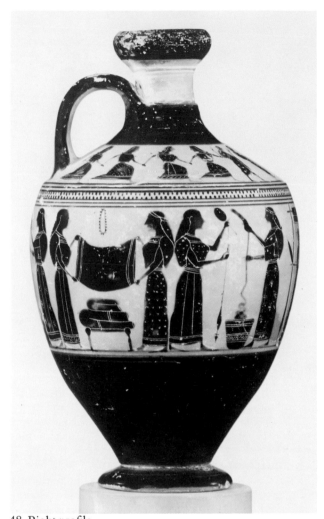

48 Right profile.

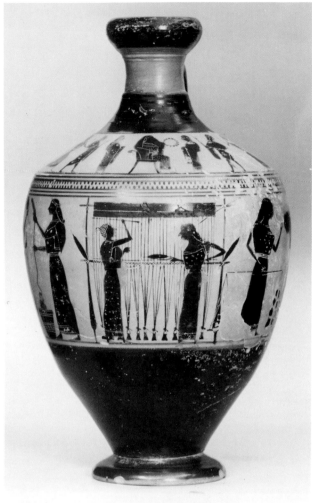

48 Front.

In the center of the shoulder frieze, a goddess or priestess clad in a peplos and veil is seated on a throne, the back of which terminates in a swan's head. In her left hand she holds a wreath. This figure is flanked by two standing youths dressed in himatia; a third youth, who also wears a himation, approaches from the left, while a fourth youth, approaching on the right, wears a chlamys and turns his head back at four dancing girls who are holding hands; a similar quartet on the left rushes up: the leader of each group looks back at her com-panions. The dancing girls wear peploi and fillets in their hair. A band of dicing, framed by three glaze circles above and below, separates the scene on the shoulder from the main figure-zone, on the body.

On the body, women engaged in wool working are shown in several stages. Two women (to the right of the loom) perform the first step, which consists of weighing the wool taken from a wool basket, the kalathos, and putting it in the right pan of a scale that is held by the first woman; the scale is even, and the controlling weight is indicated on the left pan. This operation is supervised by a third woman, who gestures with both hands. Between this woman and the loom are shown six women in three pairs. The central group has two women folding the finished cloth on a low stool, while the two flanking pairs show women spinning. The artist has distinguished the thickness of the thread as well as the types of the distaffs employed: the woman seated on the throne (of the same type as the throne on the shoulder) and the companion facing her, as well as the last spinner with her back to the loom, spin coarser yarn,

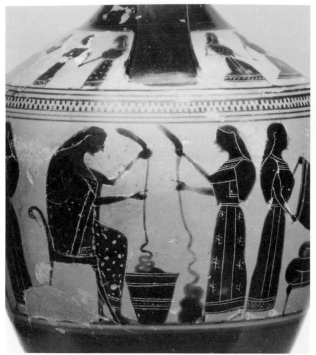

48 Detail of back.

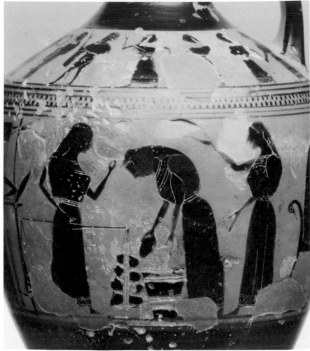

48 Detail of left side.

employing a primitive distaff and drawing directly from the wool basket or a heap of wool on the ground, while the standing girl or woman facing the last spinner uses a standard distaff, a spindle, and a whorl in the preparation of very fine thread.

The most intriguing aspect of this workshop is the upright loom shown in the center of the frieze. The finished portion of the woven material is shown rolled up on top. The girl on the left pushes the weft thread, which has been passed between the threads of the warp, against the finished texture, while her companion separates the warp threads with a heddle rod in preparation for the passage of another weft thread; the shuttle is temporarily wedged between the vertical warp. Two additional shuttles are attached to the frame of the loom at the ends of the crossbar. The ends of the warp are tied together into groups of four threads and weighted down with loom weights.

The lower body of the girl on the right faces right, while her upper body and head face left: both she and her companion are drawn on the smaller scale imposed by the horizontal of the woven fabric above their heads, which reduces the available space. All the women wear peploi and fillets in their hair. In addition, the seated woman wears a shawl.

This lekythos is reliably reported to have been found together with the other lekythos in New York, which shows a wedding procession (Cat. 47), and the two do look like a pair made by the same potter and painted by the same painter in the same month, if not on the same day. The differences in dimensions and profiles are very slight, and the scheme of decoration is identical. The only appreciable discrepancy between the two lies in the height of the figure-zones: on the wedding vase, the figures on the body are

somewhat bigger than on the wool-working vase; conversely, the dancers on the shoulder of the wedding lekythos are a little smaller than the corresponding figures on the other vase. The two vases are, moreover, united by the subjects on the shoulder. Mrs. Karouzou (p. 44) thought that the dance on this vase was in celebration of the weaving of the panathenaic peplos, but the similar dance on the wedding lekythos should be related to the marriage scene shown there, which is not connected with a religious festival. (For a late Corinthian upright loom, compare the fragment of a column-krater in the museum in Corinth [C-72-40; C.K. Williams II and J.E. Fisher, *Hesperia* 42 (1973) pl. 8, fig. 13A]).

Middle period.

Attributed to the Amasis Painter by J.D. Beazley.

DIMENSIONS AND CONDITION
Height, 17.1 cm; diameter of body, 9.9 cm; diameter of mouth, 3.55 cm;

48 Shoulder from above.

diameter of foot, 4.95 cm; width of resting surface, 0.998 cm. Height of figure-zone on body (without frame), 5.26 cm. The vase is unbroken, but it has chipped and flaked in places. The accessory colors have all but disappeared.

SHAPE AND DECORATION
Convex mouth, rounded on top; flat strap handle; slight chamfer at upper and lower edges of the black glaze shoulder-zone; the inside of the mouth is glazed to a depth of 0.176 cm; the lower part of the body, below the figure-zone, is glazed, as is the outside of the echinus foot, except for the very edge.

ADDED COLORS
Red, on the shoulder, parts of peploi, veil, himatia, and chlamys; fillets of seated figure and dancing maidens;

hair of two flanking youths and youth in chlamys. On the body, parts of all peploi; dots on shawl of seated woman; dots on cloth being folded; stripes on lower folded cloth on stool; unrolled portion of cloth being woven. *White,* all female flesh.

BIBLIOGRAPHY
G.M.A. Richter, *MMA Bulletin* 26 (1931) 291ff., figs. 4, 5; H. Faxon, ibid., 27 (1932) 70 – 71, figs. 1, 2; *MMA Daily Life* (New York 1933) 41, fig. 47; *MMA Guide* (New York 1934) pt. 1, 28; A.J.B. Wace, *AJA* 38 (1934) 111, n. 3; M. Bieber, *Entwicklungsgeschichte der griechischen Tracht* (Berlin 1934) 24, pl. 1,1; G.M.A. Richter and M.J. Milne, *MMA: Shapes and Names of Athenian Vases* (New York 1935) fig. 93; C.H.E. Haspels, *ABL* (1936) 12, 14, 99; A. Rivier, *La vie d'Achille...illustrée par les vases grecs* (Lausanne 1936) 106, fig. 40; G.M. Crowfoot, *BSA* 37 (1936 – 1937) 41, fig. 3, pl. 6; H.C. Broholm and

M. Hald, *Costumes of the Bronze Age in Denmark* (Copenhagen 1940) 117 – 120; *MMA Guide* (New York 1939) 31; M. Bieber, *AJA* 46 (1942) 153; G.R. Davidson and D.B. Thompson, *Hesperia,* supp. 7 (1943) 67; *Materialy... Archeologii SSSR* 25 (1952) 405, fig. 3; G.M.A. Richter, *MMA Handbook of the Greek Collection* (New York 1953) 58, n. 3, fig. 37,1; C.H.E. Haspels, *BABesch* 29 (1954) 6; C.J. Singer and E.J. Holmyard, *A History of Technology* 1 (New York 1954) 444, fig. 281; S. Karouzou, *The Amasis Painter* (Oxford 1956) 43 – 44, pl. 43, pl. 44,1; J.D. Beazley, *ABV* (1956) 154, no. 57; A. di Vita, *Archeologia classica* 8 (1956) 40ff., pl. 15,1; D. von Bothmer, *Gnomon* 29 (1957) 538; idem, *Antike Kunst* 3 (1960) 74, 80; R.T. Williams, *Antike Kunst* 4 (1961) 28, n. 7; Lady Evans and E.B. Abrahams, *Ancient Greek Dress* (Chicago 1964) fig. 4; C.M. Bowra, *Classical Greece* (New York 1965) 86 (ill.); G.M.A. Richter, *MMA Journal* 3 (1970) 84, 97, fig. 3; F. Villard in J. Charbonneaux, R. Martin, and F. Villard, *Archaic Greek Art* (London 1971) 86, figs. 92, 93; B.A. Sparkes, *JHS* 92 (1972) 250; C.K. Williams II and J.E. Fisher, *Hesperia* 42 (1973) 13; G.A. Christopoulos, *The Archaic Period* (Athens 1974) 462 – 463, figs. 248, 249; E. Simon, *Convegno di Studi sulla Magna Grecia* 16 (1976) 472; I. Krauskopf, *AA* 1977, 22, n. 18; D.L. Carroll, *Patterned Textiles in Greek Art* (Ann Arbor, Mich., 1980) 343, no. 300; B.K. McLauchlin, *AJA* 85 (1981) 80, n. 14; L. Campus, *Ceramica attica a figure nere* (Rome 1981) 4; C. Bérard in *La cité des images* (Lausanne 1984) 84, fig. 123.

49 LEKYTHOS (SHOULDER TYPE)

LONDON, THE BRITISH MUSEUM, B 548
(1873. 8-20.299), ACQUIRED IN 1873.

The scene shows Apollo and Artemis in a Delian setting, characterized by the palm tree. On the extreme left hangs a fillet with glaze dots. Apollo, clad in a chiton and a fringed himation over his left shoulder and arm, holds out a lyre in his raised left hand; in front of his legs is shown a campstool covered with a cushion. The palm tree has six fronds and two clusters of dates; in front of it a small deer stands to the right, facing Artemis.

The goddess is dressed in a belted peplos with a wrap over her shoulders and upper arms. Her hair is tied up in a krobylos. On her back she carries a quiver with four arrows; a fifth arrow is held in her left hand, and with her right hand she holds the bow.

In shape and scheme of decoration this lekythos is closest to the Montclair lekythos (Cat. 50). In its composition it also resembles the Vatican oinochoe (Cat. 38).

Middle period, early.

Related to the Amasis Painter by C.H.E. Haspels. Attributed to him by J.D. Beazley.

From Athens.

DIMENSIONS AND CONDITION
Height, 14.8 cm; diameter of body, 8.4 cm; diameter of mouth, 3.6 cm; diameter of foot, 4.75 cm; width of resting surface, 0.77 cm. Height of figures, 5.8 cm. The neck is broken off and has been reattached.

SHAPE AND DECORATION
The rounded mouth is glazed on the outside and the inside. Instead of a dripring, the lekythos has a slight chamfer at the junction of the neck and shoulder. The flat strap handle is glazed on the outside only. Echinus foot. The shoulder is divided into an upper black zone and a lower zone decorated with twenty-one upright buds, with twenty dots in the spandrels below each bud and twenty teardrops in the interstices

49 Left side of panel.

between and below the buds; an extra teardrop appears at the beginning of the ornament to the left of the first bud, and there is an extra dot on the extreme right, to the right of the last bud.

As on the similar lekythos in Montclair (Cat. 50), the back view of the vase is not left unpainted but is decorated with three vertical panels well separated from one another. The figure-zone is neatly framed on each side by a panel filled with twelve diagonal zigzags (cf. also the zigzags on Cats. 3, 18, 19, 52). Between these panels and directly below the handle, a third panel

is decorated with a vertical ivy branch with eight ivy leaves on the left and seven on the right; the central branch is drawn as a straight glaze line. No stems connect the leaves to the central stem. Eight dots on the left and seven dots on the right are placed between the leaves and the central branch. The panels with zigzags and the panel with ivy are framed on the sides by two glaze lines. A line in somewhat thinner glaze is drawn on the lower edge of the shoulder, and another one furnishes the groundline.

49 Right side of panel.

49 Back.

ADDED COLORS
The accessory colors are not well preserved. *Red,* line at junction of neck and shoulder; hair of Apollo, folds of his himation; wrap of Artemis, her fillet, top of her quiver; cushion on chair. *White,* chiton of Apollo, ends of lyre; hinges of chair; belly stripe of deer; flesh of Artemis.

BIBLIOGRAPHY
H.B. Walters, *Catalogue* 2 (1893) 256, no. B 548; C.H.E. Haspels, *ABL* (1936) 18, pl. 6,1; C. Albizzati, *Vasi del Vaticano,* fascs. 1 – 7 (1925 – 1939) 199; J.D. Beazley, *ABV* (1956) 154, no. 58; D. von Bothmer, *Antike Kunst* 3 (1960) 73, 80; idem, *MM* 12 (1971) 127 – 129; L. Kahil in *LIMC* 2 (1984) 704, no. 1069, pl. 529, Artemis 1069.

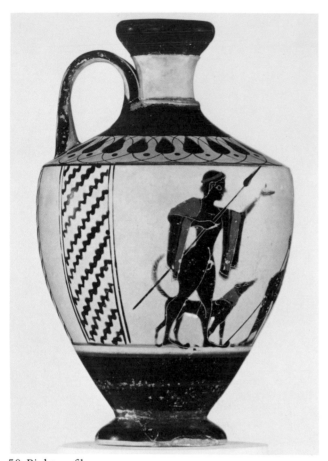

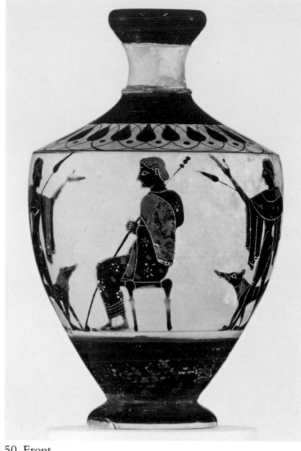

50 Right profile.

50 Front.

The subject on this vase is a youth wrapped in a himation, seated to the left on a stool and holding a scepter diagonally across his right shoulder. This youth is approached on each side by a boy wearing a chlamys over the shoulders and upper arms, holding a spear diagonally in the right hand, and extending the left hand in a gesture of greeting. The two boys are accompanied by their dogs. The boy on the left wears a fillet in his hair.

On some of the earliest lekythoi by the Amasis Painter (e.g., *ABV* 154, nos. 50 [Cat. 40], 51, 52 [Cat 42], 53 [Cat. 46], 54, 55 [Cat. 44], 56 [fig. 64], p. 714, under pp. 150 – 158, no. 61 bis [fig. 99]; *Paralipomena* 66, Tübingen [Cat. 39],

Zurich [fig. 98], and Warsaw [fig. 39]), there is a central axis to the composition toward which the figures on the sides converge, and when there are many figures, the first from the left and the first from the right meet back to back on the back of the vase. Twice, on the two New York lekythoi (Cats. 47, 48), the painter has avoided the suture by having the composition run all the way round. A third solution is presented by lateral borders behind the last figures on either side. In one instance this border is formed by a vertical row of rosettes on *both* sides (on the newly attributed lekythos Louvre Cp 10520 [Cat. 43]); on the Kanellopoulos lekythos in Athens (fig. 38; *Paralipomena* 65), the same rosettes appear, although only on the right side, like a punctuation

mark. Stronger borders—a vertical step-pattern bordered by double or single lines—are employed on the very early lekythos Louvre F 71 (Cat. 41) and the lekythos stolen from the Ceramicus Museum (fig. 59; *ABV* 155, no. 61). The lekythoi in London (Cat. 49) and the one in Montclair, shown here, combine the idea of borders for the scene with an attempt to enliven what would otherwise be the barren or confused back view of a lekythos through the application of three evenly placed and well separated vertical strips.

The London and Montclair lekythoi both belong to the Amasis Painter's early middle period and should be dated circa 540 B.C.

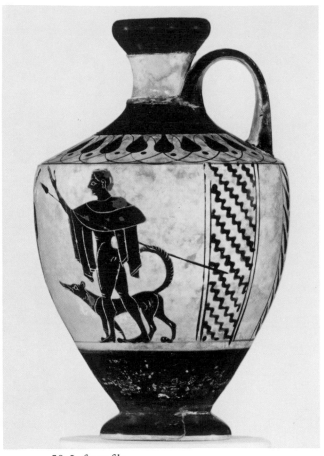

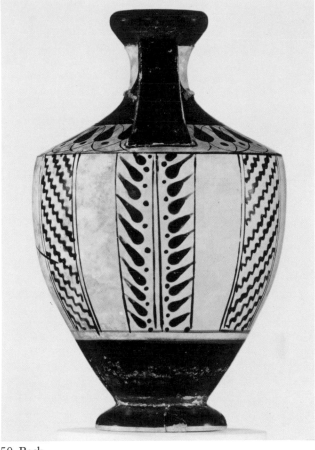

50 Left profile. 50 Back.

Attributed by J.D. Beazley in the late thirties to the Amasis Painter (quoted by E. Vanderpool in *Hesperia* 8 [1939] 252, n. 10).

Ex coll. Isaac Péreire, Paris.

DIMENSIONS AND CONDITION
Height, 12.6 cm; diameter of body, 7.63 cm; diameter of mouth, 2.95 cm; diameter of foot, 3.94 cm; width of resting surface, 0.62 cm. Capacity, 0.2 liters. The handle is broken off and has been reattached; part of the foot is restored.

SHAPE AND DECORATION
Convex mouth, rounded on top; flat strap handle. The upper part of the shoulder is glazed; it is offset from the neck by a drip-ring and from the lower part of the shoulder by a slight chamfer.

The sides and outside of the handle, the mouth, and the lower part of the body (below the figure-zone), as well as the outside of the echinus foot (except for its very edge), are glazed. The inside of the mouth is glazed to a depth of 1.55 cm. On the lower half of the shoulder is a zone of twenty-three upright buds connected by tendrils; there are glaze dots in the interstices.

As on the similar lekythos in London (Cat. 49), the back view of the vase is not left unpainted but is decorated with three vertical panels well separated from one another. The outer panels on both lekythoi bear a diagonal zigzag pattern that descends toward the central panel (cf. also the zigzags on Cats. 3, 18, 19, 52). On the lekythos shown here, the central panel depicts a branch of myrtle with the leaves pointing upward, while on the London lekythos it depicts an ivy branch.

ADDED COLORS
Red, ring at junction of neck and shoulder; hair of seated youth and boy behind him; folds of himation and folds of chlamides; cores of dot-rosettes on himation; necks of dogs. *White,* dots around cores of dot-rosettes on himation; belly stripes of dogs.

BIBLIOGRAPHY
E. Vanderpool, *Hesperia* 8 (1939) 252, n. 10; J.D. Beazley, *ABV* (1956) 155, no. 59; idem, *Paralipomena* (1971) 64; D. von Bothmer, *MM* 12 (1971) 127 – 130, pl. 26.

51 LEKYTHOS (SUB-DEIANEIRA SHAPE)

COPENHAGEN, DANISH NATIONAL MUSEUM, INV. 14067,
ACQUIRED IN 1959 (COLOR PLATE 9).

The panel represents a youth holding a spear. He is clad in a long chiton and a fringed himation worn over his left shoulder and left arm. In his hair he has a fillet. The youth faces a companion, dressed like the first youth in a chiton and himation and wearing a fillet in his hair; unlike his companion's, neither of his arms is hidden by the chiton. He proffers a dot-fillet in his raised right hand.

This lekythos, as Schauenburg has observed, may be compared with the Amasis Painter's fragmentary sub-Deianeira lekythos in the Villa Giulia (fig. 94; *ABV* 155, no. 63), which shows a man to the right who plays the flutes and faces a man singing, who holds a phiale and a cloth in his right hand. On both lekythoi, the tongue-pattern above consists of ten black tongues. In the sub-Deianeira shape, the neck is unglazed and there is no drip-ring above the shoulder. The Amasis Painter has left us one normal Deianeira lekythos, Athens 404 (fig. 101; *ABV* 155, no. 62), which is of exactly the same height as this sub-Deianeira lekythos in Copenhagen; it also has the same number of tongues above the panel and, save for the neck, has the same proportions. In date there is not much difference between the Copenhagen, Villa Giulia, and Athens lekythoi, and we may assume that the Deianeira type was not totally replaced by the modified, sub-Deianeira, shape but continued to be produced for some time, along with the newer model.

Middle period, late.

Attributed to the Amasis Painter by E. Langlotz.

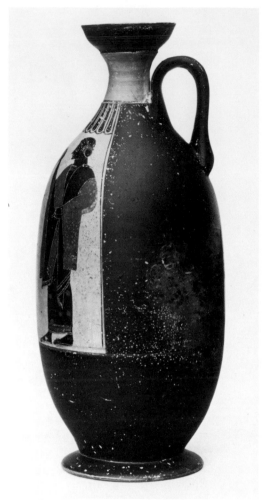

51 Left profile.

DIMENSIONS AND CONDITION
Height, 24.4 cm; diameter of body, 10.6 cm; diameter of mouth, 5.1 cm; diameter of foot, 8.1 cm; width of resting surface, 1.0 cm. Height of figures, 12.2 cm. The vase is unbroken, except for the handle, which has been repaired. The glaze has flaked off in places.

SHAPE AND DECORATION
Echinus mouth, flat and reserved on top, glazed on the outside and the inside. The unglazed neck is set off from the shoulder by a slight chamfer. The body, except for the panel, and the shallow foot, except for the very edge, are glazed. The figure scene is framed

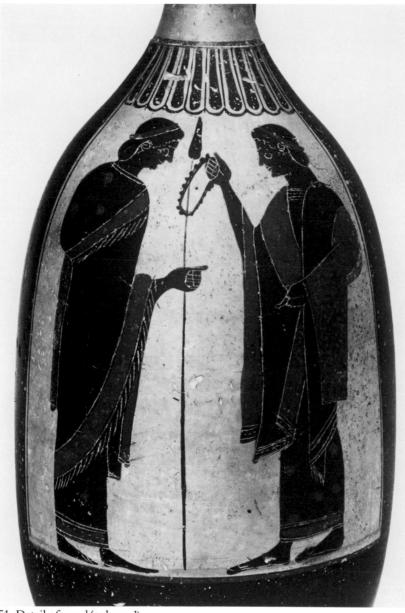

51 Detail of panel (enlarged).

on the sides by single glaze lines; the groundline is drawn in dilute glaze. Above the panel is a tongue-pattern composed of ten tongues.

ADDED COLOR
Red, line on neck at chamfer; lines on outside and inside of mouth; line encircling entire vase below panel. Dots on chitons, stripes on their lower borders; folds of himatia; fillets.

BIBLIOGRAPHY
K. Schauenburg in *Antike Kunstwerke. Nachlass Dr. Jacob Hirsch II. Teil und anderer Besitz, Ars Antiqua, Lucerne, May 2, 1959* 37, no. 95, pl. 45; D. von Bothmer, *Antike Kunst* 3 (1960) 74 – 75, 80, pl. 6,1; K.F. Johansen, *CVA,* Copenhagen, fasc. 8 (1963) 255, pl. 328,1a – c; J.D. Beazley, *Paralipomena* (1971) 66.

Fig. 101. Lekythos (Deianeira type). Attributed to the Amasis Painter. Rape of Helen by Theseus and Peirithoos. Athens, National Museum, 404.

52 ARYBALLOS

NEW YORK, THE METROPOLITAN MUSEUM OF ART,
62.11.11, ROGERS FUND, 1962.

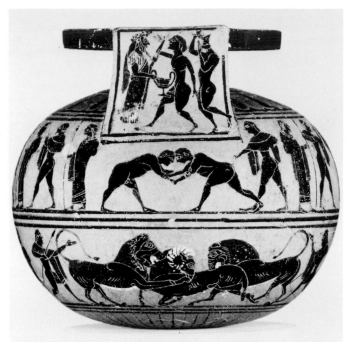

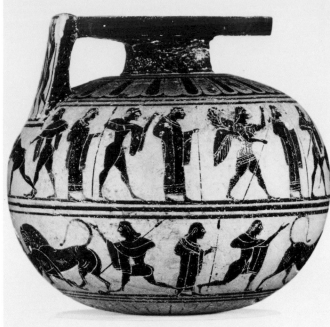

52 Back, with handle.

52 Right profile.

The subject on the outside of the handle is Dionysos facing two capering nude dancers, a boy and a man. The god is clad in a white chiton and a red himation; in his right hand he holds a kantharos; his left hand is raised in a gesture of greeting. His head is crowned with a wreath of ivy.

The top zone on the body is decorated around a central group of a naked youth moving to the right and holding two rearing horses by the reins; in his raised right hand, he wields a goad. This central group is flanked by a symmetrically arranged host of onlookers, most of them holding spears; they are alternately striding and standing still. First comes, on each side, a youth clad in a chlamys worn over his shoulders and upper arms; he is followed by a standing youth, clad in a himation. He, in turn, is followed by a winged male wearing a chiton, who is striding toward the center. The onlookers

conclude on each side with another trio, consisting of a man with a chlamys over his shoulders and upper arms advancing between two youths in himatia. The men do not hold spears. In back, below the handle (which lowers the height of the zone somewhat), two wrestling boys are watched by a youth in a chlamys on the right.

The subject of the frieze in the zone below is divided: in front, below the horses, two lions have felled a bull. The animal fight is watched on each side by a running youth in a chlamys (the youth on the right carries a spear) and a standing youth dressed in a himation holding a spear. On each side, back to back with the latter, is another youth wearing a chlamys and armed with a spear; those two youths are running up to the group on the rear, formed of a ram attacked by two lions.

Though this is the smallest vase painted by the Amasis Painter, its eight animals and twenty-five divine and human figures make it one of his most populated products. The small scale is comparable to that on many of his band-cups, on his alabastron in the Agora (fig. 34; *ABV* 155, no. 64), in his subsidiary friezes on the neck-amphora in the Cabinet des Médailles (Cat. 23) and on his amphorae in New York, Würzburg, Samos, and Berlin (Cats. 18 bis, 19; *ABV* 151, nos. 18, 21).

The subjects of this aryballos occur on many other vases by the Amasis Painter: for the scene of Dionysos facing two dancers, compare the lekythos stolen from the Ceramicus Museum in September 1982 (fig. 59; *ABV* 155, no. 61; *Stolen Art Alert* 5, no. 9 [November 1984] 1, 12, no. 1971). The youth mastering horses recurs on the panel-amphora of type B in Leningrad (fig. 102; *ABV* 151, no. 15, now republished by K.S. Gorbunova in *Hermitage* [1983] 34 — 35,

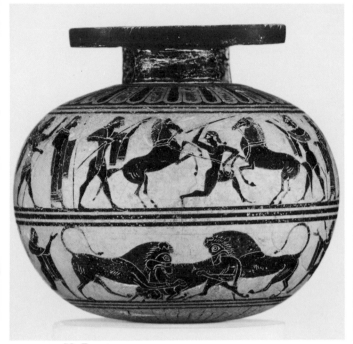

52 Front.

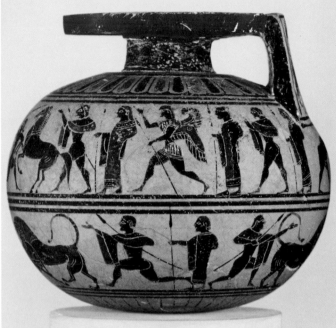

52 Left profile.

no. 16 and front cover). For the Amasis Painter's lions, we now have two new parallels on a lekythos in the Louvre (Cat. 43), and even the zigzag "pipe cleaners" on the mouth of this vase can be matched with the pattern in the lug-zone of his alabastron (fig. 34; *ABV* 155, no. 64), as well as with the pattern on

the new fragment of an amphora of type A in New York (Cat. 18).

This aryballos is of Corinthian shape, which found its way into Attic in the second quarter of the sixth century; it remains, however, a rare shape. In its purest form among the figured vases, it is best known from the Nearchos ary-

ballos in New York (fig. 21; *ABV* 83, no. 4). The Kealtes aryballos (fig. 103; *ABV* pp. 347 – 348) is somewhat more developed and is equipped with a foot (it was formerly wrongly put together: the siren, of course, should be under the handle).

Middle period, early.

Attributed to the Amasis Painter by R.E. Hecht, Jr.

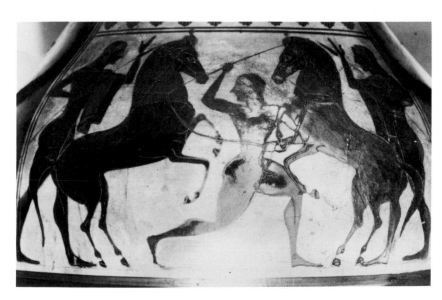

Fig. 102. Panel-amphora of type B. Attributed to the Amasis Painter. Detail of side B: youth mastering horses. Leningrad, Hermitage, inv. 161.

52 Top (majority of mouth restored).

52 Bottom.

DIMENSIONS AND CONDITION
Height, 8.17 cm; diameter of mouth, 5.93 cm; diameter of neck, 2.285 cm; diameter of body, 8.8 cm; diameter of opening on top, 1.03 cm. Five-sixths of the mouth is missing and is restored in plaster. The glaze has chipped and flaked in places, and the bottom is somewhat abraded from constant wear.

SHAPE AND DECORATION
The almost spherical body is surmounted by a narrow cylindrical neck and a broad flaring mouth that is joined to the body by a flat, almost square vertical handle. The top of the mouth slopes gently inward; it is decorated by three concentric glaze circles and a zone of radiating zigzags ("pipe cleaners") bordered on the outside by another glaze circle (for the zigzags, cf. those on Cats. 3, 18, 19, 49, 50). The edge of the mouth, its underside, and the neck are glazed black, as are the vertical edges of the handle. The shoulder is decorated by a tongue-pattern of fifteen black and fifteen red tongues framed above and below by three glaze circles. The red tongues are painted directly onto the clay body. The slightly flattened bottom has forty-nine thin rays that spring from the outermost of five concentric glaze circles. On the body, the figure decoration is in two zones bounded above and below by three glaze circles; on the outside of the handle, the figure scene is bounded on all four sides by a solid black line.

ADDED COLORS
Red, on the shoulder, alternate tongues; on the handle, himation of Dionysos;

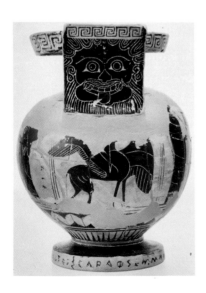

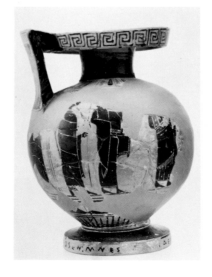

196

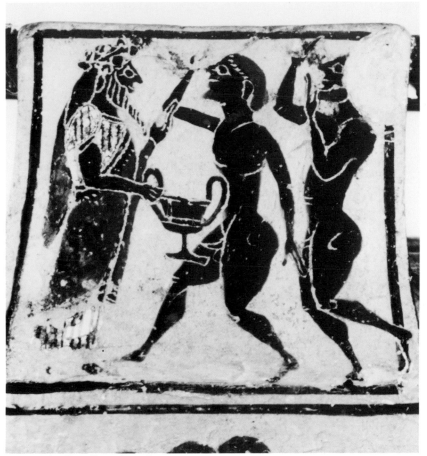

52 Detail of handle (enlarged).

hair of boy; beard of man behind him. In the top zone, necks of horses, stripes on their haunches; hair of youth holding horses, two dots on his chest; hair of first, second, third, fifth, and sixth onlookers on each side; stripes on chlamides; parts of himatia and cores of their dot-rosettes; wing bows of winged youths; hair of wrestlers. In the bottom zone, hair of onlookers; manes of lions, stripes on their haunches; stripes on onlookers' garments; necks of bull and ram. *White,* chitons of Dionysos and winged youths; belly stripes of lions, bull, and ram; horns of ram; testicles of bull and ram; teeth of lions.

The left onlooker of the lions fighting a ram has black hair.

BIBLIOGRAPHY
J.D. Beazley, *Paralipomena* (1971) 66 – 67; D. von Bothmer, *MM* 12 (1971) 125ff., pls. 27 – 29; N. Kunisch, *AA* 1972, 558, n. 33.

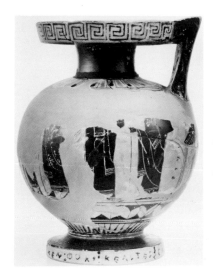

Fig. 103a,b,c,d,e. Aryballos (after recent restoration). Signed by Kealtes. Athens, National Museum, 1055.

On the obverse is a woman clad in a richly ornamented sleeved and belted peplos, wearing a fillet in her hair, an earring, and an incised necklace; she holds in her left hand a glaze wreath and in her right hand a lip-cup that is being filled from an oinochoe by a boy; he is wearing a fringed chlamys over both shoulders and upper arms. Behind the woman a nude man crowned with an ivy wreath approaches, his left arm raised and extended in greeting; in his right hand he holds an ivy branch.

On the reverse is a woman, again dressed in a sleeved and belted peplos, but with an ivy wreath in her hair. She holds an ivy branch in her left hand and with her right hand offers a lyre to a naked youth, also wreathed with ivy. In his left hand he holds a wreath painted in glaze. Behind the woman, another naked youth wearing an ivy wreath approaches. It is uncertain what he held in his left hand, since his face, chest, and left arm are missing.

The two subjects are obviously related, and Pottier labeled the scenes "preparations for a musical contest" and "libations in honor of the victory"; this inspired Mrs. Karouzou to identify the feast as probably that held at the Great Dionysia. Odd, though, that the lyre player should be nude, nor can I think of the casually worn chlamys on the obverse as a proper garment for the feast. Nevertheless, on the small amphora by the Heidelberg Painter in Basel (*Paralipomena* 27, no. 61), a youth in a very formal himation plays the flutes in front of a bearded and wreathed man who holds a drinking horn in his right hand—a scene that K. Schefold (in *Meisterwerke griechischer Kunst* [Basel 1960] 150, no. III 132) interpreted as Olympos and Dionysos, while Beazley (in *Paralipomena*) merely puts "Dionysos?" in parentheses after

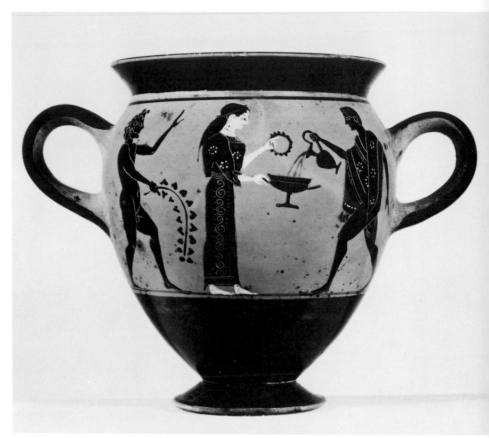

53 Side A.

"man." What connects the mastoid shown here with the fragmentary amphora by the Heidelberg Painter is the central panel on the himation of the Heidelberg Painter's flute player, which is decorated with interlocking spirals not unlike the spirals on the peplos of the woman holding a cup on the obverse here. But since the Amasis Painter uses these spirals frequently—for Athena on the fragmentary plaque in Athens (fig. 104; *ABV* 157, no. 92) and for the frontal Artemis on the Basel neck-amphora (Cat. 21)—they may be generally decorative rather than specifically connected with garments worn at festivals.

Middle period, late.

To E. Pottier the vase recalled the works of Amasis; attributed to the Amasis Painter by J.D. Beazley.

Excavated at Vulci in 1828/29. Ex colls. Lucien Bonaparte, Prince of Canino, Charles Paravey.

DIMENSIONS AND CONDITION
Height, 10.65 cm; width (across handles), 14.4 cm; diameter of body, 9.31 cm; diameter of mouth, 8.74 – 8.79 cm; diameter of foot, 4.91 cm. Height of figure-zone, 5.92 cm. On the left side of the reverse, a large area is missing; it extends from the ear of the youth to the back of the woman's head and affects the chest and upper right arm of the youth as well.

SHAPE AND DECORATION
The shape resembles the goblet called mastoid, which has an offset lip, a flat bottom, no foot, and comes either

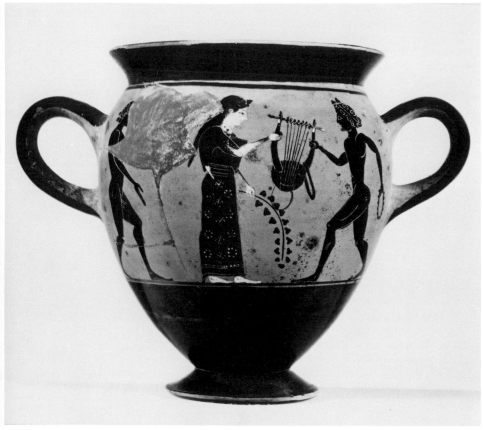

53 Side B.

antiques provenant des fouilles de l'Etrurie (Paris 1837) 55 – 56, no. 102; J. de Witte, Catalogue de la collection d'antiquités de feu M. Ch[arles]. Paravey (Paris 1879) no. 9; E. Pottier, Vases antiques du Louvre 2 (Paris 1901) 98, F 70, pl. 69; idem, Catalogue des vases antiques 3 (1906) 745 – 746; J.D. Beazley, ABS (1928) 35, no. 34; idem, ABV (1956) 156, no. 76; S. Karouzou, The Amasis Painter (Oxford 1956) 37, no. 72; B.A. Sparkes, Antike Kunst 11 (1968) 6 – 7, pl. 4,1.

without any handles or with two horizontal ones. The Amasis Painter's mastoid, however, has a flaring foot, the slanting surface of which is glazed, and two strap handles, like those of a kantharos. They are glazed on the outside only. The lip is offset. The entire inside is glazed; on the edge of the mouth is a reserved line. The figure scenes are in the handle-zone, bordered above by a glaze line and below by a line drawn in dilute glaze. The lip and the lower part of the body are glazed. The foot has no resting surface; it is glazed except for the very edge.

ADDED COLORS

Red, on side A, fillet of woman, her pupil, four dots in hair on her forehead; two dots for earring; edges of sleeve; six dots and cores of dot-rosettes on upper part of peplos; stripe on bottom of peplos, its front panel, eleven ivy leaves on its back panel; hair of boy pouring wine (which, unlike the juice of the pressed grapes on the Amasis Painter's Basel amphora Kä 420 [fig. 40; *Paralipomena* 65], is rendered in dilute glaze); upper and lower edges of boy's chlamys; two dots and centers of five dots (pendants?) below woman's incised necklace, hair on her forehead. On side B, fillet of woman, her pupil; upper part, bottom stripe, eight cores of dot-rosettes, and seven dots of peplos; hair circles on nipples of right youth, six of the seven ivy leaves in his hair. *White,* flesh of woman, dots around cores of all dot-rosettes; on side A, row of dots along border of chlamys; on side B, tips of horns and ends of crossbar of lyre; rows of dots above horizontal stripe of peplos.

BIBLIOGRAPHY

C. Lenormant in J. de Witte, *Description d'une collection de vases peints et bronzes*

Fig. 104. Detail of fragments from a votive plaque. Attributed to the Amasis Painter. Athena. Athens, National Museum, Acr. 2510.

54 CUP-SKYPHOS

PARIS, MUSÉE DU LOUVRE, A 479 (MNB 1746),
ACQUIRED IN 1879.

The subject, amorous encounters, runs all the way around the vase; the more limited space below the handles has prompted the painter to put under handle B/A a youth on one knee, holding a pantheress by the front and hind legs. The figure under the other handle, a man holding a hen on his lap, is more comfortably seated on a campstool. Both handle figures face toward the same side of the vase, which thus may be considered its obverse. The scene on this side represents three couples; in the center a man holds a fillet in his right hand and greets with his left hand a girl who faces him. In her right hand she holds a blossom with thumb and one finger, and in her left hand she holds a necklace or dot-fillet. Her hair is done up in a krobylos; her jewelry comprises a big circular earring with pendants, a wavy necklace, and two double bracelets. The couple on the left consists of a man offering a big rooster to the boy facing him. The boy holds an upright spear and an aryballos in his right hand and a fillet in his left. The couple behind the girl is similar: here the man offers a hare, while the boy holds an upright spear and a fillet.

On the reverse, the compositional scheme is repeated—there are three couples, two with boys and one, in the center, with a girl. The man talking to the girl holds a hen; the girl wears the same jewelry as her friend on the other side, and she also holds a blossom. Her hair, however, is not tied up in a krobylos but beribboned below and behind her ears, the ends gathered into a knot. The boys have switched places: here the one carrying a spear, aryballos, and fillet is on the left, and the one without an aryballos is on the right. The animals offered as gifts by the men are, on the left, a stag held by one antler and both hind legs and, on the right, a cygnet held by both legs. In the background, suspended from the coping or ceiling suggested by the black rim of the vase, are, on the obverse, two fillets and, on the reverse, a fillet and an aryballos. Everybody is naked, and all but the last man on the reverse wears a fillet. The artist has taken pains to make the boys and girls smaller than the men and to maintain a perfect symmetry, the tedium of which is relieved by the changes in the attributes and gifts. The hen, held by the seated man under handle A/B, is perhaps destined for the girl on the obverse, who, for the moment at least, goes without a prize.

The courting scenes on this cup-skyphos can no longer be called unique for the Amasis Painter, since one of the legs on the signed tripod-pyxis in Aegina gives us both the group of Beazley's type γ (*Some Attic Vases in the Cyprus Museum* [London 1948] 24ff.) and, in the center, the presentation of a gift, probably a small stag, Beazley's type β. Of the boy in this group, only a bit of the right thigh and left heel are preserved. A third group, of two males, is on the right: the knees of the second person are slightly bent, suggesting Beazley's type α. The entire scene is flanked on the left by a boy shouldering a long spear and carrying in his left hand an aryballos; I suspect that the legs of a male behind the third group, on the right, are those of another bystander.

For the stag offered by the man on the reverse of the Louvre cup-skyphos, compare also the small stag held by one of the maenads on the Amasis Painter's neck-amphora in the Cabinet des Médailles (Cat. 23).

The painter has gone to some trouble on this cup-skyphos to show that the boys and girls are not so tall as the men, abandoning, exceptionally, the traditional iso-

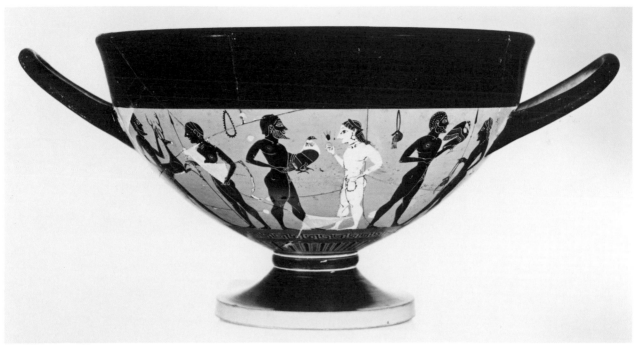

54 Side B (profile).

cephaly. Not counting figures that
are smaller than their companions
because of the exigencies of space
(as are the handle figures on Boston
01.8026 [Cat. 24], the girls weaving
on one of the New York lekythoi
[Cat. 48], and the woman in the
bridegroom's house on the other
lekythos in New York [Cat. 47]),
the examples that show an accurate
observation of scale are the little
satyr boy on the Guglielmi am-
phora (fig. 57; *ABV* 150, no. 1), the
boy in front of the horses on the
neck-amphora in London (Cat. 22),
and, perhaps best of all, the stable
boy on the Schimmel cup (Cat. 60).
(It is not clear to me whether the
little man on the Anavysos lekythos
[fig. 99; *ABV* 714, no. 61 bis] really
belongs to this vase, the other fig-
ures of which are drawn on a nor-
mal, isocephalic scale.)

The Amasis Painter has given us
many goddesses, wives, and moth-
ers of heroes, maenads, and Ama-
zons, but relatively few women and
girls taken from daily life. They
appear dancing; working wool and

weaving; in a bridal cortege (Cats.
46 – 48); in a sacrificial procession
(*ABV* 151, no. 11); playing or hold-
ing a lyre (Cat. 53; *ABV* 157, no. 88
[here fig. 114]); playing the flutes
(Cat. 36; *ABV* 153, no. 39 [here fig.
96]; 714, under pp. 150 – 158, no.
31 bis [here fig. 89]); and receiving
the attention of men (as on the cup-
skyphos shown here). The girl on
each side of this cup-skyphos is
shown naked, and Mrs. Karouzou
(p. 8) speculated that "the white
colour of her naked body was
judged suitable by the painter to
mark the centre." I believe, how-
ever, that the Amasis Painter was
not merely interested in emphasiz-
ing the center—no more than was
the Princeton Painter, when on his
olpe Basel Kä 411 (*ABV* 299, no. 25;
Paralipomena 130; J.-P. Descoeudres,
CVA, Basel, fasc. 1 (1981) III H,
pl. 26, 3 – 5 and 7) he put the naked
girl with a small child reaching
for her flutes in the center of his
composition.

The maeander pattern below
the figure-zone is of the same type
as on the lateral borders of the
amphora of type A in Berlin (inv.
3210, *ABV* 151, no. 21 [here fig.
45]); the upright tongues in the
zone below the maeander on this
vase appear already on a skyphos by
the C Painter (fig. 105; *ABV* 57, no.
118), on fragments of a skyphos by
the Affecter (joining *ABV* 247, no.
99, now published by J.H. Oakley
in *Hesperia* 48 [1979] 393 – 396, pl.
95) given by Mr. and Mrs. S. Cary
Welch to the Metropolitan Museum
(1984. 501. 1 [here fig. 106]), and on
the mannerist cup-skyphos on the
London market (*Cat. Sotheby,
December 8, 1980,* lot 238), which
shares with the cup-skyphos in the
Louvre shown here the three lines
below the figure-zone, and which
already has a slight flare in the
mouth of the bowl, suggestive of
the top-band of this Louvre vase.

The Louvre cup-skyphos should be
dated to the middle period of the
Amasis Painter, about 540 B.C.

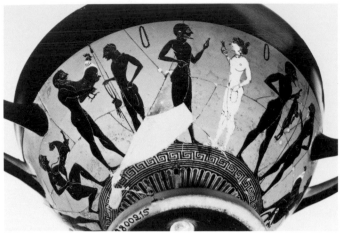

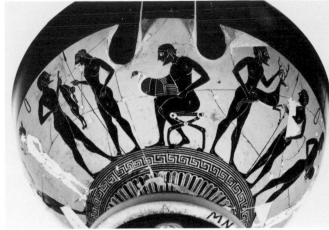

54 Side A.

54 Handle A/B.

Put near the Amasis Painter by E. Pfuhl; attributed to the Amasis Painter by J.D. Beazley.

Excavated in 1860 by Auguste Salzmann at Camiros, Rhodes. Ex coll. Parent.

DIMENSIONS AND CONDITION
Height, 11.28 – 11.41 cm; width (across handles), 24.67 cm; diameter of bowl, 17.75 – 17.97 cm; diameter of foot, 8.4 cm; width of resting surface, 0.62 cm; thickness of lip, 0.37 cm. Height of figure-zone, 6.19 cm. The vase was broken and repaired in antiquity (there are nine pairs of rivet holes); it was broken again later, suffering some losses: on side A, feet of left man; lower legs and feet of boy with aryballos, parts of lower legs of man behind him; on side B, middle of first boy, lower left leg of man behind him, and part of lower right leg of girl facing him.

SHAPE AND DECORATION
The shape combines some of the elements of the band-cup with those of a skyphos, and the vase may even count as a forerunner of the Class of Band-skyphoi that Beazley put together (*Paralipomena* 88 – 91). The inside is black, except for a reserved line near

the rim; the handles are left unglazed on the inside; the flaring foot is joined to the bowl by a fillet marked above and below by incised lines. The foot is glazed on the outside except for the very edge; its underside is glazed except for the resting surface. The lip-zone of the cup is glazed; the figure-zone extends downward to the level of the bowl where its diameter equals that of the foot. The area between the figure-zone and the fillet above the foot is ornamented: a leftward continuous maeander is framed above and below by four glaze lines; below it is a tongue-pattern of fifty-seven black and red upright tongues, framed underneath by three glaze lines. The tongues alternate between black and red; the pattern was

begun under the last youth on the obverse, at which point the last tongue, a black one, meets the first black tongue.

ADDED COLORS
Red, fillet between bowl and foot; in the figure scene, all fillets; bodies of aryballoi; mouth of aryballos held by last boy on side B; beards of last man on side A, man under handle, and first man on side B; hair below ribbon of first boy on side A; pubic hair of girls, their pupils, their earrings; neck of pantheress, two stripes on its haunch; crest, wattle, and wing bar of cock; neck of hare; wing bows and second wing bars of hens; wing bar of cygnet. *White,* flesh of girls; belly stripes of pantheress and small stag; dots on fillets held by

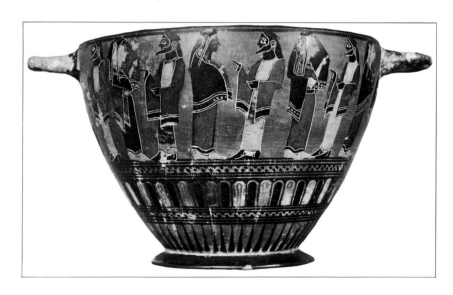

Fig. 105. Skyphos. Attributed to the C Painter. Paris, Musée du Louvre, MNC 676.

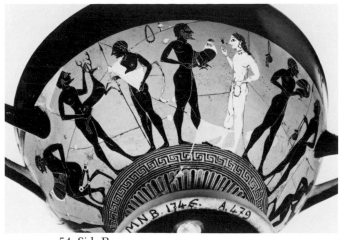

54 Side B.

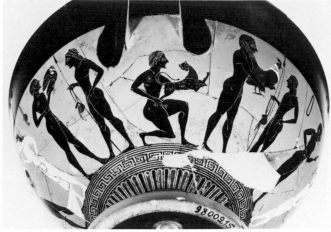

54 Handle B/A.

boys and by second and third men on side A; necks of cocks and hens; dots on tail of pantheress; muzzle of stag; rings and hinge of campstool.

BIBLIOGRAPHY

E. Pottier, *Catalogue des vases antiques* 1 (1896) 129, 171, A 479; idem, *Vases antiques du Louvre* 1 (Paris 1897) 20 – 21, pls. 17, 18; G. Perrot in G. Perrot and C. Chipiez, *Histoire de l'art dans l'antiquité* 10 (Paris 1914) 229 – 230, fig. 147; S.G. Zervos, *Rhodes, capitale du Dodécanèse* (Paris 1920) 60 – 61, figs. 114, 115; E. Pfuhl, *MuZ* 1 (1923) 262; J.D. Beazley, *ABS* (1928) 35, no. 36; N. Plaoutine, *CVA*, Louvre, fasc. 9 (1938) III He, 83 – 84, pl. 92; F. Villard, *REA* 48 (1946) 166, 169, pl. 2,6; J.D. Beazley, *Some Attic Vases in the Cyprus Museum* (London 1948) 19, B 3; idem, *Development* (1951) 61, 112, n. 59; idem, *ABV* (1956) 156, no. 80; S. Karouzou, *The Amasis Painter* (Oxford 1956) 8, 37, no. 71, pl. 12,2, pl. 13, pl. 14,3; J.D. Beazley, *Paralipomena* (1971) 65, 90; H. Mommsen, *Der Affecter* (Mainz 1975) 19, 79; A. Schnapp in *La cité des images* (Lausanne 1984) 75, fig. 108.

Fig. 106. Fragment of a skyphos. Attributed to the Affecter. New York, The Metropolitan Museum of Art, 1984.501.

55 FRAGMENTARY BAND-CUP

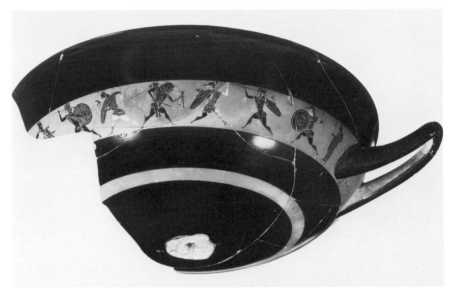

55 Side A.

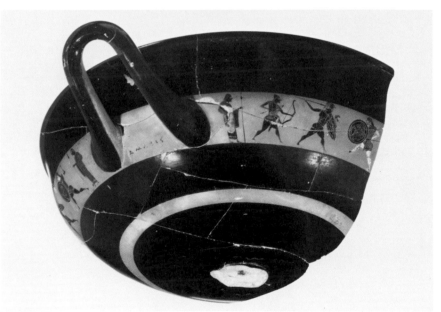

55 Side B.

The preserved portion of the cup
gives us most of the obverse and the
left third of the reverse. The cup is
signed AMASIS in the reserved
area between the roots of handle
A/B: this was followed, no doubt, by
the pronoun and verb MEΓOIESEN
under the other handle.

The subject is an Amazonomachy
that runs all the way around the
vase, interrupted only by the han-
dles. Each half had three combat
scenes, flanked on the left and on
the right by a bystander dressed in
a himation and holding a spear. The
obverse is characterized as such by
the presence of Herakles. The left
bystander is missing. In the trio on
the left, two Greeks are on the de-
fensive against an Amazon. The
first Greek wears a low-crested

Corinthian helmet and a chiton under a nebris. He is armed with a spear held horizontally at waist level and a round shield the device of which is a three-dimensional lion's head; he comes to the aid of a companion who also wears a low-crested Corinthian helmet, a short chiton, and a nebris. The companion has turned tail and defends himself with his round shield, seen from the inside, and a spear held in his raised right arm. The Amazon who attacks him with a spear held in her lowered right arm wears a short belted peplos and a high-crested Attic helmet; on her left arm she carries a round shield that bears the three-dimensional fore-part of a snake as device. In the center, Herakles, dressed in a short chiton and his lion skin, carries a quiver with two arrows on his back, suspended from a baldric slung over his left shoulder. In his extended left hand he holds his scabbard; the drawn sword is held at waist level in his lowered right hand. He attacks an Amazon who is dressed and armed like her comrades; her shield device is a three-dimensional lion head, like that of the first Greek. The opponent of Herakles runs to the right while looking back at her attacker; she holds a spear in her raised right hand. The last group consists of a Greek fleeing to the left, dressed and armed like the second Greek, save that he wears a broad belt, and that the three-dimensional blazon on his shield, seen in profile, is a snake, like that of the first Amazon. His assailant, the last Amazon, has a round shield emblazoned with a frontal panther's head.

In the continuation of the battle on the reverse, following the left youth (the bystander), a youth strides to the right clad in a short chiton and a brimmed cap; he is armed with a bow in his left hand and an arrow held in his right; the quiver by his left side, suspended

from a baldric over his right shoulder, is empty. A hoplite to his right, dressed and armed like the second fleeing Greek on the obverse, attacks an Amazon with a spear held high. The Amazon wears the same uniform worn by the second and third Amazons on the obverse. Her spear is held at waist level; the device of her shield is the fore-part of a lion. Her left foot is off the ground. All the crests of the Amazons disappear in the black band above the picture-zone.

This is the only known Ama-zonomachy painted by the Amasis Painter, and, as is to be expected, it exhibits several unusual details. As in other big Heraclean battles, on the Malibu band-cup, the group of Herakles and his opponent is in the center of one side. Unusual, how-ever, is the archer on the extreme left of the reverse, who has not yet drawn his bow but, arrow in hand, is looking for a target. He has no other arrows and resembles in this respect the two archers on Berlin 1688 (Cat. 9) or the single archer on the Ludwig amphora L 20 in Basel (Cat. 8), all of whom are content with just one arrow for their bow. Equally astonishing is the behavior of Herakles. Since he is invulnera-ble, thanks to his lion skin, his left arm is not encumbered by a shield.

The Attic vase-painters from the sixth century on normally made good use of Herakles' free left hand in various ways: in the act of seizing the Amazon by her wrist (*ABV* 98, no. 46), by the crest of her helmet (*ABV* 99, nos. 53 – 54), by her shoulder (*ABV* 98, no. 45), or by her shield (D. von Bothmer, *Amazons in Greek Art* [Oxford 1957] pl. 29,1). Euphronios placed in the left hand a bow and arrow (*ARV*² 15, no. 6), as did a contemporary black-figure artist of the Leagros Group (*ABV* 360, no. 3). The Amasis Painter, however, put the

55 Interior.

empty scabbard into the left hand of Herakles—almost, but not quite, anticipating the gesture of the Tyrant Slayers in sculpture (see fig. 10).

On this band-cup the Amasis Painter has dispensed with the pal-mettes at the handle, which have been encountered, to date, only on his band-cup in the Louvre (Cat. 57). Instead, he frames his scenes with bystanders, who already occur on his very early cup of type A in Mayence (Cat. 59) and on his band-cups in Madrid (here fig. 108; D. von Bothmer, *MM* 12 [1971] color pl. 1, pl. 24), Cracow (here fig. 109; *ABV* 156, no. 84; *MM* 12 [1971] pl. 25), and Tel Aviv (fig. 95; *Paralipomena* 67).

The Heraclean Amazonomachy with three or more groups on each side does not occur often on the exteriors of black-figured band-cups. Besides the cup in Malibu, here published for the first time, there are only two others: the splendid, though fragmentary, unattributed band-cup in Amster-dam (8192 [here fig. 107], D. von Bothmer, *Amazons in Greek Art* [Oxford 1957] 31, no. 12: detail illustrated in *Vazen uit de schenking Six* [Amsterdam, n.d.] 34, no. 9) and Hamburg 1961.61 (H. Hoffmann, *Kunst des Altertums in Hamburg*

[Hamburg 1961] 20 – 21, pl. 63 [unattributed]). Of these three, the band-cup in Hamburg repeats the subject, with minor variations on the reverse, and the lively figures that sport so much added color are not very well drawn. The cup in Amsterdam is much finer, and is earlier. Here the painter has differentiated between obverse and reverse, and has Herakles appear only on the obverse, since the other side—as on the Malibu cup—is not a repetition but a continuation of the battle. The Amsterdam cup resembles the Malibu cup in the compositional division of each side of the exterior into three distinct groups; it also shares with the Malibu cup details of dress and armor—the short belted peploi of the Amazons, the high quiver of Herakles, and the ornamental borders of chitons and peploi. The most fearsome shield device on the Amsterdam cup, a three-dimensional lion protome on the shield of the last Amazon of the obverse, is reminiscent of the Amasis Painter's similar device on the obverse of the amphora Basel Ludwig 19 (Cat. 6) and corresponds to the many two-dimensional lion protomai encountered so frequently in devices drawn by the Amasis Painter. The figures on the unattributed cup in Amsterdam are bigger in scale than the ones on the Malibu cup, and I take the Amsterdam cup to be the earlier of the two.

Of particular interest on the Mal-ibu fragment is the shield device of the last Amazon on the obverse, a frontal panther head that reminds us of the similar head rendered in outline and added colors below the handle of the oinochoe of shape I in London (Cat. 37), discussed by M. Robertson in *Antike Kunst* (supp. 9 [1973] 81 – 84, pl. 29,4). To his list of frontal panther heads by the Amasis Painter, we should add the head on the shoulder-flaps of the central warrior on the amphora Berlin inv. 3210 (fig. 45; *ABV* 151, no. 21), the left warrior on the reverse of Boston 01.8026 (Cat. 24), and the shield device of the hoplite on the shoulder of the neck-amphora in the Cabinet des Médailles (Cat. 23), which is directly above the maenad who wears a panther skin over her peplos. This shield device repeats the big T painted in added red above the eyebrows and extending along the panther's nose. The convention of painting this anatomical detail in red was also used by the Amasis Painter on one of the shoulder-flaps on the amphora once in Riehen, in the Hoek collection (fig. 43; *Paralipomena* 65). The shoulder-flap in Boston, however, has no added color and has lost some of its angular severity, since only the left eyebrow is an incised straight line, while the other eyebrow is curved; the hair on the forehead and along the ridge of the nose is rendered in short stippled incisions. On the frontal panther head in Malibu, by contrast, we observe the rigidly incised big T forming the divisions of eyebrows and nose. But in the enclosed area of the nose, the painter has used neither solid added red nor incised stippling; instead, he has painted small dots, probably in red, the color of which has disappeared, leaving merely matte traces. A careful comparison of all the frontal panther heads by the Amasis Painter reveals that the one on the band-cup in Malibu is his earliest, followed by those on the oinochoe in London (Cat. 37), the neck-amphora in the Cabinet des Médailles (Cat. 23), the amphora once in the Hoek collection (fig. 43) and last, the neck-amphora in Boston (Cat. 24).

If the band-cup in Malibu is earlier than the neck-amphora in the Cabinet des Médailles, it follows that it gives us the earliest signature of Amasis. Another chronological hint is furnished by the very fragmentary band-cup in Berlin (fig. 110; *ABV* 156, no. 83; on the condition after cleaning, see S. Karouzou, *The Amasis Painter* [Oxford 1956] 36, no. 63). The warriors on this cup are very much like those on the shoulder of the neck-amphora in the Cabinet des Médailles, and, together with the combatants on the fragment of a band-cup in London (*ABV* 156, no. 82), they are more advanced than the warriors on the Malibu cup.

A final word about the inscription "Amasis" painted in a horizon-

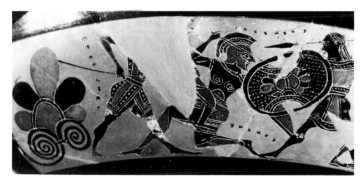
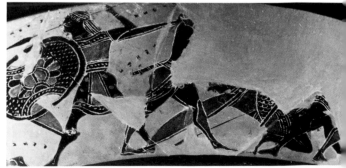

tal line between the handle-roots. For just a name, without the verb, under the handle, we have the vertical signature of the potter Anakles on a lip-cup fragment in Florence (*ABV* 159, no. 3). Beazley observed, in his fundamental article on Little-Master cups (*JHS* 52 [1932] 187–191), that band-cups are signed more rarely than lip-cups, for the obvious reason that lip-cups provided a picture-zone, as well as a zone for long signatures or salutations, whereas on band-cups the pictures either had to be very brief (not occupying the entire handle-zone) or had to be suppressed altogether to make room for the proud display of letters. The ingenious use of the undecorated area between the handle-roots for inscription is encountered only on a few band-cups. Thypheithides signs as potter with the verb, on two handles that are presumably from the same cup (*ABV* 178). The potter Glaukytes signs two band-cups (*ABV* 163, nos. 1, 2), each time with the verb, under one handle, giving over the other handle to another potter (Archikles) for his signature, as on their cup in Munich (*ABV* 163–164, no. 2), or using that space in praise of a boy (London B 400; *ABV* 163, no. 1). Kaulos, another potter, signs as such on a band-cup in Taranto (*ABV* 171–172), ceding the other handle to the painter Sakonides. I suspect that Amasis did not share the handle spaces but put his name

only under handle A/B and put the verb under handle B/A, intending the two inscriptions to be read together. In this respect he anticipated the practice of Epiktetos, a red-figure painter, who at least five times (*ARV*² 70–72, nos. 3, 6, 14, 15, 21) divided his signature into name and verb between the two halves of cup exteriors.

Middle period, early.

Attributed to the Amasis Painter (independently) by J. Frel and D. von Bothmer.

DIMENSIONS AND CONDITION
Height as preserved, 7.9 cm; estimated diameter of bowl, 22.1–22.2 cm; diameter of tondo, 5.57 cm. Height of figures, 2.49 cm; radius of compass-drawn shields, 0.6 cm. Thickness of wall, 0.31–0.37 cm. The vase is broken and has been repaired; the foot and stem were broken off in antiquity and reattached or replaced with a dowel, as proved by the ancient dowel hole in the center of the tondo.

SHAPE AND DECORATION
Glazed inside, except for a reserved tondo (decorated with a glaze circle) and a reserved line near the edge. The handle is reserved on the underside. On the outside is a figure-zone on the level of the handles; there is a reserved band halfway between the figure-zone and the bottom of the bowl.

ADDED COLORS
Red, mantles, except for panel hanging over arms of bystanders on side A and side B. On side A, shield of first Greek (except for rim), tongue of lion in his

device; helmet (except for crest); chiton and inside of shield (except for rim) of second Greek; pupil of first Amazon, her peplos, her helmet (except for crest), outside of her shield (except for its blazon and rim); chiton of Herakles, mane of his lion skin, lower jaw of lion's head; peplos and pupil of second Amazon, outside of her shield (except for device and rim); chiton and outside of shield (except for device and rim) of last Greek; helmet (except for crest), peplos, and pupil of last Amazon, rim of her shield, tiny dots on forehead and nose of her panther's head. On side B, chiton of archer; helmet of second Greek (except for crest), belt over his nebris, dots around cores of dot-rosettes on his chiton; outside of shield (except for rim and device), inside of rim; helmet (except for crest) and peplos of first Amazon, mane of lion on her shield, its lower jaw, dot on its upper jaw. *White,* all female flesh. On side A, chiton of first Greek; triangular markings on nebris of second Greek, row of dots on his chiton; dots on upper border of first Amazon's peplos; dots on baldric of Herakles, hilt and handguard of his sword, chape and crosspiece of his scabbard; dots on crest support of second Amazon, along rim of her shield, and on lower border of her peplos. On side B, dots on baldric of archer; dots around cores of dot-rosettes on chiton of second Greek, dots on his crest support.

BIBLIOGRAPHY
Not previously published.

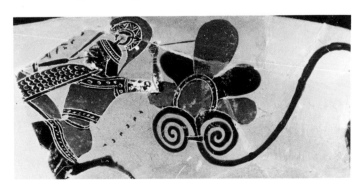

Fig. 107a,b,c. Details of fragmentary band-cup (enlarged). Amsterdam, Allard Pierson Museum, 8192.

56 FRAGMENT OF A BAND-CUP

NEW YORK, THE METROPOLITAN MUSEUM OF ART,
1984.313.1, ANONYMOUS GIFT, 1984.

The fragment gives the middle of the composition on one side of the cup, a boy in a himation holding an upright spear. He is standing to the left, facing a bridled horse, of which only parts of the head, chest, and forelegs are preserved. This horse was mounted, as the incised contours of a naked foot below the chest show. Behind the youth, facing left, is a horse with a rider who is holding a spear.

Horses and riders are not so uncommon as was once suggested (see S. Karouzou, *The Amasis Painter* [Oxford 1956] 3, 26), for many more horses by the Amasis Painter have come to light since Mrs. Karouzou's monograph, and it is no longer safe to say "his few pictures

56 Fragment.

with horses are mostly decorative borrowings from older art, without inspiration from life or poetry" (p. 26). The Munich amphora (Cat. 4), the Schimmel cup (Cat. 60), the New York aryballos (Cat. 52), and the Madrid band-cup (here fig. 108; D. von Bothmer, *MM* 12 [1971], color pl. 1, pl. 24) are sufficiently spirited to reveal that the Amasis

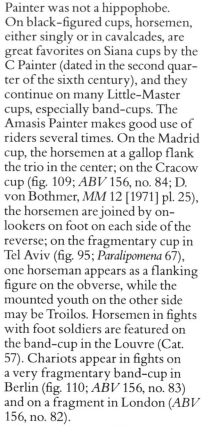

Painter was not a hippophobe. On black-figured cups, horsemen, either singly or in cavalcades, are great favorites on Siana cups by the C Painter (dated in the second quarter of the sixth century), and they continue on many Little-Master cups, especially band-cups. The Amasis Painter makes good use of riders several times. On the Madrid cup, the horsemen at a gallop flank the trio in the center; on the Cracow cup (fig. 109; *ABV* 156, no. 84; D. von Bothmer, *MM* 12 [1971] pl. 25), the horsemen are joined by onlookers on foot on each side of the reverse; on the fragmentary cup in Tel Aviv (fig. 95; *Paralipomena* 67), one horseman appears as a flanking figure on the obverse, while the mounted youth on the other side may be Troilos. Horsemen in fights with foot soldiers are featured on the band-cup in the Louvre (Cat. 57). Chariots appear in fights on a very fragmentary band-cup in Berlin (fig. 110; *ABV* 156, no. 83) and on a fragment in London (*ABV* 156, no. 82).

This fragment, published here for the first time, must be from the right half of one side, and the horse and rider facing the youth in a himation must be part of the main scene—which might be a pursuit, somewhat like the pursuit on the Tel Aviv cup.

All the band-cups by the Amasis Painter are early in his middle period, about 550 – 540 B.C.

Attributed to the Amasis Painter by D. von Bothmer.

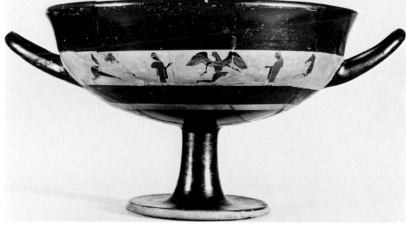

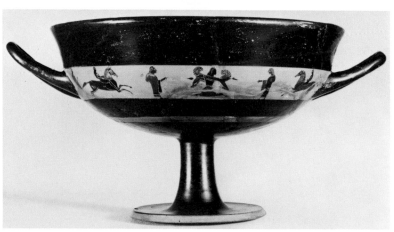

Fig. 108a,b. Band-cup. Attributed to the Amasis Painter. Sides A and B. Madrid, collection of Gomez Moreno.

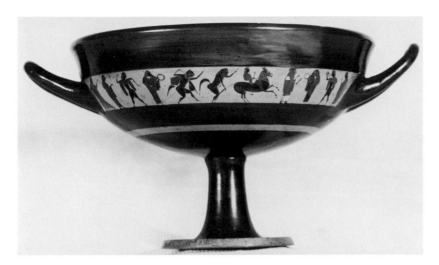

DIMENSIONS
Height as preserved, 3.215 cm; width as preserved, 3.465 cm; thickness of wall of sherd, 0.22 cm on top, 0.2 cm on bottom. Height of figure-zone, 2.65 cm.

ADDED COLOR
Red, chests of horses; hair of boy, vertical folds of his himation, dots on his himation.

BIBLIOGRAPHY
Not previously published.

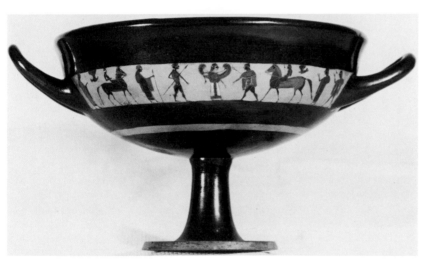

Fig. 109a,b. Band-cup. Attributed to the Amasis Painter. Side A: return of Hephaistos; side B: winged goddess. Cracow, Czartoryski Museum, inv. 30.

Fig. 110a,b. Band-cup. Attributed to the Amasis Painter. Figure-zones, sides A and B (the restored portions are shaded; from E. Gerhard, *Trinkschalen und Gefässe des Königlichen Museums zu Berlin* [Berlin 1848 – 1850] pl.1,5 – 6). Berlin, Staatliche Museen, F 1795.

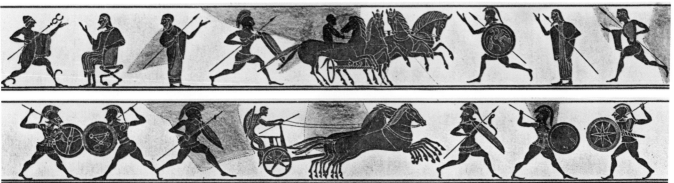

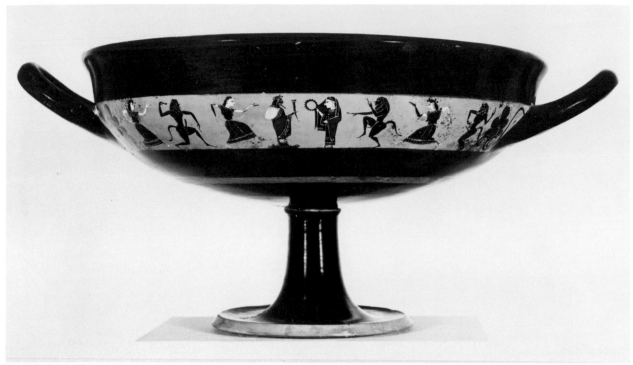

57 Side B (profile).

The obverse of the cup shows a battle scene: in the middle is a duel between two hoplites, flanked on each side by a fight between a horseman and a hoplite. The riders wear petasoi and short chitons; they rein in their galloping horses with their left hands; in their right hands they hold spears that are not yet poised for attack. The hoplite on the left is bearded. He wears a high-crested Corinthian helmet, a short fringed chiton, and a bronze cuirass; on his left arm he holds a round shield emblazoned with a cock; in his raised right hand he holds a spear ready to be hurled at the rider. In the duel in the center behind him, the warrior on the left wears a high-crested Corinthian helmet, a short fringed chiton and, over it, a linen corslet. His round shield is seen from the inside; in his right hand he holds his spear ready to attack his opponent, who has a

low-crested Corinthian helmet crowned with a fillet, a short fringed chiton, and a bronze cuirass. A sheathed sword is suspended from a baldric over his right shoulder; the round shield on his left arm has an eight-pointed star as a device; his right arm is raised, and he holds a spear pointed at his opponent in his hand. The rider in the right group is dressed and armed like the left rider and gallops toward a hoplite fleeing to the right. The hoplite wears a low-crested Corinthian helmet, a short fringed chiton, and a bronze cuirass; the device on his round shield is a wasp; in his raised right hand he holds a spear. All the hoplites are bearded; the riders are not.

The subject on the reverse is a Dionysiac thiasos, suitably spread out to cover the length of the handle-zone. In the center, Dionysos, in a stately white chiton and red himation and wearing a black ivy

wreath on his head, holds a long drinking horn in his left hand (his right hand is hidden under the garments). He faces Ariadne, who wears a peplos and has pulled her mantle over her head; in her right hand she holds a black wreath. She is further adorned with a bracelet and an earring consisting of a hoop and three pendants. This central group is surrounded by two dancing trios: on the left is a satyr between two maenads; on the right, a maenad between two satyrs; the satyr near the handle palmette seems to be standing still, his knees flexed. The maenads wear peploi; the first and third are wreathed with ivy, and the second, directly behind Dionysos, wears a fillet. The second maenad has an incised necklace, done in a single line, as has Ariadne; the necklace of the third maenad has a double line.

210

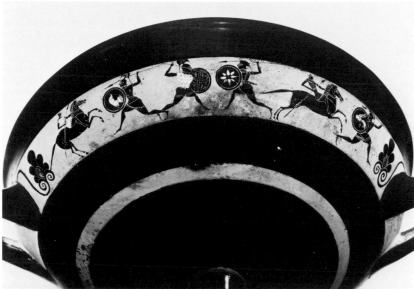

57 Side A.

The number of band-cups attributed to the Amasis Painter has doubled since the appearance of *ABV* in 1956, for in addition to the cup in Tel Aviv added in *Paralipomena* (p. 67 [here fig. 95]), we now have the cup in Madrid, Gomez Moreno collection (here fig. 108; D. von Bothmer, *MM* 12 [1971] 129 – 130, color pl. 1, pl. 24), the fragmentary cup in Malibu signed by Amasis (Cat. 55), and the fragment in New York (Cat. 56). The Louvre cup shown here, however, remains the most accomplished; it is also, oddly, the only one on which the painter frames his figure-zones by palmettes. It is, moreover, his biggest band-cup, not only in overall measurement but in the height of the figures as well. Six of the eight cups figure fights on at least one side, and Beazley (*JHS* 51 [1931] 274) has already compared the battle scene on this cup with the small frieze above the main figure scenes on the neck-amphora in the Cabinet des Médailles (Cat. 23). To his comparisons we may add that the shield device with an eight-pointed star recurs both on the fragmentary

Berlin cup (fig. 110; *ABV* 156, no. 83) and on the neck-amphora in the Cabinet des Médailles, a coincidence that yields an important clue to certain synchronisms. The Louvre band-cup here is clearly more advanced than the band-cup in Tel Aviv (*Paralipomena* 67), which is already later than the very early band-cup in Madrid.

Middle period.

Said by Beazley in 1929 to resemble the work of the Amasis Painter (*JHS* 49 [1929] 269, foot), later definitely attributed by him to the painter (*JHS* 51 [1931] 274).

From Vulci. Ex colls. Lucien Bonaparte, Prince of Canino, Arthur Auguste, Vicomte Beugnot, Charles Paravey.

DIMENSIONS AND CONDITION
Height as restored, 14.4 cm; width (across handles), 32.4 cm; diameter of bowl, 24.8 – 25.1 cm; diameter of foot, 10.9 cm; diameter of tondo, 6.1 cm; width of resting surface, 3.6 cm. Height of figures, 3.1 cm; radius of compass-drawn shield, 0.72 cm. The vase is broken and has been repaired; the losses are merely in the black portions. The foot

was broken off and reattached in antiquity with three dowels. Part of the foot is missing and is restored.

SHAPE AND DECORATION
Standard shape, with rounded lip; the round handles are unglazed on the inside; high stem; flaring foot with reserved edge. (It is not clear whether the fillet between the stem and bowl is ancient.) On the inside of the lip, near the rim, is a reserved line; in the center of the bowl is a reserved tondo decorated with glaze circles. On the exterior is a figure-zone on the level of the handles; a reserved band runs halfway between the figure-zone and the bottom of the bowl. The figure scenes in the narrow zone are set between palmettes that spring from the handles. Each palmette has a red core and five black fronds.

ADDED COLORS
Red, fillet between stem and bowl; cores of all palmettes. On side A, neck of first horse and single stripe on its haunch; coxcomb and wattles in shield device of first hoplite, rim of his shield, flare of his cuirass, stripe on his right side, his crest support; chiton, crest support, and inside of shield of second hoplite; fillet on helmet of third hoplite, flare of his cuirass, background of his shield (except rim); chiton of second rider, two stripes on his horse; shield rim of fleeing hoplite, stripe on right shoulder of his cuirass. On side B, hair and beards of all satyrs; hair on chest of first satyr, dots for hair on nipples of second and third satyrs; fillets of first maenad and of Ariadne; bottom stripes on peplos of first maenad and its upper part; two vertical panels on peplos of second maenad; mantle of Dionysos; bottom stripe on Ariadne's peplos and part of her mantle; top and central panel of third maenad's peplos; all pupils in female eyes; single-dot earrings of maenads; three-dot earring of Ariadne. *White,* on side A, chiton of first horseman; cock on shield of first hoplite, row of dots on edge of his chiton; linen corselet of second hoplite; chape of scabbard of third hoplite and star-rosette on his shield (except for center, which is red), crest of his helmet; cap of second horseman, row of dots on lower edge of

211

58 LIP-CUP (HYBRID TYPE)

PARIS, MUSÉE DU LOUVRE, CA 2918,
BEQUEST OF GUSTAVE SCHLUMBERGER, 1931.

his tunic; wasp on shield of last hoplite, row of dots along edge of his chiton. On side B, flesh of all women; row of dots on lower peplos borders of all maenads; chiton of Dionysos.

BIBLIOGRAPHY
J. de Witte, *Description d'une collection de vases peints et bronzes antiques provenant des fouilles de l'Etrurie* (Paris 1837) 19, no. 41; idem, *Description de la collection d'antiquités de M. le vicomte Beugnot* (Paris 1840) 20, no. 21; idem, *Catalogue de la collection d'antiquités de feu M. Ch[arles]. Paravey* (Paris 1879) 3, no. 7; E. Pottier, *Vases antiques du Louvre 2* (Paris 1901) 99, F 75, pl. 69; idem, *Catalogue des vases antiques 3* (1906) 748; P.N. Ure, *Archaiologike ephemeris* 1915, 119, n. 2; J.D. Beazley, *JHS* 49 (1929) 269; idem, *JHS* 51 (1931) 274, pl. 12; idem, *JHS* 52 (1932) 202; *Encyclopédie photographique de l'art 2* (Paris 1936 – 1937) 288; N. Plaoutine, *CVA*, Louvre, fasc. 9 (1938) III He, 67 – 68, pl. 81,3 – 10; E. Vanderpool, *Hesperia* 8 (1939) 252 – 253, fig. 10; J.D. Beazley, *Development* (1951) 56, pl. 26,2; idem, *ABV* (1956) 156, no. 81; S. Karouzou, *The Amasis Painter* (Oxford 1956) 19, 36, no. 62, pl. 12,1, pl. 14,1 – 2; J. Boardman, *ABFV* (1974) 55, 73, fig. 81.

The scenes on both sides of the cup are very similar. On the side that I take to be the obverse, the lions at the ends of the zone stand to the right, looking round. In the center a naked boy on horseback with an upright spear in his right hand gallops to the right and is met (or attacked?) by a naked boy running toward him, a fringed wrap in the crook of his left arm, a spear poised toward the horse's forelegs in his right hand. Behind the rider a boy with a fringed chlamys over both shoulders and upper arms runs up, a spear held diagonally in his right hand. Between him and the lion stands a boy dressed in a himation holding a spear. On the other side, behind the boy running up to the rider, are two more bystanders — two boys clad in himatia holding spears. The reverse differs from this scene chiefly in that the lion on the left does not look round and that the two bystanders are now on the left, having traded places with the single one. In this scene the boy in front of the rider does not move toward him but runs to the right, looking round; his spear is carried peacefully at a diagonal in the low-ered *left* hand. As on the Amasis Painter's lekythos in the Villa Giulia (fig. 111; *ABV* 154, no. 54), the chlamys is draped over his chest and his upper arms: the painter may have intended a back view of the body, but by incising the thigh line to the groin and the genitals, he has inadvertently confused the front and back of the boy. The figure running behind the rider and the rider himself are as on side A. Behind the rider, an eagle flies to the right.

The composition on the reverse of this cup is very close to the reverse of the cup of type A in Mayence (Cat. 59), on which, incidentally,

the Amasis Painter has avoided the mistake (discussed above) in the anatomy of the youth running in front of the rider. Coupled with the evidence of the unorthodox treatment of the lip-cup, the style of drawing bears out a dating to the very early period of the Amasis Painter. The lions at the handles provide a perfect foil for the lion on the Tel Aviv cup (fig. 95; *Paralipomena* 67), which is hardly later.

Attributed to the Amasis Painter by N. Plaoutine.

Found at Marion, on Cyprus. Ex colls. Max Ohnefalsch-Richter, Gustave Schlumberger. (A number "419," once on the foot, may refer to Ohnefalsch-Richter's inventory of the vases excavated by him at Marion.)

DIMENSIONS AND CONDITION
Height, 10.35 – 10.53 cm; width (across handles), 26.88 cm; diameter of bowl, 20.08 – 20.11 cm; diameter of foot, 8.87 cm; width of resting surface, 1.38 cm. Height of figures, 2.47 cm. The vase is cracked and one handle is broken; the stub of the handle and the adjacent area have been broken off and reattached.

SHAPE AND DECORATION
The general make of the vase is that of a lip-cup, but the foot is that of a Siana cup, and the figures, instead of being placed on the lip, are in the handle-zone. The entire interior is glazed, except for a reserved line near the edge. The handles are unglazed on the inside. On the exterior of the bowl, a glaze line marks the offset of the handle-zone from the lip. The underside of the foot has a glaze circle at the inner edge of the resting surface. There is a reserved band encircling the vase well below the handle-zone. The groundline is drawn in dilute glaze.

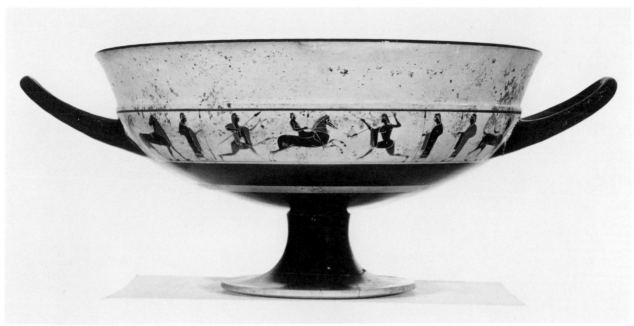

58 Side A (profile).

ADDED COLORS
Red, hair of all boys on side A, hair of all but second boy on side B; necks of horses; manes of lions, markings below their shoulders, two stripes on their haunches; some folds and panels of himatia and chlamides; cores of dot-rosettes on himatia of first and fifth boys on side A and first and sixth boys on side B; wing bow and tail bar of eagle. *White,* belly stripes of lions; dots around cores of dot-rosettes; narrow borders along red panels on chlamides of second and fourth boys on side A and of third boy on side B; teeth of right-hand lion on side B; rows of dots along lower borders of himatia on second boy on side B and first boy on side A.

BIBLIOGRAPHY
A. Merlin, *Bulletin des Musées de France* 3 (1931) 170 – 171; N. Plaoutine, *CVA,* Louvre, fasc. 9 (1938) III He, 71 – 72, pl. 84,1 – 5; E. Vanderpool, *Hesperia* 8 (1939) 253, fig. 11, 255; J.D. Beazley, *JHS* 59 (1939) 305; F. Villard, *REA* 48 (1946) 160 – 161; J.D. Beazley, *Some Attic Vases in the Cyprus Museum* (London 1948) 50; idem, *Development* (1951) 61; idem, *ABV* (1956) 157, no. 85; S. Karouzou, *The Amasis Painter* (Oxford 1956) 8, 35, no. 61; D. von Bothmer, *Antike Kunst* 3 (1960) 72; H.A.G. Brijder, *BABesch* 50 (1975) 158, nn. 6 – 8, 169, figs. 6a – b.

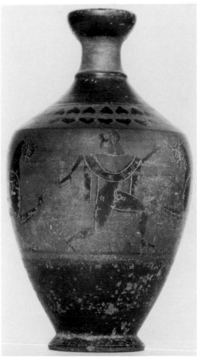

Fig. 111. Lekythos (shoulder type). Attributed to the Amasis Painter. Rome, Museo Nazionale Etrusco di Villa Giulia, 24996.

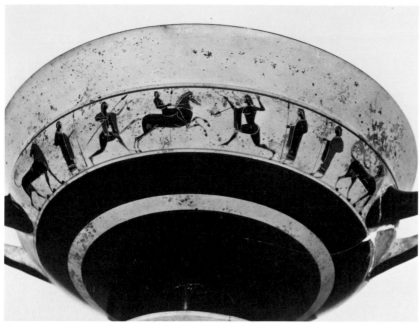

58 Side A.

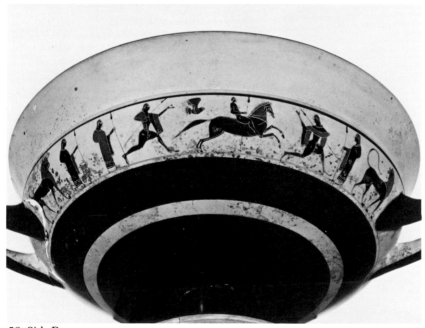

58 Side B.

59 Cup (Type A)

Mayence, University, inv. 88, acquired with a large part of the Preyss collection after 1948.

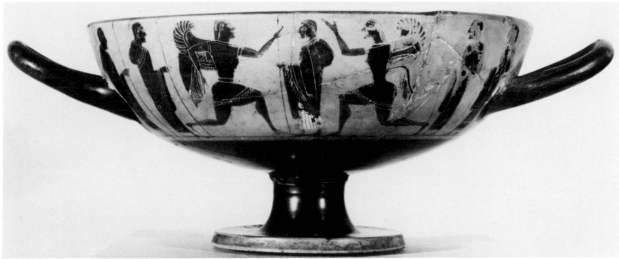

59 Side A (profile).

The picture on the obverse features two winged youths rushing up to a youth in the middle from either side. This trio is flanked on each side by two more youths; the two on the right take with them a third, who is placed under handle A/B. The winged youths wear short belted chitons with fringes along the lower edges; the figure in the middle wears a long white chiton and a himation; the bystanders wear only himatia. All but the winged youths and the bystander under the handle hold upright spears.

On the reverse a naked boy on horseback with an upright spear and the reins in his hands gallops to the right. He is preceded by a youth who runs to the right and looks round, a wrap draped over his shoulders and upper arms; in his right hand he holds a spear diagonally. The rider is followed by a running youth, who wears a wrap that covers his shoulders, his left upper arm (which is extended in a greeting gesture), and the left arm and hand. This foursome is flanked on the left by two youths in himatia holding spears in their left hands,

and flanked on the right, under handle B/A, by a third figure similarly dressed.

The winged daemons on the obverse recur on several lekythoi by the Amasis Painter. On the one in Leningrad (fig. 64; *ABV* 154, no. 56), the winged youths wear the same belted short chitons as on this cup in Mayence. There they do not run but walk toward the central figure, and are followed by a walking youth on each side; the whole scene is flanked by two onlookers, one in a himation (on the left), the other in a chiton and himation (on the right). The bystander on the right is very close to the central figure on the Mayence cup shown here. There is the same symmetry displayed on the Leningrad lekythos as on the cup, a symmetry that the painter neglects on the lekythoi in the Kanellopoulos collection (fig. 38; *Paralipomena* 66), in Warsaw (fig. 39; *Paralipomena* 66), and in Philadelphia (Cat. 40). Each of these three lekythoi shows only one winged youth, who is running at great speed: once toward a seated man (Kanellopoulos lekythos), another time facing a running

youth (Warsaw), and the third time toward a horseman (Philadelphia), always in a jumble of figures that do not help in the interpretation of the elusive stories. The composition on the reverse of this Mayence cup is repeated by the Amasis Painter on a cup in the Louvre (Cat. 58) and a lekythos in Tübingen (Cat. 39). The five lekythoi discussed here, the Louvre cup, and the Mayence cup are all rather early and may count among the earliest vases by the Amasis Painter, about 560 B.C.

Attributed to the Amasis Painter by D. von Bothmer in 1957.

Ex coll. Adolf Preyss.

Dimensions and Condition
Height, 9.2 cm; diameter of bowl, 18.5 – 18.8 cm; width (across handles), 25.8 cm; diameter of foot, 8.3 cm; width of resting surface, 2.4 cm; diameter of tondo, 4.4 cm. Height of figures, 5.5 – 5.6 cm. The cup is broken and has been repaired; there are minor losses and repainting along the fractures.

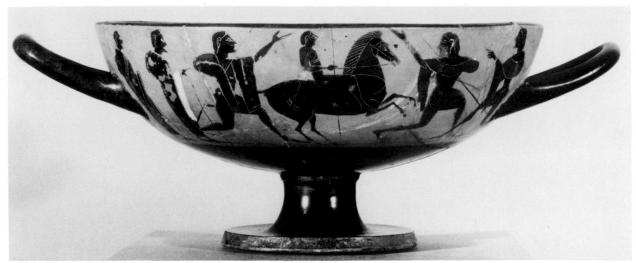

59 Side B (profile).

SHAPE AND DECORATION

Standard shape, with a continuous curve for the bowl and a fillet between the bowl and the stem of the foot. The interior is glazed, except for a small reserved tondo decorated with two concentric circles and a dot in the center. The foot is glazed on the outside to the slightly concave edge of the footplate. The lower part of the bowl and the stem are glazed. The edge of the bowl has a glaze line on the outside. The figure frieze is separated from the lower part of the bowl by a groundline drawn in dilute glaze. The inside of the stem is glazed.

ADDED COLORS

Red, hair of all figures. On side A, wing bows of winged youths; chiton of right-hand youth; parts of himatia; dots on garments. On side B, neck of horse, stripe on its haunch; panels of wraps; lower border of himation of first onlooker on left; dots on himation of second bystander. *White,* on side A, chiton of youth in center; border of wing bars of winged youths; dots on edge of their chitons.

The spear held by the mounted boy was added after the painter had already painted the horse and the rider but before he applied the incisions.

BIBLIOGRAPHY

R. Hampe and E. Simon, *Griechisches Leben im Spiegel der Kunst* (Mainz 1959) 18 (illustrated on facing plate), 43; eidem, *CVA,* Mainz, Universität, fasc. 1 (1959) 43, pl. 41,1 – 2, pl. 42,2 – 3; D. von Bothmer, *Antike Kunst* 3 (1960) 72, pl. 3,3 – 4; J.D. Beazley, *Paralipomena* (1971) 67.

59 Drawing of profile.

216

60 CUP (TYPE A)

KINGS POINT, NEW YORK,
NORBERT SCHIMMEL (COLOR PLATE 7).

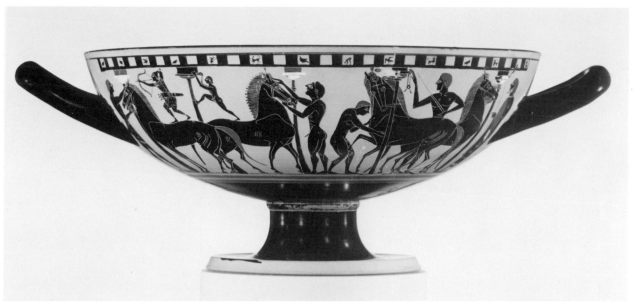

60 Side A (profile).

The pictures on the exterior of the cup tell the story of Poseidon rousing the Greeks at Troy. On the obverse the stable of Poseidon is shown with four grooms next to four horses tethered by their lead straps to four of the five columns of the stable. Their hindquarters overlap in such a way as to hide the genitals; perhaps the artist did this deliberately, since he wanted to leave uncertain whether these horses are stallions or mares. To the right, a man clad in a himation holding a staff oversees the activity in the stable, while the youth in a chlamys under handle A/B, who also holds a staff, is perhaps a mere bystander. The four grooms are of different ages and heights: the second and fourth are characterized as youths by the stubble on their jawlines. Each is engaged in a different action. The boy on the extreme left, who wears a kilt, quiets a restive horse by placing his left hand on its forehead and holding onto the lead strap with his right; the first youth

appears to be adjusting the browband; the smaller boy back to back with the youth uses both hands to calm a very nervous horse, and the taller youth on the far right, who holds a goad in his left hand, has turned round to take a headstall from the corner of the abacus.

The painter has enlivened the scene of horses being taken from the stable by adding two mysterious boys, drawn on a smaller scale, of whom the first, dressed in an oriental cap and a trousered sleeveless garment, has jumped on the back of the first horse and has drawn his bow; a quiver with the cover opened holding three other arrows is suspended over his right shoulder by an incised baldric. This diminutive archer is followed by a small naked boy who is lowering himself onto one of the horses from the entablature above. He braces himself with the right leg against the column, since his left foot is not yet firmly on the loins of the second horse, and he keeps his balance by holding onto the abacus. The activity of these two daemonlike

creatures is observed by the first and second grooms, who raise their heads in wonderment.

The five columns support a long frieze of fourteen peopled and twelve empty squares, or "metopes," separated from one another by an equal number of black squares, which may stand for triglyphs. The decorated metopes each contain a tiny figure drawn, except for the eyes, in silhouette: four birds in the first four, followed by a squatting monkey, a panther, a hen, another monkey bending over, a swan, a lion, a hen, a dog, a boy leaving his perch, and a kneeling archer. In addition to the eyes of the animals, the boy, and the archer, the painter has also incised, for greater clarity, the right leg and the left arm of the boy climbing out. The last two figures repeat the pair who are drawn on a bigger scale on the two left-hand horses and must be of the same breed, ready to take their places on the other two horses. This is no ordinary stable, but that of

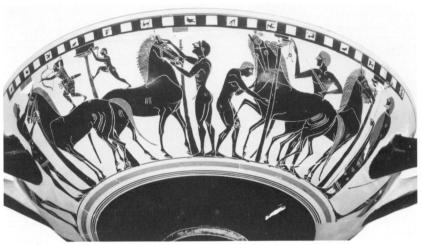

60 Side A.

60 Handle B/A.

Poseidon, who went to his "famous gold and gleaming palace" (*Iliad* 13, 17ff.) at Aigai, on the bottom of the sea, to harness his chariot when he wished to appear in the Greek camp at Troy to encourage the Greeks.

The sequel to Poseidon's departure is told on the reverse of the cup. In Homer (*Iliad* 13, 45) he appeared in the likeness of Kalchas, but the Amasis Painter has dispensed with the disguise. In the center of the cup he is seen with his trident, wearing a knee-length chiton and chlamys, and a fillet in his hair. He is advancing between two hoplites who should be Ajax the son of Oileus, and Ajax the son of Telamon, each followed by an archer (one of whom may be Teucer). The archer on the right turns to talk to a hoplite behind him, who walks next to another hoplite (whose head is missing). Poseidon and the six Greek heroes are flanked by two onlookers: on the left, a youth holding an upright spear, and, on the right, another (whose head is lost), without a spear. The figure under handle B/A is yet another warrior advancing to the left who obviously belongs to this scene.

There is much variety in dress and armor. The flanking youth on

the left has a fillet in his hair and wears a himation that differs from the himation worn by his companion on the right, in that it does not have the crinkled line running down its length. The archers wear two kinds of oriental caps and carry their quivers differently, on the shoulder (on the right) and by the left side (on the left). In addition, the archer on the left is equipped with tassled leather leggings and carries a battle-ax, while the other archer holds instead a long arrow in his right hand. Two of the

Fig. 112. Neck-amphora. Attributed to the Painter of Vatican 365. Detail showing a monkey. Orvieto, Faina Collection, 84.

five hoplites are without shields and greaves. The Ajax to the left of Poseidon wears a Corinthian helmet, a short chiton, a leather cuirass, and greaves, but he has no sword; in his right hand he holds a spear; on his left arm he carries a shield seen from the inside. The other Ajax is similarly dressed and equipped, but corslet and chiton are hidden by the round shield emblazoned by a ram. The hoplite without a shield, talking to the archer, wears a filleted Corinthian helmet (like the two Ajaxes), a short chiton, and a fringed mantle; by his left side, carried high, is his sheathed sword: the tassels of the baldric attachment show that it was slung over his left shoulder. In his left hand he holds a spear. The more fragmentary hoplite behind him is armed with a round shield that bears a lion protome as a device, greaves, and a staff or spear. The last hoplite, under the handle, wears a belted short tunic, like the two archers, and a filleted helmet; in his left hand he carries a staff (rather than a spear, as there is no spear head). In his account of Poseidon's visit to the Greek camp, Homer specifically names Teucer, Leitos, Peneleos, Thoas, Deipyros, Meriones, Antilochos, and Idomeneus

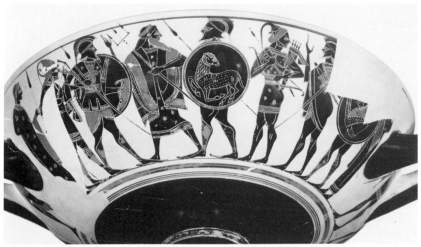

60 Side B.

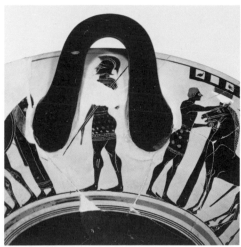

60 Handle B/A.

as the Greek heroes whom Poseidon exhorts after he has aroused the two Ajaxes (*Iliad* 13, 91ff.). Nevertheless, other than the two Ajaxes and Teucer, brother of Ajax the son of Telamon and renowned as an archer, it is not easy and perhaps not necessary to identify the four remaining heroes on the cup.

The interpretation adopted here of the two scenes is the one proposed by Marjorie J. Milne as early as the spring of 1965, when the cup was first lent to the Metropolitan Museum of Art. This interpretation was used on the label while the cup was exhibited (March 1965 – February 1967). Hans Jucker came independently to the same conclusion about the interpretation of the scene and published his views in 1966. Erika Simon accepts the Homeric source *Iliad* 13 for the reverse, but in the stable scene opts for a different chariot, that of Ares (on the strength of the two daemons, whom she identifies with Deimos and Phobos). While a thematic connection between the obverse and reverse of a vase is not necessary, on a cup that does not, by ornaments, emphasize a separa-

tion between the two halves of the exterior but rather deliberately—through the figures under the handles—tries to establish a unity, it would be odd to imagine that the painter did not want to show the palace of Poseidon at Aigai. Perhaps there existed, as Miss Milne surmised twenty years ago, a detailed description of the stable of Poseidon by some poet who was inspired by the few lines in the *Iliad* (13, lines 24 – 26) that evoke the palace of Poseidon.

One curious coincidence between monkeys and stables does not seem to have been noted before: a black-figured neck-amphora by the Painter of Vatican 365 in Orvieto (Faina 84; fig. 112) shows a monkey balancing like a tightrope walker on the reins of a chariot. The Orvieto neck-amphora is possibly a little earlier than the Schimmel cup shown here, which may be dated circa 540 – 530 B.C.

Middle period.

Attributed by H. Hoffmann to the Amasis Painter.

DIMENSIONS AND CONDITION
Height, 12.2 cm; width (across handles), 33.6 cm; diameter of bowl, 25.73 – 25.77 cm; diameter of foot,

12.24 – 12.26 cm; diameter of tondo, 6.13 cm; width of resting surface, 2.78 cm; diameter of groundline of exterior, 15.4 cm. Height of figure-zone, 8.4 cm, radius of compass-drawn shields, 1.9 cm. The vase was broken in two and mended in antiquity: three ancient pairs of holes for the staples can be seen, on the obverse, above the head of the third horse and below the fifth column, and, on the reverse, across the cap of the leftmost archer. Other breaks occurred later and have been repaired; some pieces are missing and have been restored: part of the rim to the left of handle B/A, with the heads and shoulders of the figures, part of the chest of the hoplite under handle B/A, the left leg of the figure under handle A/B, and, adjacent to him, part of the legs of the left onlooker on side B and the back of the archer next to him.

SHAPE AND DECORATION
Standard shape; flaring foot with concave profile and broad resting surface; fillet between stem and bowl. The rim of the bowl is slightly thicker than the wall and is not rounded but flattened. The inside is glazed except for a reserved tondo, which is decorated with a glaze dot in the center surrounded by a thin glaze circle and a broader glazed band. The rim is black, with a reserved line on the inside along the edge. The foot and stem are glazed on the outside to the concave edge and on the underside, except for the resting surface. The

219

lower part of the bowl is also glazed. The figure-zone on the exterior is framed above by a single glaze line 0.36 cm below the rim. The figures stand on a glaze groundline, below which appear a red band and three glaze lines. The handles are glazed on the outside.

ADDED COLORS

Red, band below figure-zone; fillet above stem. On side A, hair of first, third, and fourth grooms and of two bystanders; dots on kilt of first boy; blocks above abacus of first and third columns; dots on dress of archer on first horse; tails and stripes on hindquarters of first and third horses; capital of second and fourth columns; hair dots around nipples of second and fourth grooms; fold of himation, dots and cores of dot-rosettes on himation of bearded bystander; under handle A/B, fold and edge of chlamys of youth, dots and cores of dot-rosettes on his garment. On side B, fillet in hair of left bystander, dots and cores of dot-rosettes on his himation and one of its folds; part of oriental cap of first archer, his leggings, central panel of his quiver, dots on his tunic; chiton, greaves, fillet, and (by mistake) part of inside of shield of first hoplite (Ajax the Locrian); fillet in hair of Poseidon, his beard, stripes and folds of his mantle, lower border and dots of his chiton; rim of shield, greaves, and fillet of Ajax son of Telamon; part of oriental cap, central panel of quiver, and dots on belted chiton of second archer (Teucer?); fillet, chiton, and panel on scabbard of hoplite behind him; greaves of sixth Greek, mane of lion on his shield; diagonal stripe on himation of right onlooker, dots on his mantle; under handle B/A, dots on tunic of last hoplite. *White,* capitals and abaci of first, third, and fifth columns; dots around cores of dot-rosettes on himatia and chlamides of bearded and young onlookers; tunics of archers; chiton of Poseidon; rows of dots on crest supports of helmets with fillets, along lower edges of chiton of first Ajax, Poseidon, and hoplite under handle B/A.

BIBLIOGRAPHY

H. Hoffmann in *The Norbert Schimmel Collection,* ed. H. Hoffmann (Mainz 1964) no. 24; K. Schauenburg, *JdI* 79 (1964) 112, n. 8; D. Ohly and K. Vierneisel, *Münchner Jahrbuch der bildenden Kunst* 16 (1965) 232; H. Jucker, *Studia Oliveriana* 13 – 14 (1966) 41 – 42, n. 132; J. Charbonneaux, R. Martin, and F. Villard, *La Grèce archaïque* (Paris 1968) 88, fig. 96; G.S. Korres, *Ta meta kephalon krion krane* (Athens 1970) 81, pl. 85b; H.D. Hoffmann, *Collecting Greek Antiquities* (New York 1971) 111, fig. 90a – c; J.D. Beazley, *Paralipomena* (1971) 67; D. von Bothmer, *MM* 12 (1971) 123, n. 1; M.B. Moore, *Horses* (1978) 67, 277, 280, 313, 362, 404, no. 417; J. Boardman, *ABFV* (1974) 55, fig. 83; H. Hoffmann in *Ancient Art: The Norbert Schimmel Collection,* ed. O. Muscarella (Mainz 1974) no. 56; E. Simon and M. Hirmer, *Die griechischen Vasen* (Munich 1976) 84 – 85, pl. 70,2, pl. 71,1 – 2; K. Schefold, *Spätarch. Kunst* (Munich 1978) 221 – 223; figs. 300, 301; U. Gehrig in *Von Troja bis Amarna: The Norbert Schimmel Collection,* ed. U. Gehrig (Mainz 1978) no. 74; O. Touchefeu in *LIMC* 1 (1981) 323, Aias I, no. 61, pl. 238; H.A. Shapiro in *Ancient Greek Art and Iconography,* ed. Warren G. Moon (Madison, Wisc., 1983) 92, fig. 6.7a – b.

61 CUP (VARIANT OF TYPE A)

BOSTON, MUSEUM OF FINE ARTS, 10.651, GIFT OF
EDWARD PERRY WARREN, 1910 (COLOR PLATE 6).

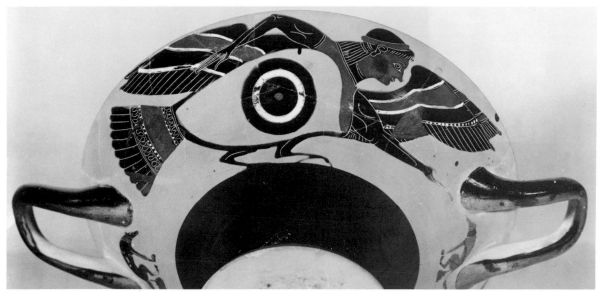

61 Side A.

The scurrilous pictures on the outside of the cup comprise, on the obverse, a male siren with two double wings spread out, a richly ornamented fantail, and the legs of a duck: its body is reserved and transformed into an eye of the type familiar from eye-cups; the human portions of the body are those of a muscular youth who wears a fillet in his hair and a tunic. The left arm is extended forward, the right arm held back.

On the reverse, two bearded nude revellers, awkwardly accommodated, are shown δεφόμενοι. The one on the left has arched his back and supports himself on his right elbow and both feet; the one on the right, who is more comfortable, having his shoulders supported by a folded pillow, has pulled up both legs and extends his free hand in a greeting. He wears an ivy wreath, while his companion has a fillet in his hair. Both wear garlands (ὑποθυμίδες) around their necks. Under each handle a small dog, facing the eye-siren on the obverse, defecates.

The best known eye-sirens occur on a neck-amphora in London

(fig. 113; *ABV* 286, no. 1), the name piece of Beazley's Eye-siren Group, a sub-group in his chapter on the Antimenes Painter and his Circle. The four London eye-sirens are standard contour eyes equipped with bird's legs, tails, and human heads (two bearded heads, painted white, facing two female heads); they lack arms, and the "standard" eye is so strong a model that even the eyebrows, a slightly curved line above the big contour-eyes, has been kept. Similar eye-sirens recur on fragments of a cup of type A in the collection of Herbert A. Cahn (HC 883) in Basel, by the same hand as the neck-amphora in London, except that the painter has extended their white necks to a generous portion of the eye contour, simulating a chest. By coincidence, a bearded figure that appears facing an eye-siren has, as on the London neck-amphora cited above, a white face. The Cahn cup was in all probability a normal cup of type A, and judging by the preserved portions was one of the biggest known; its eye-sirens faced each other in the approved manner of eye-cups. The Amasis Painter's eye-

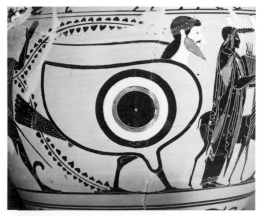

Fig. 113a,b. Neck-amphora. Attributed to a painter of the Eye-siren Group. Details of side B: sirens. London, The British Museum, B 215.

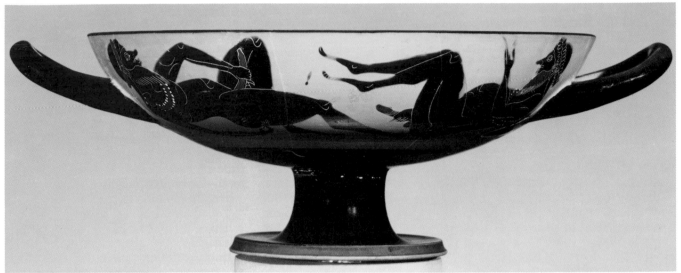

61 Side B (profile).

siren is a singleton, only vaguely recalling the pair of big eyes on eye-cups. With the addition of human arms and shoulders it becomes more siren than decorative eye to which a human head has merely been joined.

Beazley first saw the cup in Boston in October 1946 (on his previous visit in 1914, it had been sequestered in the museum with other erotic material and was unavailable for viewing). He at once exclaimed, "Amasis' answer to Exekias," alluding to the famous eye-cup in Munich said to have been invented by Exekias (fig. 115; *ABV* 146, no. 21), and he has rightly stressed in *Development* the element of parody.

The men on the reverse are drawn on a large scale—standing up, they would be as big as the figures on the New York olpe (Cat. 30) and the smaller of the two neck-amphorae in Boston (Cat. 24), with which the cup should be contemporary.

The red face of the siren is a very old-fashioned convention that goes back to the sirens painted by Sophilos (e.g., *ABV* 38 – 39, nos. 5, 7).

Late period.

Attributed by J.D. Beazley to the Amasis Painter.

Ex coll. Edward Perry Warren (who acquired the cup in Italy).

DIMENSIONS AND CONDITION
Height, 8.34 cm; width (across handles), 24.9 cm; diameter of bowl, 18.9 cm; diameter of foot, 8.17 cm; width of resting surface, 2.45 cm; diameter of tondo, 4.97 cm. Radius of compass-drawn eye, 1.57 cm. The vase is broken and has been repaired, but the restorations do not affect the drawing.

SHAPE AND DECORATION
The foot is of type A but lacks the fillet between the stem and bowl. The tondo is a reserved disk with glaze circles around a small glaze dot in the center. As on the two neck-amphorae in

61 Drawing of profile.

Boston (Cats. 24, 25), there is no groundline for the figures on the reverse of the exterior and the dogs under the handles. The figure on the obverse stands directly on the black zone of the lower part of the bowl. A glaze line runs around the rim; it is separated from the black of the interior by a reserved line. The inside of the stem is glazed to a height of 2.3 cm. The handles are glazed on the outside only.

ADDED COLORS
Red, lines around upper edge of foot profile and on top of black zone of bowl; face, fillet, and tunic of eye-siren; upper wing bars of near wings; two bars of far left wing; middle band across tail; pupil of apotropaic eye; garlands of men; fillet of left reveller, hair around his nipple, his penis; beard of right reveller, part of his cushion, genitals; necks of dogs, their excrement. *White,* borders of wing bars; line of dots above feathers of left near wing and along border of red tail bar; second ring of iris in eye on body of siren; middle stripe of folded pillow; rows of dots on garlands.

BIBLIOGRAPHY
M. True, *CVA,* Boston, fasc. 2 (1978) 43 – 44, pl. 100,5, pl. 101 (with bibliography to 1978). Add to the *CVA* bibliography: J. Boardman and E. La Rocca, *Eros in Greece* (London 1978) 82, top; A. Mulas, *Eros in Antiquity* (New York 1978) 42.

62 CUP (SPECIAL TYPE)

VATICAN, MUSEO GREGORIANO ETRUSCO, 369 A, AUGMENTED
IN 1939 BY FRAGMENTS FORMERLY IN DORCHESTER AND BOSTON.

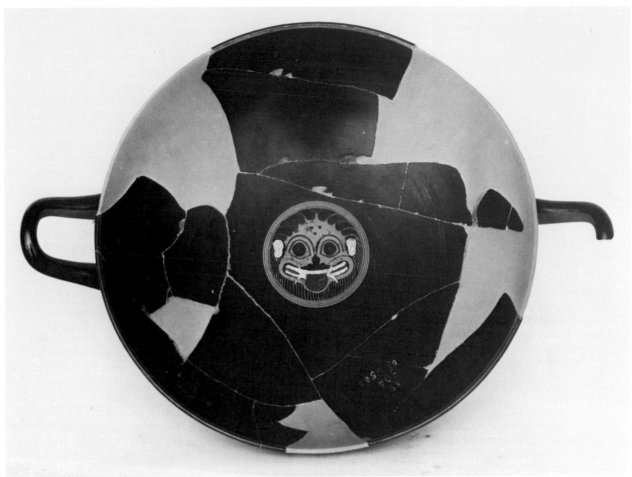

62 Interior.

On the inside, in a small tondo, is a gorgoneion. The exterior has on each side a figure between two eyes and eyebrows. On the obverse the subject is a komast running to the right. He is clad in a mantle draped over his left shoulder and left arm; ivy leaves in his hair form a wreath. In the palm of his left hand he balances a chalice-shaped cup with two short ivy branches in its handles; in his right hand he holds an oinochoe by its high handle. Signed above the left eyebrow is [AMASI]S; above the right, EΠOI[ESEN].

The obverse is connected with the reverse, on which the space between the two eyes is given over to a woman dressed in a chiton and himation. In her left hand, she holds a lyre; in her right hand, an ivy branch. Signed between the left eyebrow and the left eye AMASIS is EΠOIESEN; between the right eyebrow and the right eye,

The eyes are contour-eyes, that is, the outline of each eye is rendered with a glaze line, and its circular center, the oculus, is compass drawn. In the middle is a red disk, surrounded by a black, a white, and another black ring.

There is some evidence that this cup signed by Amasis was found together with the unsigned cup now in Oxford (Cat. 63), even though

the two differ in some aspects, notably in the profiles of the feet. A third cup, of the same make, in Florence (fig. 114; *ABV* 157, no. 88), lacks its foot (which is wrongly restored in plaster). It agrees in scheme of decoration with the Vatican cup shown here, save that it is unsigned, lacks the black line at the rim, and has a reserved tondo rather than a gorgoneion on the inside.

The cups in the Vatican and Florence owe very little to the standard black-figured eye-cups first introduced in Athens by Exekias (fig. 115; *ABV* 146, no. 21) and popularized by others. Instead, the single figure placed between the eyes connects these eye-cups by the Amasis

223

Painter with *red-figured* eye-cups; red-figure influence can also be detected in the treatment of the eyes. In black-figure, the central disk is normally black, or black with a small red dot, and this convention is observed by the Amasis Painter on his eye-siren cup in Boston (Cat. 61). On the Vatican and Florence cups, however, he breaks with tradition and paints the big central disk (the "pupil") red, which is surrounded by the iris, a black ring, a white one, and another black one. Oltos treats eyes just like this on a number of his eye-cups (e.g., *ARV*² 54–57, nos. 9, 30, 40); on other cups by Oltos, the central red disk is somewhat smaller (e.g., *ARV*² 55–57, nos. 14–16, 18, 19, 23 bis, 25, 27, 34, 38, 40, 41; *Paralipomena* 327, no. 26 bis); they resemble the two cups signed "Psiax" without a verb (*ARV*² 9).

The smaller red disk also becomes the standard for Epiktetos, who, however, consistently paints the middle circle of the iris white (*ARV*² 71, 1623, 1705, nos. 6 bis, 8, 9 bis) but also uses a red circle (*ARV*² 70–71, nos. 1–3, 6) or leaves it reserved (*ARV*² 71, nos. 11, 14; *Paralipomena* 329, no. 14 bis). In 1922 Mrs. Ure had already noted that on the Vatican cup, "the eye used by Amasis was the peculiar property of the Red Figure painters, and decoration with single figures only

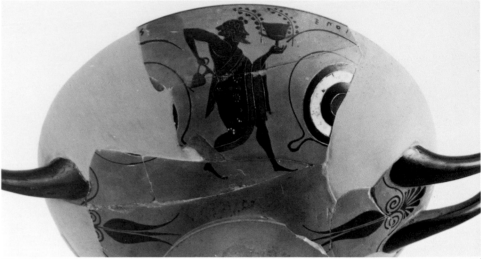

62 Side A.

between the eyes was their habitual practice" (p. 196). Beazley (in *JHS,* p. 270) more specifically saw a resemblance between the Vatican komast and figures on "such early works of Epiktetos as the signed cup formerly in the Pourtalès collection" (fig. 116; now New York 1978.11.21), and Beth Cohen has elaborated on the absence of groundlines (pp. 255ff., nn. 49, 56) and observes that on the coral-red cup by Psiax formerly in Odessa (*ABV* 294, no. 22), the absence of groundlines on the exterior heightens the impression of flight by Hermes and Perseus (p. 515). There is, perhaps, one more red-figure connection that should not be

brushed aside: the komast on the Vatican cup does not hold a kantharos in the palm of his hand (as described in *ABV* 157, no. 87) but a vase that reminded Mrs. Ure (p. 197) of the Naucratite chalices, and the same shape recurs on a late olpe by the Amasis Painter in the Agora (fig. 117; *ABV* 714, no. 31 bis). There is, indeed, a contemporary Attic bilingual chalice found in fragments on the Acropolis (*ARV*² 5, no. 5; compared by Beazley with a black-figured fragment in Lon-

Fig. 114a,b. Cup (special type). Attributed to the Amasis Painter. Detail side A: woman with a lyre. Detail side B: woman. Florence, Museo Archeologico, 94744.

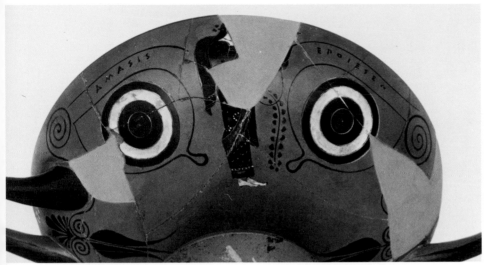

62 Side B.

don), and nothing stands in the way of taking the vase held by the komast on the cup in the Vatican and the banqueter on the Agora olpe to be a black-figured or red-figured Attic chalice.

The woman on the reverse of the Vatican cup shown here does not play the lyre, as do the woman on the Amasis Painter's Florence cup (fig. 114; *ABV* 157, no. 88) and the man on his Orvieto chous (fig. 118; *ABV* 153, no. 43), but holds it in her left hand, very much as do Apollo on the London lekythos (Cat. 49) and the youth on the oinochoe in the Vatican (Cat. 38). Again, like that youth, she holds an ivy branch in her lowered right hand. The lyre

is held at some distance from her body, hence is not in a position to be played; her gesture is, rather, that of proffering it to someone, as is seen on the mastoid in the Louvre (Cat. 53).

For a date, I suggest that the Vatican cup shown here and the Florence cup (fig. 114; *ABV* 157, no. 88) are a bit earlier than the Oxford cup (Cat. 63), and that all three are later than the Boston eye-siren cup (Cat. 61). Late period, circa 520 – 515 B.C.

The two fragments formerly Boston 03.850 were, on the strength of the signature, recognized as by the Amasis Painter by

Alice Walton; the fragment once in Dorchester was connected with the Boston fragments by Mrs. Ure (pp. 194 – 197), but she was reluctant to attribute the fragments in Dorchester and Boston to the Amasis Painter. In 1928 Beazley said of the fragments that they "at least stand close to the Amasis Painter" (*ABS*), but not until he saw some of the Vatican fragments in 1929 and found others in the Vatican in 1931 did he connect the Boston and Dorchester fragments with the Vatican pieces, determining that they came from the same cup, which he attributed to the Amasis Painter (*JHS* 51 [1931] 266 – 268). The exchange of fragments took place in 1939.

From Etruria, probably from Vulci.

DIMENSIONS AND CONDITION
Height, 7.4 cm; diameter of bowl as restored, 21.0 cm; diameter of foot, 7.56 cm; width of resting surface, 2.53 cm; diameter of tondo, 4.5 cm. Height of figure-zone, 7 cm. The vase is broken and has been repaired, with missing

Fig. 115. Cup (type A). Signed by Exekias as potter and attributed to Exekias. Side A. Munich, Staatliche Antikensammlung und Glyptothek, 2044.

Fig. 116. Red-figured cup. Signed by Epiktetos as painter. Tondo: komast. New York, The Metropolitan Museum of Art, 1978.11.21.

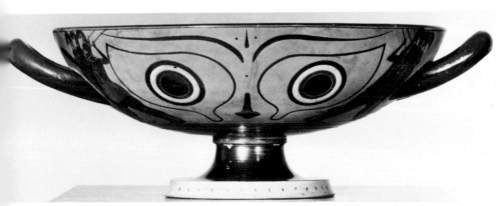

parts restored. Still missing are the face, chest, left arm, right forearm, and most of the lyre of the woman, the right ankle of the komast, and parts of the eyes and eyebrows on the obverse, including the first five letters of the potter's name and the last four letters of the verb.

SHAPE AND DECORATION
The profile of the cup curves without interruption from the bowl into the stem and foot of type A; on top of the foot, near the junction of the stem, is a small fillet. The only black areas on the exterior of the cup (other than the figure decoration) are the zone between the small fillet and the edge of the foot, and the outside of the handles. Near the rim of the cup, a black line encircles the vase. The inside of the stem is glazed almost all of the way up. The inside of the bowl is black, except for a reserved line near the rim, and the tondo, which is decorated with an outline gorgoneion framed by four thin concentric circles. Seen from the inside, the handles are strictly horizontal in relation to the tondo. The ornament below and around each handle on the exterior consists of a nine-frond upright palmette, the volutes of which curl up on each side of the handle to form a spiral near the rim; directly below the palmette is a stylized hanging flower. There is no groundline.

ADDED COLORS
Red, in the tondo, six curls of gorgoneion on its forehead, its tongue, line between teeth, its mustache, its pupils. On the exterior, small fillet on top of foot-plate; pupils of eyes; folds and borders of musician's and komast's mantles; cores of dot-rosettes; dots on mantles; dots on upper part of musician's chiton and its lower border; earring of musician. *White,* in the tondo, ears, teeth, and tusks of gorgoneion; on the exterior, second ring around pupils of eyes; female flesh; rows of dots on borders of musician's garments; dots around cores of all dot-rosettes; end of crossbar of lyre.

BIBLIOGRAPHY
A. Walton, *AJA* 11 (1907) 158 – 159, fig. 2; E. Buschor, *Griechische Vasenmalerei*[1] (Munich 1913) 141; 2nd ed. (Munich 1914) 131; A.D. Ure, *JHS* 42 (1922) 192 – 197; J.C. Hoppin, *Black-figured Vases* (1924) 32; J.D. Beazley, *ABS* (1928) 36, nos. 1, 2; idem, *JHS* 51 (1931) 266 – 270, figs. 11 – 13, pl. 10; C. Albizzati, *Vasi del Vaticano* fascs. 1 – 7 (1925 – 1939) 154 – 156, figs. 95 – 98, no. 369a; E. Vanderpool, *Hesperia* 8 (1939) 251 – 252, n. 10; H. Bloesch, *Formen attischer Schalen von Exekias bis zum Ende des Strengen Stils* (Bern 1940) 42 – 43, pl. 11,3 (with profile); F. Villard, *REA* 48 (1946) 179; J.D. Beazley, *Development* (1951) 61 – 62, 112, n. 61; S. Karouzou, *The Amasis Painter* (Oxford 1956) 23 – 24, 36, no. 68, pl. 39, 1 and 3; J.D. Beazley, *ABV* (1956) 157, no. 87; B. Cohen, *Attic Bilingual Vases and Their Painters* (New York 1978) 255ff., nn. 49, 56, pl. 126,3.

Fig. 117. Fragmentary olpe (with trefoil mouth). Attributed to the Amasis Painter. Detail showing a chalice. Athens, Agora Museum, P 24673.

Fig. 118. Chous. Attributed to the Amasis Painter. Detail showing a man with a lyre. Orvieto, Museo Civico, 1001.

63 CUP (SPECIAL TYPE)

OXFORD, ASHMOLEAN MUSEUM OF ART AND ARCHAEOLOGY, 1939.118, ACQUIRED BY EXCHANGE FROM THE DORSET COUNTY MUSEUM, DORCHESTER, AND THE VATICAN, MUSEO GREGORIANO ETRUSCO.

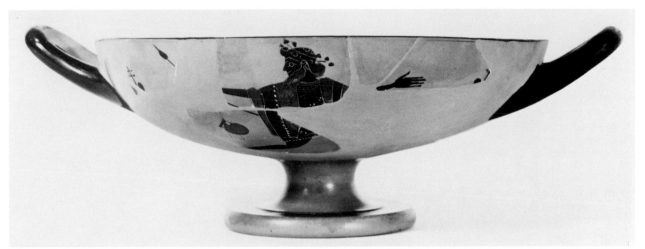

63 Side B (profile).

The figure decoration is limited to one person on each side. On the obverse a reveller in boots and a chlamys over his shoulders and upper arms moves to the left, a high-handled oinochoe in his right hand. The upper part of his body, his neck, and his head are missing, as are both arms; one of them, however, must have held an ivy branch, the end of which remains. The muscular legs are shown in profile facing left, as is what is left of his trunk: the painter has mistakenly given a right hand to his reveller when it should have been a left one.

On the reverse, a bearded wreathed komast is running to the right while looking back. He wears a short chiton and, over his shoulders and upper arms, a chlamys. In his right hand he carries a spear and a very big aryballos; his left arm is extended horizontally, with the hand opened.

The ivy wreath of the man on side B with a spear and an aryballos marks him as a komast, even if his equipment is somewhat incongruous. Boots, worn by his companion on side A, begin, at this period, to become quite fashionable for komasts in red-figure vase-painting, as on the psykter by the Dikaios Painter in London (fig. 119; *ARV²* 31, no. 6), the calyx-krater by Epiktetos in Rome (*ARV²* 77, no. 90), and his plates in London and the Cabinet des Médailles (*ARV²* 78, nos. 95, 96). From this time on, moreover, boots removed for banquets or indoor revels appear either under couches (e.g., Boston 95.61, *ARV²* 132) or in predellas below banqueters (e.g., Florence 73749, *ARV²* 355, no. 39).

The relaxed bodies and the rather loose style of drawing, coupled with the innovations of the shape, make this cup one of the latest vases by the Amasis Painter.

Attributed to the Amasis Painter by J.D. Beazley, who also reunited the fragments formerly in Dorchester with those in the Vatican.

From Etruria. One of the Dorchester fragments bore, in ink, the name of the nineteenth-century Roman dealer Campanari; hence, the vase may perhaps be from Vulci.

DIMENSIONS AND CONDITION
Height, 7.3 – 7.5 cm; diameter of bowl, 18.0 – 18.2 cm; diameter of foot, 7.9 cm; width of resting surface, 2.3 cm; diameter of tondo, 4.8 cm. Height of figures, 9.1 cm. The inside of the stem is glazed to a height of 2.25 cm. The vase is broken and has been repaired, with missing portions restored in plaster. These comprise handle B/A, except for right stub; handle A/B, except for most of upright part of handle's right half; upper part of reveler on side A, left arm, except for hand, right arm and hand, tip of left boot; on side B, parts of both arms of komast, right hand, middle of body, and entire left leg and foot; in the floral decoration, under and around handle A/B, most of palmette and upper right flower, all of flower below palmette; under and around handle B/A, tips of fronds of palmette, most of flower below it, most of upper left flower.

SHAPE AND DECORATION
The cup is most unusual in that its shape comes close to the type called B. The outside wall is continuous and has no fillet between the stem and the bowl; instead, the fillet, much reduced, has been moved to the junction of the foot and the stem. The profile of the foot is convex. The inside of the cup is black, except for a reserved tondo with two glaze circles as well as a central glaze dot. The handles—one of which is al-

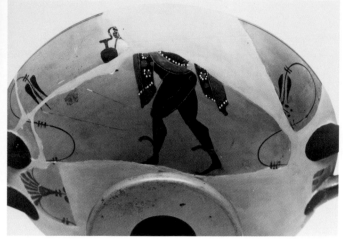 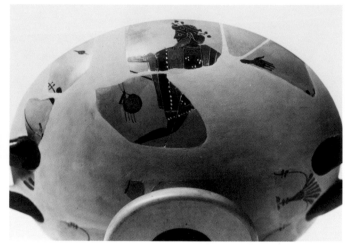

63 Side A.

most completely restored, the other of which is half restored—are glazed on the outside only. Other than the handles, the only area glazed black on the exterior is the small zone on top of the foot between the fillet and the beginning of the convex torus profile. The inside of the stem is glazed. There are no groundlines.

The decoration under and around the handles consists of an upright seven-frond palmette linked at its base to a hanging flower, drawn with three petals well separated from one another; similar hanging flowers appear on either side of each handle, connected to the palmette below the handle by gracefully curved glaze tendrils. At the point where the curve of the tendril changes direction are two or three short horizontal glaze strokes; similar strokes also appear at the junction of the palmette and the flower hanging below it; such strokes are also known from the neck-amphorae Cabinet des Médailles 222 (Cat. 23) and Boston 01.8027 (Cat. 25).

ADDED COLORS

Red, core of palmette; folds and stripes on chlamides; dots and cores of dot-rosettes; beard of komast, tops of boots of his companion; body of aryballos. *White,* dots around cores of dot-rosettes; horizontal and vertical rows of dots along horizontal and vertical red stripes; cluster of three dots on chiton of komast; row of dots between core of palmette and fronds.

BIBLIOGRAPHY

J.D. Beazley, *JHS* 51 (1931) 270–273, NN, figs. 15, 16, pl. 11; C. Albizzati, *Vasi del Vaticano,* fascs. 1–7 (1925–1939) 155–157, no. 369 b, figs. 99, 99 bis; Oxford University, *Ashmolean Museum: Report of the Visitors* (Oxford 1939) 11, pl. 5,1; E. Vanderpool, *Hesperia* 8 (1939) 251–252, n. 10; H. Bloesch, *Formen attischer Schalen von Exekias bis zum ende des strengen Stils* (Bern 1940) 42–43, n. 78; F. Villard, *REA* 48 (1946) 179; J.D. Beazley, *Development* (1951) 61–62, pl. 26,3; S. Karouzou, *The Amasis Painter* (Oxford 1956) 23–24, 36, no. 69, pl. 39, 2 and 4; J.D. Beazley, *ABV* (1956) 157, no. 89.

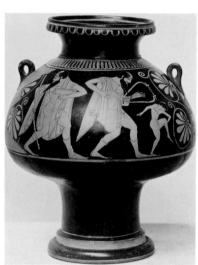

Fig. 119. Red-figured psykter. Attributed to the Dikaios Painter. Komasts. London, the British Museum, E 767.

Lekythos (shoulder type)
Malibu, The J. Paul Getty Museum, 76. AE.48, acquired in 1976.

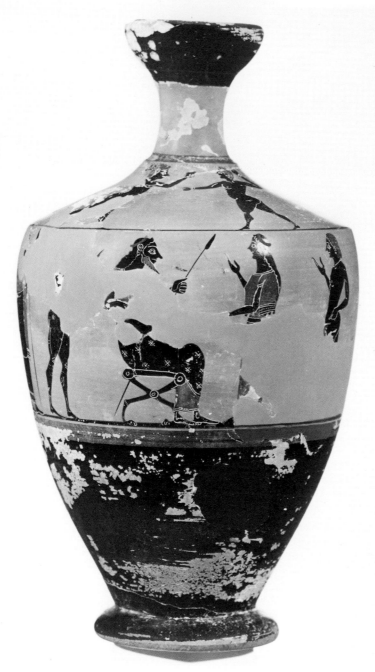

[App. 1] Malibu 76. AE.48. Front.

On the shoulder are boxing boys and an onlooker; on the body is a man seated on a campstool greeted by a woman and five boys. The vase is signed on the underside of the foot AMASISMEΓOIESEN). Height 23.0 cm.

This lekythos has been fully published by Brian Legakis (*Antike Kunst* 26 [1983] 73 − 76, pls. 19, 20). The author discusses at length the workshop connections between Amasis the potter and the Taleides Painter and goes into the question of the preserved signatures by Amasis (p. 74, n. 7; the "oinochoe once in Canino" is London B 471 [Cat. 31], and the signature on it is not in two lines, as Legakis claims, but in one line). He also refers to a lekythos attributed by Herbert Hoffmann to the Amasis Painter (p. 74, n. 13), which, however, is not by the Amasis Painter but is instead a slight work by the Painter of the Nicosia Olpe.

540 − 530 B.C.

Attributed by J. Frel to the Taleides Painter.

[App. 1] Malibu 76. AE.48. Underside of foot.

APPENDIX 2: SIGNATURES OF
KLEOPHRADES, SON OF AMASIS, ON
TWO CUPS IN THE GETTY MUSEUM.

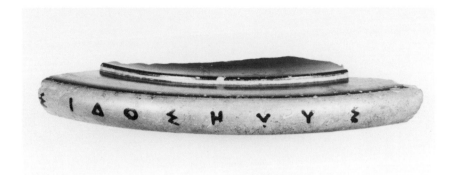

[App. 2.1] Malibu 80.AE.54. Fragmentary signature on edge of foot plate.

1. FRAGMENT OF THE FOOT OF A CUP
 (TYPE B)
 Malibu, The J. Paul Getty Museum,
 80.AE.54, acquired in 1980. Signed
 on the profile: ...]ϵΙΔΟϵΗΥΥϵ .
 Estimated diameter of foot (type B)
 17.1 cm.
2. FRAGMENTARY CUP (TYPE B)
 SIGNED ON THE INTERIOR BY
 DOURIS AS PAINTER
 Malibu, The J. Paul Getty Museum,
 83.AE.217, acquired in 1983.
 Signed on the profile of the foot:
 ΚΙΕΟΦΡΑΔΕϵ:ΕΠΟΙΕϵΕΝ:ΑΜΑϵΙΔΟϵ:
 Interior: Patroklos and Achilles.
 Side A: Herakles, six archers, and
 Iole; side B: wrestlers with spec-
 tators. Signed on the interior:
 ΔΟΡΙϵΕΛΡΑΦϵΕΝ: ΗΕΡΜΟΙΝΚΟϵΚΑΙΟϵ
 Circa 490 B.C. Height as preserved
 (without rim), 12.0 cm; diameter of
 tondo, 21.4 cm; diameter of foot,
 16.1 cm.

The potter Amasis, for whom
the Amasis Painter decorated cups
and pots, must have enjoyed some
fame in his lifetime and have been
known to his customers, for a son
of his, Kleophrades, signs several
times as potter, identifying him-
self as the son of Amasis. Two of
Kleophrades' signatures have been
known for a very long time; the
first, found in Tarquinia in 1829,
occurs on a foot of a splendid red-
figured cup now in the Cabinet
des Médailles in Paris, the name

piece of the Kleophrades Painter
(*ARV*² 191, no. 103); the other,
now almost completely obliter-
ated, was read by Adolf Furt-
wängler on the foot of a cup that
belongs to one of two fragmentary
cups by Douris in Berlin (*ARV*²
429, nos. 21, 22). On the Berlin
foot, Kleophrades signs as potter
without patronymic, but on the
cup in the Cabinet des Médailles,
the signature ΚΙΕΟΦΡΑΔΕϵ:ΕΠΟΙΕϵΕΝ:
is followed by ΑΜΑϵ ϵ: :,
which led to much speculation.

Eduard Gerhard (in *Annali dell'
Instituto* 3 [1831] 115, 179, no. 703)
assumed that the signature of the
potter Kleophrades was followed
by that of Amasis as painter, but
Heinrich Brunn rejected this res-
toration (*Geschichte der griechischen
Künstler* 2 [1859] 657), since the
last letter was clearly a sigma,
which would rule out a verb like
ΕΛΡΑΦϵΕΝ ("painted"). In 1888,
however, Jan Six came up with
the novel restoration "son of
Amasis," ΑΜΑϵ[ΙΟϵ:ΗΥΝ]ϵ:
(*RM* 3 [1888] 233–234). A pro-
posal first made by Otto Jahn in
1864 (*Annali dell'Instituto* 36 [1864]
242): ΑΜΑϵΙϵ:ΚΑΝΟϵ ("Amasis is
handsome") was rejected by Paul
Hartwig as unfitting for the foot of
a cup (*Die griechischen Meisterschalen
der Blütezeit des strengen rothfigurigen
Stiles* [Stuttgart 1893] 401). Not

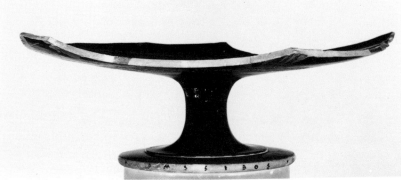

[App. 2.2] Malibu 83.AE.217. Three views of signature on edge of foot plate.

sure whether the last letter was a sigma, he reverted to Gerhard's restoration κ↓ΕΟΦΡΑΔΕξ:ΕΓΟΙΕξΕΝ፧ : ΛΜΑξΙξ:ΕΛΡΑΦξΕ . In 1910 Beazley reaffirmed that the critical last letter was a sigma and that the choice was between Six's reading, "son of Amasis," or Jahn's, "Amasis is handsome." Of the two he favored the first as "probably preferable"

(*JHS* 30 [1910] 38) and in 1933 said of Six's reading, "it fits and is highly probable" (*Der Kleophrades-Maler* [Berlin 1933] 17).

Six followed Herodotos in declining Amasis with ΛΜΑξΙΟξ for the genitive. In 1980, however, the Getty Museum acquired the fragmentary foot of an unattributed cup that gives the end of an inscription reading . . . ξΙΔΟξΗVVξ .

I took this to be the end of a sig-

nature like the one in the Cabinet des Médailles, except for the interpoints, and restored the signature on the Getty foot κ↓ΕΟΦΡΑΔΕξ ΕΓΟΙΕξΕΝ ΛΜΑξΙΔΟξ HVVξ , not deterred by the different genitive, since Six's restoration ΛΜΑξΙΟξ , which Herodotos uses when speaking of the Egyptian king, is not the one employed by Plutarch, Dinon, Diogenes Laertius, and Aelian, all of whom have ΛΜΑξΙΔΟξ . My arguments were confirmed a few years later, when the Getty Museum acquired a fragmentary cup by Douris, which on its intact foot gives a complete signature of Kleophrades as κ↓ΕΟΦΡΑΔΕξ:ΕΓΟΙΕξΕΝ: ΛΜΑξΙΔΟξ:

If nothing else, this proves that Kleophrades, when calling himself the son of Amasis, used the genitive ΛΜΑξΙΔΟξ , employed later by Plutarch and others, rather than the declension favored by Herodotos. We need not worry too much about this change, but the appearance on the Getty fragments shown here, of the two additional signatures by Kleophrades with patronymic— one of which is complete—is a splendid vindication for the scholarship of Jan Six, who almost a hundred years ago recognized the meaning of the fragmentary inscription in the Cabinet des Médailles.

On the first inscription, on Getty 80.AE.54, see D. von Bothmer in *GettyMusJ* 9 (1981) 1–4; the second inscription was published for the first time in *GettyMusJ* 12 (1984) Acquisitions/1983, Antiquities, 245, no. 69. Note that the pattern-work on Getty 83.AE.217 is very close to that on Berlin 2283 (*ARV²* 429, no. 21), one of the two cups to which the Getty foot signed by Kleophrades as potter may belong.

Amphorai (storage vases for wine or oil)

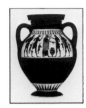

1. Panel-amphora, type B. Flaring mouth; round handles; echinus foot (Cat. 4).

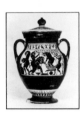

2. Panel-amphora, type A. Flaring mouth; angular flanged handles; foot in two degrees (Cat. 19).

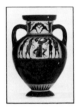 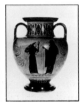

3. Neck-amphora. Echinus mouth; cylindrical neck set off from shoulders; round handles, strap handles, or triple handles; echinus foot (early), foot in two degrees, or angular foot (Cats. 21−23).

Oinochoai (jugs for pouring wine)

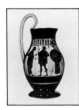

4. Olpe with trefoil mouth and high double handle; echinus foot (Cat. 27).

5. Olpe with round mouth and high flanged handle; echinus foot (Cat. 31).

6. Olpe with round mouth and low convex handle; echinus foot (Cat. 32).

7. Oinochoe, shape III (chous). Trefoil mouth; ridged handle; echinus foot (Cat. 34).

8. Oinochoe, shape I. Trefoil mouth; neck set off from shoulders; low ridged handle; echinus foot (Cat. 37).

9. Oinochoe, shape I (variant). Trefoil mouth; high ridged handle; decorated collar above junction of neck and shoulders (Cat. 38).

Lekythoi (oil jars)

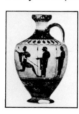

10. Shoulder type. Round mouth; sloping shoulder set off from neck by slight chamfer; strap handle; tapering body; echinus foot (Cat. 39).

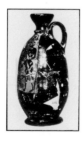

11. Deianeira type. Round mouth set off from ovoid body by heavy drip-ring; strap handle; echinus foot (Athens, National Museum, 404, here fig. 101).

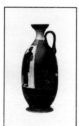

12. Sub-Deianeira shape. Like the Deianeira type, except that neck is not glazed and there is no drip-ring (Cat. 51).

Alabastron (oil or perfume vessel)

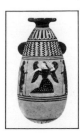

13. Slender shape, flat mouth; two small lugs on shoulder for suspension; rounded bottom (no foot). (Originally an Egyptian shape; Athens, Agora Museum, P 12628, here fig. 34.)

Aryballos (oil bottle, used mostly by men)

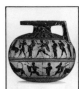

14. Spherical body; narrow neck; flat, heavy mouth sloping toward narrow opening; rectangular plaque-shaped handle; rounded bottom (no foot). (Originally a Corinthian shape; Cat. 52).

Drinking Vessels

Mastoid

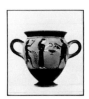

15. A mastoid normally has two *horizontal* handles, an offset rim, and a flat bottom. The special type painted by the Amasis Painter has two *vertical* handles and a foot (Cat. 53).

Cup-Skyphos

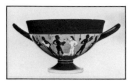

16. The Amasis Painter's cup-skyphos combines the deep bowl of a skyphos with the narrow base of a band-cup, but it lacks a stem, and instead of the ring base of a skyphos, it has a flaring foot with a heavy reserved edge. Horizontal handles (Cat. 54).

Band-cup

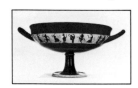

17. The rounded rim is glazed, and the figure decoration is limited to the handle-zone. Horizontal handles; fillet between bowl and stem; flaring foot with narrow edge and broad resting surface (Cat. 57). Pyxis by the Amasis Painter, see Appendix 4.

Lip-cup

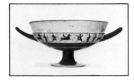

18. The only known lip-cup by the Amasis Painter is a hybrid, in that the figure decoration on the outside is not on the flaring lip but in the handle-zone, which normally carries an inscription (either the potter's signature or a greeting). The foot is that of the Siana cup, and the stem is short. Horizontal handles (Cat. 58).

Cup of Type A

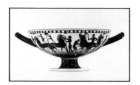

19. Standard. Convex bowl with continuous walls; fillet between bowl and stem; flat foot with broad resting surface and reserved edge (Cat. 60).

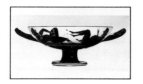

20. Variant. This cup resembles the standard cup of type A in having a continuous convex wall and a foot of type A, with the heavy foot-plate that has a reserved, slightly concave edge, but it lacks the characteristic fillet between stem and bowl. Horizontal handles (Cat. 61).

Special Cup, Approximating Type B

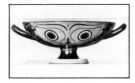

21. The chief difference between cups of type A and those of type B is the treatment of the foot and stem. In type B, there is no fillet between bowl and stem; instead, the concave stem merges with the bowl. A small fillet appears on top of the foot-plate near the edge, which is rounded. The inside of the stem meets the resting surface of the foot-plate at a sharp angle, which disappears in the later standard feet of type B (Cat. 62).

Other Shapes

The standlet of Sosian type by the Amasis Painter (*ABV* 157, no. 90, here fig. 92) is a fragment only, lacking the stem and foot. A fragment from the Acropolis (*ABV* 155, no. 71) is glazed on the inside and may come from a krater. The mastos fragment, now lost (*ABV* 156, no. 77), is probably not by the Amasis Painter but by the Painter of Louvre E 705 (Elbows Out). For a tripod pyxis by the Amasis Painter, see Appendix 4.

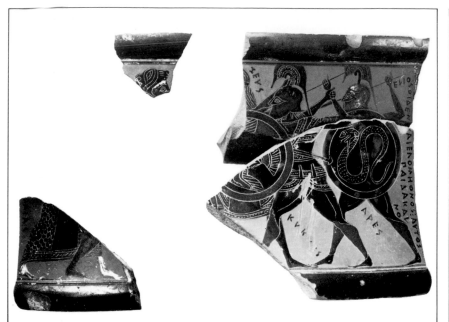

[App. 4.] A1, A2, and A3. 1:1

[App. 4.] B1 and B2. 1:1

Stories of gods and heroes—Herakles' fight with Kyknos (side A) and Kastor and Polydeukes setting out (side B)—and the contemporary Attic scene of youths mingling in conversation and love (side C) are the themes on the three faces of a tripod-pyxis by the Amasis Painter. The fragments, which delight eye and ear, were revealed in 1972 during the excavations at the temple of Aphaia on the island of Aegina. (One sherd [from B, with Tyndareos' feet] had already come to light in 1970.)

Picture A (four fragments). A1: left bottom corner, with Athena striding to right in scale-patterned chiton with central panel. Her name is written in the genitive: [AΘEN]AIAS. She is overlapped by the rear (probably right) leg of Herakles, whose head in the lion-skin appears on a sherd from the upper rim (A2). In A3 we have the right-hand half of the picture together with part of the bowl. Kyknos (KYKNOS), in the front plane

of the picture, thrusts at Herakles with raised spear. His shield bears an eagle, and he wears greaves, short chiton, corslet, and Corinthian helmet with stilted crest. His left foot and Herakles' forward (left) foot must have touched in the center of the frieze. In the second plane can be seen Herakles' left arm, the hand gripping his enemy's crest-stem. Finally, in the deepest plane, appear Kyknos' grandfather Zeus (IEYS), and father, Ares (APES). Zeus strides to the right but turns a threatening look back on Herakles. He is acting against both sides, since with his left hand he is restraining Kyknos, gripping his wrist as he thrusts his spear at Herakles. Zeus wants to resolve the quarrel, while Ares, a snake on his shield, spear raised, hurries in from the right to support his son in the combat. One may compare the artist's treatment of the Kyknos theme on the Paris panel-amphora (Cat. 5). The shields are drawn with the compass (diam. 2.5 cm.). One can see clearly how the painter drew Ares' naked body first, so that it

shows in still deeper black through the color of the shield-disc, which was applied slightly too thinly.

Picture B (two fragments). A piece of the vase-rim joining A3 gives the left top corner (B1) and another fragment, the left bottom corner (B2). Tyndareos ([TYNΔAP]EO) waves good-bye to his sons. On B2 he is overlapped by the tail and leg of Kastor's horse. Kastor (KASTO[P]) (in the genitive too?) stands behind the horse he is leading with his right hand. In his left hand he held the pair of spears on his shoulder. The bulge in front of one spear must be the neck-guard of his corslet. Tyndareos has long hair behind but is balding; wrinkles are incised on his brow and neck and dots for the stubbly hair.

Picture C (three fragments). Most of the lower edge is preserved. The picture shows eight youths or men. On the left of C1 stands an onlooker, who holds gear for exercise: javelin and round oil-flask

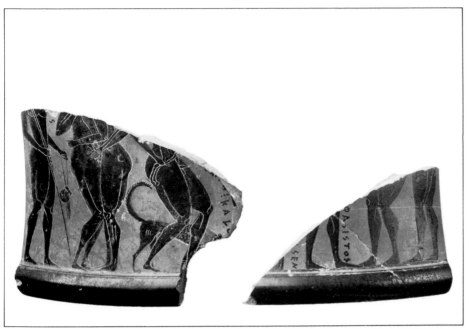

[App. 4.] C1 and C2. 1:1

(aryballos). In front of him we see a couple in an embrace. The lover, who was probably bearded, bends his knees a little. His right hand is raised, no doubt to caress the chin of his younger partner. He has reached his left arm round the beloved, whose member he clasps. The object of his passion rests one arm (a taenia, a love-gift, hanging from the wrist) on his friend's hip. At the opposite end of the frieze (C2) stands another onlooker, again with a pair in front of him, but not enough is preserved to tell how the artist treated this group. The rather larger figure on the right must have been the lover, his left hand probably touching the beloved's chin and the right his middle. The center was occupied by a third pair. Of the right-hand figure only one heel and a trace of one knee remain, but these are enough to show that he stood straight, quietly accepting the attentions of his larger and more active partner, the man with the dog. This is probably a hunting

hound, since its owner carries a hare, certainly a live animal, caught by being driven into a net: the paederast's love-gift, evidently eagerly offered to the beloved. (On the different types of such love-scenes, see J. D. Beazley, "Some Attic Vases in the Cyprus Museum," *Proceedings of the British Academy* 33 [1948] 6 – 31.) Reading from right to left, the couples in our picture correspond to Beazley's Types α, β, and γ, though the canonical present in β is a cock, not a hare; and the lover's action with his left hand in the climactic group on the left is unusual. To the right of the central pair is the end of a verb, and one may assume that the potter's signature appeared here. The most likely restoration is [ΑΜΑΣΙΣΕΓΟΙ]ΕΣΕΝ or [ΑΜΑΣΙΣΜΕΓΟΙ]ΕΣΕΝ. The painter has named the third figure from the right [ΑΓΡΟ]ΦΑΣΙΣΤΟΣ, so characterizing the boy as "nothing loth." In front of the sporting youth's breast on the left there is not much room, and here there was probably only the word ΚΑΙΟ[ς]. This

makes sense as a delighted exclamation of the onlooker. Kalos appears again in a prominent position near the middle of the picture. Before it comes an interpoint, and there are two possible restorations for the remains of letters leading up to it. One is ΕΜΕΝːΚΑΙΟ[ς] "Oh, how beautiful." This fits the context, put by the painter in the mouth of the man giving the hare, in praise of his friend (hardly of the hare). The alternative reading is: [ΑΝΘ]ΕΜΙ[Ο]Νː ΚΑΙΟ[ς] (M. Robertson). For ἦ μὴν χαλός see *LSJ* ἦ I, l; one may compare Bacchylides, ed. B. Snell (Leipzig, 1934) p. 90, fr. 18 (refrain): ἦ χαλὸς θεόχριτος (ἦ <μὴν>?). On Anthemion, a name documented in the fifth century, see E. Kirchner, *Prosopographia Attica,* 935 – 42; on Aprophasistos, *ibid.* 1573.

The painter provides one other inscription, a longer one: an important text from a poem. This he has written at the right hand edge of picture A. It has nothing to do with the legend illustrated, and in character belongs with the love-scenes on C. The only place, however, where the painter could fit it in was behind Ares. It is written in two lines, with a return of the second in end-boustrophedon, and runs: ΕΝΙΟΣΟΙΔΕΝΚΑΙΕΛΟΜΗΟΝΟΣː ΑΥΤΟΣΓΑΙΔΑΚΑΙΟΝ There are two possible ways of reading the verse. If we begin after the interpoint and then go back to the beginning, we get a complete Major Asclepiad, such as is often found in Attic symposium-songs (skolia). The meaning is then: "The sun itself and I alone know the beautiful boy." One would prefer, however, to read the poem as the painter wrote it. In that case it must be the end of one verse and the beginning

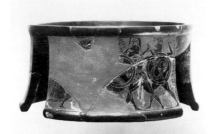

[App. 4.] Side A (reconstructed)

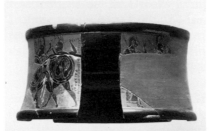

[App. 4.] Sides A and B (reconstructed)

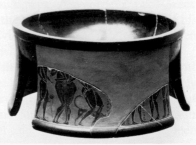

[App. 4.] Side C (reconstructed).

of a second: − − − ∪ ∪ − ‖
ʽΗλιος οἶδεν καὶ ἐγὼ μόνος:
αὐτὸς παῖδα καλὸν
‖ − ∪ ∪ − − ∪ ∪ − ∪ ῡ.
"…Helios knows and
I alone" and "the beautiful boy
he himself has…", where the
expression "he himself" refers
back to Helios. The underlying
thought is different in the two
cases. In the first the lover is con-
cealing the name of his be-
loved, known only to the divine
and omniscient sunlight. The rea-
son for concealment is probably
worry lest others should go court-
ing the loved boy. That at least is
the thought in an epigram ascribed
to Plato (*Anth. Pal.* 7.100). In the
other reading, the name of the "pais
kalos" and a descriptive epithet for
Helios may have come at the be-
ginning of the first line. In that
case the poem is in praise of a be-
loved whom no one else knows
how to appreciate, a common con-
ceit in erotic epigrams (e.g. *Anth.
Pal.* 12.51, ascribed to Callimachus;
cf. also 12.130). In any case the
interpoint marks the end of a verse.
Neither the lack of an aspirate in
"Elios" nor its presence in
"mhonos" are unusual. On the first,
see L. Threatte, *A Grammar of Attic
Inscriptions* (1980) 494, 499; on the
second, *ibid.,* 25. The poem is cer-
tainly Attic, since monos with short
o is not the Ionic form.

The pyxis, which was dedicated to
the goddess Aphaia, stands apart in
the work of the Amasis Painter. In
the first place it is an unusual form
of vase for him, but the choice and
treatment of the themes are also ex-
ceptional. Most remarkable of all
is the wealth of inscriptions, es-
pecially the two occurrences of
"kalos" and finally the revelation of
a hitherto unknown Attic skolion.
The pyxis is to be dated in the art-
ist's middle period (around 540).

Dimensions and Condition
Height ca. 7.3 cm.; outer diameter of
mouth, ca. 14.0 cm.; the convex pic-
ture fields, ca. 10.1 x 5.7 cm. (flattened
out, ca. 10.8); distance between legs,
3.1 cm. (top); width of mouth-rim,
0.75 cm. Put together from nine frag-
ments and restored; no overpainting.
Surface well preserved except on the
lower right fragment of A which has
deposit stains and scratches: Kyknos'
chiton and thighs, surface between his
legs with inscription (N and O
scratched away). Splintering on the
mouth.

Shape and Decoration
Not a scrap has been found of a lid, but
there must have been one with a lip
projecting to cover the upper surface of
the vase-mouth which is flat and left in
the color of the clay. From the broad
rectangular legs large parts of A and
C are preserved. A gives us the vase
height, and the large fragment of B
joins on the right and gives us the dis-
tance between the legs. The form of

the finely potted vessel is almost com-
pletely certain. The echinus-molding
of the mouth and the similar one at the
bottom of the feet are glazed and set
off by the very sharp grooves; and the
floor of the bowl is articulated on the
outside by a strong contraction. The
figures stand or move on a black line,
and another black line bounds the pic-
tures at the top.

Added Colors
Red: on A, middle panel of Athena's
scale-patterned skirt; wrinkles on Her-
akles' lion-mask between muzzle and
eye, and lion's ear; Zeus' hair-band and
five dots on the central strip of his gar-
ment; Kyknos' crest-stem, the neckline
of his corslet, four dots on his chiton
(below the corslet, on the backward
leg), greaves, and on his shield the
rim, the eagle's tail-root and the middle
section of its wings; Ares' crest-stem,
greaves, and eight dots on his shield-
rim (once probably nine); on B, Tyn-
dareos' head-band and beard, dots on
his chiton and the centers of the two
dot-rosettes; Kastor's crest-stem; on C,
aryballos and taenia, hair on the dog's
neck. *White:* Athena's feet; claws of
Herakles' lion-skin; circle of dots in the
two dot-rosettes on Tyndareos' chiton.
All the inscriptions are painted in black.

Bibliography
Full publication will appear in the
series "Aegina, Aphaia-Tempel" in the
Archäologischer Anzeiger. I am grateful to
Martin Robertson for translating my
text.

CHRONOLOGY

	PANEL-AMPHORAE (TYPE B) upright buds	PANEL-AMPHORAE (TYPE B) palmette-lotus festoon	PANEL-AMPHORAE (TYPE A)	NECK-AMPHORAE	OLPAI	OINOCHOAI, SHAPE III (CHOES)	OINOCHOAI, SHAPE I	LEKYTHOI (SHOULDER TYPE)	LEKYTHOS (SUB-DEIANEIRA SHAPE)	ARYBALLOS	MASTOID	CUP-SKYPHOS	BAND-CUPS	LIP-CUP (HYBRID)	CUPS OF TYPE A	CUPS OF SPECIAL TYPE	FRAGMENTS
EARLY PERIOD (560–550 B.C.)	3	1 2 2 bis				33		39 40 41 42 43 44 45 46						58	59		
MIDDLE PERIOD (550–530 B.C.)	7 8 10 11	4 5 6 9 12 13 14 15	18 18bis 19	21 22 23*	26 27* 28* 29 31*	34 35 36	37	47 48 49 50	51	52	53	54	55* 56 57	60			20 16
LATE PERIOD (530–515 B.C.)				24* 25*	30 32		38								61	62* 63	17*

239

GLOSSARY

ARMS AND ARMOR

Aegis: A breastplate of Athena (originally goatskin), to which the terrifying gorgoneion, the severed head of Medusa, is affixed.

Attic helmet: A helmet of the shape traditionally called Attic, with nosepiece and with or without cheekpieces.

Chape: The end of a scabbard, worked separately, and often of material different from that of the scabbard.

Corinthian helmet: A helmet with a nosepiece covering the nose and with cheekpieces that cover most of the face.

Corslet: See cuirass.

Cuirass: Body armor, made of bronze, leather, or linen, covering the trunk of the warrior to below the waist.

Greaves: Bronze shin guards that cover the lower legs from below the knee to the ankle and cover most of the calves. To put on a greave, the open edges are spread apart and the greave is clapped on the leg.

Half-crest: A short crest of a helmet; they often occur in pairs.

Hoplite: A foot soldier in heavy armor (helmet, cuirass, greaves, heavy shield, spear, sword, scabbard, baldric).

Protome: The forepart of an animal or monster; often used as a heraldic shield device.

Pteryges (literally "wings"): The flexible flaps of a cuirass attached to its lower rim. The pteryges protect the lower abdomen and groin of the warrior without restricting his movements.

CLOTHING

Chiton: A long undergarment worn by men and women.

Chitoniskos: The same as a chiton, but of only knee length.

Chlamys: A short mantle worn especially by hunters, travelers, and light-armed warriors.

Fillet: A wreath made of cloth or wool worn on the head.

Himation: A heavy outer garment, usually worn over one shoulder only and reaching to the ankles.

Krobylos: A fashion of tying up the long hair of men and women at the nape.

Nebris: An animal skin, normally of a deer, worn over the chiton or chitoniskos by some gods, goddesses, or heroes.

Peplos: The distinctive long Doric garment worn by women, open on one side and belted.

Petasos: A wide-brimmed hat worn by hunters, travelers, light-armed soldiers, and by Hermes and some heroes as well.

OTHERS

Corymbs: The berry clusters of ivy.

Diphros: One of several varieties of a Greek seat or stool.

Gorgoneion: The severed head of Medusa, the Gorgon slain by Perseus; it is often found attached to the aegis of Athena, as a shield device, as the tondo decoration of black-figured cups, or on the outsides of skyphoi and other shapes.

Kalathos: A wool basket.

Kibisis: The satchel in which Perseus carried the gorgoneion after he had beheaded Medusa.

Komast: A reveler.

Komos: A revel.

Lagobolon: A slightly curved stick thrown in the hunting of hares (hence the name, composed of "hare" and "throw").

Maenad: A female follower of Dionysos.

Metope: An alternating rectangular unit of the entablature of a Doric temple.

Parochos: The best man (at a wedding).

Satyr: A male follower of Dionysos equipped with horse's ears and a horse's tail; usually snub-nosed and bearded.

Thetes (plural of *thes*): The lowest class of citizen in Athens.

Thiasos: As opposed to *komos,* the revel of satyrs and maenads in the entourage of Dionysos.

Tilka: The Indian caste mark painted on the forehead, similar to the mark(s) on the forehead of Medusa.

Tondo: Originally the round bottom of a barrel; the term has been used since the Renaissance to denote a circular painting and is the standard term for the picture painted on the interior of painted cups.

Triglyph: An alternating rectangular unit of the entablature of a Doric temple.

I. Vases attributed to the Amasis Painter in the exhibition

1. J. D. Beazley	*Attic Black-figure Vase-painters* (1956)		*Cat.*
150, no. 2			1
150, no. 3			7
150, no. 4			12
150, no. 5			11
150, no. 6			5
150, no. 7			14
150, no. 8			15
150, no. 9			9
151, no. 13			13
151, no. 22			19
152, no. 24			22
152, no. 25			23
152, no. 26			24
152, no. 27			25
152, no. 29			27
152, no. 30			28
153, no. 31			26
153, no. 32			31
153, no. 36			32
153, no. 38			29
153, no. 41			34
154, no. 45			36
154, no. 46			35
154, no. 47			37
154, no. 48			38
154, no. 49			41
154, no. 50			40
154, no. 52			42
154, no. 53			46
154, no. 55			44
154, no. 57			48
154, no. 58			49
155, no. 59			50
155, no. 60			45
155, no. 65			20
156, no. 76			53
156, no. 80			54
156, no. 81			57
157, no. 85			58
157, no. 86			61
157, no. 87			62
157, no. 89			63

2. J. D. Beazley	*Paralipomena* (1971)	*Cat.*
65	Munich inv. 8763	4
65	Swiss, private	2
65	Aachen, Ludwig	8
65	Copenhagen 14397	13
65	Aachen, Ludwig	6
65	Swiss, private	21
66	New York 59.11.17	30
66	Tübingen Z234	39
66	New York 56.11.1	47
66	Copenhagen inv. 14067	51
66	New York 62.11.11	52
67	Mayence, Univ., inv. 88	59
67	Kings Point, Schimmel	60

3. Not in *ABV* or *Paralipomena*

Basel, Herbert A. Cahn	16
Malibu 79.AE.197	55
New York 1978.11.22	33
New York 1984.313.1	56
New York 1984.313.2	18
New York 1985.11.2	17
New York 1985.53	2 bis
New York 1985.57	18 bis
Paris, Louvre Cp 10520	43
Vatican 17743	3

II. Vases attributed to the Amasis Painter, not in the exhibition but illustrated in the catalogue as comparison figures:

1. J. D. Beazley *Attic Black-figure Vase-painters* (1956)

150, no. 1	Guglielmi	figs. 57, a, b
151, no. 11	Berlin 1690	fig. 58
12	Berlin 1691	fig. 63
13	Orvieto, Faina, 40	figs. 60 a, b, c
18	Samos	fig. 67
19	Palermo	fig. 57 bis
20	Bonn 504	figs. 27, 44 a, b
21	Berlin inv. 3210	figs. 45 a, b, 74
152, no. 23	Lausanne, Embiricos	figs. 56 a, b
153, no. 39	Athens Acr. 1882	fig. 96
153, no. 42	Florence 1791	fig. 79
43	Orvieto 1001	fig. 117
44	Bristol H 803	fig. 84
154, no. 54	Villa Giulia 24996	fig. 111
56	Leningrad inv. 2635	figs. 64, a, b, c
155, no. 61	once Athens, Ceramicus inv. 25	figs. 59 a, b
62	Athens 404	fig. 101
63	Villa Giulia	fig. 94
64	Athens, Agora P 12628	fig. 34
67	London B600.31	fig. 61
156, no. 83	Berlin F1795	figs. 110, a, b
84	Cracow inv. 30	figs. 109 a, b
157, no. 88	Florence	figs. 114 a, b
90	Athens, Acr. 2481	fig. 92
92	Athens, Acr. 2510	fig. 104
714, no. 31 bis	Agora P24673	figs. 89, 117
61 bis	Athens 19163	fig. 99

2. J. D. Beazley *Paralipomena* (1971)

65	Basel Kä 420	figs. 32, 40
65	Kavala 983	figs. 70 a, b
65	Riehen, Hoek	figs. 43 a − b
66	Athens, two fragments	fig. 87
66	Vogelsanger	figs. 98 a, b, c
66	Warsaw	fig. 39
66	Kanellopoulos	figs. 38 a, b, c, d
67	Tel Aviv	figs. 95 a, b

III. Vases attributed to the Amasis Painter, not in the exhibition and not in Beazley *ABV* or *Paralipomena*

Aegina	Appendix 4
Cyrene Sb. 417.6	fig. 42
Cyrene inv. 81.40	fig. 52
Madrid, Gomez-Moreno	fig. 108
Oxford G 568	fig. 62
Samos	fig. 71

IV. Vases not attributed to the Amasis Painter but illustrated in the catalogue (by cities and collections with *ABV, ARV²*, and *Paralipomena* references). (The shape is given only when there is no museum number.)

Amiens, Musée de Picardie
3057.179.40	*ABV* 691, no. 5	fig. 86

Amsterdam, Allard Pierson Museum
8192		fig. 107

Athens, National Museum
192		fig. 6
1002	*ABV* 4, no. 1	fig. 91
1055	*ABV* 347 – 348	fig. 103
1260	*ARV²* 1060, no. 145	fig. 5
15499	*ABV* 39, no. 16	fig. 36
Acr. 607	*ABV* 107, no. 1	fig. 24
Acr. 611	*ABV* 82, no. 1	fig. 22

Basel, Antikenmuseum und Sammlung Ludwig
L 21		fig. 48

Basel, Helene Kambli
(amphora)	*ABV* 109, no. 25	fig. 28

Basel, private
(amphora)		fig. 47

Berlin, Staatliche Museen
F 1714	*ABV* 169, no. 6	fig. 82
F 1720	*ABV* 143, no. 1	fig. 16

Boston, Museum of Fine Arts
98.923	*ABV* 169, no. 3	fig. 76
60.1	*Paralipomena* 107, no. 7	fig. 65

Brussels, Musées Royaux d'Art et d'Histoire
A 714	*ABV* 169, no. 1	fig. 81

Brescia, Museo Civico
(amphora)	*ABV* 292, no. 1	fig. 66

Budapest, Hungarian Museum of Fine Arts
50.189	*Paralipomena* 61	fig. 35

Cambridge (Mass.), Fogg Art Museum
1925.30.125	*ABV* 108, no. 9	fig. 97

Chicago, Art Institute
1978.114		fig. 50

Florence, Museo Archeologico
4209	*ABV* 76, no. 1	fig. 23

Giessen, Justus Liebig-Universität
(lekythos)		fig. 100

Ischia, Museo
(inscribed cup)		fig. 7

London, The British Museum
B 148	*ABV* 109, no. 29	figs. 30, 31
B 166		fig. 85
B 210	*ABV* 144, no. 7	fig. 41
B 215	*ABV* 286, no. 1	fig. 113
B 295	*ABV* 226, no. 1	fig. 33
B 421	*ABV* 181, no. 1	fig. 83
E 767	*ARV²* 31, no. 6	fig. 119
W 38	*ABV* 313, no. 2	fig. 53
1948.10 – 15.1	*ABV* 108, no. 8	fig. 29

Madison (Wis.), Elvehjem Museum of Art
(amphora, on loan to)		fig. 51

Malibu (Calif.), The J. Paul Getty Museum
76.AE.48		App. 1
80.AE.54		App. 2.1
83.AE.217		App. 2.2

Munich, Staatliche Antikensammlung und Glyptothek
1447	*ABV* 81, no. 1	fig. 73
1468	*ABV* 315, no. 3	fig. 49
1717	*ABV* 362, no. 36	fig. 15
2044	*ABV* 146, no. 21	fig. 115
2307	*ARV*² 26, no. 1	fig. 17
inv. 7739	*ABV* 64, no. 28	fig. 55

New York, The Metropolitan Museum of Art
14.130.12	*ABV* 322, no. 6	fig. 14
26.49	*ABV* 83, no. 4	fig. 21
31.11.4	*ABV* 78, no. 12	fig. 93
56.171.13	*ABV* 136, no. 50	fig. 18
56.171.21	*ABV* 321, no. 2	fig. 88
64.11.13	*Paralipomena* 71, no. 4 bis	fig. 77
1972.11.10		fig. 54
1978.11.13		fig. 37
1978.11.21	*ARV*² 75, no. 54	fig. 116
1984.501	(belongs to *ABV* 247, no. 99)	fig. 106
1985.11.1		fig. 25

New York, private
(neck-amphora)	fig. 78

Orvieto, Museo Civico
296	*ABV* 58, no. 126	fig. 20

Orvieto, Museo Faina
84	fig. 112

Oxford, Ashmolean Museum of Art and Archaeology
G 568		fig. 62
1965.135	*ABV* 137, no. 59	fig. 80

Paris, Bibliothèque Nationale, Cabinet des Médailles
535	*ARV*² 191, no. 103	fig. 75

Paris, Musée du Louvre
F 53	*Paralipomena* 55, no. 49	fig. 68
MNC 676	*ABV* 57, no. 118	fig. 105

Philadelphia, University of Pennsylvania, University Museum
MS 3442	*ABV* 145, no. 14	fig. 19

(once) Riehen, Mrs. Margarete Gsell-Busse
(amphora)	*Paralipomena* 27, no. 61	fig. 46

Rome, Museo Nazionale Etrusco di Villa Giulia
M.430	*ABV* 108, no. 14	fig. 26

Toledo, (Ohio), Toledo Museum of Art
61.23	*Paralipomena* 147, no. 5 ter	fig. 13
80.1022 A and B		fig. 69

The photographs and illustrations reproduced in the comparison figures have been provided by the owners of the original works except as noted in the photo captions and in the following cases:

Archaeological Service, Athens 87; Ars Antiqua, Geneva 48; Marie Beazley 57a, b; Gad Borel-Boissonas, 51; Dietrich von Bothmer 31, 39a, b, 60a, b, c, 64, 68, 75, 81, 86, 102, 111, 112, Cat. 6 lid; Andrew J. Clark 61, 62; Deutsches Archäologisches Institut, Athens 59, 67, 71, 101, App. 4; Deutsches Archäologisches Institut, Madrid 108; Deutsches Archäologisches Institut, Rome 60b; Ecole Française d'Athènes 38a, b, c, d; Giraudon, Paris 29708, 105; Max Hirmer, Munich 24, 66, 91; *JHS* 51 (1931), p. 265, 94; Craig A. Mauzy 117; The Metropolitan Museum of Art, New York 90; National Museum, Athens 92; Ronald Stroud, 12; Summa Galleries, Beverly Hills 50; Dieter Widmer, Basel 32, 43, 46, 47, 56a, b, 78, 98a, b, c; Donald White 42.

Profile drawings have been inked by Martha Breen Bredemeyer from drawings published by Hansjörg Bloesch in *CVA* Geneva, fasc. 2 (1980): Cat. 15; and by Heide Mommsen, *CVA* Berlin, fasc. 5 (1980): Cat. 9 and ibid., in *CVA* Mainz, Universität, fasc. 1 (1959): Cat. 59; and from drawings provided by Dietrich von Bothmer: Cat. 3, 13, 19, 20, 23, 24, 38, 60, 61; by Andrew J. Clark: Cat. 26, 27, 28, 30, 31, 32, 33, 34, 36, 37.

The following graffiti and dipinti were inked by Martha Breen Bredemeyer after *Sammlung Ludwig,* p. 53: Cat. 6 (dipinto of four dots added by Dietrich von Bothmer); pp. 54 – 57: Cat. 8; p. 18: Cat. 14. The four maps (figs. 1, 2, 8, 9) were drawn by Martha Breen Bredemeyer.

Editor	Sandra Knudsen Morgan
Design	Dana Levy, Perpetua Press, Los Angeles
Copy Editor	Sylvia Tidwell
Typography	Andresen Typographics, Tucson, Arizona
Printing	Nissha Printing Company, Kyoto
	Printed in an edition of 2,000 clothbound and 2,500 paperbound copies